The Language of Silence

"*The Language of Silence* is a particularly important contribution to literary criticism. More than half a century after the Holocaust it is the first book-length study that analyzes in a critical manner how the West German novel has tried—and often failed—to cope with the burden of the past, with the legacy of the Shoah. Schlant contributes to what she misses in many German novels: mourning of the destruction of Jews in Germany and Europe."

—*Paul Michael Lützeler, Rosa May Distinguished University Professor in the Humanities, Washington University*

"Ernestine Schlant's *The Language of Silence* is one of the most important books on West German culture to appear since the fall of the wall. Schlant details how the Holocaust remains the central preoccupation of (non-Jewish) writers and thinkers from 1949 to the present. Schlant's book is subtle; it presents to an English-language audience the dilemma of major writers, from the Nobel prize–winning Heinrich Böll to the German emigrant novelist W. G. Sebald, who define themselves as Germans through the Shoah. She provides revealing insights into the obsessive nature of West German culture and its positive transformation of guilt into art."

—*Sander L. Gilman, Henry R. Luce Professor of Liberal Arts in Human Biology, the University of Chicago*

"In *The Language of Silence*, Ernestine Schlant turns the postwar German fiction that portrays—or distorts—the inferno of the Holocaust into a whole spectrum of images mirroring present-day German societal attitudes toward the past. Breaking new ground as a critic, she holds such novels and stories, given their awesome theme, not only to conventional literary but also to the highest ethical standards. By going beyond narrow analyses of her selected texts she provides both experts and readers unfamiliar with them with an eerily gripping account of the German perspective of the aftermath of the Holocaust."

—*Guy Stern, Distinguished Professor of German, Wayne State University*

The Language of Silence

*West German Literature
and the Holocaust*

ERNESTINE SCHLANT

Routledge
New York London

Published in 1999 by
Routledge
29 West 35th Street
New York, NY 10001

Published in Great Britain by
Routledge
11 New Fetter Lane
London EC4P 4EE

Printed in the United States of America on acid-free paper.

Designed by Jeff Hoffman

10 9 8 7 6 5 4 3 2 1

Library of Congress Cataloging-in-Publication Data

Schlant, Ernestine.
 The language of silence : West German literature
and the Holocaust / Ernestine Schlant.
 p. cm.
 Includes bibliographical references and index.
 ISBN 0–415–92219–4 (alk. paper). —
 ISBN 0–415–92220–8 (pbk.)
 1. German literature—20th century—History and criticism.
 2. German literature—Germany (West)—History and criticism.
 3. Holocaust, Jewish (1939–1945), in literature. I. Title.
 PT405.S3443 1999
 830.9'358—dc21 98-41108
 CIP

For my daughters
Stephanie and Theresa Anne

Contents

Acknowledgments

It gives me great pleasure at the completion of this book to acknowledge the support of many friends and colleagues over nearly a decade. Their sustaining interest helped me to grapple with painful issues, and their suggestions sharpened my thought. In addition, many colleges and universities gave me the opportunities and the forums to test my ideas against critical opinion.

The Woodrow Wilson International Center for Scholars awarded me a fellowship that gave me the time to bring the book into focus; Miriam Weissbecker and Jason Wright of the center taught me the luxury of having dedicated research assistants. During several semesters, Montclair State University lightened my teaching load and granted me a Distinguished Scholar Award, which gave me essential time for the final stages of writing. The staff of the Montclair State University Library, in particular Norman Stock and Thomas Trone, always went beyond the call of duty to provide me with books and information.

I want to thank the following journals for giving permission to reprint revised versions of published articles: *Modern Language Studies* (Winter 1991), *Studies in 20th Century Literature* (Summer 1994), and *German Studies Review* (October 1996).

In particular, I want to express my appreciation to Lily Gardner Feldman, who was one of the earliest and most insistent supporters of the project; her encouragement helped me to conceptualize a book rather than a series of isolated articles. I owe thanks to Peter Holquist, Ben Lapp, Fran Lebowitz, Frank Mecklenburg, Sybil Milton, and Carla Petievich for keeping me updated on areas of research less familiar to me. Irmgard Feix verified sources at the Militärgeschichtliche Forschungsamt in Freiburg, and Kersten Koch of the American Institute of Contemporary German Studies responded with great speed to my frequent inquiries. Ingeborg Glier, Rita Jacobs, and Carol Strauss read parts of the manuscript at various stages. I profited immensely from discussions with Guy Stern and Sidney Heyman, who encouraged me to write an early version of my thoughts for the *Aspen Institute Quarterly*. Hermann and Hanne Lenz, Peter Schneider and Ruźa Spak, and Omer Bartov provided stimulating food for thought.

I am particularly grateful to Sara Lippincott, who edited the manuscript with more care than I could ever imagine was possible; to Bill Germano, my editor at Routledge, who saw the importance of timely publication; to Nick Syrett, Liana Fredley, and Matthew Papa, who chaperoned the project through the process.

To Sander Gilman I owe a special debt of gratitude; he was there when I most needed help. Walter Hinderer supported the project from its inception, with advice and opportunities to discuss my emerging views.

More than anybody else, I want to thank my husband, Bill Bradley, for his steadfast encouragement and editorial suggestions and for his imperturbable patience as I made infinitely slow progress. He understood and supported my need to write this book and gave me the confidence to see it through to completion. But, as the saying goes, it takes one to know one.

A Note on Translations

Unless otherwise indicated, I use the published English translation of a text.

If a work has not been translated into English, my translation of the German title into English follows in parentheses after the German title; quotations in English from all such texts are my own translations.

In the bibliography, the first date in parentheses in translated publications refers to the publication for the German original; the second date is that of the English publication.

Introduction

Perhaps I write because I see no better way to be silent.[1]

There are many kinds of silence and many ways to be silent. . . . Silence . . . speaks and is as risky as speech.[2]

In Berlin, outside the Grunewald train station where the trains left for Auschwitz, there is a monument to those who were deported and killed. It is a long straight wall of exposed concrete, perhaps 15 feet high, which appears to hold back the earth rising up behind it. Cut into the wall are the outline of human figures moving in the direction of the station. The figures themselves are nonexistent; it is the surrounding cement that makes their absence visible.

This monument, in which presence is stated as absence, and in which the solidity of the wall serves to make this absence visible, has its analogue in literature. It is my contention that in its approach to the Holocaust, the West German literature of four decades has been a literature of absence and silence contoured by language. Yet this silence is not a uniform, monolithic emptiness. A great variety of narrative strategies have delineated and broken these contours, in a contradictory endeavor to keep silent about the silence and simultaneously make it resonate. My aim in this study is to convey some sense of the multiplicity of these strategies and of the motives that prompt them.

The Holocaust has been a presence in German literature from the early postwar period to the present, and the strategies employed in the

attempts to circumvent, repress, or deny knowledge of it are as much an indication of that knowledge as the often groping and inept efforts to face up to the crimes of the Nazi regime. Although the word "Holocaust" immediately conjures up the vision of concentration and extermination camps in which millions of human beings were murdered under the most horrifying circumstances, a more clearly elaborated definition is necessary for the purposes of this study.[3] By "Holocaust" I mean more than the annihilation of millions of human beings under hitherto unimaginable bestiality; I include in this definition the mechanisms, behavior, and attitudes that operated in all of Nazi-occupied Europe for the purposes of hunting down and rounding up Jews in order to murder them. These mechanisms included the "laws" that deprived the Jews not only of their political and civil rights, but also of their human dignity. For Jean Améry, Holocaust survivor and expatriate German intellectual, these "laws," issued from 1933 on, already contained the threat of annihilation.

> The death threat, which I felt for the first time with complete clarity while reading the Nuremberg Laws, included what is commonly referred to as the methodic "degradation" of the Jews by the Nazis. Formulated differently: the denial of human dignity sounded the death threat.[4]

Ultimately these "laws" led to the establishment of what has been termed the *univers concentrationnaire*, defined by the literary scholar Sidra DeKoven Ezrahi as follows:

> The adjective *concentrationary,*used here as in the English version of [David] Rousset's memoir as a rough translation of *concentrationnaire*, is not necessarily limited in its reference to the geographical confines of the camps but may allude to the general condition of the Jew in Europe during World War II, who, whether incarcerated in a ghetto or a concentration camp, posing as an Aryan, or hiding in a barn, an attic, or a forest, was marked for extermination.[5]

"Holocaust" and *univers concentrationnaire* are not exactly coterminous; nevertheless, in the present study I shall use the word "Holocaust" in the sense of *univers concentrationnaire*.

Despite frequent allegations that Germans prefer to forget the Holocaust, the enormity of these crimes and their legacy have become part of German self-understanding. How Germans cope with this self-understanding, what strategies they have developed to omit, distort, or cushion this realization, what contexts needed to be set up in order to confront this past, what blind spots are operating to this day, will be analyzed in the following chapters.

• • •

The use of purely literary works to analyze German attempts to come to terms with the crimes of the Nazi regime—specifically, the genocide of the Jews—needs, if not a justification, at least an explanantion. As the boundaries between historiography and fiction as repositories of memory become ever more blurred and the problematics of narrativity dominate current scholarly debates, it is all the more important to point up the differences between the two fields and to focus on the qualities that distinguish literature from historiography. This study is premised on the privileged position of literature as the seismograph of a people's moral positions. Historians, political scientists, economists, and journalists are constrained (or ought to be) by facts and other objective criteria, whereas literature projects the play of the imagination, exposing levels of conscience and consciousness that are part of a culture's unstated assumptions and frequently unacknowledged elsewhere. Because they are unconsciously held, these assumptions provide greater insight into the moral positions of a work than do its explicit opinions and images, which are often censored or the expression of wishful thinking. Literature lays bare a people's dreams and nightmares, its hopes and apprehensions, its moral positions and its failures. It reveals even where it is silent; its blind spots and absences speak a language stripped of conscious agendas. The literary works to be discussed in this study therefore reveal a level of discourse that, though it may have eluded authorial consciousness, does not elude careful literary exegesis. The British scholar Terry Eagleton speaks of a work's "sub-texts" and areas of "blindness" that reveal these unconsciously held assumptions.

> [W]e are constructing what may be called a "sub-text" for the work—a text which runs within it, visible at certain "symptomatic" points of ambiguity, evasion or overemphasis, and which we as readers are able to "write" even if the novel itself does not. All literary works contain one or more such sub-texts, and there is a sense in which they may be spoken of as the "unconscious" of the work itself. The work's insights, as with all writing, are deeply related to its blindnesses: what it does not say, and *how* it does not say it, may be as important as what it articulates; what seems absent, marginal or ambivalent about it may provide a central clue to its meanings.[6]

Of all literary genres, the novel is probably richest in these unstated assumptions. Fiction is malleable and protean in its appropriation of the most diverse kinds of discourses. Even at its sparsest, it is not as hermetically closed as poetry or as situationally confined as drama. It is inclusive and panoramic. (Only film can undertake similarly encompassing narratives and there are many examples in this different artistic medium that parallel the endeavors of the novel.)

I shall confine my inquiries to the prose fiction of West Germany—
specifically, to the fiction written in the postwar period, from the end
of World War II and the formation of West Germany in 1949 until the
unification of East and West Germany in 1990, and shall suggest post-
unification developments. With unification, the political situation and
intellectual climate have changed sufficiently to warrant speaking of the
closing of an era. Although novels continue to be published that make
the Holocaust the center of their concern, there is a shift in Holocaust
discourse from literature to memorials and museums—a shift that will
be discussed in the concluding chapter. At the same time, during the
decade preceding unification and into the 1990s, there is a noticeable
growth in minority literatures, especially literature by younger German
and non-German Jewish writers living in Germany who speak about the
problems of living in a post-Holocaust Germany.

Until unification, German was the language of four distinct litera-
tures: the literatures of East and West Germany, of Austria, and of
Switzerland. However, it has been maintained that compartmentaliza-
tion into "four distinct national literatures matching the four major
German-speaking states . . . is no longer possible."[7] It may be true that
with the postmodern dismantling of "master narratives"—the narra-
tives of cultural hegemony—and the increasing presence of minority lit-
eratures that affirm heterogeneous, multicultural points of view, the
concept of a national literature of any stripe is losing ground. Yet in a
study of *one* people's efforts to examine—or avoid examining—their
particular past, I must take national and historical boundaries into ac-
count. Since the literature I discuss thematizes precisely the issues of a
specific society, ignoring those boundaries would be tantamount to ig-
noring all-important aspects of that literature. Most important for the
study at hand, ignoring the boundaries would destroy the specific con-
text of the Holocaust and would make any such discussion meaningless.

While there was a rapprochement between the literatures of East and
West Germany in the decade before the fall of the Berlin wall, their com-
monality rested precisely on the division: East and West German writers
wrote about the division of Germany from their own particular perspec-
tives. During the period of the cold war, the literatures of East and West
Germany rested on such vastly different suppositions that comparisons
can be undertaken only anecdotally. With few exceptions, East German
literature made no effort to come to an understanding of the Nazi period.
As a Communist regime, East Germany saw itself *ipso facto* as inimical
to fascism and hence under no obligation to acknowledge its own Nazi
past. Fascism was interpreted as an outgrowth of capitalism, and capital-
ism was still the reigning economic system in West Germany. It hence

fell upon West Germany to deal with this past. Peter Schneider, respected author and astute observer of Germany's political and social scene, spoke to this difference and its implications at the time of unification, when he noted: "After the first thrill of unity, it will become clear that, on either side of the Wall, not only two states, but two societies have developed."[8]

As for Switzerland, its perceptions about itself and its role during the Nazi regime were shaped by an understanding of itself as a neutral country, at least until the recent revelations about its banks' collusions with the Nazi regime. In the postwar era, the playwrights Max Frisch and Friedrich Dürrenmatt addressed some of the psychological mechanisms that gave rise to and perpetrated the Holocaust, but they did so by appealing to reason and from the secure vantage point of distance; such a position was not available to West German writers.

Nor are Austrian writers, who began to discuss their country's own Nazi past extensively only relatively late, part of the present inquiry, again, because the political situation in Austria elicited responses different from those in West Germany. Postwar Austrian politics has cultivated the myth of having been annexed instead of admitting that Austria actively courted the 1938 annexation to Germany and it found its special status confirmed in the separate peace treaty of 1955, which guaranteed Austrian neutrality on the Swiss model. In the early postwar decades, Austria regarded its special status as exculpatory and left the Holocaust a uniquely German "problem." Only with the emergence of the postwar generation of Austrian writers, mostly those born in the 1940s and later (e.g. Gerhard Roth, Peter Henisch, Brigitte Schwaiger, and the slightly older Thomas Bernhard), was there a sustained and vigorous investigation of Austrian complicity in the Nazi past that could be compared to efforts in West Germany. And even then, the different social and political contexts led to different literary structures. One finds, for example, very little documentary literature in Austria since there were no trials to fuel it, as there were in West Germany.

In fact, the literary scholar Jean-Paul Bier has identified a fifth German literature, that of the German exiles.[9] Many of the writers in this category were Jewish and worked under the conditions of the *univers concentrationnaire*; very few of them returned to West Germany. This fifth German literature, though it is not a monolithic body of writing, reflects the ideological conditions of its genesis, which are precisely not those of postwar West Germany. It, too, lies outside the boundaries set for this study, but its contributions as German literature must be acknowledged.

For one overarching reason, I have confined myself in this study to a discussion of non-Jewish writers. In presentations of postwar German

literature, there is frequently no distinction made between East and West German writers or, in studies of either country, between Jewish and non-Jewish writers. This seems to me a grave oversight, since the conditions under which Jewish and non-Jewish writers write and the perspectives they bring to their work are separated by the abyss of the Holocaust. The elimination of the crucial distinction between victims and perpetrators can itself be viewed as an attempt to level and equalize their separate histories. There is a large body of literature by survivors and witnesses, and it is vastly different in tone, perspective, and outlook from that written by the generation and successor generations of the perpetrators. For the victims, "the literature of atrocity is concerned with an order of reality which the human mind had never confronted before, and whose essential quality the language of fact was simply insufficient to convey."[10] In an effort to find a language more suitable than "the language of fact," techniques of irony, of the macabre, of the laughter of despair, and of gallows humor became part of the narrative strategies of the victims, whereas the perpetrators who have not experienced the boundless sufferings, torture, and death, shy away from "inappropriate" attitudes, seeking safety in *Betroffenheit* (consternation).

Some may find this distinction—and especially my exclusive focus on the texts of the perpetrators and their successor generations—objectionable, arguing that such an analysis perpetuates the view of the victims as the "other" and turns them into objects deprived of individuality. But inclusion of Jewish authors as subjects who present their own perspectives would have changed the focus of this study. It would no longer have been an investigation into how the successor generations of the perpetrators are trying—or not trying—to come to terms with a past that is constituted by the legacy of the Holocaust. If, in this study, Jewish voices are heard, they are filtered through the consciousness of a non-Jewish author. In most instances, however, the reader will take note of the Jewish voices as absences only—and understand the implicit challenges to break down the "language of silence" and the demands that the view of the other as object must be erased by the interest in the other as subject. The novels discussed here by no means exhaust the many different attempts in West German literature to come to any terms with the Nazi past. But they offer a cross section of techniques and points of view that betray the "subtexts" and blind spots of the "language of silence."

Consideration must also be given to the fact that Jews were not the exclusive victims of the Holocaust, that "gypsies and Poles, political prisoners and asocials, criminals and homosexuals were all incarcerated and exterminated."[11] Political prisoners are the subject of a considerable

body of literature. Since they were opponents of the Nazi regime, their sufferings were invested with a sense of pride and there was no need for strategies of silence. The murder of the Sinti and Roma and other minorities has not received much acknowledgment, perhaps because their numbers were comparatively small and the survivors remained silent. The fact that these minorities are virtually not presented in literature indicates that their fate has not penetrated to levels of unstated assumptions, where articulation would become imperative.[12] If literature is the seismograph of a people's conscience, then this void tells its own story. It is the genocide of the Jews that holds the central place in the acknowledgment of the atrocities of the Nazi regime and that stirs the ever renewed efforts at articulation—an articulation that includes the many strategies of silence.

The Different Kinds of Silence

Some comments are in order with respect to "silence." Silence is not a semantic void; like any language, it is infused with narrative strategies that carry ideologies and reveal unstated assumptions. Silence is constituted by the absence of words but is therefore and simultaneously the presence of their absence.[13] This is where the image of the Grunewald memorial is most pertinent: language becomes the cover and the cover-up for a silence that nevertheless operates and becomes audible only through words.

For the purposes of this study, some rudimentary differentiations concerning silence are in order. It has been suggested that there are two kinds of silence: "The first comes from too much knowledge, while the second is a refusal to become aware. This second silence is the escape into which memory and guilt are repressed."[14] One might be tempted to identify "too much knowledge" with the silence of the victims and the "refusal to become aware" with the silence of the perpetrators, but such an identification ignores the undoubted fact that the perpetrators kept silent because they had "too much knowledge" and that many victims, in an effort to survive after they survived the Holocaust, took refuge in a "refusal to become aware" of the atrocities to which they had been subjected. A more useful separation may be one that distinguishes between the silence *of* the Holocaust and the silence *about* the Holocaust.

The silence *of* the Holocaust is not the concern of this book. The silence *of* the Holocaust is the silence prompted by the horror of the atrocities committed. Here, controversy has arisen over the notion that the Holocaust, as an unspeakable reality, defies conceptualization in lan-

guage, let alone literary language. This silence recognizes that, in the
words of the historian Saul Friedländer, "our traditional categories of
conceptualization and representation may well be insufficient, our lan-
guage itself problematic," but he concludes that "in the face of these
events we feel the need of some stable narration: a boundless field of
possible discourses raises the issue of limits with particular strin-
gency."[15] This complex ambiguity of silence and narration is particu-
larly evident in Elie Wiesel, who has been one of the most adamant
proponents of silence despite the fact that his oeuvre seems to contra-
dict his position.

The question of whether or not literature is an appropriate vehicle to
express and to remember the crimes of the Nazi regime surfaced soon
after the end of World War II, when Theodor Adorno, the eminent social
philosopher and a returned exile, stated that "to write poetry after
Auschwitz is barbaric."[16] While his exegetists have interpreted this sen-
tence in a variety of ways, Adorno himself amplified his position a few
years later: "The question . . . 'Does living have any meaning when men
exist who beat you until your bones break?' is also the question whether
art as such should exist at all," and he explained further: "The so-called
artistic rendering of the naked physical pain of those who were beaten
down with rifle butts contains, however distantly, the possibility that
pleasure can be squeezed from it."[17]

Adorno's apprehension was shared by many and by some was sup-
ported in its radical consequence: "I firmly believe that art is not appro-
priate to the holocaust. Art takes the sting out of suffering. . . . It is
therefore forbidden to make fiction of the holocaust. Any attempt to
transform the holocaust into art demeans the holocaust and must result
in poor art."[18] This intransigent position was, if not refuted, neverthe-
less modified by the scholar of Holocaust literature Lawrence Langer,
who suggested that Adorno prejudged "perhaps too dogmatically" and
proposed instead:

> [A]n essential characteristic . . . of almost all the literature . . . is not
> the tranfiguration of empirical reality . . . but its disfiguration, the con-
> scious and deliberate alienation of the reader's sensibilities from the
> world of the usual and familiar, with an accompanying infiltration into
> the work of the grotesque, the senseless, and the unimaginable, to such
> a degree that the possibility of aesthetic pleasure as Adorno conceives
> of it is intrinsically eliminated.[19]

The first objection to art giving voice to the Holocaust was of a general
nature ("Art takes the sting out of suffering"). Another, related objection
was more specific. Art, by definition, imposes order and creates meaning,

while the Holocaust defies any such attempt. Here again, Langer counters Adorno and answers by shifting from a categorical position to one of technique:

> The validity of Adorno's apprehension that art's transfiguration of moral chaos into aesthetic form might in the end misrepresent that chaos and create a sense of meaning and purpose in the experience of the Holocaust (and hence, paradoxically, a justification of it in aesthetic terms) depends very much on how the artist exploits his material.[20]

The concern that aesthetic "transfiguration" might justify even the grimmest reality is rooted in the concept of the autonomy of a work of art and is frequently connected with a devaluation, even a rejection of reality. Severance of the two realms—art and reality—culminated in high modernism, of which Adorno is one of the highest points and last expounders. Yet the very existence of the Holocaust invalidates the aesthetics of high modernism and imposes a redefinition not only of art but of humanity and of the world that humanity created. It seems anachronistic, if not outright false, to evaluate the literature of the Holocaust according to definitions which the very existence of the Holocaust has destroyed. In 1966, seventeen years after his severe pronouncement, and possibly swayed by the extraordinary Holocaust poetry of Paul Celan and Nelly Sachs, Adorno recanted when he said: "The enduring suffering has as much right to expression as does the tortured man to scream; therefore it may have been wrong that after Auschwitz poetry could no longer be written."[21]

Still another set of objections to a literary presentation of the Holocaust centers on the problematics of language—specifically, on silence and speechlessness. George Steiner, the distinguished Cambridge scholar, has advanced positions that needed to be answered, particularly in relation to the German language. When he asserted that "the world of Auschwitz lies outside speech as it lies outside reason. To speak of the unspeakable is to risk the survival of language as creator and bearer of humane rational truth," he proposed to relegate Auschwitz to silence in order not to contaminate human language.[22] Yet a language that serves only as the "creator and bearer of humane, rational truth" and expurgates the frightening, inhuman, and unspeakable aspects is a censored language, and is on the road to becoming as barbaric as any of the manipulated languages of totalitarian regimes. The language Steiner desires would not retain the memory that is perhaps the only meaningful association we can have with Auschwitz: never to forget the abyss of inhumanity of which man is capable.

To succumb to a moral or aesthetic imperative that demands the silence of the Holocaust would be tantamount to acknowledging the very

barbarism of which Auschwitz stands as the horrifying exemplar. It would extend the inhumanity of the action to the inhumanity of nonarticulation. It would signal the capitulation of the human mind and of human language to the polemics of those who deny that the Holocaust ever happened. The Holocaust, as an unspeakable reality, paradoxically demands speech even as it threatens to impose silence. As the scholar of Holocaust literature Alvin H. Rosenfeld has observed, that speech "may be flawed, stuttering, and inadequate, but it is still speech."[23]

If the silence *of* the Holocaust can be articulated only as paradox and (in the words of Saul Friedländer) a "probing of the limits of representation," silence *about* the Holocaust is of a different order. There is the silence into which victims have retreated and there is the silence of the perpetrators, the silence that is the subject of this book. Much has been said about German efforts to repress, deny, or avoid speaking about the Nazi regime and the genocide. But every strategy, conscious or unconscious, employed in the service of this denial is also an acknowledgment. One can as easily maintain that West German postwar literature has continually been aware of the Holocaust,[24] and that the silence, contoured by a vast number of narrative strategies, is its most expressive indicator. If silence is an admission of knowledge, then the paramount question is: What knowledge about the Holocaust is being repressed, denied, avoided, and how does this avoidance find expression?

The Corruption of Language

Literature uses words to strategize silences, to contour avoidances, to reveal unstated assumptions, to disclose what it wants to hide or deny. To return to the guiding image of the wall outside Grunewald station, one can say that without the wall (the body of literature), the empty spaces cannot be perceived. Yet the language which makes up that literature is not neutral; it is shaped—indeed, created—by historical circumstances and political pressures. This material is used to construct the analogous wall, and it determines the contours that limn the empty spaces. Just as the wall and the material quality of the wall stand in an intimate and reciprocal relation to the gaping spaces, so language and silence mutually condition each other. A brief discussion of the language available to, shaping, and shaped by the postwar generations seems therefore in order.

After the collapse of the Hitler regime, there existed profound doubts about the viability of the German language itself. Ezrahi notes that its "syntax, style, and symbolic associations were profoundly and abidingly violated by what came to be known as 'Nazi-Deutsch,'" as it tried to

reconcile "the incompatible goals of maintaining precise written records of Nazi deeds while camouflaging them in euphemisms for the outside world."[25] The corruption of the language in this fashion led the German critic Heinrich Vormweg to regret that no "linguistic denazification" took place and that the young writers who started to write after 1945 could not design a radically new, uncontaminated language.[26] According to him it was not enough to present critically Nazi key words such as "hero," "vassal's allegiance" (*Gefolgschaftstreue*), "Volk," "blood"; the language needed to be cleansed of the unconscious associations of deeply imprinted speech habits.

As late as 1959, George Steiner asked what the German language could express after it had been dehumanized and "infected not only with these great bestialities" but also "called upon to enforce innumerable falsehoods."[27] However, a few years later, in an optimistic postscript to this assessment, he conceded a new vitality to the German language and he saw this vitality directly related to attempts to confront the crimes of the Nazi past. He now found: "It is precisely by turning to face the past that German drama and fiction have resumed a violent, often journalistic, but undeniable force of life."[28]

The Inability to Mourn

The psychological mechanisms operating in this silence have perhaps been best captured by the social psychologists Alexander and Margarete Mitscherlich in their study *The Inability to Mourn*,[29] a book that was pathbreaking at its time and that has influenced the discourse concerning the German silence about the Holocaust to this day. Published in 1967, after the trial of Adolf Eichmann in Jerusalem in 1961 and the Auschwitz trials in Frankfurt/Main from 1963 to 1965, but before the explosive student movement of 1968, it sought to explain the apparent lack of an affective "working through" of the crimes of the Nazi regime. The Mitscherlichs found the West German "inability to mourn" rooted in the country's inability to mourn the loss of its Führer (23). This mourning would have necessitated an understanding of themselves and of the sociopsychological reasons why Hitler was— had been allowed to become—the all-powerful idol. They explained this need for an idealized leader as resulting from a historically conditioned weak national ego that sought refuge in obedience, resented this obedience, and overcame the aversion to it by increased idealization of the leader to whom it was obedient (22) and with whom it identified narcissistically (63).

Following Freud, the Mitscherlichs posit two means of expressing be-
reavement: mourning and melancholy. Mourning expresses the pain
over the loss of an other, while melancholy causes in the melancholic
(and here they quote Freud) "an extraordinary diminution in his self-re-
gard, an impoverishment of his ego on a grand scale" (26). With the loss
of the "exalted and deified object" (22) and the realization of the enor-
mity of the crimes committed, there would have occurred "a loss of self-
esteem that could hardly have been mastered, and a consequent
outbreak of melancholia in innumerable cases" (26). The Mitscherlichs
then use this core thesis to advance their hypothesis:

> The Federal Republic did not succumb to melancholia; instead, as a
> group, those who had lost their "ideal leader," the representative of a
> commonly shared ego-ideal, managed to avoid self-devaluation by
> breaking all affective bridges to the immediate past. This withdrawal
> of affective cathecting energy, of interest, should not be regarded as a
> decision, as a conscious, deliberate act; it was an unconscious process,
> with only minimal guidance from the conscious ego. The disappear-
> ance from memory of events that had previously been highly stimulat-
> ing and exciting must be regarded as the result of a self-protective
> mechanism triggered, so to speak, like a reflex action (26).

Yet this avoidance came at great cost. The Mitscherlichs identified
several aspects: (a) a "striking emotional rigidity" as the only response
"to the piles of corpses in the concentration camps, to the disappearance
into captivity of entire German armies, to the news of the slaughter of
millions of Jews, Poles, and Russians, and to the murder of political op-
ponents in one's own ranks" (28); (b) a de-realization of the past (includ-
ing a de-realization of the former attachment to the magnified idol),
which also facilitated the abrupt switch to identifying, without much
inner conflict, with the victors, and which "helped ward off the sense of
being implicated" (28); and (c) an enormous collective effort of postwar
reconstruction, in which the Mitscherlichs see the expression of a
"manic undoing of the past" (28).

The Mitscherlichs emphasize that the defense mechanisms of denial,
repression, and de-realization led to a "tremendous impoverishment of
the ego" (63) and, together with the "manic" attempts at economic re-
construction, to a "psychic immobilism" (63)—that is, to apathy and in-
difference. An important aspect of this de-realization bears on the
abruptness in the switch of identification and its consequences: as Adolf
Hitler and the ego investments in him were de-realized, the German peo-
ple needed to see themselves as duped and as victims (45/6). This self-
identification as victim is part of the defense mechanism and further

blocks any access to a genuine empathy with the sufferings inflicted upon one's fellow human beings, upon the other as subject, not object.

Since Freud's interest was invested in the individual, one must further address the legitimacy of arriving at more widely applicable statements and inquire into the relation of the individual to the larger social context, which ultimately includes the problematics of individual vs. collective responsibility and/or guilt. In this study, I follow to a large extent the thinking of Dominick LaCapra, scholar of European intellectual history, as he has struggled with the perceived "binary opposition between the individual and society" and has suggested that "what happens to the individual may not be purely individual, for it may be bound up with larger social, political, and cultural processes that often go unperceived."[30] He points to the necessity of public forums and the need for "suitable public rituals that would help one to come to terms with melancholia and engage in possibly regenerative processes of mourning" (213). While there have been an increasing number of "public rituals" staged (particularly around the 40th and 50th anniversaries of significant events during the Nazi regime such as the "night of broken glass," the liberation of Auschwitz, the end of World War II), none, with the possible exception of Chancellor Willy Brandt's visit to the Warsaw ghetto, has had an affective impact that would involve the entire personality and thus lead to genuine expressions of mourning. In fact, one can maintain, as I will in this study, that despite increasingly available knowledge about the Holocaust, Germans individually and collectively have been unable to work through and to mourn the crimes perpetrated, if working-through demands "the possibility of judgment" that is "argumentative, self-questioning, and related in mediated ways to action." If not accompanied by affective mourning, public rituals will assuage the individual's conscience without self-questioning and will foreclose any insight into the need for action in whatever mediated ways.[31]

Another point to be considered, and of importance for this study, is that of the passage of the generations. The Mitscherlichs published their study in 1967 and thus had a perspective of more than twenty years after the end of the Nazi regime to formulate their conclusions. Since that publication, another three decades have passed and the generation of those who lived during the Nazi regime is rapidly dying out. The Mitscherlichs could still clearly identify the generation of the perpetrators as the one characterized by an "inability to mourn," yet in subsequent years it has become obvious that the successor generations are equally burdened with their elders' legacy, and that they, too, may be unable to recoup the affective dimension required for genuine mourning— not remorse for deeds they did not commit or mourning for a Hitler who

to them is at most a historical figure, but a mourning for the parents' generation, the deeds committed by them, and for the victims.

Later in this study, I will discuss the burdens under which the successor generations are laboring as they have tried to confront the legacy of their parents. In the present introductory context it may suffice to refer to the conclusion that Eric Santner, a scholar of German film and literature, has drawn when he states that "the second generation inherited not only the unmourned traumas of the parents but also the psychic structures that impeded mourning in the older generation in the first place."[32] Based on this insight, he can offer only dim prospects for the future, even as he includes the third generation: "To carry out their labors of self-constitution the second and third generations face the double bind of needing symbolic resources which, because of the unmanageable degrees of ambivalence such resources arouse, make these labors impossible" (45).

As I hope to show, roughly every decade and a half the successor generations developed different strategies and different approaches in their attempts to fashion an identity for themselves and come to terms with the legacy of their elders. Yet "coming to terms" is not equivalent to "working through," and it leaves the victims and the crimes as unmourned as they have always been.

The Break in Civilization

The Holocaust has shattered all previous assumptions about the nature of humankind and the perfectibility of society, creating, in the words of the Israeli and German historian Dan Diner, a "break in civilization."[33] It opened an abyss in the definition and self-perception of human beings, an abyss reflected in language and narrative strategies. Eric Santner suggests that the break in civilization constituted by the Holocaust is replicated in a "rhetoric of mourning" that appeals to "notions of shattering, rupture, mutilation, fragmentation, to images of fissures, wounds, rifts, gaps, and abysses" (7). This is the realm of disorientation, disfigurement, disarticulation, displacement, discontinuities, and disjunctions, a realm that post-Holocaust art has tried to inhabit. For a discussion of this realm, Santner further relies on the deconstructionist concepts of decenteredness, instability, and nomadism, and on the need to tolerate difference, heterogeneity, nonmastery. The deconstructionist Barbara Johnson makes an even tighter connection between deconstruction and the Holocaust when she states that "it may well be that [deconstruction] has arisen as an attempt to come to terms with the holocaust as a radical disruption produced as a logical extension of Western thinking."[34]

The undercurrents in this understanding of the postmodern as post-Holocaust (and evident in Johnson's statement) are arguments disavowing the Enlightenment's faith in progress. The Holocaust has destroyed the "master narrative" of the "liberation of humanity,"[35] and the idea of "the redemption of modern life through culture,"[36] that is, the idea of the perfectibility of humankind. Zygmunt Bauman takes this line of reasoning even a few steps further when he asserts: "It is our Western Civilization which the occurrence of the Holocaust has made all but incomprehensible . . ."[37]

And indeed, the analyses in the following chapters will in some cases show a literature of ruptures, disfigurements, displacements, and involutions. Other examples, however, suggest a desire for and tendency toward continuity. This desire for continuity can be seen as an attempt to deny the radical break constituted by the Holocaust. The desire for the reconnection with a historical past in which the Holocaust would be a horrifying anomaly negates its shattering impact in favor of the fantasy of a totalizing and "normalizing" worldview.

The following chapters will suggest how West German authors have attempted, in a variety of strategies spanning more than four decades, to address these problematics. I will give an account of their efforts, their failures, their blind spots, their conscious agendas, and their unconscious desires, and show how the silences enveloping the Holocaust speak the language of ambiguity, indeterminacy, instability, and absence, but speak a language, nonetheless.

A Word on Organization

The sequence of the chapters follows roughly a chronological order. This arrangement helps to show how the nature of the silence has changed over the decades and has even become compatible with a knowledge of and discourse about the Holocaust. Heinrich Böll (chapter 1) is a member of the generation that tried, in the first postwar decade, to find its literary voice in the "literature of the rubble," while struggling to free itself from a language infested with Nazi ideology and impoverished by clichés. Wolfgang Koeppen, who wrote at the same time but made his literary debut at the end of the Weimar period, retained a sense of pre-Nazi language and therefore felt free enough to attack the Nazi language, its taboos, and the thinking that went with them, although with minimal success.

About a decade later (chapter 2), the Eichmann trial in Jerusalem in 1961 and the Auschwitz trials in Frankfurt/Main from 1963 to 1965 pro-

vided an official, "objective" language in which to speak about the crimes of the Holocaust. This "documentary" language had a great impact on all literary genres but was appropriated differently by various writers. Alexander Kluge radically subverted the supposed objectivity of documents, showing that even documents are man-made and hence serve the specific interests of those who create them. Using a great variety of literary techniques, he constantly reminds the reader that even in the most "objective" of documents one is confronted with subjective statements. Günter Grass, by contrast, evinces no such skepticism toward objective facts and the ability of language to convey them. He uses documents for pedagogical purposes, to teach the young, upcoming generation about the Holocaust and address simultaneously the problematics of German identity.

The 1960s saw the first postwar generation grow into adulthood. As in the United States, it was a generation involved in protest movements, in marches and demonstrations for various political causes. In the United States, the civil rights movement and the demonstrations against the war in Vietnam were the focus of protest. In the Federal Republic of Germany, it was the discord among the generations, particularly the younger generation's demands to know what their parents had done during the Nazi regime. Transferred from the personal to the political arena, these protests and demonstrations escalated into terrorism. Just as the number of participants in the demonstrations was huge, so was the number of novels, written in the 1970s, after the political activities had died down. The economic crisis following the oil shock of 1973 (and, in the United States, the conclusion of the war in Vietnam and Watergate), along with a simple exhaustion of activist fervor, contributed to the general mood of the 1970s, which was overall one of introspection and of taking account. (In the political arena, this mood turned toward concerns with the environment and formed the basis of a new party, the Greens.) Because so many of the novels of the 1970s are occasioned by similar interests (an exploration of the parental role in the Nazi past) and follow similar patterns of autobiographical exploration, it has become customary to group them together as the "novels about fathers and mothers" (chapter 3). Built on the publicity surrounding the trials, the knowledge of the Holocaust in these novels is a given. However, the use to which this knowledge is put relegates it to silence once again. This knowledge is not concerned with the victims and their sufferings but is an instrument in the battle with the parents.

Hanns-Josef Ortheil shows that the concern with the parents' role during the Nazi past can be so consuming that the lives of both parents need to be analyzed (chapter 4). While an exploration of the life of the

mother provides the male protagonist with some understanding of his own burdened childhood, only the journey into the self after the death of the father can set the protagonist free on the road to a mature adulthood. The Holocaust is here seen as an event that has significantly—and silently—shaped the lives of both parents, who then raise their son as they labor under this burden. Ortheil traces the parents' inscriptions on the psychological makeup of the next generation, yet the Holocaust as the "break in civilization" and as suffering and death inflicted upon millions of people remains outside the circumference of his concerns.

Hermann Lenz (chapter 5), born in 1913, is one of the oldest writers presented in this study. In his case, the impetus to write autobiographical fiction is an attempt to understand his own generation, the parent generation against whom "the generation of 1968" rebelled. In a major effort, he subjects his entire life to the scrutiny and observations of one (himself) who has remained an outsider. To date, nine volumes of this life have been published. *New Times* (1975) records his military service on the Eastern front. The atrocities committed by the German military during World War II in Poland and Russia have only in the last decade and a half come to the foreground of scholarly and public discussion. It is therefore of great interest to find out what the protagonist knew, what he witnessed, and how he coped. In this novel, the workings of memory and the recording of silences are, so to speak, the main actors. Fissures, gaps, and discontinuities—the arsenal of postmodern/post-Holocaust literary tools—are the distinguishing characteristics of Lenz's narrative. *New Times* is a demonstration of how the devastating impact of knowledge was kept at bay.

Gert Hofmann (chapter 6), who died in 1993, did not participate in the trend of autobiographical fiction. His enormously impressive prose oeuvre spans hardly more than the last decade of his life and many of the novels and novellas that he published in these years go obsessively over the same ground—the Nazi era. Split perspectives, fragmentations, silences are the means by which he shows the impact of the legacy of the Nazi regime on the postwar generation, and that generation's accommodation—or lack of accommodation—to West Germany's postwar prosperity as a covering up of the crimes of the Nazi past. Through his disjointed (and in some instances half-insane) protagonists he shows the tremendous toll the past takes on the present when this past has never been openly mourned or worked through but instead is repressed and covered with silence.

From the 1980s on, the literature that tries to work through the Holocaust cannot be easily typified. Literature concerned with the Holocaust continues to be written at an unremitting pace, and the nature of the

"language of silence" undergoes further changes. Chapter 7 focuses on three novels with Jewish protagonists—a 1967 novel by Alfred Andersch and two novels of the mid-1980s by Peter Härtling and Gert Hofmann. These novels respond from their divers points of view to the annihilation of many millions of individuals by attempting to restitute personal identity to Jewish victims. Blind spots and omissions reveal Andersch's and Härtling's difficulties in imagining their protagonists' suffering; only Hofmann, in *Veilchenfeld*, has depicted the humiliation and destruction of a Jewish victim in terms that restitute personal identity to that victim and allow him to emerge as the subject of his own history. All three novels raise the question of whether or not and within what limits nonvictims can ever imaginatively and affectively create an empathic identity with the sufferings of the Jews—and whether a better approach to overcoming the language of silence and mourning the victims would not start with what Robert Schindel has suggested in his novel *Gebürtig*: an apology followed by the amends implicit in the invitation "Come back. You are welcome."[38]

The 1980s, the decade that ended with unification, was a decade of literary, academic, and political controversies that centered in one way or another on the Holocaust. Chapter 8 examines the most important ones. The various anniversaries of events that occurred in the Nazi regime were commemorated in ceremonies and speeches and frequently gave rise to vigorous public debates, beginning in 1985, when President Reagan, at the invitation of and accompanied by Federal Chancellor Helmut Kohl, visited Bitburg military cemetery, which contains the graves of soldiers of the Waffen-SS. On the literary scene that year, Rainer Werner Fassbinder provoked demonstrations and sit-ins with his anti-Semitic play *Garbage, The City and Death*, and a year later, the Historians' Controversy erupted over whether the Holocaust was a unique event in history or comparable, for example, to Stalin's terror. In 1988, Philipp Jenninger, the president of the Bundestag, was forced to resign because of a speech he gave on the 50th anniversary of *Kristallnacht*, the "night of broken glass," in which he employed Nazi language in a misunderstood attempt to demythologize it. The Holocaust also figured significantly in the debates surrounding German unification in 1990. Günter Grass argued against unification because of Germany's past history. In his view, since a united Germany had instigated two world wars and brought immeasurable suffering, a divided Germany would be a better guarantor against future German aggression. By contrast, Martin Walser, another prominent and popular West German author, felt that West Germany had learned its lesson in the forty years since its inception. It had become a stable democracy and had proved a reliable ally of

the West; unification would acknowledge that lessons can be learned. Political developments overrode Grass's concerns but their debate highlights the continued significance of the Holocaust for German self-understanding.

Literature written after unification continues to be occupied with the Holocaust. Chapter 9 discusses the efforts of some novelists—efforts missing in earlier West German literature—to introduce a dialogue between Jews and non-Jews. Bernhard Schlink uses the pattern of the novels of generational discord to find out about the Nazi past of a person loved by the protagonist, but his portrayal of a Holocaust survivor as subject rather than object is still brief and tenuous. Peter Schneider uses Berlin as the most appropriate setting for personal and political separations and "couplings" (the title of his novel). Coupling includes friendship with Jews and his novel explores the fragile grounds on which these relations are built. In *The Emigrants*, W. G. Sebald looks for common elements in the lives of uprooted and alienated people. He begins to mourn the destruction of Jews in Germany—a unique achievement in German literature—and gives voice to the culture and the lives that were destroyed. Here, the language of silence is broken and a long-delayed melancholy emerges.

No concluding chapter can bring this complex topic to a closure; mine will point to a shift of discourse in two new directions, one within literature, one outside it. There are today in Germany numbers of young German Jews and Jews writing in German who are making their voices heard. Their writing differs from the literature of Holocaust survivors in that they belong to the successor generation and address issues concerned with living in post-Holocaust Germany. Impatient with the German "inability to mourn," they determine how they want to be perceived and accepted—not as objects but as subjects of their own history with voices of their own. As Peter Schneider's novel acknowledges, their presence will have an impact on the novels written by non-Jewish writers struggling with the attempt to overcome ever-new metamorphoses of the language of silence.

At the same time, it is becoming apparent that literature, an art for private consumption, is no longer the primary field of discourse about the Holocaust. Starting with the Eichmann and Auschwitz trials in the 1960s, German awareness and acknowledgment of the Holocaust has become increasingly public. The second shift in direction is toward the most public of arts—architecture. Recently constructed or planned memorial sites, memorials, and museums have provoked a degree of public controversy that emphasizes the general knowledge of the Holocaust but also the conflicted and unresolved attitude in confronting it.

The Holocaust is as much a permanent part of German history as it is of Jewish history. How it is to be memorialized is an issue that will continue to be in the forefront of discussions. In the public sphere, commemorations may become—or are already in the process of becoming— institutionalized, thereby relieving the Germans as a group of personal memory work. But individuals, and among them the artists as seismographs of a people's conscience, continue to struggle with the Holocaust and may, as Sebald's example shows, begin to mourn the destruction and loss.

The First Postwar Decade

Heinrich Böll and Wolfgang Koeppen

Speaking is silver, silence is gold.

German proverb

The end of World War II and the first public realizations of the atrocities committed by the Nazi regime called out for voices that would speak to these horrors. As early as 1946, the German philosopher Karl Jaspers posed "the question of German guilt"[1] and Eugen Kogon published *The Theory and Practice of Hell: The German Concentration Camps and the System behind Them*, based on his experiences as an inmate at Buchenwald.[2] Yet even as the Nuremberg war crimes trials were taking place and the atrocities of the Nazi regime were exposed, denial and rationalizations began to prevail. These attitudes were further strengthened since most Germans were absorbed in their own postwar misery, brought on by the considerable destruction of the cities, the influx of many millions of refugees and displaced persons, the lack of food, and the generally chaotic conditions in the country. Most Germans were preoccupied by three questions: how to get food, how to find housing, and how to locate missing family members. The incipient cold war and the farce of the denazification trials, which Jean-Paul Bier has characterized as "a crafty system of fakes, truncated biographies, and exchanges of mutually accommodating testimony" only hardened this posture.[3] The

"missed opportunity to account for the past"[4] allowed the Germans to believe in a collusion with the Western allies, since the West seemed to need the recently defeated in drawing up the cold war's battle lines, and created a presumption of innocence since few war criminals were rigorously punished.

Still shackled to the Nazi indoctrination of striving for "higher ideals," the literature of the immediate postwar years was dominated by "vague feelings of guilt, the appeal to the ideals of the 'essential' and the 'higher,' one's own sufferings, and the relief over having managed to escape."[5] In the early postwar months, Thomas Mann provoked extensive controversy when he declared from his exile in the United States that "it was not a small number of criminals" who were responsible for what had happened but "hundreds of thousands of the German elite."[6] He admonished the German people to "return to the spiritual tradition" and, instead of admiring power, to foster "the development of the free spirit."[7] Writers who had not gone into exile, such as Frank Thiess, found Mann's admonitions objectionable. Thiess claimed that "Germans involved in an inner emigration had gathered far more important experiences within Nazi Germany than those who had looked on 'from the dress circle and first row seats abroad.' "[8] (The fact that Thiess could call what had happened in Nazi Germany a "gathering of experiences" and found them "far more important" than what had happened to the exiles, is in itself a shocking example of the recalcitrance and obtuseness of those who described their passive attitude toward the Nazi regime as "inner emigration.") The concept of an "inner emigration" was, upon closer inspection, hollow. With very few exceptions (such as Ernst Wiechert), the "inner emigration" had produced no documents of the "experiences" it had "gathered" and no literature of dissent that it would have had to hide in desk drawers during the Nazi regime. Writers who did publish under the Nazis, such as Ernst Jünger, Werner Bergengruen, Gertrud von le Fort, and Frank Thiess, continued to write and publish in the postwar period. Writers who had gone into exile for political reasons (such as the Communists Bertold Brecht and Anna Seghers) returned to the Soviet occupation zone; Thomas Mann eventually returned to a German-speaking country—Switzerland; but few exiled writers came back to live in the Western zones. They were not invited to return, in itself a sign of continued recalcitrance.

This was the situation for the generation of writers who had been established before the caesura cut by the Nazi regime. After 1945, there was now a younger generation ready to make its literary debut and wanting to articulate its experiences. With the German cities in ruins, a "literature of the rubble" (Trümmerliteratur) searched for ways to describe

the suffering of the German population during and after the war. The German language was profoundly compromised, and the language of exile harked back to the Weimar Republic and Expressionism. The young generation found only a few poets (Rainer Maria Rilke and Gottfried Benn) meaningful and worthy of their interest. The attempt was made to start anew, to proclaim a "zero hour" from which to go forward. In their search for a new language, young writers of the "literature of the rubble"—often war veterans, (such as Wolfgang Borchert and Heinrich Böll)—experimented with a spare, colloquial style in the manner of newly accessible writers like Hemingway and Faulkner. As the distinguished literary scholar Peter Demetz has noted, some of these writers had been prisoners of war in the United States, where they were exposed to American literature and to "courses in the social sciences as training for becoming the future administrators of a liberated Germany." Among them were Alfred Andersch and Hans Werner Richter, who founded *Der Ruf (The Call)*, according to Demetz "the most intelligent and liberal German camp newspaper in America (1945–1946)."[9] After the return of the POWs, *Der Ruf* continued to be published in the American occupation zone and its discussions of "topical issues, including collective guilt and American distrust of German political spontaneity" were "acute and intelligent."[10] After about a year, its license was not renewed by the U.S. Military Government. Presumably, "the ban was issued at the promptings of the Soviet authorities, provoked by Hans Werner Richter's open letter to the French Stalinist Marcel Cachin."[11] The contributors to the journal continued their discussions and at a meeting in fall of 1947 near the Bavarian Alps established what came to be known in literary history as Group 47.[12] However, the mood and outlook of the members of the group changed, not least because of their growing conviction that political statements and involvement would not achieve success. In contrast to the *Trümmerliteratur* of the young writers, quasi-mystical journeys of quest were composed by members of an older generation, such as Elisabeth Langgässer and Hermann Kasack, much of it influenced by the French existentialists, notably Sartre and Camus.

With the signing of the Marshall Plan in April of 1948 and the currency reform in June of that year, economic recovery was on the way, albeit at a cost: it exacerbated the differences between the Western allies and the Soviet Union. At the end of June, access to Berlin was cut off by the Soviets, and the Berlin airlift began. Within a year, the Western occupation zones merged; with the adoption of the Basic Law in May of 1949, the Federal Republic of Germany (West Germany) came into existence, and in October the German Democratic Republic (East Germany) was constituted. The two Germanies would go their separate ways for the next forty years.

As the ruins disappeared under the single-minded reconstruction ef-
fort, what was later termed "the economic miracle" began to take shape
and *Trümmerliteratur* began to vanish. Instead of inquiring into what
had made the Nazi regime so powerful, and how the crimes and atroci-
ties could have been committed, the Germans funneled all their energy
into economic reconstruction. No one asked questions about what had
consolidated Hitler's power or brought on the war, about what the role
of the individual German citizen in those years had been, about the con-
centration camps, or about what had happened to the millions who dis-
appeared. The Basic Law implicitly acknowledged the Nazi atrocities in
Article 18, which prohibited the revocation of citizenship if it would re-
sult in statelessness and opened West German borders to all politically
persecuted asylum seekers. Since West Germany with its horrifying
Nazi past was not considered a desirable country for asylum seekers,
this paragraph had little relevance at the time and did not significantly
enter public awareness. At the same time, lively economic interest com-
bined with political inactivity was not new in Germany; it had been
practiced in the 19th century. But in the postwar years, the narrowly fo-
cused, feverish quality of the economic activity sought to avoid looking
at the immediate past.

Knowledge of the Nazi past was channeled into denial and repression;
this tactic canceled all hopes invested in a "zero hour" with its promise
of a new start. Retrospectively this "zero hour" was viewed as having
been an "absurd hope." The literary critic Heinrich Vormweg sees "zero
hour" as "the hour of extreme physical and ideological misery, the hour
of the incapacity to think critically, the hour when one was ready for the
tiniest consolations. In this hour, neither a new society nor a new litera-
ture could be shaped."[13] Therefore the "culture industry," which began
to establish itself soon after the currency reform (and soon recognized
that its hopes for a new start were dashed), can "indeed be interpreted as
the withdrawal of the intellectuals from the field of politics into the
realm of aesthetics," as the prominent literary scholar Walter Hinderer
has pointed out.[14]

Early postwar literature, whether as "literature of the rubble" or on
its quasi-mystical journey, focused predominantly not on the Nazi atroc-
ities but on the wartime and postwar travails of the German population.
While that was certainly a legitimate enterprise, it carried within it the
burden of an ominous silence. In his introduction to a selection of texts
from Group 47, the critic Fritz Raddatz notes: "In the entire volume, the
words Hitler, concentration camp, nuclear bomb, SS, Nazi, Siberia do
not appear—the themes do not appear."[15] (Interestingly enough, Rad-
datz himself omits in his list of missing words the most heavily charged

and tabooed word of all—"Jew.") This silence was pervasive; it rested on unstated shared thinking, established unconscious bonds of complicity, and relied on code words for communication. To be sure, there were also works of literature that featured Jewish characters, but most of these were idealized, unrealistic stereotypes inspired by a compensatory philo-Semitism.[16] The Israeli historian Frank Stern notes with respect to this early postwar philo-Semitism that "one of the fundamental conditions governing the effectiveness of philosemitism was the public taboo on antisemitism in the wake of initial early measures taken by the Allied forces."[17] Heinrich Böll and Wolfgang Koeppen both included Jewish characters in their works, but they exemplify two very different perspectives as they grapple with the silence.

Heinrich Böll

Heinrich Böll (1917–1985) published his first prose pieces in 1947 and established himself, in the course of a prolific and morally committed career, as one of West Germany's most widely read and internationally acknowledged authors. In 1972, he was awarded the Nobel prize in literature. In his early work, he was a practioner of the "literature of the rubble," motivated by a moral imperative to speak for the underdog, the "little guy." Though his language is bare and full of colloquialisms, he does not explore new modes of expression, and his narrative presentations follow traditional patterns, on occasion bordering on clichés. This is particularly evident in his preference for epiphanies as narrative closures where the very desire for closure reflects a pre-Holocaust sensitivity. Cliché-inspired traditionalism has also been seen in his "touching faith in education [and] an etherealizing concept of love, a love without desire . . . as abstract protection from the pains and sufferings of life."[18]

In his 1950 story "Across the Bridge," the narrator, a war veteran, returns home in a train that must cross a bridge. The bridge serves as a symbol of Germany itself: "Once, before the war, [it] had been strong and wide, as strong as the iron of Bismarck's chest on all those monuments, as inflexible as the rules of bureaucracy; a wide, four-track railway bridge over the Rhine, supported by a row of massive piers."[19] Now, ten years later, he returns in a freight car and as the train approaches the river "a strange thing happen[s]":

[O]ne after another the boxcars ahead of us fell silent. It was quite extraordinary, as if the whole train of fifteen or twenty cars was a series of lights going out one after another. And we could hear a horrible, hol-

low rattle, a kind of windy rattle; and suddenly it sounded as if little hammers were being tapped against the floor of our boxcar, and we fell silent too, and there it was: nothing, nothing . . . nothing; left and right there was nothing, a ghastly void . . . in the distance the grassy banks of the Rhine . . . boats . . . water, but one didn't dare look too far out: just looking made one giddy. Nothing, nothing whatever! . . . The temporary bridge was not wider than the tracks, in fact the tracks themselves were the bridge, and the side of the boxcar hung out over the bridge into space, and the bridge rocked as if it were about to tip us off into space. (13)

The stability of the bridge in the prewar past is contrasted with its dilapidated state in the postwar present. But although the present is characterized by a precarious crossing over an abyss, the solidity of "the grassy banks of the Rhine" on both sides of the river suggests a stable past and holds the promise of a stable future. The present of ruination will again lead to solidity. There is a semblance of hope, a consoling sense that the hard times will eventually be overcome when the new shores are reached.

Yet the new shores are revealed as not so new. The veteran remembers that before the war when he had crossed the bridge, he had been fascinated by a house on the far side of the river, a house whose windows were washed systematically and with grim determination by a woman and her young daughter, according to a fixed schedule. The obsession of the two window washers had transferred itself to the young man, who became so caught up in their schedule that he finally took a day off from work to verify its accuracy. Now as he returns across the abyss of ten years and of ruination, he remembers the two women and their house. As the train approaches the house, a woman—this time the daughter—is again, or still, cleaning the house, which the narrator describes as "silent and uncommunicative . . . almost inhospitable, although it was clean . . . a clean and yet unwelcoming house" (10–11). With these two women the author indicts all of German society, in the sense that they continue their compulsive work, value order and cleanliness above any warmth or human contact, and act as if the past ten years had not happened. The devastations of the war have not left an imprint on them and have not forced them to reevaluate their previous habits and indeed their lives.

Yet the narrator is not an impartial observer with nothing at stake. In the opening sentence, he notes that what he is about to tell us is not really a story and may not even have any content to it, yet he is compelled to tell it. Why is he "compelled" to tell the story, he wonders, even

though it has no content? Why, as he recognizes the house, does he feel "gripped by an indefinable emotion. Everything, the past of ten years ago and everything that had happened since then, raged within me in a frenzied, uncontrollable turmoil"? What was it about that particular house that pushed him into this state? The thrust of the first part of the statement (i.e., that he is compelled to tell "it") expresses an urgency that does not seem warranted by the blandness of what he thinks he will tell and that is explained—or not explained—only by his admission of "a frenzied, uncontrollable turmoil." The tension between his urgency, the "frenzied, uncontrollable turmoil" and the described blandness of the scene prompts the reader to step into the narrative and provide the answers the narrator cannot supply.

The narrator is caught in the crosscurrent of continuity and rupture and finds a compromise in the image of transition. He suggests that the break is only temporary. He shows the continuity in the young woman's (the next generation's) habits that effectively ignore or rather cover up the rupture and devastation; but he also neatly divides time into "ten years ago" and "now," thus insisting on rupture. The house as an image of "inhospitable" continuity stands in contrast to the unsettling image of the bridge that spans the abyss between "ten years ago" and "now." Unpleasant and unfriendly, the house is nevertheless seen as a point of orientation and stability after the anxiety of crossing a yawning chasm. But when he speaks of the "frenzied, uncontrollable turmoil" within himself "now" as he thinks back to "ten years ago," he is focusing not on the continuity of the past into the present, but on what happened then that causes him the feelings of turmoil now. Anchored on the two shores of the "ten years ago" and the "now," he is jumping back and forth across the abyss of those ten years. These intermittent years are swallowed up by silence, but what occurred then causes his turmoil now.

"Ten years ago" the narrator needed to cross the bridge regularly and frequently because he was employed as a messenger for the *Reichsjagdgebrauchshundverband* and had to deliver documents from one branch of the agency to another. The term *Reichsjagdgebrauchshundverband* is of course an ironic play on the convoluted language of Nazi bureaucracies, but the nouns of the compounded word tell a story. *Reich* clearly refers to the Third Reich, whose many bureaucratic agencies were frequently prefixed this way (e.g. Reichstag, Reichskanzlei, Reichsministerium, etc.); *Jagd* (hunt) conjures up ominous compounds, such as "manhunt"; the noun *Gebrauch* in this instance works like a prefix indicating usage, so that a *Jagdgebrauchshund* would be a dog (*Hund*) used for hunting; *Verband* is an association. "The Reich's association of dogs used in hunts" carries unpleasant undertones. Since the

word's very length calls attention to itself, one is drawn to wonder what kind of dogs these were and what (or whom) they hunted. The importance and the sinister nature of the association's business is stressed in the fact that its documents were not entrusted to the mail but needed to be transported by courier.

What sort of documents did the narrator carry? As he explains in his state of "frenzied, uncontrollable turmoil," they were "urgent correspondence, money, and 'Pending Cases.'" These pending cases were in a big yellow folder. In an aside that serves only to betray his anxiety, he protests that he knew "of course" nothing about dogs, since he had not had "much education." What appears as modesty (he views himself as an uneducated "errand-boy") is rather an apparently unnecessary excuse: there is no reason he should have been expected to know anything about dogs. So why does he stress his ignorance? The excuse is furthermore built on a non sequitur: there is no logical connection between knowing or not knowing anything about dogs and being educated or not—unless, of course, these were hunting dogs who required handling by "educated," trained people. The narrator's denial blurs the issue: while he was "uneducated" enough not to "understand" anything about dogs, he knew enough *not* to want to know more and to prefer ignorance. While no specifics are mentioned, an aura of unease is created. His description of himself as "uneducated" also seems to answer a question that was never asked, but that seemed important enough for him to be answered—namely, What was in the yellow folder? Here, his professed insignificance reads like an exoneration: "Being only a messenger, of course, I never was told what was in the folder" (9).

"Never being told what was in the folder" is an ingenious use of the passive voice. It renders the narrator passive and powerless vis-à-vis a decision-making bureaucracy. In fact, the narrator hides in two ways: behind the passive voice (he never was told) and behind the lowliness of his position. Unstated but implied in this sentence is the understanding that as a rather lowly employee his conduct could only be submissive and he had to obey directives. He was in no position to ask; he was only a messenger. But why would he plead ignorance with such insistence if he truly did not know what was in the folders? The key to this professed ignorance lies in the resounding silence of the code word "yellow."[20] It evokes, even as it keeps its silence, the most unique and public use of the color during the Nazi regime: the yellow Star of David that all Jews were forced to wear. Victor Klemperer, a university professor who was himself forced to wear it, gives this account of the impact this "order" had on him:

What was the most difficult day for the Jews in the twelve years of hell?

Never did I receive from myself, never from others, an answer other than: September 19, 1941. From that day on, the Jewish Star had to be worn, the six-pointed Star of David, the rag in yellow color which to this day indicates pestilence and quarantine, and which in the Middle Ages was the identifying color of the Jews, the color of envy and of bile that had entered the bloodstream, the color of the evil to be avoided; the yellow rag with the black imprint "Jew," the word surrounded by the lines of the two juxtaposed triangles, the word written in printed letters that suggest in their isolation and exaggeration of the horizontal lines Hebrew characters.

Is the description too long? But no, on the contrary! I only lack the skills for a more precise, a more penetrating description.[21]

In Böll's story, the narrator's position appears completely compromised: not knowing what the folders contained precluded any need to act on that knowledge, and in the process imperil himself. The passivity inherent in not being told (and never asking to know) what the yellow folder contained becomes a refuge, since knowledge would call for action. A lowly employee can cloak himself in silence until he is all but invisible, but he is still—and the "turmoil" in himself tells him so—an ever so faint collaborator. In this respect, Böll's protagonist is representative of the many other "lowly" Germans who pretended ignorance because they felt powerless against the Nazi regime; they were afraid of shedding their passivity and ended by creating a complicity of silence. (There are incidents documented in other countries where in similar situations such documents were "lost.")

We realize only gradually why the narrator does not tell a story, does not even think that there is a story to be told, yet invests his nonstory with much emotional weight: he is making a confession. It is an explosive confession of omission and inactivity, welling up in him like a "frenzied, uncontrollable turmoil" whose intensity can be gauged only by the strength of his plea of ignorance and powerlessness. It is a call for exoneration built on false witnessing. The most burdensome continuity from "ten years ago" into "now" is the continuity of hiding in alleged ignorance. Between the silent cooperation then and the lack of admission now, the Enlightenment idea of man had collapsed and hitherto unimaginable crimes had been committed. Böll knows this, as the panicked state of the narrator and the telling use of the key word "yellow" indicate. But the bridge functions as an ambiguous symbol: its precarious state tells of the destructions suffered, while its very existence tells of

the effort to maintain continuity; and it shows how the abyss between the two shores gets crossed: with inner turmoil and the silence of non-acknowledgment.

A year later, Böll published his first novel, *And Where Were You, Adam?*,[22] an interconnected series of episodes (echoing Böll's early preference for short prose pieces each with its own epiphany) loosely held together by the figure of one soldier, the architect-turned-infantryman Feinhals. The title is taken from an epigraph by Theodor Haecker which precedes the novel: "A world catastrophe can serve many things. Among others, to find an alibi before God. Where were you, Adam? 'I was in the world war.'" The title of the novel is a call for individual accountability, but the answer of the epigraph takes refuge in an alibi that seemingly submerges the individual in the enormity of the world war. As the literary scholar Alan Bance has observed, it is both "an excuse and an accusation . . . indictment *and* exoneration."[23] The war seems to become its own excuse; the individual is swallowed up in it, follows and obeys, and displays a passivity similar to the narrator's in "Across the Bridge." The understanding of war as an event beyond the individual's control is further asserted in the second epigraph to the novel, taken from Saint-Exupéry, where war is viewed as an illness that has an existence of its own.

The interconnecting scenes of the novel depict the retreat of the German army through Hungary in 1944. Böll was twenty-two years old when World War II started in 1939, and he served for the entire war as an infantryman in France, Poland, the Crimea, and Romania. At the end of the war on the Western front, he was taken prisoner by the United States army. These experiences undoubtedly formed the basis of much of his writing and nourished a rather Manichaean dualism: sympathetic descriptions of the common soldier contrast with unflattering portrayals of the officers, who are frequently depicted as selfish, cowardly, and ambitious at the expense of the rank and file. Over the last two decades, the behavior of the "ordinary men" serving on the Eastern front has been scrutinized by historians, and the noninvolvement of these soldiers in anything other than strictly military operations has been revealed as a myth.[24] Böll's dualistic and ultimately simplistic conception protected the common soldier: atrocities are committed not by the common soldiers, but by the SS. When Böll was asked—in an interview in Moscow during his first postwar visit there—what he had done during the war, he gave this answer:

I could testify that I did not shoot in this war, that I did not participate in any battles. But I was a soldier in Hitler's army. I was in your territory, in the Ukraine, in Odessa. And I constantly feel my part of the re-

sponsibility for what this army did. And everything I write stems from this realization, from this sense of responsibility . . .[25]

This statement is highly ambivalent and, just as the title of the novel *And Where Were You, Adam?*, it circles the problem of the individual's responsibility in confrontation with an overwhelming machinery without a conclusion: did he or did he not shoot in the war? What does he imply when he says that he was in the Ukraine and in Odessa? Does he suggest that he knew of, or participated in, the crimes committed there, since he "was a soldier in Hitler's army?" And if he feels "his" part of the responsibility for what this army did, what precisely does he feel responsible for? Is he trying to show solidarity with comrades even though he did not participate in their activities? Or is he actually admitting his participation in the activities committed? Is the ambiguous language meant to hide his complicity, or does it demonstrate a spirit of solidarity? Despite its apparent openness and its confessional aura, the sentence raises, but does not answer questions.

There are two Jews included in *And Where Were You, Adam?* In one instance, the young officer Greck is surprised to find, in a small Hungarian town, that "there were so many Jews still around" (48)—a remark that, as in "Across the Bridge," invests the speaker with an unstated knowledge of the Holocaust; moreover, the matter-of-fact nature of Greck's surprise over the fact that there were still many Jews around suggests a complicity with its goal. Contrasted with the unemotional response as concerns the fate of the Jews are Greck's repeated, emotionally charged assurances that he will "deny" something, "simply deny everything," since "life was worth a denial, after all" (47). What he is going to deny, if found out, is that, against all regulations, he has just sold a pair of trousers to a Jewish tailor.

> Although he didn't want to, he couldn't help thinking about it, how he had undressed in the Jewish tailor's back room: a stuffy little hole with scraps of patching material lying around, half-finished suits with buckram tacked onto them and a repulsively large bowl of cucumber salad with drowning flies floating around in it—he could feel fluid rising into his mouth, and he knew he was turning pale, disgusting fluid in his mouth but he could still see himself, taking off his pants and revealing his second pair, taking the money and the toothless old man's grin following him as he hurried out of the shop (51).

There is irony in the juxtaposition of the young officer's disdain at the surrounding squalor, which nevertheless does not stop him from doing

business with the tailor, and his violation of the order not to have con-
tact with Jews—an order so strict that he may be risking his life. Greck
is presented quite unsympathetically: he is saddled with psychological
impairments stemming from a rigid childhood education which find a
warped release in the monthly hygiene of sexual intercourse, in his in-
testinal preoccupations, and so forth. Böll is also openly critical of the
corruption of the German military when officers sell army property (as
Greck sells his trousers) to finance the luxuries of alcohol and women.
But when Böll wants to include a Jew, he needs to rely on clichés. Here a
legacy of the Nazi regime is evident: Böll cannot transcend a dualistic
world, in which the "others" are the subhumans unworthy of recogni-
tion as human beings. Böll's officer Greck sees an East European Jew
with eyes clouded by prejudice and Böll's text nowhere dispels these
prejudices. When the young officer sees the tailor in his environment, he
sees what the author has been taught to see. The brief description of the
old Jew and of the townspeople is unreflected, and this lack of critical re-
flection demonstrates precisely the power of indoctrinated stereotypes.

The second appearance of a Jewish character is weightier than this
first one. Here, the protagonist Feinhals and a young Jewish woman fall
in love. When she tries to visit her parents in the ghetto, she is appre-
hended with the rest of the Jews (including Greck's tailor) and deported
to an extermination camp. Since the Soviet troops are approaching, the
camp has to be razed while the "crematorium" still works at full capac-
ity. When the camp commander asks her to sing—a performance he has
demanded from every arriving prisoner in order to enlist the best voices
for his choir—she sings the litany of All Soul's Day so beautifully that,
beside himself, he shoots her and orders the massacre of all those who
have survived so far. The camp commander is another cliché, with his
brutal nature evident in his "angular, oversized chin" which "dragged
down the finer part of his face and gave his intelligent features an ex-
pression of brutality that was as shocking as it was surprising" (102).
The stereotype of the sadistic and disturbed camp commander implies
that only insane persons could lend themselves to implementing the
Holocaust and that their evilness was visible in their features—a wish-
ful thought discredited a decade later by Hannah Arendt, who exposed
the banality of evil.[26]

The Catholic Böll created a special personality for Ilona, the young
Jewish woman with whom Feinhals falls in love, similar to a Jewish
woman who figures in his later *Group Portrait with Lady*. Both women
are converts to Catholicism. The Jewish woman of *Group Portrait with
Lady* has even become a nun; in *And Where Were You, Adam?* Ilona
contemplated taking vows and decided against it because she wants a

family and children. As he does in other novels, Böll shows a certain idealization of women as underdogs and as the prey of those in power. This image of women may well be related to or influenced by the cult of the Virgin Mary;[27] it elevates women while separating them and their problems from those of ordinary citizens. Böll can focus instead on Ilona's goodness and on the anguish of unconsummated love. She is even given time to reflect on her impending death, and she uses this time to pray.

The sympathetic description of Ilona rests on three criteria: she is a devout Catholic; she is an underdog; she is a woman. What if she had not been a convert? What if she had been married and the mother of children? What if she had had a Jewish husband? These questions find no answer, although Böll clearly indicates that Ilona was not alone in the van that transported the Jews from the ghetto to the extermination camp. With Ilona and the tailor, the limits of conceptualizing the "other" are reached. According to the logic of the narrative, Feinhals can love Ilona because she is Catholic, while the tragic inevitability of her death is determined by her Jewish heritage. This determination is taken for granted, as if it were an incurable disease. It is a fate that must be submitted to. The extermination of an entire people is never cause for outrage. Ilona and Feinhals are both seen as victims, united in victimhood; both are subjected to orders that result in their death. The fact that genocide is criminal madness and therefore on quite another plane from the death of a soldier in battle is ignored.

Böll also includes a scene in the novel in which two drivers transfer the last sixty-seven Jews, including Ilona and the tailor, in a van to an extermination camp.[28] As the two drivers stop on the way to drink their coffee, eat their bread with butter and sausage, show each other photographs of their wives and children, and sing soldiers' songs, they are the "ordinary men," who could simultaneously submit the people in the van to great suffering (six of them die in transit) and ultimately send them to death. In the postwar years, people like the drivers could of course plead innocent since they did not kill anybody. The ambivalence of the answer to the question "And where were you, Adam?" which uses the overwhelming power of the war as an excuse for what was done, is here particularly poignant, since clearly the drivers could have shown some humanity toward the victims.

The two drivers, as "ordinary men," have names and are set in opposition to the SS, who are identified only by their titles. The killers are anonymous. A brief conversation between the drivers and an SS man demonstrates how the language of silence based on complicity operates in all its sparseness.

"The camp," he said, "there's no more camp now—by tonight there'll be no more camp—it is empty."

"Empty?" asked Plorin; he had sat down and was slowly rubbing his sleeve along his machine pistol, which had got damp.

"Empty," repeated the SS lieutenant; he grinned faintly, shrugged his shoulders. "The camp's empty, I tell you—isn't that enough?"

"Have they been taken away?" asked Schröder, already at the door.

"Damn it all," said the SS lieutenant, "leave me alone, can't you? I said empty, not taken away—except for the choir." He grinned. "We all know the old man's crazy about his choir. Mark my words, he'll be taking that along again . . . "

"Hm," said each of the two men, and then again: "Hm . . ." and Schröder added: "The old man's completely nuts about his singing." All three laughed (100–1).

The difference between the inmates being "taken away" and the camp being "empty" is the difference between life and death, separated by genocide. The SS man grins when he stresses the word "empty." This grinning seems a cover-up for an embarrassment caused by the drivers' questions and is stressed when he says: "Damn it all . . . leave me alone, can't you?" Apparently the atrocities themselves do not disconcert him, but the questions of outsiders, whom he nevertheless considers comrades and to whom he feels he owes an answer. Evident here is the clear fault line between denial toward outsiders and strangers and a language of complicity among "comrades" which depends on silences and gaps for communication, and where the SS man's change of subject from "empty" to "choir" functions as cover-up and as diversion to a more pleasant topic. The repeated "hm" which the drivers utter suggests that they have understood the meaning of "empty." Schröder's comment on the choir, following the SS man's lead, is also not only a turn to a more pleasant subject—from those killed to those living, and to the commander's folly in taking them along—but repeats the SS man's tactic of diversion to cover up his previous inquisitiveness. It is an admission that he knows what he perhaps does not want to know, and signals to the SS man that he does not want to pursue his earlier question—perhaps even that he knows he should not have asked. When all three of them laugh together in the end, the laughter establishes (or reestablishes) a bond that for a precarious moment seemed in jeopardy, a bond that includes the knowledge of what "empty" means and how this emptiness comes about; it affirms their cameraderie and the drivers' understanding of the SS man's "duty."

The language of *And Where Were You, Adam?* is a sparse language. The sentences are short, the descriptions are realistic, adjectives and

verbs predominate. The perspective is narrowly focused, as if a camera were steadfastly registering a small scene, never pulling back to allow a wider angle and a more complex context or to orient a character within a larger frame. Exclusion of a wider perspective perfectly reflects the characters' narrow point of view, their obliviousness to anything other than the situation at hand, a tunnel vision validated in the novel by the volatility and omnipresent perils of war. Preoccupied with their immediate circumstances, the soldiers, among them Feinhals, make no attempt to understand why they are where they are, and they do not ask themselves why they are participating in genocide, why they do not assert their humanity. The passivity of "Across the Bridge" is here presented in greater detail and demonstrated "in action." This passivity goes hand-in-hand with orderliness and obedience and is not recognized as an abandonment of humanity. There is no hint in the novel that either the author or one of the protagonists has reflected on these circumstances, much less thought of rebelling or resisting, whether on a moral, mental, inner, or active plane. One suspects that even in Böll himself this passivity and sense of powerlessness is so internalized that no alternatives can be contemplated; and, more important, no questions can be asked as to the ground on which the orders from above must be obeyed.

Böll's inclusion of the scene with the concentration camp was, at the time, a significant achievement. It spoke directly of the existence of the extermination camps and constituted a very early undermining of the carefully cultivated myth that "ordinary soldiers" had no knowledge of these camps and of the genocide. Yet "having knowledge" is different from perpetrating genocide, and that, he seems to indicate in this novel, was the province of the SS. The pathology of the camp commander immediately sets him apart as a madman with whom sane people have nothing in common. In this early novel, Böll relies in his descriptions much on what one must call clichés. In fact, one can interpret these clichés as safe retreats into generalities that do not demand individual accounting. There remains, however, an inherent irresolution: the question addressed to "Adam" as an individual is answered with the alibi of war. Yet "war," as Böll shows in this novel, is not only the all-embracing, monolithic event that smashes the innocent victims like Ilona and Feinhals. "War" is also composed of the many actions of individuals, and these individuals have options, as Böll shows in the drivers of the van. His rigorous dualism (into commanders and victims) and the concomitant perception of passivity, even fatality, make him ignore the many opportunities for expressions of humanity—opportunities he himself set up in the title of the novel and in some tenuous scenes. Despite these shortcomings, Böll's texts never again attained the level of critical

presentation and the *desire* to find a language to speak about the Holocaust seen in these early and perhaps least guarded articulations.

The overwhelming emphasis on the victims and their inability to escape their "fate" made Böll a highly successful writer. As the seismograph of a people's conscience he reflected general postures; he, like most Germans, did not address issues that needed urgently to be confronted. In his later career, Böll became an outspoken activist and a sharp critic of postwar consumer society. In his identification with underdogs, rejects, and outsiders, he tried to understand the outrage of the student protesters and the terrorists of the 1970s and showed abiding and deep sympathy for the Russians. Yet the Catholic Böll could include Jews among Hitler's victims only when they were converted, female, and unattached. That this should be the case in a writer with an acute moral conscience shows how deeply ingrained and unconscious the prejudices against Jews were and how silently they operated.

Wolfgang Koeppen

Böll's writings were highly popular and many Germans identified with his little guys in the difficult years following the end of the war. Böll wrote about the soldiers at the front and returning home to cities in ruins and without food, and about the deprivations of those who were living in the rubble and trying to cope despite their traumatized state. His negative characterizations of Germans who had been in positions of power during the Nazi regime and were maneuvering to regain these positions echoed the sentiments of many. At the same time, his stripped, unpretentious, and colloquial language resonated with his reading public; they too used that language and saw themselves reflected in it. None of this applies to Wolfgang Koeppen. Koeppen published *Pigeons in the Grass*, the first volume of a trilogy, in 1951, the year of *And Where Were You, Adam?* The second volume, *The Hothouse*, appeared in 1953, and the third, *Death in Rome*, in 1954.[29] *Pigeons in the Grass* is set in Munich in 1948 soon after the currency reform and intertwines in several narrative strands aspects of the disorientation of postwar society; the second volume describes in disappointed and pessimistic terms the evolving political life in the provisional capital of Bonn; the third, *Death in Rome*, targets more generally the Nazi past and the survival of some of its basic tenets into the early years of what was later termed, after the first chancellor of West Germany, "the Adenauer restoration," driven by "the economic miracle."

The novels of this trilogy represent the first major literary efforts in the postwar period to reconnect German literature to the heritage of high modernism, and Koeppen's artistic achievement in these novels is considerable. He made no attempt to forge a "literature of the rubble," to find a language stripped of Nazi contamination, or to rediscover the literary innovations and traditions prior to the Nazi regime because for Koeppen these forms were a living, though long-silenced, presence. His language has been praised as one of breathtaking richness and sensuality.[30] Much has been said about the influence of James Joyce, notably his *Ulysses*, which Koeppen read when it was first published in German in 1926,[31] but also of Faulkner, Proust, Kafka, and especially Thomas Mann, whose *Death in Venice* is frequently cited as the model for *Death in Rome*.

How could Koeppen draw on an uncompromised literary heritage? His dates give a partial answer. He was born in 1906, in Greifswald, Pomerania, more than a decade before Böll. In distinction to Böll, whose adolescence and early adulthood were drowned in the slogans of the Nazi language, Koeppen had heard—and practiced—literary German of a world-renowned caliber. As a young man he participated in the heady intellectual atmosphere of Berlin during the Weimar Republic. After Hitler came to power in January of 1933, Koeppen went into voluntary exile in the Netherlands, but in 1938 was forced to return for financial reasons. "Hiding" as a scriptwriter for films, he survived through a chain of lucky circumstances until the end of the war. Driven by a sense of urgency that compelled him to publish three major novels in four years, he found himself in the anomalous position of reintroducing German writing of an avant-garde, international caliber to the German public, and he did so by presenting a highly critical panorama of German society in the first postwar decade. His preference for a sophisticated literary language and techniques that reconnected to the little-beloved Weimar Republic reminded his German readers that they had welcomed Hitler as one who would replace the chaos of democracy and avant-gardism with the order of dictatorship, and Koeppen's indictment of postwar society was not well received. *Death in Rome* sold only about 6,000 copies. This lack of success led to a crisis that he contained temporarily by writing travel literature. The influential literary critic Marcel Reich-Ranicki saw Koeppen's situation in a larger context when he said:

It turned out that the West German public had at first little and later no understanding at all of Koeppen's epic formulations of unsavory truths. None of the three novels became a commercial success, none

received an award, no paperback publisher was interested in *Death in Rome*. It should not surprise that such a situation led to a crisis. Nobody has the right to reproach Koeppen for not having continued to write against the grain. Perhaps he tried, we do not know. . . . It is an embarrassing symptom of the literary life in the Federal Republic that in the mid-1950s Koeppen saw himself confronted with a decision that was not dissimilar to the one he had to make in the mid-1930s.[32]

With the Marshall Plan and the election of Konrad Adenauer as the first West German chancellor, the signals were set for economic recovery. Immersion in postwar economic reconstruction blotted out any attempts to work through the past, but governmental and bureaucratic institutions also contributed their part. Adenauer shrewdly manipulated the need of the Western allies for reliable partners in the cold war (which soon escalated into the "hot war" in Korea), and while Koeppen was working on his trilogy debates were taking place on reestablishing a military force in the Federal Republic. There were considerable public outcries full of references to the disastrous consequences of Germany's military history that advocated a demilitarized Germany to demonstrate that attitudes had changed and that the lessons from the past had been learned. But these were protests against expensive military commitments and did not express a revulsion against the crimes committed. (In 1956, compulsory military service was reintroduced.) The historian Norbert Frei has convincingly shown the success of the judiciary in minimizing the number of war criminals and in reducing the sentences of those so defined, and brought to light the speedy resolution of the war crimes trials and the full reinstitution in the civil service of those who had served in similar positions during the Nazi regime.[33] The former German military organizations seized the moment and pressed the Adenauer government to accord extremely lenient treatment to former members of the military. When West Germany was accepted into NATO in 1954, the year *Death in Rome* was published, its military could join with reinstated reputation.

The initial phase of the Adenauer restoration was marked by consistent efforts to ignore, repress, deny, and/or circumvent acknowledgment of the atrocities committed during the Holocaust. As the ruins and rubble disappeared and the "literature of the rubble" lost ground, there arose a new emphasis on the "inner life" as the refuge of "spiritual man." The Mitscherlichs analyzed the situation a decade and a half later as "psychological immobility" reflected in the particular combination of apathy in political matters and a near frantic involvement in economic reconstruction. With the tacit agreement of the Allies, West Germans

effectively ignored the crimes of the Nazi regime, and people prominent during that time continued in public service. Alfried Krupp and Friedrich Flick were just two of the industrialists who did not have to serve their full jail terms. Many civil servants from the Nazi regime were reinstated, even in high positions of government (such as Konrad Adenauer's secretary in the chancellery, Hans Globke, who wrote the commentaries on the Nuremberg racial laws) and officials in the postwar judiciary and police were found to have been high-ranking members of the SS, the SD (security service), and the Gestapo. Indeed, Frei notes that "ultimately, the majority of the Gestapo-people were reinstated in their old civil service privileges."[34] The lenient sentences for many of the Nazi criminals brought to justice in the postwar decades were handed down by judges who had also served as judges during the Nazi regime. Moreover, high-ranking members of the Nazi regime, including the military, qualified for sizable pensions, while inmates of concentration camps received minimal restitution. Such injustices were to inflame the student movement of the late 1960s and particularly the terrorists of the 1970s.

While these domestic currents ran underneath the surface of the economic miracle, the Federal Republic was also in need of political rehabilitation. This rehabilitation could best be achieved by a rapprochement with the newly founded state of Israel. Israel was not at all eager to negotiate with West Germany, but, as the political scientist Lily Gardner Feldman has pointed out, the two countries both had reason to develop a "special relationship [based on] Israel's moral and economic right to reparations [and] Germany's need for political rehabilitation."[35] In March of 1953, the Luxembourg Reparations Agreement was ratified by both countries. The philo-Semitism of these years, evident in official and public pronouncements, should also be seen in this context. As a result of the Reparations Agreement in the early years of both states, relations between Israel and West Germany, despite many and varied oppositions, intensified over the decades, in marked contrast to transatlantic efforts. Much time elapsed before relations began to be established between American Jewish organizations and West Germany.

Death in Rome speaks to many of these issues. The novel presents an intricate interweaving of several narrative strands, in which the principals meet or bypass each other in a quasi-ritualistic way that has led the writer Alfred Andersch to speak of a "choreography" of narrative structures.[36] One might also speak of a "dance of death,"[37] in which the meeting of the characters obeys the logic of the plot but has very little probability. The stylization of the dance de-realizes the events in order to heighten them on a surreal plane. In the grand finale, all the charac-

ters meet in an ironic parody of comedies in which all the actors assemble onstage in the final scene. This assemblage is followed by a negative coda, the inversion of the redeeming and life-affirming satyr play of classical tragedy. Koeppen "plays" with this tradition in order to invert it into unredeemed negativity.

During three days in May of 1954, with the fall of Dien Bien Phu as the landmark second day, members of the Judejahn and Pfaffrath families meet in Rome. (The fall of Dien Bien Phu, only casually mentioned but omnipresent, hints at the end of the age of colonial and imperialistic aspirations.) Gottlieb Judejahn, an SS general condemned to death at the Nuremberg war crimes trials, has escaped to an Arab state, whose military he is now building up. He is in Rome to buy weapons and to meet with his family, who have come from Germany to see him. His nearly crazed wife, Eva, is frozen in a profound mourning for Adolf Hitler and the lost dream of German world domination. At moments she regrets that her husband did not die for this idea; at other moments she hopes he will revive it. When she meets him, she senses that his days (and hers) are past. Her sister is married to Friedrich Wilhelm Pfaffrath, an opportunist who is now a stalwart democrat and, in fact, the mayor of the same town in which he once was a high-ranking National Socialist administrator. His son Dietrich has followed his opportunistic lead and is preparing himself, ironically, for a career in law, ready to do anything that will further his ambitions. In contrast, the Pfaffraths' second son and the Judejahns' only son have cut the family bonds and attempted to extricate themselves from the parental and political heritage imposed on them. Adolf Judejahn is in Rome to be ordained into the priesthood; Siegfried Pfaffrath, a young composer, is there to hear the first performance of his symphony and receive a prize. Outside this clan, but from the same hometown, is the conductor Kürenberg, whose wife, Ilse, is Jewish. The couple emigrated after the department store of Ilse's father was burned to the ground and he was killed in "protective custody." Married to a gentile, she was fortunate in that her husband, an internationally renowned conductor, could afford to live abroad.

Koeppen draws the characters with great sensual intensity and psychological acumen, but they also represent types that, taken together, provide a cross section of early postwar German attitudes toward the Nazi past. In some instances, Koeppen anticipates literary and political trends that will not come to the fore until several years and even decades later. In the shameless recalcitrance of old Nazis like Gottlieb and Eva Judejahn, he strikes a theme that reaches to Peter Schneider's *Vati* of 1987, in which a fictive Josef Mengele still upholds the tenets of Nazi racial stereotyping in his hiding place in South America. Koeppen's

portrayal of the political reinstatement of former Nazis and of the nation awash in the anesthesia of the economic miracle sets the tone for much of the social, political, and psychological criticism of German society in the years to come. He blazed the trail for early novels such as Martin Walser's *Marriages in Philippsburg* of 1957, and Heinrich Böll's *Billiard at Half Past Nine* and Günter Grass's *The Tin Drum* of 1959. Koeppen also foresaw the consequences of parental denial and cover-up in his depiction of the younger generation's responses to their parents' past. He anticipated by a decade and a half the turbulent student movement and the attempts of the students to sever all ties with their parents. The two cousins, Adolf Judejahn the incipient priest and Siegfried Pfaffrath the incipient composer, stand in a complementary relation. Both have rejected their families and their early upbringing in Nazi Party schools (*Ordensburgen*). But Koeppen sees Adolf's motives as questionable. Joining a religious order after the demise of the party schools and their military order does not signal freedom or insight but rather a continuing abdication of individuality. The school's imprint on Siegfried is Siegfried's pedophilia; he may fancy himself free, indeed alone, but he seeks the warmth of community through the re-creation of early school bonds. While Adolf's life may be one of service and expiation, and Siegfried's may be one of artistic creativity expressing lament and despair, it is important to the interpretation of the novel that neither Adolf nor Siegfried will procreate. The same break with continuity in the refusal to have children is evident in the exiled conductor Kürenberg and his wife Ilse.

The break with the parent generation that these two young Germans symbolize does not lead to renewal through mourning, but to extinction. In Koeppen's extremely pessimistic view the best and most sensitive young Germans refuse to integrate into and contribute to contemporary society, while the ambition-driven opportunists, the Dietrich Pfaffraths, will thrive. Here Koeppen anticipates the debates on post-Enlightenment that would focus on the shattering realization that the Holocaust has destroyed Enlightenment faith in progress. In contrast to Böll, who shows a weary attitude toward temporary rupture and renewed continuity, as in "Across the Bridge," Koeppen radically insists on discontinuity in face of the continuity that has appeared to carry the day; he all but abandons any hope that the Germans will ever come to reflect on the Nazi past, let alone mourn it or work through it. Koeppen's conclusion is stark: the Germans are already dead and inhabitants of hell.

The literary scholar Christiane Schmelzkopf and others have observed that the presentation of Jews in the first postwar decade was philo-Semitic in an effort to compensate for the extreme hate directed at Jews

during the Nazi regime. Schmelzkopf notes that these presentations were, however, less inspired by "a living encounter with and working through of the various problems of the Jewish historical reality than by the effort to find literary expression for [an author's] clear intellectual self-orientation."[38] In contrast, Koeppen pioneered a presentation of Jews which was unmatched in openness and directness. In order to highlight the abyss separating the worldviews of his characters, he uses a double approach: in the Judejahn and Pfaffrath families he typifies the various postwar responses of former Nazis and their children to the Holocaust, and the persistence of anti-Semitism into the present; in Ilse Kürenberg, he presents a Jewish protagonist who was driven into exile and who is marked by the Holocaust.

Judejahn is the most vicious and unmitigated anti-Semite imaginable. His visit to Rome recalls in his mind his former stay as the all-powerful SS general, dispensing death wherever he walked. Like the cousins Adolf and Siegfried, he rejects postwar German society, but for opposite reasons; he sees in the opportunistic adaptation of the Germans a betrayal of Nazi ideology. His rabid ferocity seems wildly exaggerated and out of place in postwar Rome; yet in this isolation and outside a politically supportive environment his rantings show themselves for the madness and the evil they are. While Koeppen presents Judejahn's psychopathology using a number of highly skillful narrative techniques—inner monologue and editorial interruptions woven into a naturalistic account of the events of his visit—the most important clue to Judejahn is not the narrative language but the language Judejahn uses. Koeppen uses the Nazi language in all its vileness, hate, and denigration. In a time of philo-Semitism and rapprochement with Israel, this is a bold strategy intended to remind readers that this language was in fact their language in the not-so-distant past. His effort is aimed at perforating the wall of philo-Semitic cover-ups, and he dares to use the recently tabooed vocabulary in all its offensiveness, in an effort to provoke a confrontation with a past that used this language and subvert the silence of denials. He concentrates on carefully chosen key words for heightened impact and is careful to tie this language to a specific character, Judejahn. In *style indirect libre*, Judejahn harangues himself: "Why didn't he . . . fill his belly, fill it the way the Jews were doing it again?"(69); he imagines himself "lecherous like the Jews," (66, my trans.) and describes Laura, the cashier in a gay bar, as "a Jewish bitch, . . . Jewish cunt" (89, my trans.).[39] Rather stereotypically, Judejahn is portrayed as someone who did badly in school and suffered the denigrations of his father, and who therefore later found deep satisfaction in a hierarchy that allowed him to kill and to torture, to command and be obeyed. The simplistic ferocity of this

type always includes a sexual dimension; to be sexually aroused, Jude-jahn fantasizes about the "forbidden"—that is, about Jewesses: "It was a sin to consort with Jewesses, . . . but the thought of sin tickled the testicles, stimulated sperm-production, but the association remained prohibited" (168/9) and he sees copulation as lustful destruction along the lines of a Nazi racial mythology current not so long ago. "After the completed sperm-sacrifice, after the lustful hateful liberating thrusts, one smashed the vessel born of circumcized union, the unclean container of inexplicable seduction and cabbalistic magic, which had subtly lured to itself the precious Aryan genes" (169). This taboo also extends to Laura, whose divine, Petrarchan smile he does not even see, although he is responding to it: he must simultaneously disguise and stimulate his desire for her by imagining that she is Jewish. When they have sexual intercourse, his stimulant is to whisper to Laura, "You're a Jewess, you're a Jewess" (196). When he realizes that Ilse Kürenberg, née Aufhäuser, is Jewish in actual fact, he goes into a paroxysm of excitement, collapsing the past and the present in the image of naked women ready to be executed in front of ditches (168). In the novel's bitterly ironic coda, the apoplectic Judejahn is executioner and executed in one; he sees both women, Laura and Ilse, as Jewesses who must be violated and killed. After Laura's violation, he shoots and kills Ilse, who is standing in the window of her hotel room, and thereby completes the "botched final solution" (168), executing her himself. "He didn't just give the orders, orders were disregarded, he had to do his own shooting, and at the last shot, Ilse Kürenberg fell, and the Führer's command had been executed" (198).

In postwar Rome, Judejahn the unrepentant killer is clearly insane. Koeppen juxtaposes the present time of the novel with the wartime past, when the same Judejahn strutted through the same Rome executing people on a much grander scale, and was viewed then not as a mad executioner but as one whose orders were to be obeyed. Just as Judejahn's present Nazi language is meant to shock and outrage, so the activities condoned a decade earlier should now be seen in their criminal madness.

Koeppen portrays the Pfaffraths' anti-Semitism as more insidious than Judejahn's rant, and in its casual habitude exposes the superficiality of the philo-Semitic gestures that characterized German society in the first postwar decade. Friedrich Pfaffrath, the mayor, finds in Rome compatriots who, like him, have prospered in the economic miracle and prefer to use a language that has excised the events of the past. They are "compatriots, . . . fortunate survivors but with short memories . . . VW owners, drivers of Mercedes, redeemed by German efficiency" (30). As a concession to the Nazi crimes, Pfaffrath euphemistically admits that "mistakes had been made, you had to own up to them," and he opts for

the convenience of a zero hour in which one may "make a fresh start" (32). While the Nazi past is for Pfaffrath and his likes shrouded in a heavily tabooed language, they speak plainly enough about the Jews they encounter in the present. Pfaffrath père reflects on his son's compositions and the award he is to receive in this manner:

> The programme of the musical concert was full of surrealism, cultural Bolshevism and negroid newfangledness. Was the boy blind? But perhaps that was the way you made your name nowadays, now that the Jews were back in business internationally, dishing out fame and prize-money once again (33).

In the grand finale of the novel, all principal characters meet at a reception after the concert and the Kürenbergs are confronted with the past from which they fled into exile. Ilse finds herself in the same room with those who were instrumental in the killing of her father and the burning and sacking of his department store. In a pensive and melancholic mood, she assesses Pfaffrath as one of the many "ordinary men" who contributed their share to the catastrophes of her own life and of the Holocaust.

> Maybe he had bought his shirts in my father's department store, he bought his child's first toys from my father, and when my father's shop burned down, and the shirts and the toys were plundered, then he was satisfied, and when my father was murdered, he made a note of it in the files, and he approved (163).

While Ilse reflects on these losses, Pfaffrath is heedless of the past and his role in it, a personification of the change in outlook premised on the de-realization which the Mitscherlichs would identify a decade later. He is pleased to chatter in stupefying tactlessness with Kürenberg, never acknowledging why the Kürenbergs had to leave their hometown, and in fact behaving as if there had never been any interruption in their contact. He makes no reference to the intervening years of criminality and feels magnanimous when he "honors" the conductor with the invitation of "a prestigious engagement in the old still-ruined, but soon-to-be-restored theatre" of their hometown (163–4). He is an example of the many other Germans afflicted with "the inability to mourn," who are obtuse toward the suffering of others, and their own role in it, but extremely sensitive when they feel slighted. When Pfaffrath's invitation is not gratefully accepted, he responds to the rebuff with mental insults ("That's the way they are, whining or snooty"), in the process revealing that he clearly remembers the time when the Aufhäusers petitioned him for help and he refused to give it.

Only Siegfried and Adolf, sensitive members of a species that will become extinct with their death, show in their different ways a thoughtfulness and empathy that has nothing to do with philo-Semitic overcompensation but with simple human interest in the other. At the end of the war, Adolf and his schoolmates are making their way back home from their boarding school. As they walk along the railroad tracks, they see the remnants of a train that had transported concentration camp inmates. Here Adolf meets a "ghost" his own age, and it is the first time in his life that he sees "a live Jew, even though the Jew was barely alive" (75). When the young Jew starts to shake, Adolf covers him with his jacket. "He didn't know why he did it. Not out of pity. Not out of love. Not even out of guilt did he cover the boy. He just did it because he thought he was cold" (76).

Siegfried's moment occurs when he is invited for dinner at the Kürenbergs and discovers in the course of the conversation that it was Kürenberg who, two decades before, had come to his father with a request to help his father-in-law Aufhäuser, and the request was turned down. Even as a child Siegfried had realized that his father could be put in a bad mood,

> as he generally was when people came to him for help, they didn't seem to understand him in our town, because they often came to him for help, and it never even crossed his mind to intervene in lost causes. Not out of hatred, no, he wasn't twisted (he didn't like them, that was probably true enough), but he was afraid of them since they had been declared lepers. And most of all, even at that time, he feared Uncle Judejahn (46).

Siegfried now looks at Ilse and, knowing that her father was beaten to death in "protective custody," experiences an intense commingling of the present and the past that transcends empathy with the other in a moment of mourning and genuine sorrow for what happened.

> And we went to table, we sat down, Kürenberg served the food, she poured the wine. It must have been a delicious meal, I had to compliment the chef, but I couldn't do it, nothing had a taste—or rather, I tasted ashes, dead ashes blowing in the wind. And I thought: she did not see her father's house burn; and I thought: neither did she see our houses burn; and I thought: this has happened, happened, happened; this cannot be changed, this cannot be changed, this is damned, damned, damned. (47, my trans.)

The first part of the passage stresses in its slight preciosity the exquisitely prepared dinner, then negates its effect ("I couldn't do it, nothing

had a taste") to arrive at the core: "ashes." Preceded by the "delicious meal," the "ashes" present an even starker contrast. From "ashes" on, it appears as if the language were in shock; it is a stripped, almost inarticulate language that needs to repeat the same words as the incantation of trauma. For all their brevity, "ashes" and "damned" are not code words but directly address the crimes, the impossibility of undoing them and their damning consequences. Siegfried's thoughts, dressed in words, are the first, groping attempts to acknowledge what has happened and to break through the wall of opportunistic silence so amply personified in the Pfaffraths. Siegfried not only realizes but experiences the burden and the legacy of his realization. In the triad of "this has happened—this cannot be changed—this is damned," Koeppen also touches on a realization, at the time of his writing shrouded in total taboo, that these crimes will not go away and will haunt future generations in their attempts at self-definition.

Siegfried's mourning is even more speechlessly expressed in his music. Ilse Kürenberg rejects Siegfried's music; there is "too much death in these sounds, and a death without the merry dance of death present on antique sarcophagi" (154). "From the outset [it was] brittle, full of doubt, doomed to despair" (15), and she feels sorry for her husband because "he was taking trouble over something inchoate and hopeless, an expression of sheer, unworthy despair, shameless in its nakedness" (17, my trans.). When Adolf hears his cousin Siegfried's music at the concert, he invests it with aspects of his own affective autobiography and feels that "he could recognize himself in the sounds. It was like a reflection of his childhood in a broken mirror" (157). He hears "the memory of a time before guilt in these sounds" (157), but he also hears "cynicism and unbelief, the narcissistic flirtation with despair, and the drift into anarchy" (157). Siegfried's conflicting emotions, his inner fragmentation and despair, are the circumstance of those who have chosen to reject the denials and gloss-overs concomitant with the economic miracle; his mourning and sorrow, and his aversion to see life continued are the legacy with which he is burdened and out of which he must shape his music. He sees himself as Ilse sees his music: "I am naked. I am bare. I am powerless. Naked bare powerless" (93). But this admission of powerlessness is not made as an exculpation; it rather indicates utter destitution over the enormous burden of a past that cannot be undone. The nihilism, hopelessness, and despair that many have seen in this novel result not only from the realization of the enormity of the crimes but from the desire to annihilate oneself in response to them. Music is presented as the only voice that can adequately express the lament for which words, as Siegfried has shown at the Kürenbergs' dinner, are inadequate.

In the North-South polarities (reminiscent of Thomas Mann) that structure the narrative, the Kürenbergs represent Apollonian clarity, an enlightened humanism, an emphasis on reason, in opposition to the Northern ghost-riddled context of the Judejahns and Pfaffraths, who are marked by unreason, near madness, or denial. Immersed in the Apollonian aura of music, both Kürenbergs are presented as if they were statues from antiquity, perfect, self-contained, and timeless. He is "moulded by antiquity. His tailcoat fitted as on a marble statue, and over the white of the collar, shirt-front and tie, his head looked Augustan." Ilse Kürenberg wears "a simple black dress" that "looked as though it had been pinned on marble. It was like a tight, black skin on a well-preserved marble bust" (149).

Despite their agreeable lifestyle and the conductor's dedication to his art, the Kürenbergs do not pretend that the break in civilization created by the Holocaust has not occurred. Like Siegfried and Adolf, they make this obvious in their refusal to have children. Yet Ilse is not altogether different from other Germans in the sense that she, too, does not want to think about the traumas she experienced. She and her husband prefer a life of hedonistic pleasures, although their peripatetic, uprooted existence is a constant reminder of their broken, post-Holocaust lives. Not given to excesses of any kind, their measured enjoyment is mirrored in the references to classical antiquity and set in the brightness of Apollonian clarity.

> They were tired, and they enjoyed their tiredness. They saw the wide bed and they enjoyed the prospect of the cool clean linen. It was broad afternoon. They didn't draw the curtains. They undressed in the light, and lay down between the sheets. They thought of the beautiful Venus and the leaping fauns. They enjoyed their thoughts, they enjoyed the memory, then they enjoyed each other, and fell into a deep sleep (18/9).

Ilse wants to repress the thoughts about her father and the trauma associated with them, and therefore she rejects Siegfried's music, which expresses and laments what has happened. The conductor, on the other hand, wants to humanize this music in all its horror and despair (thereby aligning himself with those who tried to "aestheticize" the Holocaust).

> Kürenberg smoothed, accented, articulated Siegfried's score, and Siegfried's painful groping, his search for a sound, the memory of an Edenic garden before the dawn of mankind, an approximation to the truth of things, which was by definition unhuman—all that, under Kürenberg's conducting hand, had become humanistic and enlightened, music for a cultured audience; but to Siegfried it sounded unfamiliar and disappointing, the feeling now tamed and striving for harmony (6).

When Ilse Kürenberg is confronted at the reception with the murderers and would-be murderers of her father, she cannot tolerate the negativity emanating from them. She again takes flight and rejects all contact with the evil they embody. Mad, evil, and apoplectic, Judejahn later shoots her, as he himself is about to die. Ilse's death is a bitterly ironic comment on the unrepentant fanaticism of Nazi racists, and it also expresses Koeppen's refusal to engage in philo-Semitic amends.

Koeppen's novel has been interpreted, along the lines of postwar existentialism, as an expression of *Sinnlosigkeit*, an existential meaninglessness.[40] Yet one can hold this view only if one neglects the intimate connection between the abyss of despair and hopelessness and its origin in the Nazi regime. The meaninglessness in Koeppen's novel does not emanate from an existential void or from a spiritual exhaustion. Rather, it seems to be the only response possible to a realization of the atrocities of the Holocaust and the current political maneuverings. Even as attempts at reparations were being negotiated in the early 1950s between Israel and West Germany, Koeppen clearly could not accept them as restitution—nor could he suggest any affectively appropriate way of making amends or of working through this shattering legacy. Paralysis, negativity, meaninglessness, and extinction were at that time perhaps the only ways of expressing horror and sorrow. No other German writer for many years to come would have the courage of such intransigent convictions.

The collapse of past and present time, and with it the thought that certain human characteristics are "eternal" (as embodied in Rome, the "eternal" city), might suggest a denial of the Holocaust as a uniquely rupturing event and therefore the possibility of ultimate exculpation. This is not the case. *Death in Rome* is an ambitious artistic effort that connects with the literary endeavors of high modernism. The grand epic narratives of this pre-Holocaust period are often viewed as "polyhistorical." Polyhistorical perspectives entail the juxtaposition of multiple time levels, the collapse of time into timelessness, or cyclical recurrences. In *Death in Rome*, the polyhistorical depth is achieved by the constant references to Rome's long history, key events and key personalities of which are juxtaposed on the present. There are also frequent and character-specific references to figures from Nordic and classical mythology and mythological archetypes. The identification of the Kürenbergs with statues from classical antiquity is supplemented by many other references to classical models, as when Ilse is equated with one of the Eumenides, the sleeping goddesses of revenge (19). Judejahn is identified throughout with the realm of death in its most sinister associations. He was "a butcher. He came from the Underworld, carrion

smells wafted round him, he himself was Death, a brutal, mean, crude and unquestioning Death" (14).

Yet time in this novel is not strictly circular; it charts a downward spiral. Koeppen patterns the novel on the mythological concept of the four ages of man and gives it, with this pattern in mind, a fairytale opening: "Once upon a time, this city was a home to gods." From that point on, life and history are presented as a continual degradation from an original state. The temporal image of an ongoing degradation in a downward spiral is spatialized and made static in the very image of Rome, city of past glory and present putrefaction. Does the downward spiral suggest that eventually some bottom will be reached? Would the Holocaust then represent the descent into the most abominable depth of humanity, the nadir of the age of iron? And would this age of abomination be the one celebrated by the Nazis as the high point and fulfillment of their age of racist ideology?

There are many enactments of the myth of descent into the netherworld in the novel, yet there is no indication that there is a reemergence attended by new insights that presage a changed life. The nadir shows no promise of relief, just as Siegfried's music remains frozen in its utter despair and as the refusal to procreate signals extinction. Just as Siegfried and Adolf are without hope or a future, so the novel does not point to eventual redemption or regeneration. Those who embody reason, conscience, and suffering over the past shatter continuity, while the unrepentant opportunists will live in, literally, eternal and unchanging hell.

Koeppen's pervasive use of mythology has elicited a variety of interpretations. It has been argued that he makes uncritical use of mythological paradigms, or does not comment ironically on their use (as does Thomas Mann) in order to distance himself from the imputation that he himself subscribes to a cyclical view of history. He has been accused of a mythologizing of history, "a removal from history . . . and a distancing into the mythical" that deprives his work of its political and critical impact.[41] But the novel has also been interpreted as "banalizing" and ultimately "voiding" mythical structures.[42] Both these interpretations work within the framework of a modernism that has not yet been disrupted by the realization of the impact of the Holocaust. Koeppen, however, works with this realization. He not only "banalizes" and "voids" mythological patterns (and therefore the Western heritage built on them); he also shows that their presumption of continuity can be maintained only in the timelessness of hell and by the most unsavory assortment of people. He recapitulates the modernist legacy of polyhistoricism in order to subvert it. The Enlightenment faith in progress is shattered, and consecutive, redemptive time is annihilated. The Holocaust as absolute discontinuity

and break in civilization has destroyed humanity's earlier conception of itself. A realm of negativity, unrelieved by any hope and therefore timeless in its condemnation, is all that is left. This view is simultaneously the most stringent criticism of the Adenauer restoration. It is possible to read *Death in Rome* as a novel that struggles to find an appropriate language for what it wants to say. As Siegfried's shocked and stuttering attempts to find words for the horror and the sorrow have shown, there is no language to express it. Language fails, not because it wants to repress or cover up but because it cannot express the devastations. Instead, the novel is structured on inversions and subversions of the Western heritage, as compressed in its mythology, to pronounce the verdict and to show a world literally gone to hell.

Yet it is difficult to accept the rigorous consequences Koeppen draws from the shattering break in civilization. Extinction may well be the most radical disruption of continuity, but in its radicalness it devalues life itself. Koeppen's disappointment with the Adenauer restoration (and with the lack of response to his bitter jeremiad) led him to follow his young protagonists, who refused to participate and who, perhaps, speak for him. He seemed to agree with the critic who said of him that "his entire work is directed toward silence, toward falling silent, and . . . the silence today of the writer Koeppen is a consistent act of self-refusal."[43]

Documentary Literature

Alexander Kluge and Günter Grass

> To communicate something in [language] is simple; but not
> to communicate something, to let the communication dis-
> appear in an excess of language, that is a work performance
> of extraordinary quality.[1]

Wolfgang Koeppen's criticism of the Adenauer restoration and his bla-
tant attacks on the holdovers from the Nazi past did not gain him a large
readership, but his concerns were shared by thoughtful observers. The
"economic miracle" focused all energy on rebuilding the economy and
the cities, literally and figuratively covering over the ravages and de-
structions caused by the Nazi regime. There was much pride in the
speed and thoroughness of the recovery, in the work ethic, and the coun-
try's economic success, but no questions were asked about Germany's
role in the war that now led to this frantic activity. Economic recon-
struction eliminated the physical ruination of World War II, but it was
not as successful in eradicating the memories of what had brought about
this ruination. These memories had to be repressed, denied, and covered
up in a maelstrom of subterfuges and *mauvaise foi*. The newly acquired
consumer comforts may have been an end in themselves, but they also
distracted attention away from any inquiry into the historical causes of
the devastation (the Hitler regime) or the less obvious motives (the de-
sire to forget that past). In all this ratiocinating, complex time manipula-
tions were necessary: the past was the propelling force in the present,

yet the past was also to be shown as overcome. The past drove the present to legitimate itself in the accomplishments of the economic miracle; but the past also wanted to be forgotten—and succeeded only in inventing strategies of denial and repression. The past could not become memory, because it was nightmare.

Within five years after publication of Koeppen's *Death in Rome*, several novels of significance were published that spoke clearly to the conditions of the Adenauer restoration. A single aspect of Koeppen's novel—the postwar prosperity enjoyed by the former Nazi, now mayor, Pfaffrath and his ilk—becomes the exclusive focus in Martin Walser's *Marriages in Philippsburg* of 1957.[2] This is a rather cynical account of postwar accommodation to the economic miracle and, like Koeppen's novel, is suffused with a subtext of death, which permeates all four sections of the narrative. Two years later, Heinrich Böll's ambitious *Billiards at Half Past Nine* takes the first long view, down three generations of Germans, to show a continuity of personalities and attitudes from the Nazi into the postwar period.[3] As in "Across the Bridge," Böll uses an architectural structure—this time the building and subsequent destruction of an abbey—as metaphor to symbolize the state of West Germany. As in *And Where Were You, Adam?*, the characters generally fall into two categories: victims and persecutors, metaphorically identified in the novel as "lambs" and "buffalos." Both Böll and Walser avoid in their novels any direct references to the Holocaust; in Böll's novel, the victims (the "lambs") are persecuted for political, not racial, reasons. To mark the disruption of continuity between the Nazi and the postwar period, and as a gesture of amends for silence during the Nazi regime, Böll has one of his "lambs," in the postwar period, attempt to shoot a "buffalo." In all these novels, death is an active participant in the discourse about Germany. Günter Grass's *The Tin Drum*, also published in 1959, concludes the literary outburst of the 1950s with great fanfare: it is the first postwar West German novel to win international acclaim. Common to all these novels is the strong note of criticism of German society as it evolved from the Nazi into the postwar period.

In contrast to the 1950s, in which Adenauer's "restoration" meshed with the stable but unexciting presidency of Dwight Eisenhower, the 1960s were a decade of political turbulence and civil unrest. A few months after President John F. Kennedy's visit to the Berlin wall in summer of 1963, but a month before his assassination, Konrad Adenauer, then age eighty-seven, resigned his chancellorship. This resignation ended the postwar era proper, with its domestic emphasis on the economic miracle and West Germany's integration into the Western alliance. Adenauer's successor, Ludwig Erhardt, had presided over the economic miracle as minister

of economics, but he could not steer the course as chancellor. Uneasy and short-lived coalitions and economic stagnation under the chancellorship of Kurt Georg Kiesinger, a former leading member of the Nazi Party, led, in 1969, to the election of the Social Democrat Willy Brandt as chancellor. The polarization was particularly reflected in an increasingly active and politicized student movement and in the leftist positions of the decade's prominent writers.

The Eichmann trial of 1961 in Jerusalem and the Auschwitz trials from 1963 to 1965 in Frankfurt/Main made public the atrocities of the Holocaust. The dramatic courtroom testimonies were of an immediacy and directness that left no room for repression, and the historical documentation and the authority of the witnesses allowed for no evasion or subterfuge. Although strategies of denial and circumvention persisted in the long run, the nature of the silence changed. The concurrent debates about the expiration of the statute of limitations in 1965, just as the Auschwitz trials came to a conclusion, further sensitized a new generation to the genocide. After intense debates, parliament voted to extend the statute of limitations for crimes involving genocide for four years (and then, in 1969, extended it another decade to 1979 when, after renewed heated debates, it was determined that there was no expiration for these crimes).[4]

Not surprisingly, the courtroom drama of the trials first inspired the dramatists. Trial documents provided the authority of fact as well as a language, and an alternative to unreliable narrators and a relativizing multiperspectivism. Document-backed drama could also be more aggressive in its apparent lack of narrative ambiguity. In quick succession, there appeared Rolf Hochhuth's *The Deputy* (1963), Heinar Kipphardt's *In the Matter of J. Robert Oppenheimer* (1964), Peter Weiss's *The Investigation* and Kipphardt's *Joel Brand: The History of a Business Deal* (both 1965), and Hochhuth's *Soldiers* (1967). Some of these plays focused on German responsibility for the atrocities committed during the Holocaust, but in Hochhuth's play *The Deputy* the Pope, too, was implicated for not having spoken out on behalf of the Jews, and *Soldiers* took issue with the Allied bombing of German cities. Heinar Kipphardt's *In the Matter of J. Robert Oppenheimer* moved altogether to the United States and drew on the American nuclear physicist's conflict between loyalty to his country and disagreement with his government's policies. In blurring the focus on German criminality, these plays invited and silently encouraged a comparative outlook in which crimes against humanity were seen as non-unique and to that degree softened condemnation of the perpetrators. *The Investigation*, by the exile Peter Weiss, was based on transcripts of the Auschwitz trials; it was criticized both for aestheti-

cizing the atrocities (Weiss modeled the eleven scenes of the play, each divided into three parts, on the thirty-three cantos of Dante's *Inferno*) and for giving a Marxist interpretation to the Holocaust, thereby "explaining" the Holocaust as the result of capitalism.

In the United States, the increasing politicization of the 1960s saw the emergence of the civil rights movement and the protests against the war in Vietnam. The techniques developed in these protests were then adopted in Germany, but also in Italy and France. The protests in Germany were directed against U.S. imperialism and the perceived close connection between the German political establishment and the United States. German students organized in the APO (the *Außerparlamentarische Opposition* or extra-parliamentary opposition) and joined the militant SDS (Students for a Democratic Society), which had originated in the United States. They also formed terrorist cells, most notably the Red Army Faction. The June 1967 murder of the university student Benno Ohnesorg during a student protest against the visit of the Shah of Iran to Berlin in 1967,[5] and the near fatal shooting of the SDS leader Rudi Dutschke in April of 1968 which anticipated the Kent State shootings in the United States, fueled the student protests and strengthened student commitment to the left. In these protests, the Holocaust seemed a peripheral issue, but it was nevertheless an unstated presence. This presence is evident in a statement made by then chancellor Kurt Georg Kiesinger in his state of the nation address in 1968; Kiesinger tried to defuse criticism of the United States' escalating war in Vietnam by saying: "We especially have not the slightest reason to lord it over the United States." Martin Walser, who reports this incident, then editorializes: "Which means, of course: we have committed genocide, they are committing genocide, and one crow should not pluck out the eyes of another one."[6]

1968 was also the year of the Paris Spring and of the Chicago Seven's disruption of the Democratic National Convention in summer of that year. The West German authorities, still imbued with an authoritarian intolerance of dissent, responded to the German student protests by passing the "emergency laws" of 1968 and followed them up in the early 1970s with "the decrees against the radicals," which barred former protesters from entrance into civil service jobs.

The German students of the 1960s were the first postwar generation not implicated in the crimes of the Nazi regime. But when they wanted to confront the Holocaust, their leftist orientation protected them from the need to work through the Nazi past and its legacy. Their equation was simple: the Holocaust was an outgrowth of fascism and fascism was the most reactionary and most imperialistic development of capitalism.

Therefore, the most important issue was the battle against capitalism. This position allowed them to attack the United States for its imperialistic war in Vietnam and, on the home front, the generation of elders who had embraced fascism, were now allies of the United States, and continued to practice capitalism in pursuit of the economic miracle. This position would ultimately lead the terrorists to target "representatives" of "those sections of German society that had helped Nazism to power and had maintained it there, notably the banking establishment and heavy industry, the judiciary, the army and the civil service."[7] As the literary scholar Andreas Huyssen has so cogently remarked:

> It is time to criticize left theories of fascism which relegate the Holocaust to the periphery of historical events, and which demonstrate the indifference of many German leftists toward the specificity of the "Final Solution." The left's instrumentalization of the suffering of the Jews for the purpose of criticizing capitalism then and today is itself a symptom of post-war German amnesia. To what extent, indeed, is the German left's insistence on comparing Auschwitz to Vietnam different from the right's claim that Auschwitz is balanced out by Dresden or Hiroshima?[8]

By the early 1970s, documentary drama began to lose its impetus. Nevertheless, twenty years after the publication of Hannah Arendt's *Eichmann in Jerusalem,* Heinar Kipphardt still connected the interest in documents and the need to confront the past in his documentary play *Brother Eichmann* (1983).

Along with documentary drama, documentary prose became a widely practiced literary subgenre. It lacked the vivid impact of drama, but it was equally pointed in its social and political criticism. In documentary drama, there was a greater tendency to accept documents as objective statements and to build on their presumed factualness. Prose, as a more intimate and subjective genre, could inquire into its own preconditions and question accepted notions of authenticity. The selective preference for certain documents and their use in collages and montages was soon problematized, and the "objective" and "factual" aspects of the documents themselves were radically undermined. Some of the more interesting examples of documentary prose were published in the 1970s, a generally less dramatic and action-oriented decade, in which politics was leavened with more introspective and psychological explorations. Uwe Johnson's *Anniversaries,* published in four volumes between 1970 and 1983; Hans Magnus Enzensberger's account of the death of a Spanish anarchist leader in 1936, in *Der kurze Sommer der Anarchie: Buenaventura Durrutis Leben und Tod (The Short Summer of Anarchy: Bue-*

naventura Durruti's Life and Death) of 1972; Heinar Kipphardt's study of schizophrenia, *März*, of 1976, and Tankred Dorst's *Dorothea Merz* of the same year are some of these examples; and Heinrich Böll was awarded the Nobel prize in 1972, one year after the publication of *Group Portrait with Lady*, in which an authorial narrator does "research" into his protagonist's past and presents the "documents" of his endeavors. The most rigorous and far reaching of these novels is Rolf Hochhuth's *A German Love Story*, published in 1978.[9] In it, and in the play *Jurists*, published a year later, Hochhuth uses documents to buttress his accusations of a postwar society that glossed over the Nazi crimes and allowed prominent personalities—in particular judges—to continue in office. *A German Love Story* investigates the documents and records of an affair between a German woman and a young Polish prisoner of war and interviews witnesses and the executioner of the verdict—death by hanging for the young Pole and concentration camp for the woman. He is particularly persistent in his accusations of then Minister President of Baden-Wurttemberg Hans Karl Filbinger, who served as a judge in the navy during World War II. It was in great part due to Hochhuth's persistence and documentary evidence that Filbinger was forced to resign his office in 1978.

Alexander Kluge

Perhaps the most radical position in the field of documentary literature is pursued in the work of Alexander Kluge. Kluge, born in 1932, studied law and minored in history and church music, but by 1960 he had become a writer and filmmaker. On occasion, he has made use of his legal background to assist the artistic community: his "Oberhausen Manifest" of 1962 demanded, among other things, the founding of a German film academy to train a new generation of filmmakers, and he took part in battles over the Federal Film Subsidy law.

Kluge's ideological outlook is situated on the left, yet he also acknowledges the influence of phenomena such as the emotions, irrationalism, and the driving force of desire. In his film and prose works, he builds on Brecht and the suppositions of the left—namely, the belief in the didactic mission and power of art.[10] Yet Kluge goes beyond Brecht's modernist aesthetics in the radical development of techniques of distancing. Although there are vast, media-inherent differences between film and literature, Kluge's films and prose narratives share many structural characteristics. They are both decentered: there are no privileged story lines, no principal characters, no plots. Instead, they consist of an accumulation of montages of seemingly unrelated discourses and images

and (in the films) sound tracks. Kluge assigns a special significance to the gaps between the elements of a collage, since these gaps establish a relation between the elements which is not otherwise apparent, and he mixes theoretical exegeses, fairy tales, philosophical statements, traditional literary prose in an effort to abolish narrative boundaries. Most important, Kluge undermines (indeed, disempowers) the privileged authority of documents, since "the document may very well be invented and the invented material can be based on facts."[11] He dismisses the differences between literary and documentary texts to show how any sort of discourse expresses the interests of those who create it. This practice has grave consequences when the narratives deal, as do practically all of Kluge's, with history—specifically, German history during the Third Reich and into the postwar period.

Kluge's literary texts have been seen as part of the crisis of narrativity, which is generally related to the upheavals and devastations of the twentieth century. One of its characteristic features is the dissolution of the individual, who is either crushed by forces he or she cannot withstand (and often does not even recognize) or disappears into anonymity and the collective in response to a sense of powerlessness and an inability to penetrate the multitudinous and interconnected forces. In this context, the Holocaust is then seen as the ultimate manifestation of rapid technologization and its concomitant anonymity. This leads to a facile exoneration, since it argues a near inevitability of the Holocaust as a "logical" development and reinforces German self-interpretations as being powerless in the face of overwhelming forces. Kluge attempts to illuminate the processes that lead individuals to become deindividualized and dehumanized, leaving gaps and silences in the text where individuals could have asserted their humanity and thus implicitly subscribe to the view that humankind cannot be held responsible for its acts. Portraying an individual in the environment that shapes him/her requires an enormous amount of information on the diverse aspects of the individual's societal existence. Moreover, each bit of information is itself "interested" in that it has invariably been put together by someone or some entity with a specific point of view, so that to arrive at any factuality innumerable fragments are needed to supplement and/or counterbalance each other.

Kluge's rigorous demonstration of the socially mediated destruction of the individual has consequences for the narrative point of view. Kluge runs into the limits to his rigorous approach when he attempts to eliminate the narrator, since it is inevitable that the author's consciousness selects, shapes, and arranges fragments and scenes and thus betrays the author's interests. Moreover, Kluge's drive to eliminate the narrator is itself a reflection of the dehumanizing processes he portrays. But at the

very point where the weakness of his approach is most apparent, he per-
forms a volte-face and asserts his belief in the power of didacticism. His
fragmented and "disinterested" language and the juxtaposition of diver-
gent scenes are then challenges to analyze and form opinions of one's
own. This didacticism is founded on faith in the Enlightenment con-
cept of human perfectibility and the ability to learn, and stands in open
contradiction to his portrayal of figures who are counterexamples of
this faith.

If Kluge is radical in this adamant insistence that all discourse is "in-
terested" and that the boundaries between different types of discourse
must be abolished, he is equally radical in his elimination of the lines
between authenticity and fiction or between fact and hypothesis. This
sets him apart from most other writers who also use hybrid forms, but
who do not question the authenticity of documentary evidence. When
Andreas Huyssen compares Kluge to other contemporaneous writers of
documentary literature, he comments on Kluge's advanced theoretical
and practical position. As documentary drama burst upon the literary
scene in the early 1960s, he says,

> Kluge was already beyond certain aesthetic and political propositions
> on which much of the documentary wave was based. For instance, he
> did not make a categorical distinction between fiction and document,
> as so many of the documentarists did. He did not believe in the myth
> of the real, the myth of authenticity, which the document suggested to
> many at that time. He was skeptical of the claim that the document as
> used in the literary texts was closer to reality than to fiction, that only
> real documents could serve as the basis for a new realism, for a reinvig-
> orated effectiveness of literature in the public sphere.[12]

Kluge's undermining of the narrative boundary between "documents"
and "fiction" further reflects his skepticism about the "narratability" of
events, scenes, portraits—a skepticism premised on what the historian
Hayden White calls "cognitive disorientation and a despair at ever being
able to identify the elements of the events in order to render possible an
'objective' analysis of their causes and consequences,"[13] and on the prob-
lematics of shaping a language able to express this disorientation and de-
spair. The conditions created by the Holocaust have invaded all
cognitive, linguistic, and experiential realms. The postmodern attempts
to find a voice for "representing" the Holocaust have pioneered a lan-
guage of ruptures, fissures, gaps, and fragmentation. Kluge clearly situ-
ates himself within these realizations. Hayden White might have been
talking about Kluge's narratives when he says:

This is why the kinds of anti-narrative non-stories produced by literary modernism offer the only prospect for adequate representations of the kind of "unnatural" events—including the Holocaust—that mark our era and distinguish it absolutely from all of the "history" that has come before it.[14]

If these "anti-narrative non-stories" offer "the only prospect for adequate representations of . . . the Holocaust," their constitutive elements must be scrutinized. It is not enough to know that Kluge is "an author who is interested in the structure and paradigms of documentary discourse rather than in their claims to empirical truth or factual accuracy."[15] A preference for "structure and paradigms," or despair over the unattainable "empirical truth or factual accuracy" will not suffice as evidence of an attempt to come to some understanding of the Holocaust. Despite the narrative fragmentations and the discontinuities associated with it, the Holocaust demands the adoption of a moral position. Kluge's language bears all the gaps and wounds and fissures associated with the problems of speaking about the Holocaust, but his skepticism about the factualness of "interested" discourse defies the unequivocal position a discourse about the Holocaust demands. In fact, his concern with "interested" discourse can be seen as an attempt to elude direct confrontation. If his compulsive concern with the German past indicates a desire, or a need, to confront this past, the skepticism about language and the distancing techniques seem to indicate an evasion, while his didactic impulses point in the direction of an intellectual continuity based on Enlightenment faith in teachability that ignores the abyss cut by the Holocaust.

Yet Kluge has written one remarkable narrative that defies evasion. This is the short narrative "Ein Liebesversuch" ("An Experiment in Love," or "An Attempt at Love") which is part of Kluge's first publication, *Case Histories* (1962).[16] *Case Histories* was published between the Eichmann trial and the Auschwitz trials, before the avalanche of documentary literature. As Kluge's first published work, it is the least radical, although narrative boundaries are no longer clearly discernible. The later, deliberate fragmentations are anticipated in compressed, minimalist portraits. Kluge presents a gallery of portraits of individuals and examines the events and traditions that shaped their lives. These individuals are "functionalized" human beings, acting from a dead center and frequently without a moral compass. They are marked by the acts and roles they played in the Nazi regime, and with this baggage they now live in the postwar period.

"An Experiment in Love" is presented as a fictive interview, but the substance of the interview—medical experimentations in the concentration camps—is based on well-documented practices.[17] The interview itself is a curiously disembodied affair: it is recorded in no-place and no-time (although the use of the past tense and the fact that these experiments can be spoken about freely indicates the postwar period), and it takes place under no particular auspices. One cannot even be quite certain that the text presents an interview—that there are two voices, one that asks questions and one that answers—since the "interview" could also be a dialogic monologue, a self-interrogation. The voice that asks the questions is anonymous; the voice that answers is that of a former concentration camp guard, equally anonymous. Several short and mostly impersonal questions elicit answers in a terse, dry, bureaucratic language that admits at first of no personal opinion or emotion. The entire text is a scant three pages long. The interview concerns an experiment that was conducted on two concentration camp inmates, a man and a woman, who had been lovers against many social odds before they were apprehended and deported. In the "experiment," they are brought together in an environment conducive to sexual intercourse, in order to test the success of sterilization campaigns with X-rays conducted in the camps. The "experiment" fails, because the two lovers cannot be made to copulate. The voice answering the questions sketches the scene of the "experiment"—a scene that has much in common with the mural outside the Grunewald train station: the mute and motionless prisoners are present as absences and silence, surrounded by the inescapable cement wall of those who busy themselves in preparing the "nuptial chamber" and then retreat behind one-way mirrors to watch. The setting also evokes scenes of interrogation and torture, in which prisoners are caught in beams of bright light while the interrogators hide in the darkness behind the lamps. Kluge places the two concentration camp inmates in the center of the narrative as he places them in the center of the ring of the guards and observers. While he individualizes the denigration and murder of these two people, he also has an introductory paragraph describe the mass sterilizations in the camps, so as to leave no doubt that this was a widespread practice. Kluge thereby manages the double perspective, reminding the reader of the enormous number of victims and individualizing their suffering in one specific instance. The brutality of the mass sterilizations is echoed on the individual level in the brutality of the efforts to get the couple to copulate and ultimately in their being killed.

The interview speaks across a distance of time and of place; the events described are remembered, not actually happening. The interview distances the events even as it brings them into the foreground as mem-

ory. The impact of the experiment is filtered through the interviewee's answers, so that the narrative proceeds on two levels simultaneously: one is the level of the experiment as remembered, the other the portrait and self-presentation of the narrator. The interviewee's report appears quite matter-of-fact, yet this very matter-of-factness expresses the narrator's "interest." The "objective" presentation of this "interest" gets, toward the end of the interview, slightly cracked.

The brutality involved in preparing the prisoners for the "experiment" is not so much an exercise in prurient sadism as a demonstration of depravity and of subservient anxieties—a high-ranking SS officer has announced his intention to watch the "experiment," so there is much pressure to make the experiment work. In order to excite the prisoners, their clothing is removed; they are hosed down with cold water, so that they will seek warmth from each other's body; their bodies are pressed together and rubbed with alcohol; they are fed protein and alcohol, even champagne; records are played and the lighting is adjusted to create a "mood"; but even after two days in the same room, the prisoners would not have intercourse. It is not the passivity of the prisoners that is striking but the expectations of the "experimenters" that their depraved methods in an environment of generalized inhumanity will be successful. What must "love" mean to them (and what sort of "love" must they have practiced themselves) if they think love can be implemented (*bewerkstelligt*) according to their plan? But one of the points of the text is precisely that the practices of the experimenters were for them not out of the ordinary. This is evident in the reference to an "Oberscharführer" (an SS man) who "knew something about such matters" and who tried "everything that works normally for dead certain (*totsicher*)." If he "knew something about such matters," he must have used these methods himself many times. The crudeness of a language that does not perceive itself as crude but merely informative is further indication that crudeness and depravity were not even recognized as such and that the practices of this "connoisseur" were widely used and appreciated.

To demonstrate that "facts," too, are the expression of specific "interests," Kluge subverts the "scientific" status of the "experiment." Could the "experiment" really be considered an experiment? Would observation of the intercourse have granted a scientific status to this "experiment" that lack of observation withheld? Would the observers really have observed what they said they were looking for? Even if intercourse had occurred, would it necessarily have led to pregnancy, or would the absence of pregnancy have proven that the participants were now sterile? The "interest" or rather the conflict of various "interests" behind the "experiment" is eventually revealed. In one of the last questions a

certain sense of urgency arises: "Has really everything been tried?" ("Hat man denn alles versucht?") The "really" ("denn") of the question is insistent enough to elicit in the answer an additional comment: "After all, we couldn't ourselves go in there and try our luck, since that would have been racial defilement." In the next question, the impersonal bureaucratic tone is abandoned and replaced by the personal "we": "Did we get aroused?" (The "we" in this question can be read as the interviewee's repetition of the question, posed to him by an unacknowledged interviewer and perhaps repeated to gain time for an answer; or the switch to "we" could have been provoked by the "intimacy" of the question.) Whatever the case, the answer to the question "Did we get aroused?" is a tortuous circumvention of an inadmissible "yes," and (to paraphrase the epigraph to this chapter) a "communication that has disappeared in an excess of language."

> In any event, more so than the two in the room; at least that's what it looked like. On the other hand, this would have been forbidden to us. Therefore I do not believe that we were aroused. Perhaps excited, since this thing did not work (108).

Voyeurism in the guise of scientific observation seems designed to satisfy prurient and infantile desires. When Kluge sketches sexual pathologies, he suggests that individual pathologies are part of a much larger reservoir. He wants to exploit the tension between the individual and the group by keeping the interviewee anonymous, while having him alternate, particularly in the last few exchanges of the interview, between a disembodied "I" and a generic "we." His attempt to present the anonymous, depersonalized, dehumanized, and functionalized individual as a product of the social environment, to the point where the absence of sexual arousal is the result of orders, is here most explicit.

The anonymity of the participant(s) in the interview is the same as was that of the guards in the experiment. Only the highest-ranking member of the group has a title and a name: Obergruppenführer A. Zerbst. Specific name and anonymity stand in direct relation to each other: individuals (such as Obergruppenführer A. Zerbst) *can* be identified as perpetrators, denying them the alibi of not having known about the atrocities; at the same time, his initials A. Z. suggest the inclusion of all names, from A to Z, so that Zerbst stands despite his individual name for the many. On the other hand, the anonymity of the others supports their portrayal of themselves as merely having obeyed orders from above—that is, from identifiable individuals. Kluge here presents the dialectics of individual responsibility versus the safety (even enjoyment) of anonymous obedience and shows that both shirk responsibility for

their acts. The relation of name to anonymity also reflects the larger postwar scene, where *some* individuals were tried for crimes against humanity while the anonymous multitude was never brought to justice. Furthermore, the identification of Obergruppenführer A. Zerbst by name and title does not help any purpose. He has watched a despicable event, but he has not committed a criminal act. In the postwar period, he will be unblemished.

The two prisoners have not full names but initials and, most important, they have a history. The initials endow them with a past history, when the initials were names, and with an individuality that is simultaneously denied by the aura of bureaucratic technicalities and dehumanization. Depriving them of their full names both acknowledges their humanity and attempts to destroy it. In a narrative full of internal tensions, it is the silent, apathetic victims who have a rich, full, and individual life story—the story of their love—while the perpetrators hover on the periphery feeding like vampires on their victims, and the interviewee exists only in his voice and the voyeuristic event he narrates. The victims as the silent center of the narrative are granted a humanity and passion foreign to the perpetrators, who in their pathologies are mechanized beings. Paradoxically, the humanity of the victims is shown in their lack of response to the brutal "experiment," although the reader can only guess whether their refusal to cooperate is motivated by dignity, apathy, despair, a sense of extreme isolation, or a mortal lassitude.[18] In a narrative built on continual reversals of accepted norms, it is the victims—reduced to manhandled objects—who incarnate in their sheer stillness and silence the last exhausted vestiges of humanity, while the brisk and bustling experimenters, engrossed in demonstrating their ingenuity and their organizational skills, are the inhuman ones.

A set of questions posed in the interview indicates a reflective consciousness that also wonders about the prisoners' state: "Were they afraid of the moral dissipation to which they saw themselves exposed? Did they believe this was a test in which they had to prove their moral standards? Was the misery of the camp erected between them like a high wall?" The consciousness reveals and betrays itself in this array of questions. It has no sense of how phony it is, in a concentration camp where all human rights have been destroyed and any morality long been abandoned for obscene criminality, to speak of the fear of "moral dissipation." That this question can be asked shows breathtaking obtuseness about the condition of the prisoners and obliviousness to the "morality" of what is going on in the camp, and demonstrates a profound dehumanization in the questioner, who can no longer distinguish between moral and immoral acts. The last of the three questions acknowledges "the

misery of the camp" and that this misery might have consequences for the individuals. But because the third question is asked in the same voice as the two preceding ones, suggesting their equivalence, it loses its aura of greater sensitivity. It is the reader who must differentiate between the questions. The text concludes with the question: "Does that mean that at a certain point of misery, love can no longer be implemented?" The language in this question remains function-oriented (love is "implemented"), and "love" is understood as an entity that can be handled like an object. Similarly, the spirit of measurement ("at a certain point") echoes the "scientific" intent of the experiment. But behind this functionalized question there shines, in the word "misery," the human dimension, although in its utmost destitution.

One might object to Kluge's refusal to let the victims speak. But just as their remaining objects and their refusal to become acting subjects under the brutal proddings of the camp guards was the only way to retain their humanity, so their silence is the only language left in which they can voice their total rejection of those around them. And silence is the only language in which to acknowledge the suffering inflicted on them. Kluge provides an answer to the question asked by Klaus Briegleb: "To what extent is it taboo for a German to fantasize a Jewish existence, during and 'after' annihilation?"[19] Kluge responds by showing two such "existences" as they have become mute objects for those watching them. In a narrative that fudges the boundaries of discourse, he absolutizes the distinction between victims' and perpetrators' discourse and acknowledges that, for a German, only the perpetrators' discourse is possible. When the victims are presented, the language of silence can only contour but not penetrate their misery. By presenting them as objects, Kluge shows what has been done to them. In the display and indictment of the inhumanity of the perpetrators through their acts and their language, and in the contrasting silence of the victims, Kluge comes as close as perpetrator discourse can come to imagining the suffering of the victims.

The interview's unemotional, ostensible matter-of-factness is an indictment not just of a past when such crimes were possible but also of the present, the postwar period, when these activities can be described without a trace of sorrow or even self-recrimination. Here, Kluge the skeptic makes room for Kluge the didact: he gambles on the impact of his text. The readers may be shocked at the "experiment," but unless they break through the outer ring of the perpetrators and penetrate to the silence of the victims they have failed in their reception of the text. Then the text is reduced to mirroring the adaptation of society to the prevalent system, in which case "An Experiment in Love" merely "documents" the failure of the postwar generation to learn anything from

that horrendous past—least of all a horror over the deeds committed and a compassion and sorrow for the victims.

"An Experiment in Love" is unique in Kluge's work. Two years later he published the monumental and protean *Description of a Battle* chronicling the destruction of the 6th army at Stalingrad in winter of 1943—a "chronicle" composed of the records and reports of the army, the clergy, and the general staff, and the letters and biographies of many of the participants. As in "An Experiment in Love," there are frequently interspersed questions that create a roster in which the multitudinous answers are organized. In this "chronicle," Kluge perfected his deconstructionist approach and demonstrated the "interest" inherent in all documents. Over the next decades, he made films, authored and co-authored theoretical treatises, and continued assembling texts. In 1977, he published *New Stories. Notebooks 1–18. "The Uncanniness of Time,"* which was written over a long period of time.[20] "Notebook 2" contains the detailed account of "The air raid on Halberstadt on April 8, 1945" and includes maps, photographs, strategic planning records of the air raid, diagrams of the formations flown and of the bombs used in the attack, biographies of the pilots who flew the mission, and a large number of minimalist scenes of the civilian population before, during, and after the raid. Halberstadt was Kluge's hometown, so one can assume that the animus behind the construction and assemblage of all this material is a personal one.

His attention to technical details is again prominent in "Notebook 4," entitled "The area south of Halberstadt as one of the seven most beautiful regions in Germany. 'Becoming scrap by means of work' " (*"Das Gebiet südlich von Halberstadt als eines der sieben schönsten von Deutschland. 'Verschrottung durch Arbeit'"*). It consists of the fragmented portraits, activities, calculations, documents, photographs, and descriptions accumulated around the side camp (*Außenlager*) Langenstein in the vicinity of Halberstadt. The camp feeds on the human beings available from the main camp of Buchenwald and is set up as late as 1944 to build underground tunnels for the production of war machinery and airplanes.

The title of the narrative plays the beauty of the region off against the uses to which the region is subjected. Its claim as one of the seven most beautiful regions in Germany is attributed to the statesman, scholar, and humanist Wilhelm von Humboldt and in the text substantiated by Germany's most renowned poet, dramatist, prose writer, and statesman, Johann Wolfgang von Goethe, who commented on the charms of the region around Langenstein. If the reader accepts the authority of these two men, paragons of the best German culture ever produced, the expecta-

tions raised by their pronouncement will be dashed in the second part of the title "Becoming scrap by means of work." The collision of these two seemingly unrelated parts, and the gap that separates yet ties the parts together, create a new narrative level, based on nonarticulation. The shock of contradiction in the two parts of the title is reemphasized in the second part alone. "Becoming scrap" suggests the use of equipment until it is worthless and will be discarded; "by means of work" abruptly introduces the human dimension, since "work" is an activity characterizing human beings. The gap, or rather the abyss, between these two parts forces the reader to think about what it means to conceive of human beings as dispensable industrial waste. And when "becoming scrap by means of work" impinges upon "the area south of Halberstadt as one of the seven most beautiful regions in Germany," this area can no longer stay the same. The topographical beauty is destroyed through industrial (human) waste and building activities; parallel to it, the heritage of humanistic thinking is morally perverted.

"Becoming scrap by means of work" refers to the prisoners forced to work in this camp, but it also characterizes those who, in this once beautiful region, degrade the prisoners. The dialectics that operate in any master-slave relation and that demean the master as he stoops to demean the slave are also operating here. Thinking that the prisoners can be considered dehumanized "material," the surveyors of this dehumanization are themselves dehumanized. The camp commander, Lübeck, "later called: the 'sadist Lübeck,'" (133) is a former high school teacher, with a professional interest in the Age of Enlightenment and *Sturm und Drang*, which culminates in his writing (off duty) a booklet entitled "Voltaire in Pomerania." Lübeck's inhumanity rests not only on his sadistic activities (these activities are never specified) but also on the fact that they can coexist with an interest in the Enlightenment and *Sturm und Drang*, one of Germany's intellectual high points, famed for its humanism, and the period to which Humboldt and Goethe, the *genii loci*, gave their stamp. One can, of course, see in this juxtaposition an ironic denial of the pedagogic and "enlightening" impact of that age, in agreement with current scholarly discourse on post-Enlightenment, as one can see in the reference to *Sturm und Drang* an ironic commentary on an age that discovered the irrational and the affective and ended in supporting politicized irrationalism. Lübeck's not learning from what he studies is an ironic observation Kluge offers to the reader. It would seem to contradict Kluge's own faith in didacticism, were it not that Kluge's demonstration of Lübeck's personality can be read as a lesson in failed learning. Lübeck exemplifies how dehumanization, once accepted, follows its own "logic." When the camp is still small, he cannot help but

see the prisoners, "especially the political ones," as "faithful helpers," and he remembers their faces. Soon he no longer accepts their personal services and abandons his former posture of benign paternalism. He considers it a temptation to see the prisoners as "faithful helpers" and prides himself in rejecting that temptation, thereby dehumanizing himself even further. Once the human face and the personal contact is erased, he is free to dispose of them as "scrap."

Kluge structures the narrative around the metaphor of imperialistic colonization, referring ironically to the camp as a *Gründerkolonie*[21] and has Lübeck compare his situation to that of the colonial farmers of German South-West Africa. Yet the subtext in this "Notebook" in which the genocidal practices of the Nazi regime are seen as an intrinsic part of imperialism is factually wrong (there were many imperialistic countries, but only the Nazi regime reverted to systematic racial genocide), and it subsumes the Holocaust under imperialistic exploits and deflects from its singularity. As Kluge explores in gruesome details the inhumanity of the camp conditions, he shifts the emphasis away from genocide to the "economics" of a work camp. He shows, for example, a camp administrator in the grip of capitalist thinking when the man inveighs against the loss of human energy because the prisoners have to stand by the hour in freezing weather; he does not want a more humane but a more energy efficient treatment of the prisoners. Yet this sketch can serve to refute the Marxist claim that fascism is a late-stage development of capitalism, because, as the example shows, the madness of Nazism could not be tamed by considerations of economic efficiency. When Kluge shows the shoddiness of the camp "imperialism," the insanity of its planning, the divergent opinions on feasibility and operations, he presents on a small scale what was standard practice in the camps: the exploitation of the prisoners from every (in)conceivable point of view, including their consideration as "scrap." The ideological fanaticism that drove these exploitations subsumed capitalism but was not restrained by it. Sadistic chicaneries and mass executions defied capitalistic rationality. The range of Nazi barbarity would be narrowed if one saw it too closely as an outgrowth of imperialism.

The many fragmented scenes ultimately raise the question of why the author focuses so much on the technological and economic side of this kind of imperialism. Does he, as has been suggested in relation to his ubiquitous use of the languages of experts and his frequent choice of writing about the war, try to "protect" something or to "flee" something?[22] Should the assembled fragments be seen as attempts to find a voice, but simultaneously as attempts to dilute or circumvent? Then the abolition of discourse boundaries would serve to explain why the dis-

courses never progress beyond a demonstration of their own inherent skepticism, shored up by a multitude of fragments. When language is powerless to establish authority, the abolition of discourse boundaries and the ubiquity of "interested" fragments that deny an absolute moral position (because these moral positions would themselves be "interested") can be seen as a way to avoid asking the hard questions about the German Nazi past and the Holocaust.

Kluge's manipulation of language is then the ultimate, and perhaps most finely honed, consequence of a tendency to evade confrontation. He writes openly about the camps, discards taboos, makes the atrocities his characters commit parts of their biographies; he shows the absence of affect and self-questioning in the postwar period, and thereby unequivocally maintains that the legacy of the Nazi crimes is a legacy that must be addressed; he writes innumerable mosaics about the war and its consequences of suffering and destruction for the German people, and in distinction to Böll he has a theory about what made the war with its disasters possible; he finds in imperialism as a late phase of capitalism a short-circuited answer that allows him to demonstrate how in a system of technological and economic predominance people become functionalized. As he gives a minute technical and economic composite of the *Außenlager* that is "supplied" mostly with political prisoners (at least only the political prisoners get mentioned), the most pernicious aspect of the Nazi regime—its racism, leading to genocide and specifically to Judeocide—is excluded. The center in which the two mute prisoners of "An Experiment in Love" sat for a brief and memorable moment remains empty. Kluge seems averse to leaving the safe territory of the problematics of language for the problematics of the Holocaust.

Günter Grass

Certain things I should like to pass over in
circumspect silence.[23]

Another considerable experiment in the hybridization of documentary literature and the abolition of narrative boundaries is Günter Grass's *From the Diary of a Snail*. It was published in 1972, ten years after Alexander Kluge's *Case Histories*. By this time, documentary drama had pretty much run its course, but in prose experimentation with documents brought a rich harvest throughout the 1970s. The decade from *Case Histories* to *From the Diary of a Snail* had been a decade of great social unrest and participation in the political process and it came to a

conclusion with the oil crisis in 1973, a slowdown in the economy, the Watergate scandal, and President Nixon's resignation from office. For Günter Grass, too, the 1960s were a decade of increasing political activity—not, however, along the leftist lines of the radical student movement, which he saw in its fanatic idealism as a recapitulation of the parent generation's fanatical adherence to the Nazi regime. Grass instead made his contribution to the democratic process by actively campaigning for the party of his choice, the Social Democrats. Born in Danzig (Gdansk) in 1927, he was at least a decade and a half older than the "generation of 1968." At the end of World War II, still in his teens, he served briefly in the army; he was wounded and taken prisoner by the Americans. His coming-of-age occurred not in the turbulent sixties but earlier, in the decade of the economic miracle and the pervasive silence over the Nazi crimes. He burst upon the literary scene in 1959, the year of Böll's *Billiards at Half Past Nine*, with his novel *The Tin Drum*, which gained him immediate literary prominence both in Germany and abroad. The novel has uniformly been understood as a serious attempt to reckon with the German past, just as it has been praised for reconnecting with the rich literary tradition of German high modernism so ruthlessly disrupted by the Nazis. More than any other postwar writer before him (with the exception of Wolfgang Koeppen), Grass tried to fashion a new language that was indebted to tradition yet sought new modes of expression, commensurate with the experiences of the Nazi regime and ranging from the burlesque to the harrowingly desperate.[24] Ingeniously, Grass creates an observer protagonist who can scrutinize trenchantly but who is ultimately neither implicated in the activities of the Nazis nor called to task for his own inaction: he is both a child and a midget. In fact, Oskar Mazerath is a picaro. Picaros—socially peripheral characters, who have the power to observe but lack the commitment or the know-how to take a stand—were a widely preferred character choice in early postwar fiction, and irony was the preferred mode of presentation. When the midget Oskar finally decides to grow, he develops into a stunted human being and ends up in an insane asylum. Surely, this is a powerful metaphor for how Grass saw West Germany. But his reasons for presenting Oskar as deformed, and averse to become a responsible adult in *that* society, are accessible only if one can "read" the literary techniques of inversion, indirection, parody, and irony, and can understand the grotesque metaphorically.

Grass has a moving chapter on the "night of broken glass" (*Kristallnacht*) in the novel that ends in a dirge for the toy merchant Sigismund Markus. Throughout the novel, the narrative perspective switches between Oskar as third-person narrator and Oskar as first-person involved

actor; in this dual role he comments on and experiences the vandalism done to the toy store where his mother used to buy his drums, and he notes Sigismund Markus's suicide with an unusual economy of words that conveys his sadness convincingly. The gap between Oskar's unemotional description of this event and the motives he "naively" imputes to the vandals creates the sense of distressed irony. Not outrage and scorn but ridicule carries the indictment and serves the observer as a weapon.

> They, the same firemen whom I, Oskar, thought I had escaped, had visited Markus before me; dipping a brush in paint, they had written "Jewish Sow" obliquely across the window in Sütterlin script; then, perhaps disgusted with their own handwriting, they had kicked in the window with the heels of their boots, so that the epithet they had fastened on Markus could only be guessed at. Scorning the door, they had entered the shop through the broken window.[25]

Oskar presents the suicide of Sigismund Markus from an equally "naive" angle. It is precisely the gap between this perspective and the magnitude of the scene described that cries out for the reader's sympathy as he/she provides the missing information.

> The toy merchant sat behind his desk. As usual he had on sleeve protectors over his dark-grey jacket. Dandruff on his shoulders showed that his scalp was in bad shape. One of the SA men with puppets on his fingers poked him with Kasperl's wooden grandmother, but Markus was beyond being spoken to, beyond being hurt or humiliated. Before him on the desk stood an empty water glass, which thirst must have commanded him to empty at the very moment when the crashing noise of the splintering shop window dried his mouth (202; my trans.).

Yet there is an enormous difference in the perception of the victims of the Holocaust between a well-intentioned gentile writer and his Jewish interpreters. The literary scholar Ruth Angress takes this view of Grass's presentation of Sigismund Markus:

> Markus, like the typical Jew of the Nazi press, is unattractive as a man, though he lusts after an Aryan woman, and ludicrous as an individual, for he acts and looks like a dog. He is a harmless parasite, a Jew without a Jewish community or a family, without a background, or religious affiliation, but with business acumen of sorts. . . . He has no conviction, has just converted, a pathetic gesture from which he vainly expects to benefit, and seems to have no emotion about the German victory, which he predicts, except that it might help him elope with Agnes to England.[26]

This assessment weighs heavily, particularly when one considers that Grass is one of the most explicit among postwar German writers to condemn the Nazi genocide and to speak about it to his own and the next generation. In a public lecture given in February 1990 and titled "Writing after Auschwitz," he sketches an intellectual autobiography in which he sees Auschwitz as the motivating force of his entire artistic career and his considerable political engagement, and recognizes Auschwitz (and by extension all the concentration and extermination camps) as "a deep and irredeemable rupture in the history of civilization."[27] Nevertheless, in his creative writing, which should be nourished, in the words of George Steiner, "at depths below conscious articulation,"[28] there is an ingrained obtuseness and insensitivity to those who suffered and died, evident in a language where silence is veiled in verbal dexterity and a creative exuberance rooted in pre-Holocaust aesthetics.

Grass's politization falls into the years between writing the novella *Cat and Mouse* (1961) and the novel *Dog Years* (1963) and was in part a response to the building of the Berlin wall in 1961. In the federal campaign of 1965, he went for the first time beyond polemics and participated in the campaign itself: he traveled and gave speeches for the SPD. His party was defeated, but this did not keep Grass from continuing to campaign in the 1967 state races, and most vigorously in the federal elections in 1969, when he thought it no longer tolerable that Kurt Georg Kiesinger, "a former National Socialist, should be bearable as federal chancellor of the grand coalition."[29] During this campaign, from early March, when Gustav Heinemann (SPD) became president of the Federal Republic, until September, when Willy Brandt was elected chancellor, Grass kept a diary or *"Sudelbuch"* (as the author calls it in reference to the Enlightenment scholar and writer Georg Christoph Lichtenberg), with sketches, impressions, and observations, which he purportedly wrote for his children. This notebook became the structural backbone for *From the Diary of a Snail*.

Thematically, the text is grouped in several clusters, narrative strands that form an intricate but ultimately unbalanced pattern in a montage of autobiography, fiction, and documents. There is the autobiographical level, with the reports of campaign episodes, of the people he meets and with whom he works, the flavor of the events on the road and after the speeches he gives. There are glimpses into the author's personal life as a family man and cook, who, with a strong pedagogical interest, tries to share his experiences and thoughts with his children. The central fictional metaphor is the snail and its slow progress, which, transposed to the political arena, becomes the leitmotif of "stasis in progress." There is Dürer's engraving "Melancolia I," which serves Grass the cultural and

social critic as a reference point in his ruminations on contemporary Germany. And there are the collected documents about the disintegration and demise of Danzig's Jewish community.

These clusters overlap and intermingle. The central character, Hermann Ott, called "Doubt," covers all of these clusters. He collects snails, is attached to a reproduction of Dürer's Melancolia, and in one instance cures his future wife's melancholia with the application of a snail which in the manner of leeches sucks the melancholy into itself. As the narrative clusters interweave, so do the narrative frames and narrative modes and raise a number of questions. Is *From the Diary of a Snail* really a campaign diary? Is the *Sudelbuch* really written for his children? (There are passages of a strictly political and/or philosophical-critical nature that must be utterly boring, if at all comprehensible, to children.) Isn't the impetus to write a *Sudelbuch* in an attempt to answer their questions rather a literary conceit? And which of the characters are "invented" (as the children demand to know—but demand to know through the author's words, which means these may be "planted" questions, not at all posed by the children), and which ones are "real?" (Is it even fruitful to ask these questions?)[30] Like Alexander Kluge, Günter Grass wishes to abolish narrative boundaries—in this instance between diary, fiction, and document. But in distinction to Kluge's radical skepticism, Grass assumes that language can indeed communicate, and he highlights this confidence when he teaches his children.

The difficulty of assigning the book to a specific genre is immediately apparent in the title. "Diary" suggests a circumscribed genre, raising in the reader expectations that "snail" subverts; clearly, "the diary of a snail" removes the work from consideration as a genuine diary and places it in the realm of imaginative writing. The author, father, and political campaigner of the narrative is thus not just the "real" Grass. The careful selection of scenes, documents, and portraits, and the high level of self-aware discourse on the construction of the work reveal an artistic sensibility at work, which belongs to the author Grass and encompasses the I-narrator Grass as a fictionalized character—just as his colleagues, campaign workers, wife, and children are fictionalized. "Fictionalized," of course, does not mean that they are not modeled on existing personalities, but it is precisely the process of fictionalizing that matters in the writing of the work. This is evident in the character of Doubt—Hermann Ott—who is "invented" by the author in answer to the inquisitive proddings of his children. But Doubt is a composite of two actual figures: his first name and postwar activities as a cultural affairs official in West Germany are an homage to Dr. Hermann Glaser, the organizer of the Dürer festivities, while Doubt in the cellar is modeled on the

grand master of German postwar literary criticism, Marcel Reich-Ranicki, who told Grass how he survived the Nazi regime, as Grass then reported in the *Diary*. The many self-referential comments of the narrating author—including comments about his work habits and their execution, which the reader witnesses as the author proceeds to write—further reinforce an interpretation of the book as a demonstration of the creative process, as a literary work that performs its own genesis. On this level, *From the Diary of a Snail* is a work charting the transformation of "reality" into literature.

Yet Grass's account, forever crossing and recrossing and abolishing the boundaries between facts, events, and their fictionalization, also contains an important cluster of texts that document facts. These documents—petitions, statistics, reports, official and personal correspondence—are woven into the narrative, not simply quoted, and emphasize the "constructed" aspect of the work. They constitute a record of the destruction of the Jewish community in Danzig and were collected by one of the survivors, Erwin Lichtenstein, whose endeavors resulted in a book, published in Tübingen in 1973.[31] Grass as narrator, in documentary fashion, acknowledges the use of this material and his contact with Erwin Lichtenstein and his wife. According to the *Diary*, the Grasses and the Lichtensteins met for the first time in Tel Aviv in 1967, a few months before the Six-Day War (108), then in Berlin in September 1971 (280), and again when the Grasses visited Israel in November of that year (34). Grass obviously had access to Lichtenstein's manuscript long before it was published. On his trip to Israel in 1971, Grass carried his own manuscript in "the final draft" with him (34) and it contained Lichtenstein's material.

It is the children's questions about the Jews and what happened to them that force the author to realize that no simple, linear answers will do, and he responds with the complex, intricate writing of the *Sudelbuch*. *From the Diary of a Snail* hence claims to have as its first and principal goal the purpose of providing some kind of answer to the children. The children's questions and the narrator/author's answers are arranged in clusters with intermittent spaces—a technique reflecting his hesitancy; and his answers are in constant need of elaboration. At the same time, the author uses the children's "naive" perspective to ask direct questions about a subject adults are usually reluctant to broach.

> Because, sometimes, children, at table, or when the TV throws out a word (about Biafra), I hear Franz or Raoul asking about the Jews:
> "What about them? What's the story?"

You notice that I falter whenever I abbreviate. I can't find the nee-
dle's eye, and I start babbling.

Because this, but first that, and meanwhile on the other, but only
after . . .

I try to thin out forests of facts before they have time for new
growth. To cut holes in the ice and keep them open. Not to sew up the
gap. Not to tolerate jumps entailing a frivolous departure from history,
which is a landscape inhabited by snails . . .

"Exactly how many were they?"

"How did they count them?"

It was a mistake to give you the total, the multidigitate number. It
was a mistake to give the mechanism a numerical value, because per-
fect killing arouses hunger for technical details and suggests questions
about breakdowns.

"Did it always work?"

"What kind of gas was it?" (11/12)

After the father/I-narrator ruminates on the many false or insufficient
answers that continue to be given in official publications and memori-
als, and motivated by what he sees as the resurgence of Nazism in the
rise of the Neo-Nazi Party (NPD) and the election (in 1966) of the former
National Socialist Kurt Georg Kiesinger as chancellor, he concludes:

> Now I'll tell you (and go on telling you as long as the election cam-
> paign goes on and Kiesinger is Chancellor) how it happened where I
> come from—slowly, deliberately, and in broad daylight (12).

The decimation of the Jewish community of Danzig is twice de-
scribed. The author Grass has the narrator Grass weave sections of
Lichtenstein's documentary material into the narrative which the narra-
tor tells his children. At the same time, the "invented" figure Doubt in-
teracts with the Jews whom Lichtenstein describes in his collected
documents. In this fictive dimension, Doubt had at one time worked
with Jewish relief agencies in the 1920s, when refugees from the
pogroms in the Ukraine passed through Danzig on their way to else-
where (17). In March 1933, he became a teacher at the Kronprinz Wil-
helm Gymnasium (19); a year later, the private Rosenbaum high school
was founded, because of the increasing harrassment and intimidation of
Jewish students in Danzig's public schools, and Doubt teaches there
until the school is disbanded in 1939. In a dizzying effort to further con-
fuse the factual aspects of the text with the "invented" ones, the narra-
tor has Lichtenstein confirm Doubt's position at the Rosenbaum school
(27) and has one of its former students (whom the narrator meets in Is-
rael) believe that he remembers "Dr. Doubt" (77); however, an English

journalist who left Danzig as a twelve-year-old in a children's transport and who briefly accompanies the narrator on his campaign tour cannot remember Doubt (70). The fictionalized fragility of memory adds yet another layer to the fictionality of the text.

It is a rare occurrence in German postwar literature for a gentile character to acknowledge what was happening to the Jews, let alone help them for no reasons other than altruistic ones. When the narrator questions Doubt's motives, he can find no ideological or other reasons for his actions (36); however, the narrator is careful not to ascribe them to philo-Semitism (28/9). In the book as a whole, personal relations—intimate, casual, or professional—are full of argumentative dynamics, and this holds without distinction for Doubt's relations with members of the Jewish community. Doubt not merely witnesses, he also shares the discrimination and physical abuse to which the Jewish community is subjected. When the Gestapo summons him for a second time in March of 1940, he packs a few of his belongings on a bicycle and, without any specific destination, leaves town, ending up in the cellar of a bicycle shop owner, Anton Stomma, and his distraught daughter, in the village of Karthaus,[32] where he hides until the end of the war. Since this hiding is modeled on actual events in Reich-Ranicki's life, Doubt shares the calamities of a Jewish life. This sharing of Jewish suffering has occasioned divergent interpretations. The literary scholar Kurt Lothar Tank, knowing that at least part of Doubt is modeled on a Jew makes the point that "the teacher Ott" is not a Jew because Grass, as a non-Jew, might have shied away from representing the sufferings of a Jew, and Tank cites Max Frisch's *Andorra* as another example of this reluctance.[33] The literary scholar and novelist Winfried Georg Sebald, however, sees in Hermann Ott a "retrospective figure of wishful thinking on the part of the author," who is trying to prove that "the better German" really existed.[34]

While Doubt is still in Danzig, the narrator follows the dispersal of the Jewish community in significant detail. Based on Lichtenstein's information, he describes the ever shrinking periphery of the lives of the members of the community and follows the hair-raising odysseys of groups transported illegally to Palestine. He includes some miniature portraits—of the greengrocer Laban, the student Fritz Gerson, and Ruth Rosenbaum, the founder of the Rosenbaum school, whom the narrator Grass meets in Haifa—and they are vivid and energized by observations of personal detail. It appears that Grass's personal acquaintance with some of the former Danzig Jews (and with the extraordinary poet and Holocaust survivor Paul Celan[35]) has helped him avoid the stereotyping of which he was earlier accused by the critic Ruth Angress. But the portraits are brief and highlight only few aspects of each personality. No

doubt, Grass the father and observer of the social scene understands that in order to speak with his children about the annihilation of the Jews and impress upon them even a slight sense of the enormity of the crimes, he must avoid stereotypes and statistics and instead individualize the devastation of these lives. The narrator tells his children about the concentration camps and the mass executions, for which the victims had to dig their own graves. On occasion, his syntax reveals an apparent wish to protect the children from the full weight of the horrors, as for example when the atrocities are expressed in a dependent clause, which is followed by the more upbeat information of the verb of the main clause concluding the sentence: "Before over a thousand inmates of the camp, among them the Danzig group, were shot by German execution teams, Israel Herszmann, an engineer who like Hermann Ott had lived in the Danzig Lower City, escaped" (122).

The juxtaposition of the fate of the Danzig Jews with the campaign against Chancellor Kurt Kiesinger and for Willy Brandt allowed Grass to be concrete and specific as he switched back and forth between Danzig during the Nazi regime and the Federal Republic in the narrative present. The didactic impulse, directed at his children, not only elucidates the past but interprets for them the narrative present. The persistence of ideological fanaticism (instead of the SS it is now the SDS) is paralleled by the persistence of former Nazis in the highest offices (Kurt Kiesinger as chancellor). The narrator is astute in his observations of Germany as he travels the country, and his comments on contemporary life are trenchant. When he reflects on himself, his tone is self-exploratory, even confessional. His critical perspectives are skillfully integrated with the central metaphor of the snail, with the concept of "stasis in progress," with a hopeful skepticism, an anti-idealistic earthiness, with melancholy as projected into Dürer's "Melancolia I" and melancholy's partner, utopia. As he campaigns for the "melancholic" candidate Willy Brandt and the SPD, Grass seems hopeful that Germany may learn, at a snail's pace, to be a genuine democracy, and that it will slowly shed its fanaticism and intolerant idealism, which, in the narrator's terms, brought about the disaster of the Holocaust. But in all these current concerns and ruminations about the present, Jews do not figure. They appear only as inhabitants of the past, or as foreign visitors.

Although the book has purportedly been written to tell his children about the decimation of the Danzig Jewish community, after chapter 17 (or slightly more than halfway through the book), there is no longer any mention of any member of the Jewish community until the concluding chapter. In chapter 17, the answer to the children's urgent "And then what? What happened then?" is: "Then Augst happened" (161). Augst

(whose name is a play on the word *Angst*) is a fictional embodiment of the idealist without direction who found refuge in Nazism and floundered in the postwar years; he commits suicide in public at a church congress by swallowing cyanide. The narrator, who participates as a speaker at the congress, is deeply upset; he decides to visit Augst's widow and children and to find out more about the life of the suicide. This information is then woven into the subsequent chapters, where Augst in fact replaces the Jews of Danzig. This is true even in the story of Doubt, for now imaginary meetings between Augst and Doubt are organized. Of course, the reader cannot object to Augst's presence in the narrative, except to note that he appears rather late and that the elimination of one set of characters and the late introduction of a new one creates a structural imbalance. But more important, the physical dispersal and destruction of the Jews in the camps, in the fields, on the boats has its parallel in their narrative elimination. As they have vanished from German territory, so they vanish from the narrator's consciousness. If this destruction is to be told to the narrator's children in its entirety, and if it is to be kept alive in memory (as the narrator seems to wish in the early parts of his narrative), then simply abandoning this complex subject is a serious shortcoming. Grass's recounting of the different groups' voyages to Palestine is confined to little more than generic enumerations of the way stations on these trips, and on occasion seasoned with a sense of deep irony (when, for example, those who left on an earlier boat are detained and have to watch those pass by who left later); but the human dimension of the anguish and despair is never individualized. Once Grass leaves the safe confines of Lichtenstein's accounts, he cannot live up to his intention to narrate an "individual destiny" or "the flight of a family—here into death, there to their goal: Palestine." Despite his openness in speaking about the Holocaust, he, too, falls into the category of German intellectuals of whom Sebald has noted in general terms: "German *literati* still know very little of the *real destiny* of the persecuted Jews."[36]

Grass lets go of the problematics at precisely the same point where Lichtenstein concludes his documentation. Narrating the destruction of the Danzig Jewry from the safe vantage point of Jewish documentation does not demonstrate an affective concern with individual lives but rather an intellectual, though profoundly committed, interest. In a text so full of critical analyses and pedagogical stances, one would expect to find the narrator's personal reflections, perhaps even expressions of sorrow. Should not the father, when telling his children about this destruction, express sadness over it and venture beyond the safe confines of the documents assembled by Lichtenstein? Precisely where Grass's own affects and sentiments should come into the open—where individual lives

in all their inexorable fatality should be restored, where speaking about the Holocaust should elicit expressions of grief and sorrow, and where he should teach his children by example—there is a void. In contrast, he does show his distress over the individual Augst's suicide (133ff.), demonstrating his concern in his visit to Augst's family and the intellectual ruminations triggered by Augst's death.

Similarly his figure Doubt, once he has descended into the cellar and settled down to thinking and philosophizing, does not once wonder what has happened to the Jewish people he left behind. In a narrative as loosely constructed as the *Diary*, the author could surely think of any number of narrative possibilities to indicate that with their dispersal and decimation the Jews of Danzig have not ceased to exist—not in the memories of those who survived and not in the minds of those who must come to terms with their destruction. If almost the entire second half of a book purportedly written to tell their catastrophe does not mention them, then this silence reveals a blind spot in the author's capacity for imaginative projection. Here, the language of silence illuminates a dominant aspect of perpetrator literature: Grass certainly wants to write about the Nazi crimes and wants them to be known to successor generations, but without a guide (Lichtenstein and his documents) he cannot enter unknown territory and create individuals or imagine their suffering. Grass's unacknowledged inability to express affect and mourning is, paradoxically, balanced in a scene where the very absence of words indicates the highest affective expression, where body language replaces words. In the concluding speech, entitled "On Stasis in Progress," Grass derides his fellow Germans for their habituation to genocide and easy exculpation of the Nazi crimes as "irrational aberrations," and he sees in Chancellor Willy Brandt's wordlessly kneeling at the site of the Warsaw ghetto an affective expression of guilt and sorrow.

> This ability to get used to genocide has its parallel in a premature readiness to shrug off the crimes of the National Socialists as momentary insanity, as an irrational aberration, as something incomprehensible and therefore forgivable. Perhaps the wordless action of a statesman, who shouldered the burden and knelt at the site of the Warsaw ghetto, has given belated expression to a people's awareness of undiminished guilt (302).

Just as Grass relied for his account of the destruction of the Danzig Jewry on Erwin Lichtenstein's documentary testimony, he relies for his account of an affective expression also on someone else's model, this time Willy Brandt. It seems as if Grass can speak about the Holocaust and its burden of guilt only in mediated terms, through the filter of others' testimonies and gestures.

As for the emergence of a genuine sense of tragedy or the expression of grief, Grass looks to history in order to maintain hope for the future. Again, he cannot address these problems directly and needs another layer of mediation—in this instance he uses a model of his own construction. In his speech on Dürer's quincentenary, he draws parallels between the humanism of Dürer's times and our times and, relying on the central metaphor of the snail's "progress in stasis," anticipates the ability to mourn at some undefined time in the future:

> Foreseeing disintegration and disruption, war and chaos, the humanists despaired of their impotent knowledge and of the ignorance of the powerful. Conscious of their helplessness, they took refuge in formal, controlled melancholy. Not until the following century, during the Thirty Years' War and in its wake, did baroque language find its way to tragedy . . . did baroque poetry treat of grief . . . did hope springing from chaotic disorder become a principle; its locale was the vale of tears, its goal redemption (302/3).

Grass does not compare the "disintegration and disruption, war and chaos" of the 16th century to the Holocaust. But he does suggest that the turmoil of these times could, for over a century, only be expressed in melancholy. Taking "refuge in . . . melancholy" is, however, according to the Mitscherlichs, precisely what the Germans did not do and what Grass, in this book, belatedly tries to suggest. Not only does the election of Willy Brandt, a melancholic and decision maker at a "snail's pace," point in this direction; the artist writes with black bile, a synonym for ink.[37] If one accepts Grass's proposition (and it is a debatable one) that melancholy prepares for the expression of tragedy and grief and allows for hope to emerge, then *From the Diary of a Snail* ultimately delivers a hopeful message. But even in this hopeful projection, Grass relies on supportive constructs: while "tragedy" and "grief" are certainly terms applicable to the Holocaust, recourse to Christian imagery and concepts ("vale of tears" and "redemption") indicates again a need for preestablished conceptualizations reinforced by his interpretation of the 16th and 17th centuries. Perhaps Grass feels that "the awareness of undiminished guilt" that forced Willy Brandt to his knees is so overwhelming that only reliance on already existing structures can help articulate and bear it. In accordance with the slow pace of the snail, Grass takes the long view on the expression of grief and sorrow over the crimes of the Holocaust. His own need for preestablished models and guides and his inability to find a voice without the help of some mediator give a sense of how long this road will be.

Autobiographical Novels

Generational Discord

The work of mourning is essential, not as "penance" but as an indispensable prelude to the formation of autonomous and mature identities for both nations and the individuals who comprise them.[1]

In the period between spring of 1969, when Günter Grass began traveling for the SPD campaign, and 1972, when *From the Diary of a Snail* was published, the student movement in West Germany and other countries as well reached its apogee and just as quickly spent itself. This rapid demise of a movement which lasted little more than two or three years has been the subject of much hypothesizing. Among the causes mentioned are an economic downturn and rising unemployment that "more and more included academicians,"[2] the ideological breakup of the left into splinter groups (including the terrorists),[3] and the growth of the drug culture, which destroyed the sense of solidarity and of which Timothy Leary was the great American guru. There was a gradual end to political sloganeering and a movement away from a politically inspired utopianism that could be achieved overnight by revolutionary means. Theodor Adorno, returned exile, fountainhead of the Frankfurt School and dialectician par excellence, who had taught many of the members of the student generation, died in 1969. Hans Magnus Enzensberger returned from Cuba, significantly sobered after his intoxication with Marxism. Some writers, such as Heinrich Böll and Peter Schneider, con-

tinued into the 1970s to decry what they considered authoritarian practices—particularly the "decrees against the radicals," which, in addition to barring "radicals" from civil service jobs, gave unprecedented rights to the government branch for the "protection of the constitution" (*Verfassungsschutz*). Since many of the formerly radical students planned on careers in teaching, these decrees hit them hard. After the "revolt of the sons," these decrees were clearly seen as the "revenge of the fathers."[4] Fear of reprisal, disappointment and disillusion with the movement, and a rapidly deteriorating economic situation led these failed revolutionaries into introspection and a withdrawal from political engagement; in the United States, the oil crisis, the conclusion of the war in Vietnam, and Watergate resulted in a similar toning down of activist fervor. In Germany, this retreat became known as the *Tendenzwende* (a change of tides), an intellectual response to the changing political and intellectual climate. The general lassitude and rejection of political activism was countered by a fringe group of terrorists, who had their equivalents abroad, principally in Italy and Japan, and whose activities culminated in the so-called "German Autumn" of 1977.[5]

Although the student protests were a common phenomenon in many democracies, the young of each country took up specific issues. In the United States, it was the civil rights movement and the war in Vietnam; in West Germany, it was, above all, the Nazi past. And while in the United States the marches and demonstrations and sit-ins had an undoubted impact, in Germany the protesters were fighting a battle they knew they could never win, for no amount of demonstrating could alter an abhorrent past or change the recalcitrant, self-defensive posture of the parent generation. The destructive fury of the West German terrorists can ultimately be linked to hopelessness. Peter Schneider, an active participant in the protest movement, explained retrospectively to an American audience:

> In the United States the anti-war protestors could appeal to the democratic traditions of their fathers, who had after all waged war against Hitler. In Germany, we could only voice our protest by taking a stand against our fathers. From the beginning we were burdened with the historical urge—*to not be like our fathers*. On an emotional level, the protest in Germany was specifically addressed to the generation responsible for Nazism.[6]

Although the demonstrations started with the hope that West Germany's present and future course could be influenced for the better, it soon became apparent that the battle was being fought over a past that extended on several levels into the present: as undeniable history; as

continued self-defensiveness or silence and unacknowledgment of past crimes on the part of the parent generation; and as inscription on the psychological makeup of the students themselves. The students' attacks on the "fascist" behavior of the authorities of the present turned into an indictment of the fascism of the past, where the indiscriminately labeled "fascists" of the past were the parents. Furious attacks on the parent generation were meant to demonstrate that one was not like the parent and was therefore released from a heinous past. This shortcut avoided any true confronting of the past and its legacy and any concern for the victims; it was motivated not by sorrow and shame but by rage and despair, and led Elisabeth Domansky to state:

> As long as the generation of 1968 continues to believe that it has escaped from the legacies of the Nazi past by virtue of exposing the older generation's ties with National Socialism, by fighting a recurrence of fascism in the present and by subscribing to "correct" political beliefs, it will continue to carry on the tradition of denial passed down to it by its parents.[7]

When the generation of 1968 attacked the parents for their past fascism, they included in their attacks the "fascist" way of raising children. The personal invaded and overwhelmed the political—or, rather, the political stance became an instrument of generational warfare. Here it becomes apparent that the students' revolt was not so much motivated by democratic ideals but that their idealism seemingly legitimized a revolt which was driven by personal grievances. At the end of the decade, the writer and cultural critic Michael Schneider assessed what had happened to the "generation of 1968" in terms that clearly fused the political with the personal, but he couches his analysis in a context that shows him to be part of the group he analyzes, rather than an outside observer. This context is one of passivity and therefore of ultimate exculpation.

> Many of these people in their late thirties are now attempting untiringly to base and therefore justify their almost notorious historical despair by means of the current crisis-oriented state of social affairs, but their *a priori* resignation, their crippled will power, and their vain, anxious terror in the face of the State and of history, which once again appear to them now to be a kind of "Leviathan," certainly dates back further and is more likely to be rooted in their inner world than in the antagonistic and dominating outside world constructed by their phantasy.
>
> It is almost as if, at some point early on, a bullet had struck the spinal cord of this generation, a stray bullet that, over a period of time, has crippled all of its social organs—its energy, its will, its courage, its

capacity to hope, its utopian phantasies and, along with these, its ability to creatively transform relationships. This bullet can obviously be traced back to the armories of the war generation. In any case, it would appear that the defeated, latently depressive sense of life which had afflicted the generation of the fathers after they had experienced war and fascism had been, so to speak, displaced onto their children, and manifested itself for the first time in them. If the generation of the fathers had manicly [sic] defended itself against sorrow, melancholy, depression, and all the emotional problems which went along with it, the present generation is made up of little else.[8]

Schneider may have a point in suggesting that their "*a priori* resignation, their crippled will power, and their vain, anxious terror in the face of the State and of history" date "back further" and are "more likely to be rooted in their inner world than in the antagonistic and dominating outside world constructed by their phantasy." This insight is supported by studies into the psychological and familial makeup of this generation, notably of the terrorists.[9] But when he uses the image of a bullet that has "struck the spinal cord of this generation" and has "crippled all of its social organs," he takes refuge in powerlessness. If a bullet struck this generation, then clearly this generation is not responsible for its crippled energy, crippled will, crippled capacity for hope, or its utopian fantasies, or its crippled ability to creatively transform relationships. Not only does the bullet excuse whatever "crippled" activities this generation may engage in, it also turns this generation into victims. Exculpation and victimization explain a failure that was preordained. This is precisely the posture that the parent generation assumed when held accountable for the crimes committed under its stewardship during the Nazi regime. Here is one of the seeming paradoxes in the relation of the two generations: while the young vehemently attack the parent generation, the two generations are tied together in their self-perception as "victims" who cannot be held accountable for their deeds. The older generation saw itself as "duped" and "betrayed," and thus victimized, by Hitler and Nazism; the younger generation has been "crippled" by bullets from "the armories of the war generation." The bullet is, furthermore, a "stray bullet" (a *Wandergeschoß*), a bullet fired by accident and without a specific aim, so that those from whose armories it came cannot be held accountable for the damage. Therefore, the young generation finds itself not in a paradoxical but a schizophrenic situation: it violently attacks and insults the parents and sees itself as their victims at the same time that it exculpates them.

Peter Schneider, in his own retrospective assessment, addresses the conflicted situation of the protest generation as he comments on the left's exculpatory view of their parents:

> It is now clear, in retrospect, that the protestors were terribly naive and unself-conscious in their anti-fascism. . . . In a kind of reflex insult response, anyone who opposed the "revolutionary" order of the day was sent to the corner as fascist. . . . After "fascism" had become a generalized term of opprobrium in Germany it served hardly at all to refer to the twelve years that gave it its concrete meaning. . . . Only now has it become apparent that the Leftist misuse of the accusation of fascism is an equally reflexive attempt at relief: for the reduction of the historical profile of Nazism to general and transferrable characteristics also had, apart from its instructive value, an unburdening function. If National Socialism was the "conspiracy" of a couple of powerful industrialists, our parents, no matter what they had done, were the victims of the conspiracy.[10]

As introspection and self-assessment began to replace attacks and accusations, the search for self-identity assumed national dimensions and attracted the interest of social scientists and politicians. In literature, the term "New Subjectivity"or "New Sensibility" came to designate this literature of self-exploration. Poetry became a dominant force, in contrast to theater and the theatricality inherent in the demonstrations, street theater, and agitprop of the preceding decade. In prose, there appeared a great number of self-exploratory, autobiographical novels. Inspired by similar generational confrontations, and finally coming to an awareness of its own Nazi past, a younger generation of Austrian writers also began to vigorously pursue self-explorations in writing autobiographical novels.

As the designation "autobiographical fiction" indicates, this is again a hybrid literary category. The literary scholar Ralph Gehrke has reflected on the dissolution of a previously firmly established literary category and finds that "changes in the autobiographical genre stand in close relation to the complexity and differentiation of modernism as it evolved through rationalizations and increasing technology" and that "the pluralism of modern society confronts the individual with a vast variety of meanings, which in turn demand that he/she design his/her own meanings to protect his/her personal identity."[11] However, these observations seem applicable not only to autobiographical fiction but to other literary genres as well: hybridization, or the dissolution of previously theorized narrative boundaries, is an ongoing activity in all prose narratives.

In the autobiographical fiction written after the *Tendenzwende*, re-membrance is an essential element of the quest for self-identity; it pro-pels and structures the narrative together with the newly rediscovered freedom to fabulate and to experience the irretrievable losses of child-hood. At the same time (and as an echo of leftist thinking), there is an awareness that the individual and his subjective experiences stand in a dialectical relation to social groups and society, so that "in the autobio-graphical 'dialectic of the public and private sphere' a form of individual historiography is realized that understands subjectivity not as singular-ity but as the realization in the subject of what is general in society."[12]

While autobiographical fiction covered a wide territory, the so-called *Väterliteratur* (novels about fathers—or, more correctly, novels about fathers and mothers) was particularly prominent in the years surround-ing the 30th anniversary of the Federal Republic, from the middle of the 1970s into the 1980s. The specific characteristics of these novels became blurred in subsequent years, but variations on the main themes continue to be published into the present.

These autobiographical novels are strikingly similar in theme and content. The language and literary techniques reflect their authors' com-mon training—most are professional writers, journalists, editors, teach-ers—and a homogeneous point of view. In fact, the novels share so many substantive, structural, and linguistic characteristics as to be virtually formula novels. Those I shall discuss as a group are, in the chronological order of their publication between 1975 and 1981, Peter Henisch's *The Small Figure of My Father*, Elisabeth Plessen's *Informing the Nobility*, Hermann Kinder's *The Grinding Trough*, Bernward Vesper's *The Trip*, Paul Kersten's *The Everyday Death of My Father*, Roland Lang's *The Attic*, E. A. Rauter's *Letter to My Educators*, Ruth Rehmann's *The Man in the Pulpit: Questions to My Father*, Sigfried Gauch's *Father's Tracks*, Barbara Bronnen's *The Daughter*, Ingeborg Day's *Ghost Waltz*, Peter Härtling's *Belated Love*, Christoph Meckel's *Composite Portrait Con-cerning My Father*, Brigitte Schwaiger's *Long Absence*, and Irene Ro-drian's *House Peace*.[13] Most of these authors are part of the student generation of the 1960s; all have approached the complex task of forging an identity by exploring the impact their parents had on their lives. In many cases, the parents' breathtakingly barbarous child-rearing methods were coupled in the minds of the authors with the Nazi past. Nazism in fact sanctioned "strict" child-rearing practices but did not invent them. Such habits antedate Nazism and are rooted in authoritarian family and social structures.[14] The rage that boils in these writers is a rage moti-vated not by the atrocities of the Holocaust, of which the children learned only later, but by personally sustained psychological injuries.

The genocide thus became an "objective" and powerful instrument in the attacks on the parent generation.

With few exceptions, the authors choose a first-person-singular narrator, which suggests extreme closeness to the subject and deliberately blurs the lines between fiction and autobiography. They all engage in "the autobiographical 'dialectic of the public and private sphere,'" thus indicating a clear departure from the novels with a wider social panorama, such as those of Heinrich Böll, Günter Grass, Uwe Johnson, Siegfried Lenz, and Walter Kempowski that continue to be written at the same time. One might assume that the process of self-exploration would include reflections on the authoritarian family structure of which most of these authors feel they are victims, and which they describe so vividly in its day-by-day manifestations—and that they would hint at some connections, tenuous though they might be, between family life and political practice. Yet this is only rarely the case.

In each of those novels, the search for the self begins with or shortly after the death of the father. His death releases a chain of questions that the protagonist/narrator was not able to explore during the father's lifetime, either because the parent-child relation did not allow any kind of questions, or because the parent was incapable of giving answers that were not stereotypes, or because "each adult/child is able to confront this 'giant' of childhood only when the threat of his physical presence is removed."[15] The narrator is thus forced to reconstruct the father's life. This is a superb fictional device that entails in practically all the novels the use of rather similar techniques. The narrators piece together the father's life by means of personal recollections, dreams, conversations; they conduct interviews with people who knew the deceased; they do research into official documents, photographs, newspapers of the period, and read material—letters, diaries, literary fragments—the father has left behind. Yet the juxtaposition of these multiple perspectives does not lead to a well-rounded presentation of the father or the protagonist, nor does it master the complexities of placing the individual within a historical context. The fictional devices are used in the service of an allegedly objective investigation, and the narrator surrounds the father figure with historical events and historical data, but the person the narrator remembers is never fully integrated into the social and political past. The reader has the impression that the narrator wants to include these scenes in order to present himself or herself as thorough and fair. But the real interests lie elsewhere. They lie with the autobiographical "I."

This autobiographical "I" dominates the multiple points of view and the relativizing perspective by dwelling on the mistreatments it suffered—which range from silence to verbal abuse, from occasional pun-

ishment to systematic beatings and permanent mutilation, and (in families where violence and aggression were totally internalized) from gentle reprimands to the heavy pressure exerted in the name of love. What strikes one in many of these accounts is not just the brutality, physical as well as psychological, but also the peculiar, mechanized, alienated manner of punishment: counting in a soft voice the lashes meted out, switching from physical abuse to reading the Bible, demanding that the child fetch the strap with which it will be beaten, expecting a pleasant bearing and even gratitude after savage beatings, or making the punishment a test of manhood and courage. In laying bare the psychopathology of these family interactions, the narrators infuse their descriptions with an element of fury and frustration resulting from past grievances, from the humiliations he or she had to suffer, from the thwarted expectations of finding acceptable role models. This polarization into a presumably objective inquiry with its multiple perspectives on the one hand and the overwhelming personal recollections on the other constitutes the emotional core of these novels and frequently bars the narrator from comprehending the complexities of the social dynamics or even of his or her own emotions. The reader is left with a sense of work still to be done on the long road toward defining the self and coming to terms with an individual and a collective past.

In almost all the novels, the father returns from the war broken, alienated, "betrayed" in his ideals—that is, he sees himself as a victim. The strategy of seeing onself as a victim who innocently followed the promises of fascism into destruction and defeat is of course an attempt to circumvent responsibility, and the Mitscherlichs have explained this mechanism with a psychological model. But the sense of victimization and powerlessness has a long history in German thought. In his study *The Germans*, the prominent cultural historian and sociologist Norbert Elias has pointed to a long tradition of subaltern indoctrination and subjection to obedience and other authoritarian disenfranchisements of a free and independent personality. The perception of oneself as a victim is therefore not new in the intellectual and affective repertoire of postwar Germany. It reinforces passivity and apathy, and it solicits a pity that, not so ironically, only the victim is ready to dispense, in the form of self-pity. The exculpatory and self-pitying undertones are the *basso continuo* in any discourse about the Nazi regime and the postwar period. This is the atmosphere in which the future student rebels and protesters grow up.

The parental sense of powerless victimhood is independent of the positions the fathers held during the Third Reich. Most of these novelized fathers were in the military; a few were members of the Nazi Party; and two were in the SS. Most wives (the narrators' mothers) had to navigate

the children through the war and the collapse of the Third Reich and in many instances developed great ingenuity and strength. Yet with the return of the disillusioned and disoriented husbands, the wives resume their earlier roles, in which the only choice is between actively supporting the husband's moods or passively submitting to them—the choice between being collaborator or victim. The mother is, in a few instances (Plessen and Vesper), the convinced and active equal of the father, and overall there is not much indication that mothers were ideologically opposed to their husbands or without prejudices. At best, they bear out Ralph Gehrke's assessment: "The mothers, exhausted from too many demands in everyday life, try to soften the strict rule of the fathers with fleeting tenderness and loving attention, but agree that discipline and order are necessary."[16]

It should not surprise that imitation of the father's behavior is particularly evident among the male authors in the glimpses these authors sometimes give of their own family lives as adults. In these brief sketches, wives or girlfriends perform roles not unlike those the narrator's mother performed for her husband; they are peripheral figures and their services are equally taken for granted. These women help and comfort; they get up in the morning to have the coffee ready, make the disagreeable phone calls, lick the wounded psyches of their partners. When a woman does come into her own (in Hermann Kinder's novel, the wife becomes a union member and then a union organizer), the husband finds this emotionally unacceptable despite his professed belief in equality (which he demonstrates by sharing the housekeeping chores). In Kinder's novel, as in the novels of Gauch, Lang, and Rauter, the authors carefully refrain from introducing any critical perspective; they seem to assume that their obvious psychic distress automatically assures the reader's sympathy. Yet what impresses the reader most is the overwhelming concern with self—not in pursuit of insight or personal growth but in pursuit of exoneration from responsibility.

The inability to establish mutually fulfilling personal relationships apparently extends to the next generation: the children of these male narrators can likewise not count on paternal understanding. Sigfried Gauch provides an example. He teaches brain-damaged and otherwise handicapped children, a professional choice that has been interpreted as expiation for his real-life father, a high-ranking Nazi official, onetime aide to Hitler, and inveterate postwar supporter of Nazi rallies, who spent the last years of his life trying to prove that it was physically impossible to murder as many Jews as has been alleged. The narrator of Gauch's novel describes the empathic response of his handicapped pupils to the death of his father, and in talking to them about his loss allows these children to

show a thoughtfulness and a sense of mourning which they usually suppress. Yet in the scenes in which his own daughters learn of their grandfather's death, there is no intimation of love or affection, or sense of a family community in a time of grief, but rather a petulant manipulation of the family by displaying a sour mood to which he feels entitled. In a counterexample of a "caring" father, Bernward Vesper takes his toddler son along in the back of his car, on his trip through Europe and into drugs. In a last moment of lucidity, he leaves the child with a relative, before he checks himself into a mental hospital. In the saddest and most extreme example, E. A. Rauter mentions his "destroyed progeny"—destroyed through abortion—but can speak about it only cynically and with great callousness.

In novel after novel, the reader finds variations of the same family constellations, which transcend class differences and argue strongly for the homogeneity of the German educational system. Whether the father is a count (Plessen), a clergyman (Rehmann), a photographer (Henisch), a lawyer (Härtling), a physician (Gauch, Schwaiger), a writer (Vesper, Meckel, Bronnen, Kinder), a farmer (Rauter), a manager of a firm (Rodrian), an investigator for the railroads (Kersten), or a glass cutter (Lang), whether he is mercurial or sanguine, mean or kind, he either dominates the family through his behavior or dominates by default because of the submissiveness of the rest of the family. All the narrators are socially aware enough to know that authoritarianism and obedience to mindless and brutal treatment is inculcated by education (in school as well as in the home) and through the internalization of social pressures and roles. Yet instead of translating this awareness into action and breaking with the established bonds, many of them take refuge in an implicit determinism. Allegiance to this determinism is particularly obvious in descriptions of the father's childhood. Then, invariably, a domineering grandfather is seen as the cause of the father's dismal childhood and of the father's later tyrannical behavior.

The female authors appear at first to be better off psychologically. More out of necessity than desire, they have shed patriarchal family structures and thus seem to be leading more flexible lives. These women are single mothers (either divorced, as in Day's novel, or unwed, as in those of Bronnen and Rodrian; or the husband is nonexistent for unspecified reasons, as in Rehmann's). Like their male counterparts, they hold intellectually oriented and often freelance jobs, but sexual discrimination (within the family and/or at work) has forced them to become more resourceful. Moreover, children are an integral part of their circumstances. If the narrators have no children of their own, those of relatives or friends figure in the accounts, to convey the author's realization that

present actions have consequences in the next generation. The children's presence in these novels helps to show time as dynamic and introduces the possibility of change as opposed to the more static and closed universe that most male authors suggest.

Yet the seemingly greater freedom among the women is not a sign of true emancipation. Nor are these women radical feminists who have a program for a more open, nonauthoritarian future. Some of the protagonists may have shed their sexual inhibitions, but their perceptions of sexual roles and power hierarchies are still well within the traditional model. Thus, Barbara Bronnen's Katarina, seemingly the most liberated of the woman protagonists, yearns for marriage to the father of her son, and within a sexual relationship is quite ready to function according to male expectations as the conventionally submissive and supportive female. Similarly, Irene Rodrian's Hanne is headed for a breakdown at the end of the novel, unable to live with her daughter as the single mother she wanted to be.

A small but nevertheless encouraging number of these female authors build (or at least suggest) bridges to the future. Ruth Rehmann's narrator is bent on bringing up her teenage children democratically and pays attention to their questions and suggestions. They are explicitly included in her quest for self-identity and the search for her father's role in the past. She turns to them and shares with them her anxiety and distress over Germany's past, managing to fashion this emotional bond into a pedagogical tool that teaches them not only about the past but about the individual's responsibility for it, and she shows how difficult it is not to repress and avoid the hard questions.

In Elisabeth Plessen's novel, the quest for self is carefully worked out and the conclusions are unflinchingly drawn. During a two-day trip to her father's funeral, Augusta, the protagonist, reviews her relationship with him and decides, within sight of the parental home, not to attend. She also rejects her brother, whom she sees as following in their father's footsteps, and breaks with her self-absorbed, insensitive boyfriend. Plessen complements this threefold rejection by sketching alternatives. Augusta's aunt, for example, paid for her independence with spinsterhood and occasional hallucinations; for Augusta, this is a fate preferable to that of her mother, whose strong temperament found only one outlet, a vehement and unswerving identification with her husband. Augusta's sister has responded to the pressures of their upbringing by turning into a shrew and a double-dealer. As if to counterbalance the radical severance from her family, the author has Augusta spend a few hours with friends who have a small child. This brief interlude serves to illustrate that relationships based on mutual support are possible.

By refusing to attend her father's funeral, Plessen's Augusta breaks the stranglehold that family and tradition have exerted. It is an individual act of liberation set against the continuity of family patterns. The novel is a hopeful book in the sense that Augusta's aim is total intellectual honesty and she has the courage to act on the basis of her insight. Severance from her family and the privileged social status they represent is an informed act, not a rash one. It comes only after many excruciating attempts to make contact with her father, who, as a member of the aristocracy, had despised Hitler as riffraff, but who, as a man of the military, would never dream of disobeying a command or breaking an oath. Unfettered by sentimentality, Augusta tries to understand her father's thinking, but ultimately recognizes the insurmountable barriers imposed by his inflexible adherence to stereotypes and clichés.

Augusta's break with her father and her family is a rare occurrence indeed in these novels. Much more frequently, the narrator-protagonist is caught in a love-hate relationship with the father from which he or she cannot escape. The most extreme example is Sigfried Gauch's narrator, who concludes his account by spending the night after his father's funeral in his father's bed, hoping that this physical *imitatio patris* will function as exorcism and initiate his liberation. Yet this act of filial piety, in which the symbolic gesture rather than hard thinking and painful self-exploration is seen as the vehicle of deliverance, remains just that: filial. In a variation on Gauch, Brigitte Schwaiger concludes *Long Absence* with her narrator's rejection of the fantasy of lying in the coffin with her father. The strident psychological implications of this scene reemphasize the narrator's state of utter turmoil.

Among the male authors, Peter Henisch presents the most successful filial relationship—largely because the father, a prominent combat photographer during World War II, is able to see himself and his opportunism in clear perspective, and can communicate this to his son. The openness between father and son allows a relaxation of the genre formula: the son must still piece together the various elements of the father's past (many of them documented in the photographs), but before this father dies the two record their conversations on a tape recorder for the son's later reflection. Henisch, too, uses the passing of the generations as a motif imbued with hope. The father's death is balanced by the birth of the narrator's daughter. The progress of the narrator's quest and the writing of the account of his quest are paralleled by the progress of his wife's pregnancy. Just when the narrator has completed his quest, he is called upon to assume the paternal role himself. The birth of his daughter seals his new identity.

By contrast, Bernward Vesper's ostensible openness leads not to liberation but to destruction. His novel, notes for a leftist program that com-

bines Marxism with the vaporings of R. D. Laing and Timothy Leary, traces the agony of his own disintegration. The indignities that Vesper suffered in childhood were magnified and projected onto the political arena through his later contacts with terrorists. (The terrorist Gudrun Ensslin was the mother of their child.) Unable to break the bonds of an extreme emotional dualism that tied him to his family, he ultimately committed suicide in an insane asylum. The fact that his novel became a cult book in Germany indicates clearly that a great many of his contemporaries identified with his distress and lack of a vision for alternatives.

Burdened by their own and their parents' past, how did this generation attempt to come to terms with the Holocaust? Certainly, the Holocaust was of prime importance in their search for self-identity, since their fathers' roles in the atrocities committed during the Nazi regime were a focal point in their exploration of who they were. The novels as fictionalized autobiographies approach the Holocaust subjectively, through the narrators' attempts at conversations with their elders.[17] But in almost all the situations depicted in these novels Jews are peripheral. The narrators see no inconsistency in attacking the parent for his role, no matter how grand or innocuous, in the Nazi regime and simultaneously *not* referring to the atrocities committed by the Nazi regime. Just like the term "fascist," the Nazi regime and the atrocities remain abstract concepts, devoid of personal meaning and personal investment, such as horror or shame or sorrow or even "consternation" (*Betroffenheit*). Most of the authors allow the parent generation to speak for itself; thus, the authors repeat the clichés and evasive euphemisms that served their elders to justify, diminish, circumvent, or deny their accommodation to the Nazi regime. Obviously, the authors subscribe to the notion prevalent in the 1960s and 1970s that a critique of language (*Sprachkritik*) implies a criticism of society (*Gesellschaftskritik*), and that the parents, in speaking for themselves, clearly pronounce their own indictment. However, the clichés and their widespread use are nowhere analyzed or even commented upon. The authors cannot avoid the criticism that they let the fathers speak for themselves, because their narrators do not command an analytical perspective that would demonstrate the connection between what the parent says in the present and what he did in the past, and they cannot imaginatively project their own affective response to the Holocaust into the text. In narratives that are full of one specific sort of affect—anger against the parent and rage at the mistreatment of the child—there is a curious lack of affect when it comes to the Holocaust. Here is most evident what Eric Santner has pointed out: "The second generation inherited not only the unmourned traumas of the parents, but also the psychic structures that impeded mourning in the first place."[18]

Who is the father of Henisch's narrator—who is the narrator him-
self—if clichés such as "I am sure the Führer knows what he is doing"
(42) as the father is shipped to the Eastern front are simply accepted? Is
the father's "I could not have changed anything" (61) merely the response
of those accustomed and resigned to authoritarianism or is he making ex-
cuses for irresponsible passivity? Could the father of Gauch's narrator re-
ally believe, and could the narrator really accept without much
argument, that "the goals [of the National Socialists] were clearly idealis-
tic"? (104) or, in Christoph Meckel's account, could either father or son
believe that the father "had wanted the honorable and done his best"?
(89). Why don't the narrators subject these clichés to critical analysis?
Why don't they investigate how these clichés serve as alibis and place-
bos? Here, perhaps, was a missed opportunity for the younger generation
to learn instead of judge, to listen instead of accuse, and to feel sorrow for
themselves as the children of these mechanized parents, sorrow for the
parents, and ultimately sorrow for the victims and shame for what had
been done to them. But this road was too arduous for those traveling with
the heavy baggage of anger and fury; indeed, the heavy baggage could
serve as a demonstration of "good intentions" and simultaneously as an
excuse not to look any further. As a result, the younger generation re-
mained as locked in their position as were the parents in theirs.

Elisabeth Plessen's *Augusta* tries, more persistently than other narra-
tors, to reach her father by cracking open the hermetically closed world
of these clichés. She does not succeed, but in the process she disengages
herself as she comes to a fair, yet hopeless, realization:

> He tried to be honest with himself, but he only repeated this horrible,
> inculcated vocabulary, nothing but words from Uhland ballads, offi-
> cers' mess halls, and black-white-and-red newspapers. He did not even
> realize it, did not realize that these words obliterated all he had in-
> tended to do, all honesty, and in the end, everything was as it had been.
> He merely had repeated himself (237).

Ruth Rehmann's narrator remembers with pained clarity the father's
response—a stereotypical assurance that all is for the best—when his
only friend, a Jew, visits him clandestinely one night. Rehmann makes it
particularly clear that since the father, a Protestant pastor, knows no
way out, he cannot afford to accept what his Jewish friend is telling him
and therefore must take refuge in clichés. The father says: "You must be
mistaken. People talk a lot. You must not take it personally" (178). And
farther in the conversation, he exclaims: "No, I cannot believe it! that
would be . . . ," leaving the sentence incomplete, since after "that would
be . . . " he would have to *name* what it would be, and in naming this re-

ality would have to acknowledge that it exists. He uses the modal in each of these sentences ("you *must* be mistaken . . . you *must* not take it personally . . . I *cannot* believe it . . . ") to emphatically support the verb, since the verb alone would not carry enough conviction. At the same time, the modals introduce an element of counterreality, a world of wishful thinking, in which "you *must* be wrong" and "I *cannot* believe this" are rearguard battles fought in a war that is already lost. But Rehmann herself never asks what service these clichés rendered. If the father had not hidden behind them, the reality he would have had to acknowledge would have been inconvenient, to say the least. Wouldn't he have had to help his friend, even if that had meant endangering himself?

Since the fathers remain inaccessible, some members of the younger generation try a different approach. They establish an identity with the realization, even fantasy, that they are partly of Jewish descent. But this fantasy has nothing to do with an attempt to understand what it means to be (or to have been) a Jew in Germany; rather it instrumentalizes and idealizes being Jewish, for altogether personal purposes. In general, this imaginatively projected identification with the victims of the parent generation is peripheral to the autobiographical search and cannot bring a resolution to the problem of self-definition. But it attempts to establish a bond with Jews that excises the parents as perpetrators and allows the children a false relief from their historic responsibility since they, like the Jews, are the victims of the same generation of perpetrators. The identification *as* Jew remains a fantasy; it exists in a vacuum, without social or personal implications; it is a strategy rather than a shaping experience, and it feeds the self-perception as victim, which makes for petrification instead of growth; it is a substitute for mourning and as such blocks any empathy or sorrow for the real victims of the Nazi regime.

In the second generation "the inability to mourn" has a different context from that of the perpetrator generation. The first generation operated mostly through denial and repression of the Nazi atrocities, and except for philo-Semitic expressions talk *about* Jews (never mind there was no talk *with* Jews) was taboo. This taboo functioned at the same time as a barrier against unguarded anti-Semitism. In the second generation, Jews are no longer a taboo subject, but they are instrumentalized for specific purposes. The literary scholar Jack Zipes notes: "Jews become functional only in helping [German leftists] establish their personal and national identity"[19] and Santner argues that German identification with the victims ultimately robs Jews even of their authentic status as victims. "[I]n extreme cases of identification with the victims . . . the Jewish survivors are expropriated once more, only now

not their property or citizenship but the struggles and memories of their survivorship."[20]

Two authors in the group under discussion speak openly about Jews. This is most poignantly the case in Brigitte Schwaiger's *Long Absence*. In a rather self-indulgent fantasy, Schwaiger's protagonist, whose mother "probably" had a Jewish father, hopes to hurt her intransigent Nazi father by having an affair with an older Jew, who serves as father-substitute and as an attack on the father at the same time. But the author is so close to the material that she cannot show the pathology of the narrator or give a credible portrait of the Jewish lover, his personality, or his own motives for participating in the affair. The author does not question or analyze, but completely identifies with the narrator's feelings of hatred and revenge toward the father. The lover never emerges as a person; his function in the narrative is to be used as an instrument in the battle with the father. Not surprisingly, anti-Semitism is an ingredient in this witches' brew of intense, contradictory emotions. The narrator denigrates her Jewish lover with the same anti-Semitic slogans used by her father, and shows, in this vituperative outburst of hatred at the other, chiefly hatred of herself. The lack of authorial control over the chosen subject suggests that little attempt has been made to work out problems of self-identity, much less the true nature of the narrator's relationship with her Jewish lover, and least of all an understanding of him as his own person.

Ingeborg Day's narrator, on the other hand, exposes herself to the full horror of collective guilt. Unable to reconcile the image of her father as a loving and caring human being with her knowledge of his Nazi Party and SS membership, she literally goes to pieces: the novel documents this as well as the process of her tenuous reintegration. Hers is the only novel to explicitly place the Holocaust at the core of the quest for the self. This may be so because Day left her native Austria, married and then divorced in the United States, and continues to live here. The daily contact with American Jews may have made the Holocaust more real to her. Her disintegration shows the toll this confrontation can take, when an individual is overcome by feelings of guilt and shame and sorrow and simultaneously attached to one of those who perpetrated the crimes.

Taken together, these novels show an irreconcilable dualism as the insidious legacy of the parent generation. Gauch's narrator states this most concisely: "Why, Uwe, I say out loud, I know my schizophrenic situation quite well: to love my father as a person and to be revolted by his personality" (135). Frozen into this dualism, the narrators cannot rise to a level of critical insight in which the desire for clear-cut answers and resolutions is recognized as futile. Accusing their elders of recalcitrance, most of the narrators themselves lack the dimension of empathy

and of compassion that could conceivably lead to the labor of mourning. They are incapable of working out a frame of reference in which occasional personal acts of kindness can coexist with mass atrocities, and in which a child in search of an acceptable father will not ignore the recognition of that person as an unacceptable citizen. Most of them seem to have learned nothing from the harrowing lives of their characters. Moored in their frustrations, they cannot grow into personal or political maturity—or even understand that growing into responsible adulthood is a hard process demanding painful decisions and the strength to cut filial ties. Enraged accusations and fantasies of victimization and exculpation only perpetuate the avoidance of working through a past that will not go away. As a step on the road toward the wrenching labor of mourning, they should heed the tough council of Holocaust survivor Jean Améry:

> What happened is no concern of yours because you didn't know, or were too young, or not even born yet? You should have seen, and your youth gives you no special privilege, and break with your father.[21]

While these self-exploratory novels represent the groping and misguided attempts of a young generation of intellectuals, a much more popular appeal in a much more popular medium elicited a much more widespread response: the American TV series *Holocaust* aired in West Germany in early 1979, just as the avalanche of autobiographical novels gained momentum. A comparison between the two concurrent phenomena is interesting. In the novels written by Germans the concern is never with the Holocaust for its own sake; the emphasis lies on using the Holocaust to accuse the parent. In the case of the American TV film, Germans did not have to generate a view of the Holocaust on their own, they only needed to respond to a prepackaged presentation. The fact that the presentation was foreign-made and sentimentalized apparently removed inhibitions and allowed a response to the "other's" story—a story that also turned out to be one's own history. Even though the airing occurred at a politically sensitive time (the ongoing Majdanek trial, the "Filbinger affair," and the heated debates in parliament over further extending the statute of limitations for Nazi crimes), these events created no obstacle to the overwhelming response to the series. In the TV series, the personalized fate of the Jews, their denigration and ultimate annihilation as portrayed in the family of Dr. Weiss, and the portrayal of the Nazis and SS in the formerly unemployed Eric Dorf, made theoretical knowledge concrete and provided an emotional focus. Anton Kaes notes rightly:

> An American television series, made in a trivial style, produced more for commercial than for moral reasons, more for entertainment than

for enlightenment, accomplished what hundreds of books, plays, films, and television programs, thousands of documents, and all the concentration camp trials have failed to do in the more than three decades since the end of the war: to inform Germans about crimes against Jews committed in their name so that millions were emotionally touched and moved.[22]

Yet this unusual emotional outpouring needed further explanation; the scholar Thomas Elsaesser identifies it more closely when he states:

The emotions touched were themselves of a complex kind; . . . the metaphor of "floodgates opening up" recurred almost stereotypically, and expressions of guilt, shame, and remorse were made public with sometimes hysterical and sometimes exhibitionist fervor . . .[23]

Certainly, "expressions of guilt, shame, and remorse" were a positive response and could be viewed as a precondition for expressions of mourning for the crimes committed, for the people and the culture destroyed. Yet the "sometimes hysterical and sometimes exhibitionist fervor" cast doubt on the emotions displayed. While the "hysterical fervor" may have been caused by the confrontation with this up-close-and-personal view of the horrors of the Holocaust (and may have prompted many German viewers to identify with the victims), the "exhibitionist fervor" may well have been occasioned by the realization that "the world's eyes were on Germany to see how it would react to the series."[24] The absence of a German self-generated mourning for the victims was compensated by the fervor with which the American model was embraced. Anton Kaes quotes the director of the radio station SWR, Peter Schulz-Rohr, who recognized "the almost exhibitionistic German inclination to engage in self-abnegation" which, he felt, "combines in a fatal way with the performance of public acts of atonement and exemplifies the kind of moral gesture made to impress others that, for anyone with a sensitive conscience, calls into question the very morality it is meant to demonstrate."[25]

It is profoundly ironic that the trivialization and sentimentalization of the Holocaust stirred German viewers to display abhorrence and empathy—a feat that historical reality could not accomplish. Their display of emotions resonated with the same sense of overly eager inauthenticity that showed in the writers' identification as Jews, while the intense desire to vent media-generated emotions betrayed the absence of genuine insight. The Holocaust was now widely talked about but under conditions that blotted out access to the horror of the historical reality. The ambivalence of this position—a false identification premised on a media-generated portrayal and resulting in an overwrought response jux-

taposed with a surprised and new awareness of the Holocaust—is com-
mented on by Anton Kaes when he states:

> *Holocaust* allowed the Germans to work through their most recent
> past, this time from the perspective of the victims, by proxy, in the in-
> nocuous form of a television show. . . . Because the collective catharsis
> felt by many viewers came about through a *film* (that is, through a fic-
> tion, a simulation), one might well suspect that the catharsis, if there
> indeed was one, rested on a self-deception. Still, no matter how skepti-
> cal one may be about the long-term effect of a media event like *Holo-
> caust*, it cannot be denied that in its wake a new historical
> consciousness emerged in the Federal Republic.[26]

This new consciousness was to hold center stage in the following
decade.

Autobiographical Novels

Hanns-Josef Ortheil

> The biography of my own existence . . . means: the biography
> of a post-fascist life in which fascism nevertheless plays the
> formative and dominant role that must never be forgotten.[1]

Hanns-Josef Ortheil was born in Köln-Lindenthal in 1951. He belongs to
the generation of German writers who were too young by about a decade
to have participated in the student movements of the late 1960s and
early 1970s. He became an adult during the *Tendenzwende,* the turn in
the intellectual and social climate, as the wave of autobiographical nov-
els gained momentum. Among this emerging group of *Nachgeborene*
(the successor generation), Ortheil is without doubt one of the most pro-
lific and versatile. He published his first novel, *Fermer,* in 1979 and has
since produced novels, essays, and critical studies at an unremitting
pace. The recurrent theme of the Nazi past in a number of his novels
demonstrates that even the generation of those born after the war is bur-
dened with that past. Ortheil's writings attest to an undiminished need
to arrive at a definition of self against the background of the Nazi
regime. In his early novels, *Fermer* and *Hecke (Hedges)* (1983), he depicts
with almost lyrical intensity the young protagonists' search for identity
and for values by which to guide their lives. In 1987, he published a
major novel, *Schwerenöter (Go-Getter),* a wide social and historical
panorama in a picaresque mood.[2] In 1992, after the wave of autobio-

graphical novels had subsided but possibly motivated by the death of his father, Ortheil published *Abschied von den Kriegsteilnehmers (A Farewell to the War Veterans)*, which can also be considered a farewell to the "literature about fathers and mothers."[3] This novel is a sequel to *Hedges*, of almost a decade earlier, in which his mother and her life during the Nazi regime are his principal concern. Ortheil is unique among the writers of autobiographical novels in that he needed to explore the lives of both his parents. As in all his novels, the protagonist of *Hedges* and of *A Farewell to the War Veterans* struggles to comprehend the impact of the Hitler past on his own life, "a post-fascist life in which fascism nevertheless plays the formative and dominant role." Perhaps because Ortheil is younger than the turbulent 1968ers, he is more thoughtful than explosive in his reflections and tries to understand each of his parents on their own terms.

Fermer, Ortheil's first novel, contains many of the themes and constellations that appear in the two novels about his parents, but it is closer to the literature of the New Subjectivity of the 1970s, which includes novels such as Peter Schneider's *Lenz* (1973), Nicolas Born's *Die erdabgewandte Seite der Geschichte (The Side of the Story Turned away from Earth)* (1976), and Botho Strauß's *Die Widmung (The Dedication)* (1977). Like the autobiographical novels, these novels signaled a turning away from the activism of the student movement toward introspection and self-analysis, but they did not focus on the family and the parents' role in the Nazi regime. *Fermer* is considered a "novel of initiation" or "novel of adolescence," modeled on such precedents as J. D. Salinger's *Catcher in the Rye* and characterized by the protagonist's experience of crisis.[4] Common to these novels is a "quest," frequently a literal journey of search. The titular hero of *Fermer* is a nineteen-year-old recruit who one evening, "suddenly and without intention" (34), does not return to the barracks of the *Bundeswehr*. His desertion is the beginning of an inner as well as an outer journey. In a comment written ten years after the novel's publication, Ortheil explained what he meant by "desertion": ". . . in my opinion the deserter lives in a vacuum, in between camps, restless, in movement; [it is] a kind of desperate loner's role without the guarantee of ever reaching a community."[5]

In a carefully structured novel of six chapters with six subheadings each, Ortheil presents a sensitive, thoughtful portrait of a young man acquiring the emotional and intellectual maturity to come to terms with his flight and the reasons for it, and to find his own standards and values. The narrative time of six months moves from Fermer's desertion in late winter to late summer, when he illegally crosses the border to Denmark, ultimately on his way to Italy. There are frequent flashbacks, often pre-

sented as conversations, to his childhood, his parents' lives, and the histories of the friends and families he meets on his journey north. In the process, Ortheil depicts an uneasy consumer society in the act of covering up its past. There are peripheral but sharp attacks on institutions—particularly the educational system and the military, both of which are designed to crush any sense of freedom, any play of the imagination, and all resistance to conformity.

The novel defies closure, since Fermer's escape from Germany does not resolve the problem of his desertion. It also emphasizes the sharp division between the generations. Fermer finds support, understanding, and acceptance among his peers, most of whom share his unease and rejection of contemporary society, while the older generation, including his parents, shows total incomprehension at the young generation's behavior and insists that only its ways are right. This generational conflict and the problematics of initiation into adulthood are a common theme in many societies and literatures, and *Fermer* is in this respect part of a larger and international group. However, German "initiations" inevitably include a confrontation with the Nazi regime and, by implication, with the Holocaust. One can see the sequence of *Fermer, Hedges,* and *A Farewell to the War Veterans* as Ortheil's accelerating attempt to understand this past. Before coming to any understanding of the historical past, Fermer must overcome the authoritarian conditioning of his own personality. The protagonist of *Hedges* can then examine the life of his mother and understand her personality as it was formed—and deformed—during the Nazi regime, and he can calculate the effect of his mother's personality on his own upbringing. Nearly a decade later, Ortheil can then have the protagonist of *A Farewell to the War Veterans* look at his father's life—a far more harrowing enterprise, since this father's role during the Nazi regime, in distinction to the mother's passive and traumatized withdrawal in *Hedges*, was an active one. The sequence of the three novels can thus be read as an autobiographical search in which the writer needs three successive steps to approach from the periphery to the center of the Nazi atrocities.

Ortheil relates Fermer's six-month journey under the guiding principle of two qualities that permeate German society and that establish a continuity from prewar to postwar times: they are order or orderliness and *Geborgenheit,* a complex noun that denotes the sense of well-being that comes from feeling sheltered and protected.[6] These qualities may seem positive, or at least innocuous, yet they are more than personal predilections—they have social and political consequences. One of the merits of *Fermer* is the demonstration that no personal characteristic or act is merely personal; characteristics and acts have social implications

and political results that may, in the end, even be contrary to their initial purpose. The German need for order is illustrated in many different situations in the novel, and practically all the principal characters are identified in relation to it. As in the descriptions of parental brutality in the autobiographical novels, wherein the brutalizing parent was once a brutalized child, there are in *Fermer* several indications that the older generation's need for order and *Geborgenheit* had its origins in their early lives—in the chaos of World War I and its aftermath. The successor generations are thus imprinted not only with the fear of chaos but with the desire for protection from chaos in *Geborgenheit*, and with the means by which this chaos is tamed—namely, rigid order. Fermer's father (like the father in *Hedges* and *A Farewell to the War Veterans*) is an engineer/surveyor, who explains his career choice in terms of the creation and maintenance of order: "The technique of land surveying then also interested me, because through the drawing, order was created in the landscape" (224). Wives keep houses in immaculate order; even the photographs are "carefully labeled" (163), as are the small, sentimental pictures of flowers that Fermer's father draws (225). Ortheil shows the conditioning impact of this love or need for order on the next generation when Fermer remembers that as a child he had been deeply impressed with "the delicate lines and the exactness" (224) of these drawings. Fermer's own emotional turmoil is also expressed in terms of order: at one point, "he could no longer order his words" (42). While in flight, he stops at his parents' house, and well-indoctrinated behavior patterns take over. He immediately puts his shoes in their assigned spot "under the small radiator" and carries his dirty laundry into the basement, where he sorts it and puts it in a laundry basket (211). This small gesture shows how deeply internalized the parental patterns are, and that this routine provides comfort and suggests stability compared to the "disorderly" behavior of the deserter; it is also an indication of the tremendous pressure to revert to habituated conduct.

After Fermer arrives at his parents' house, his first major activity after sorting the laundry is to take a bath. When he starts to sing in the bathtub, his parents knock on the door and ask him not to make so much noise (213–14). Instead of being happy to see their son after a long absence, they are upset by his disruption of their orderly routine. But more important, they are afraid that someone will discover their clandestine visitor in this well-ordered center of *Geborgenheit*, even though their house stands alone on a fairly large piece of property, surrounded by woods. Fermer is hurt when he discovers that his mother is more ashamed of his desertion, a major instance of "disorderly conduct," than she is interested in knowing why he deserted, and he is struck that the ritual of the dinner table fol-

lows old, established rules that completely ignore the altered circumstances under which the son sits at the table (216 ff.).

As Fermer comes up against the defining limits of his own personality, he learns to understand his fears, including the fear associated with the violations of socially imposed restrictions. He realizes that compliance with sanctioned rules provides a sense of satisfaction and security, a *Geborgenheit* he must learn to sacrifice. When he stays for a while with his friends Lotta and Ferdinand and their parents (who are unaware that he is a deserter), he shows his appreciation for their hospitality by giving their garden an extensive spring cleaning. There is pleasure in this quasi-therapeutic activity, but it is not pleasure for its own sake. Fermer is honest enough to know that he must not admit to himself the source of this pleasure—which is that he is creating order and fitting into approved patterns:

> He did not say why he liked the work; he viewed it as a continuous cleaning-up. Gradually the garden that had collapsed in winter, as by an earthquake, took on order . . . sometimes the small, clearly delimited area appeared to Fermer as a valid order of things in which he was allowed to participate. . . . The old doubts and questions became weaker; in working, he believed he perceived a connectedness in the garden in which he participated and which calmed him the more patiently he dedicated himself (140).

Finding solace by doing work that creates order means, of course, that he is following the older generation's principles. That he views this "valid order of things" as something in which he is "allowed to participate," although it is his own creation, is an indication of how deeply he is imbued with their spirit of obedience. Fermer learns to execute a precarious balancing act between the person he has become as a result of his upbringing and the person he wants to become. He knows that some kind of order is essential, yet when his father tells him that "[y]ou will find out that life without order and rules is not posssible, that there must be safeguards," he exclaims in reply: "I don't want to rely on someone else's prefabricated rules" (219–20). Fermer is not a radical; he opts for creating his own world, and his choice lies in the direction of an open, ever changing society. But first he must learn to recognize as temptation (and reject) the conviction that rigid order is necessary and that compliance with the established order promises comfort and *Geborgenheit*. This rejection, whether unconscious or conscious, spontaneous or deliberate, is inevitably accompanied by multiple and contradictory layers of fear: the fear of having broken the rules; the fear of failure (always a possibility in the exploration of new territories); the fear of succumbing

to the temptation to opt for personal comfort, attained as psychological and social reward for abiding by the established order at the expense of individual growth. This link between order and *Geborgenheit*, and the conflicting currents of fear, together go a long way toward explaining why individuals succumb to a group or mass identity, and they carry important implications for the workings of a democracy. Ortheil shows in his protagonist's irresolution the existence of these mechanisms and the need to recognize and excise them. It is a sign of Fermer's growing personal and political maturity that he comes to understand the "pleasant feelings" culminating in *Geborgenheit* as a cover-up for a deeply hidden fear—the fear of independence, of personal responsibility, of open-endedness.

The outward manifestation of *Geborgenheit* in *Fermer* is the family house and the family garden. However, the ambivalence of *Geborgenheit* surfaces immediately, since the spatial arrangements are not those of trust and communal sharing but of a fearful seclusion clearly indicated by fences, gates, and shutters—demarcations separating the personal cosmos from surrounding chaos and excluding all that is not invited into this homogeneous universe. Yet, like the panicked activities of the animal in Kafka's *Der Bau (The Burrow)*, the establishment of barriers cannot safeguard *Geborgenheit*, since the fears and concealments come from within. An old recluse is the only adult who seems to understand Fermer and offers him temporary refuge during his flight. This recluse also needs order, but his order-creating activities are directed at exposing a hidden core. He orders time into a history of the region, since he wants "to know where the memories [lie] hidden and concealed" (197). He sees the inhabitants of the region marked by "the pathos of a self-satisfied stupidity that is averse to all civilization" (201–2) and as having welcomed the Nazi regime because it glorified their narrow-minded, bigoted existence. He illustrates their backwardness and rigid sense of order in a mocking description of their food chain: "The history of food here is also a sad chapter; . . . Potatoes are for people, corn is for the cows, leftovers for the pigs, bones for the dogs, cats they are not used to" (201).

Ortheil is keenly aware of, and plays on, the common stem of the words *geborgen* (protected) and *verborgen* (hidden). In his fictional universe, *Geborgenheit* always contains something *verborgen*. Hence *Geborgenheit* is a sham, since it contains a hidden secret that undermines any sense of security, but the relation between the two words also suggests that one feels safe and comfortable only when one is hidden away. In political terms, this is a variation on the "nonpolitical German," for whom to be *geborgen* means to be *verborgen*—invisible, concealed in the anonymity of the crowd, or hidden in a never-well-enough-guarded sanctuary of some kind. The realization that something is hid-

den underneath appearances occurs throughout the novel, most poignantly halfway through, when Fermer has found a temporary refuge in the country house of Lotta and Ferdinand's parents. During the ritual act of spring cleaning, Ferdinand and Fermer find in the basement, in the deepest and darkest recess of the house, several cartons. The two young men, *geborgen* in a comfortable room, sort the content of the cartons as they enjoy some alcohol that Ferdinand (who has learned in a secretive society to keep his own secrets) has carefully hidden away. Among the various letters, diaries, photographs, and drawings,[7] Ferdinand comes across some photographic negatives that his parents have obviously hidden, and discovers after he develops them that they have been retouched so as to eliminate somebody from them. The self-defeating deviousness of this elimination mirrors the *geborgen/verborgen* complex. What did the parents want to preserve and yet eliminate when they went to the trouble of erasing the figure while preserving the rest of the negative? The secret of this person's identity is not resolved until much later in the novel, leaving a core of darkness and absence at the very center of the narrative. Later during his flight, Fermer learns from Lotta that the erased figure was that of a much loved brother, born during the war, who drowned after confronting his parents with the father's Nazi past. (Whether the death by drowning was an accident or suicide is left a "secret.") The brother had been outraged that his father, who had attained "not unimportant positions" (233) in the Hitler regime, could, in the postwar years, return to running his small publishing house as if nothing had happened, as if there were no past and no activities in that past that needed to be accounted for. Lotta's retrospective description of the brother's rage and destructiveness (233–5) echoes the behavior of many of the students of the late 1960s, a generation to which the brother clearly belonged. In a "magic" gesture that is ironic, naive, inefficient, malevolent, and short-sighted all in one, the parents remove all traces of his existence, as if this elimination could keep them from remembering their past and the son's tragic death associated with it. In this short scene, Ortheil recapitulates an entire generation's futile acts of denial and repression.

Ferdinand's discovery of the "elimination" of the brother goes right to the core of the German postwar malaise: no amount of order and cleaning up can disguise the marks of erasures, which even as negatives are positive indictments and even as absences are powerful presences. The death of the older brother illustrates the futility of enraged confrontation (like that of the terrorists of the 1970s). Perhaps the past can be laid to rest only by a younger generation whose very identity and self-conceptualization depend on bringing this past to light, and only when this

past is openly discussed, openly acknowledged, openly worked through. As the parents hope to erase the memory of their son and the cause of his death by erasing his presence in the photo negatives, they think they can also distance themselves from their complicity with the Nazi Party. Even though the father had held "a not unimportant position," he now wants to dissociate himself from people "on whom the traces of brown politics are still noticeable" (127). The opportunistic self-righteousness of this remark is a blatant denial of his own past; it is also remarkably cynical, for he does not object to someone's having a Nazi past, only to the detectable traces of it.

One of Ortheil's insights in this novel bears on his realization that the break with *Geborgenheit* cannot be accomplished in one generation, since the first postwar generation has been too strongly conditioned. As Fermer meets those who become his friends and they make their way north in order to arrive south (in Italy), they know that their youth is conditioned, even traumatized by their parents' past. Recognition of this burden, of the desire for *Geborgenheit* and the resolution not to be tempted by it is their only lodestar. This readiness to face the unknown is a clear departure from the need for order, stability, and security, and from the explosive rebellion of the 1968ers. On the personal level, it promises growth; on the social level, tolerance; on the political level, democracy and liberalism, which in Isaiah Berlin's interpretation of the word means "living with unresolvable conflicts of values and goals."[8]

Some of the same themes appear in Ortheil's next novel, *Hedges*, published four years later in 1983. *Hedges* is properly part of the "literature about fathers and mothers," but unlike these novels Ortheil's novel does not bear the marks of parental violence but rather of a profound parental disorientation, a consequence of Nazism, that resulted in mental instability and temporary autism and deeply influenced the narrator/son. Nevertheless, *Hedges* shares common assumptions with most of these novels: the search for the protagonist's self-identity, as it intermeshes with the parent's role in the past, can occur only in the parent's absence. This absence enables the protagonist to assemble information about the parent from many different sources: from newspaper clippings, diaries, letters, photographs; from varying accounts of specific incidents; from unreliable witnesses who have either fallible memories or their own agendas; and as in most of these novels, the fragmentary and relativizing bits of information are held together by a tight time frame.

In *Hedges*, the mother, Katharina, is the principal focus of investigation. She is away on a week's vacation with Henner, the narrator's father, while the thirty-year-old son (who is never identified by name) is

house-sitting. He is an architect, a profession whose plans and blue-prints embody the orderliness Ortheil explored in *Fermer*, but it is also a career he does not "particularly like" (7). In a professional crisis, and therefore relieved of habitual strictures, he immerses himself in his mother's life during the Hitler years. The novel is structured on his week-long inquiry. By day, he investigates; at night, he writes. The house, located in Siegerland, is very much like the parents' house in *Fermer*; the time of the year is again spring and demands a lot of spring gardening. The seven-day journey through Katharina's life is for the narrator/son a journey of liberation.

As is the case with so many of Ortheil's key concepts, the title word "hedges" (*Hecke*) is fraught with ambiguities and acquires new meanings with each new context. *Hecke* and *Gehege* (enclosures) can metamorphose into *Gespinst* (web, cocoon; 168), *Gestrüpp* (thicket; 173), *Käfig* (cage; 23), *Umschnürungen* (ropings, tie ups, strangulations; 169); it can suggest the protective wall of "dark bushes that fenced in our property" (294) and can indicate a magic circle enclosing a place of refuge (94) and a comfortable hiding place in times of need (12).[9] These metamorphoses emphasize the "openness" of the image and with it flexibility and the promise of freedom; they also indicate an absence of the very security and stability that the image seems to convey and suggest a profound distrust in the appearance of phenomena, a distrust that can—presumably—be laid to rest by the establishment of order. As in *Fermer*, the promise of refuge is always undercut by apprehension over what might be hidden in this hiding place. The titular "Hedges" is also the name of a nearby farm, where members of the narrator's family took refuge in the last days of World War II. "Hedges," rather than indicating safety, became for the narrator-as-child "a word fraught with absolute terror" (293), since it was here, long before the birth of the narrator, that Katharina's young son—her only surviving child after the stillbirth of a first boy—was killed by a hand grenade in the last days of the war.

Driven by the initial question "But how can we put into words what we don't comprehend?" (34), the narrator in his quest pays particular attention to the means by which his exploration is conducted—namely, language, or more specifically, the language that shaped him, which means his mother's language. Like the family photograph in *Fermer*, in which absence proved presence, the language in *Hedges* is a means both of erasing and of storing information. As the narrator begins to assemble his mother's story/history, he realizes the role that language has played in obscuring it: "My mother forgets by telling a story" (23). The hedges (of language) are a cover for secrets that have to be hidden. But the reassuring wall of hedges can also metamorphose into a cage or a prison.

Aware that his mother's predicament is shared by many, Ortheil sees her mannerisms reflected in society. The desire to forget is a trait common to them all: "The narrators sit in the cages of their own words, they cover themselves almost lovingly with them, they burrow like fieldmice ever deeper into darkness. Only late did I realize that one can forget only in this manner" (23).

Language becomes the cover for events that must not be remembered. Not unlike the heroes of mythical journeys who have to breach formidable barriers to expose secrets and in so doing redeem themselves and their people, the narrator must deconstruct the hedges of his mother's stories, penetrate to the erased core of her forgetting, and uncover the sources of her distraught personality in order to find out who he is. He is well aware, and he describes it in incidents throughout the novel, that salvaging language from the attempts to use it as cover and as a means of "forgetting" is also imperative if he wants to become a writer. Guided by his mother's distress, the son eventually recognizes that the same hedges that protected against contamination by the Nazi regime also prevented reaching out. During the early years of the Nazi regime, hedges constituted protective walls against the knowledge of what was happening outside them: "Whatever happened all around, lost in significance. . . . Instead, one acquired a kind of inner protection, a delicately woven enclosure made up of reading, cultured education and lifestyle" (174–5). But as the Nazi regime stepped up its intimidations and brutalizations, withdrawal behind hedges changed from a passive resistance and a turning away (a position that later allowed many Germans to plead that they had known nothing about the Nazi crimes) to a defense mechanism that amounted to imprisonment. The narrator surmises of his mother that "she was careful, she covered herself, she protected herself, she did not dare attack. The *cocoon* in which she lived became ever denser, since she could no longer tear it with words, gestures, or actions" (168; emphasis added).

The narrator's reconstruction of Katharina's behavior does not plead her ignorance, however. On the contrary, he sees her withdrawal behind the hedges and into an ever more impenetrable cocoon as a conscious rejection of the world outside, accompanied by a growing loss of self-confidence and ending in resignation. For the narrator, this resignation is inseparable from shame in its multiple dimensions: shame at the resignation and at the Nazi brutalities, and shame at one's fear or inability to prevent these brutalities. Long before the concentration camp atrocities were committed, there existed reason for wanting to forget one's role in the Nazi regime.

Forgetting through *erzählen* (putting into words/narrating) is only one use into which language can be pressed. Another one is asserting control. As the son notes, " . . . by telling her stories she controls her forgetting" (23). And, one might add, she controls those to whom her stories are addressed. Yet the use of language to exert control is precisely what Katharina has in common with the Nazis. Not aware of her own practices, she notices them in others. As a young woman in Berlin, she observes Nazi informants exerting political control through their control of language, and she is appalled: "Even the slightest deviation from the regimented use of language does not escape their attention" (251). It is exactly this "regimented use of language" between mother and son, her means of bonding and exerting control over him, that he must break.

From a less harsh but no less ensnaring aspect, language is an instrument of seduction. The narrator comes to understand that he has been seduced by his mother and by her particular use of language since early childhood. The ambivalence that informs so many of Ortheil's characters and their basic attitudes is presented here in unambiguous terms. On the one hand, seduction through *erzählen* (telling stories) gives the child a sense of security (language as hedge), as when the narrator-as-child admits: "She can seduce with her stories, one feels protected, even when she talks about the most horrible things" (24). On the other hand, this sense of security proves false, because although these "most horrible things" lose their horrifying sting in her narration, they remain horrifying as actual events. The abyss between the events and her narration of them is glossed over by her words. Significantly, she refuses to pause between sentences (20), since the pauses would reveal the abyss. Her manipulative, controlling narrations help her to forget and to seduce others to follow her into her forgetting. The triad of "seducing," "feeling protected," and "the most horrible things" is also a litany that recalls common practices during the Nazi regime, when personal responsibility and clear thinking were abandoned for the "magic" of being seduced and swept away. This "seduction" by the Nazi regime creates a sense of feeling protected, because it operates on the premise that the individual is part of the larger "story," relieved of individual responsibility and protected in the anonymity of the masses. Being seduced into and protected by the Nazi ideology allows these "most horrible things" to be recognized as such, but the impact of their horror is blunted. The narrator here implicitly projects the mother-son relationship onto the political plane, where an entire nation was willingly seduced and protected, therefore less horrified at "the most horrible things," and never tried to shake off this seduction.

One could take issue with Ortheil's seduction theory as being too facile and too exculpatory. In fact, Ortheil is not proposing the theory to explain the overwhelming success of the Nazi regime but rather to explode a highly popular myth of exculpation, which had many adherents in the postwar period, when people exonerated themselves by insisting they had been "duped" and "seduced" by the Nazis. The young child's experience of having been seduced provides him with a genuine insight into the causes of dependency. His growth requires breaking this dependence (just as Fermer had to resist the temptation to take refuge in *Geborgenheit*—a synonym for being protected behind hedges). On the political plane, however, the feeling of having been duped and seduced never led to a decision to abandon passivity and assume responsibility for the crimes of the Nazi regime—and never led to the desire to break out of the "magic circle"; it led to self-pity, which served only to perpetuate the sense of victimhood. In his own liberation from seduction, the narrator/son performs a task incumbent on all those who subscribe to this myth.

Katharina's ambiguous position is illustrated in her suggestion to her friend, the church painter Peter Hacker, that he paint an apocalyptic Temptation of St. Anthony on the ceiling of the local church: while she seduces with her stories, she urges the painting of the rejection of temptation. The description of the progress of these frescoes becomes a megacode for the adult narrator's realization that resistance to the temptations of his mother's stories is imperative. During the Nazi regime and the time of his mother's youth, resistance meant to reject the "magic" promises of the Nazis. In the postwar period, the son must reject the very practices of seduction that the mother thought she had rejected during the Nazi period but that she had practiced in her son's upbringing. The son recognizes that he has been imprinted with practices his mother disdained yet shared with the Nazis as she hid behind metaphorical hedges and rejected the Nazi regime. The political dimension of this personal behavior is stressed when the narrator describes the seductive practices of his mother with the same words that he uses for a speech of Hitler's. He notes, almost resentfully, that "in my childhood she had made me addicted with her stories. . . . I was supposed to listen, to succumb to this *singsong*" (42; emphasis added), while Katharina, as a young wife in Berlin, heard Hitler and "did not understand what was said; she listened carefully to the *singsong*, to the crackling and the spitting" (214; emphasis added). Opposed to the Hitler regime and driven by it into a fear and mental distress that will be the determining factors of her life, Katharina is nevertheless seen by her son as sharing in the seductive practices of Nazism. Here we touch the core of Ortheil's political insights in the novel: even those opposed to the Nazi regime were on some unacknowledged level part of it.

The deeply rooted ambiguities in the mother's seductive practices, perceived by the son as paralleling Nazi practices and not, as the mother intended, evading or resisting them, become more pronounced as her distress during the years of the Nazi regime increases. Just as the Nazis invent their own language and slogans, so the mother's aversion to the regime also searches for an appropriate language. After the trauma of a stillbirth in Berlin during the war, she returns to her parents' village and there, protected by her family, raises her second son, born in 1943. She creates a language incomprehensible to all but him, since "the language that all of them used has become forever maimed, like that of evil ghosts, and behind each sound hunkered the bleating noise of the dead" (259). Indeed, the greater her distress and disorientation become, the more she hopes to resist, through extreme acts of language magic. Thus, she insists that "certain words had to be completely exterminated and sorted out in time before the arrival of the victors, so that nobody would still use them inadvertently" (287), and she produces, to the dismay of her family, who fear to be detected behind their hedge, "slips of paper with the torn or crossed-out names of the party members of the Security Service or the Storm Troopers" on them (287). This "magical" thinking is perhaps uncommon in its traumatized intensity, but is grounded in commonly held convictions: that when the word is destroyed, the thing it denotes will also be exterminated. Hence she subscribes to a commonly held belief in the postwar era: nonexistence of the words (silence) will extinguish the Nazis and the Nazi horrors. New, freshly invented stories will cover the silence so that this silence, as deliberate erasure, may be buried under words. In her "magical" destruction of the names Katharina performs a ritual of denial. Caught in the seduction of magical thinking, she does not want to know that the dangerous, indeed subversive power of words can never be contained (just as the erased figure in the photo negative can never be hidden). A case in point is the use of the word *vernichtet* (exterminated), as when the mother feels that certain names must be "exterminated" before the arrival of the Allied victors so that the bearers of these names might also be exterminated. Yet the crimes committed by the bearers of these names culminated precisely in the acts of *Vernichtungen* committed in the *Vernichtungslager* (extermination camps) of the Holocaust. No amount of magical thinking can annihilate annihilation. She is also beside herself when her husband, in a letter from the war front, uses words such as "extinguish," "exterminate," and "wipe out," and she responds to these descriptions of destruction by destroying the letter (260). Yet when she tries to purify the language by exterminating the names of Nazis, or when she destroys the letter containing words of annihilation, she has no other resources but

to repeat "magically" what the Nazis practiced factually. In Katharina's magical world, her acts of annihilation are obliterated by erasure and silence, and she masks these obliterations with her stories. Her stories are ultimately tales of denial. From this perspective, the adult son's quest for a language uncontaminated by these subterfuges is not only imperative for his integrity as a writer but also for the integrity of his search. In distinction to the mother, who "exterminates" the unbearable, the son uncovers and in uncovering preserves his mother's acts of annihilation and her stories as cover-ups. Only by bringing these hidden secrets out of their protecting enclosures can the magic circle of lies, denials, and silences covered by stories be broken. Only then will a language be shaped that can serve as a vehicle for genuine search and as a means to express unbearably painful memories.

In the son's reconstruction of his mother's life, the crucial episode giving rise to her disturbed personality occurs at the beginning of the Nazi regime. One day in February of 1933, when she is twenty years old, she is detained by Nazis and interrogated for a few hours. In a narrative in which words are the principal actors, it is perhaps not surprising that she is detained for having used a word insulting to the Nazis. (The word is *Mäckeser*, a Siegerland expression for those who don't belong, wandering peddlers; 59, 60–1, 65). The narrator surmises that the detention was meant as a warning to her father: the family is Catholic and part of a strongly anti-Nazi population. In the son's eyes, this day was "the beginning of a fear that lasted for decades" (36), that ate away at her self-confidence and self-esteem and burdened her increasingly fragile mental health. While she became more and more distraught and intimidated in the course of the twelve years of the Nazi regime, the death of her infant son at the end of the war, after the stillbirth of her first son in Berlin, was the final catastrophe that sent her for some time into autism. Here, the narrator also examines the psychological breakdown of those Germans who were socialized into obedience. While obedience may be rewarded with a sense of *Geborgenheit* if one agrees with the expectations of the dominant group, it creates severe trauma when those expectations are at odds with the individual's values.

Katharina's sudden and surprising decision to marry Henner, an early member of the Nazi Party, comes after he protects her brother's ordination ceremony from interruption by the Nazis. Henner is a farm boy, who finds the *völkische* (nationalistic) farm ideology of the Nazis congenial; he is a childhood friend of Katharina's, who has made good as an engineer and surveyor. In protecting her brother and standing up to his fellow Nazis, Henner appears in Katharina's eyes as someone in control and on her side. He is the "hedge" to ward off the evil powers of a regime

she does not understand and is afraid of. In marrying him, she thinks she can pit herself against the party by challenging Henner's beliefs with the full weight of her youthful confidence, the convictions of her astute observations, and her magical seductiveness. Again, the ambiguity of an existence enclosed within a protective "hedge" is all too clear. While she thinks she has found protection through her husband's affiliation with the Nazis, she cannot understand how he can accept and be part of a regime she abhors. If she could pry him away from the Nazis, magical reasoning suggests that all the Nazis would vanish. Their relationship becomes a duel, fought on the battlefield of words. Eventually, the son realizes that his mother's most personal battle was simultaneouly her most political act: "They had aligned themselves against each other; each of them tried to pull the other over, to take possession of the other in order to belong to the other" (157). In the end, mother and father, for all their divergent opinions and actions during the Hitler regime, share a need to be *geborgen/verborgen*. The mother is *geborgen/verborgen* behind her isolating "hedges"; the father is *geborgen/verborgen* in the Nazi Party and the mass movement of the Nazi regime.

The mother exemplifies the many Germans who did not speak out against the Hitler regime and who kept their silence in the postwar era. She embodies the efforts and the personal cost of attempting to question and, however timidly, defy the Nazi rule, even as one crouches behind the hedges of a *Geborgenheit* in a regime that one finds loathsome. As the son explores his mother's life and in the process confronts himself, he is on his way to accomplishing what lay beyond his mother's capacity, even beyond her imagination: only a breaking of the bonds of personal dependence allows maturing into individual and political adulthood. He inquires not only into the political events but into the intermeshing psychological and social structures that allowed the nefarious Nazi programs to prosper. Realizing the strength of these bonds, he is not just coming to terms with the past but warning of the need for constant vigilance in the future.

As the son deconstructs Katharina's history, he breaks the spell and penetrates the hedges of the stories she had built around herself and drawn him into. Nevertheless, his newly found adulthood is tenuous: he is not ready to confront his mother and her seductive, appropriating rituals. He departs from the house with the surrounding hedges an hour before she arrives back home, after he has set the house, the garden, the past, and his self-perceptions in order. As homage and farewell, he leaves his notes, dedicating them to his mother. The narrator's initial question, "But how do we put into words what we do not comprehend?" is answered when he concludes that he can relate only what he has come to

understand, and that is not the abstract enormity of truly incomprehensible crimes but the concrete life of his mother—a life in need of hedges, riddled with efforts to forget, pervaded by distress and a sense of shame. It is this life that significantly shaped her son's "biography of a post-fascist life in which fascism neverthless plays the formative and dominant role that must never be forgotten."

A Farewell to the War Veterans was published in 1992, three years after the fall of the Berlin wall and two years after German unification. The narrative time extends from early spring to September of 1989, when the Hungarian borders were opened and East Germans began to pass from Hungary through Austria into West Germany. The "Farewell" of the title is a farewell in several respects. It is a farewell to the father of the narrator, who has died and whose funeral is the opening scene of the novel; it is a farewell to that generation of Germans that contributed to and was implicated in the Nazi regime and World War II; and it is a farewell to the wall, the most visible sign of the division of Germany, which represented for many people a punishment for the Nazi regime.[10] To some extent, Ortheil still relies on the pattern of the "literature about fathers and mothers": he explores his father's life only after the father has died. However, the context in which this pattern operates is vastly different. After the death of the father, who is never personalized with a name, the son sinks into a deep mourning that "imitates" his father's death in a mythical journey (with strong allusions to Egyptian iconography) from which he will return at the end of the novel to a life of his own. In accordance with the father's profession as a surveyor, and as the son's homage to the father who had initiated him into ways of looking at landscapes and countrysides, the journey is laid out on an East-West axis. The East-West axis stresses the father's part of the journey during World War II, which was eastward, across the River Elbe to Berlin, Cracow, and Katowice. After the war, this East becomes a forbidden region for him, politically as well as personally, never again to be entered, and the events associated with it are to be "forgotten" or denied. After the war, and until his death, the father travels only in westerly directions. The West symbolizes for him continuity with pre-Nazi life, to be reached by a leap across the abyss of the Nazi past.

The son accepts a friend's invitation to visit him in St. Louis, "gateway to the West," on the borders of the Mississippi, "father of all waters," and from there proceeds farther, without a planned itinerary, guided by accident and intuition. Since the journey is also a journey of self-exploration and an exploration of what it takes to become a writer, in which the powers of imagination guide (or misguide) him, there are

also many literary and cultural references. From St. Louis he takes a trip to Mark Twain's Hannibal, and in a "journey into the interior" he is emulating the explorers Lewis and Clark. The friend in St. Louis has an eight-year-old daughter; the son unconsciously reenacts his father's role by taking her on trips, ultimately on a steamboat down the Mississippi to New Orleans. (In mythical terms, this is the journey across the river Styx into the realm of the dead.) When he recognizes that imitation of his father is the driving motive of his trip (and spurred by the child's preadolescent theatrics), he sends this little guide to the netherworld back to her father. New Orleans, surrounded by the waters of the labyrinthian bayous, becomes Hell, the country of erasures and forgetting. He slowly falls into a state of drunken stupor, weaving in and out of hallucinations, battling his memories of his father and any emerging insights into his own state of mind. Fragments from Faulkner's *Light in August* guide him on this part of the journey, while his own writing degenerates into hieroglyphic scribbles. In this twilight zone between myth and reality, only jazz provides moments of lucidity, and a jazz musician suggests that he go to Santo Domingo, in the Caribbean, which he does. He makes his way to a mountain hamlet, where he settles briefly and begins to write. References to the island of the dead abound, enhanced by the geography of Hispaniola. In an echo of the scene in Thomas Mann's *The Magic Mountain* in which Hans Castorp has a mystic experience in a mountain snowstorm, he reaches an epiphanic moment of profound and existential disorientation during a tropical rainstorm. When he leaves the hamlet, symbol of "nothingness," his inner journey has left its marks on his appearance. Customs officers do not want to accept his passport as valid, since he no longer resembles the person in the photograph. He is extremely thin and his skin is leathery, dark, yet transparent. He has been to the realm of the dead and has taken on the look of an Egyptian mummy, or of his dead father. On this journey of accidental yet significant encounters, he then meets up with a former acquaintance, an Austrian woman, and they travel to Key West, westernmost point of the Floridian keys and home of "Papa" Hemingway. In a dreamlike night scene, complete with a ritual bath of purgation in Hemingway's swimming pool, he bids farewell to his literary father figure, author of the Nick Adams father-son stories. Reluctant to return to West Germany, he accepts the invitation of his traveling companion to go back to Vienna with her, and he arrives just as many East Germans, eager to leave for the West, have overrun the West German Embassy in Prague asking for asylum.

The cultural reference points of this part of the *Bildungsreise* (journey of education) are no longer American authors, with their focus on the in-

timate and the personal, but Pieter Brueghel's paintings of the months, which attract the narrator "magically" with the stories inherent in their peopled landscapes: he sees his father's life and his own expressed in them. In an attempt to help some East Germans in Vienna locate their friends sequestered in the embassy, the narrator journeys to Prague and in the process breaks the eastward injunction, the father's old taboo. The East Germans' movement toward political liberation coincides with the narrator's self-liberation from the oppressive parental bonds, and the liberating westward move of the East Germans is matched in the narrator's liberating eastward journey. In a dreamlike vision, he carries his father and four brothers, who died as infants during and after the war,[11] on his back, in the manner of St. Christopher, in an easterly direction, past the River Elbe, past Berlin, past scenes of war and devastation, to a burial mound in the flat, eastern country, where he buries them.

This detailed description of the journey with its way stations would be extrinsic to our discussion were it not that it offers a unique example of an enactment of mourning. In this novel, written nearly fifty years after the end of World War II and the Holocaust, the "inability to mourn" has given way to a kind of mourning. In distinction to other novels about fathers and mothers, which are infused with polarized emotions that impede insight and growth, *A Farewell to the War Veterans* performs the long ritual of genuine mourning for the father with all the painful steps necessary to arrive at an eventual release. This maturing process parallels the political events: the son's nonviolent confrontations with his father reflects East Germany's "Velvet Revolution," which led (at the very time the novel was being written) to hope for freedom and a mature political future. In the process of mourning and its conclusion, the novel brings to a closure the postwar period marked by the Nazi legacy. While the narrator is wary of returning to what at the end of the novel is still West Germany, he has nevertheless been able to break the taboo of a unilateral direction of avoidance and repression; he closes a circle in which the easterly direction has been decontaminated. It is important in an interpretation of the novel that this circle (and the many references to circular movements throughout) is not an enclosure that imprisons but a symbol of the completion of a journey that through its completion sets the protagonist free.

On this journey of self-discovery, the narrator must also explore his father's role and activities during the Nazi regime. The progress of the journey implies progress in understanding and accepting aspects of the father heretofore inaccessible. Epiphanies lead, if not to clear answers, then at least to the son's recognition that there were secrets. One such recollection hinges on the word "despair." Lost on the Caribbean moun-

tain in the tropical storm, the narrator succumbs "to despair" and in a flash of memory recalls being lost as a ten-year-old with his father on a hiking trip. Totally disoriented, the father, too, succumbed "to despair" and out of this high anxiety told his son of a similar situation during the war on the Eastern front, when, as punishment for some small infraction, he had to lead a troop on a night reconnaissance and was almost discovered by the Russians (282–4). To the son's consternation, the father, overcome by his memory, cried. From that moment on, the son realized that the father had "secrets" rooted in "that other time" and that because of this discovery their relation was irretrievably changed.

> In truth, this scene had been the beginning of my collusion with him; this scene had changed the image of my father for me, because, since this scene, my father not only represented comfort and familiarity but also something alien, and this alien quality had its roots in that other time. This discovery appeared to me like the discovery of a secret knowledge; from then on I considered the other time, the time of the past, as a time of secrets. Fortunately for me, I had come to know one such secret—in fact, I had thought, This is the first secret, but there will be many more, and I will have to discover them all (285).

The sense of hidden secrets echoes scenes from Ortheil's previous novels in their *geborgen/verborgen* dialectic. In this example, the "secret" is hidden in an apparent contradiction. When the father tells his son of the reconnaissance, he evokes primarily sounds, since presumably hearing is the dominant sense in the dark of night. He hears "Russian voices" nearby, thinks they have been discovered, and "with closed eyes" waits for the impact of the grenade, but then there is only silence, "unbearable silence" (283/4). The narrator then concludes: "This experience, father said, had kept him preoccupied for a long time, he was not able to rid himself of the nocturnal images [*Bilder*] for a long time, no, he had never been able to rid himself of them, not to this day" (284). But what images are these, if he has supposedly only heard intermittent sounds and silences but not seen anything, since his eyes were closed? The father's account contains a secret—he keeps silent on what he saw. It must have been something so shocking and so horrible that many years later, unguarded, he had to cry. Like Katharina's stories in *Hedges,* the father's story of the night reconnaissance covers an underlying secret that nevertheless reveals its presence; the story's function is to hide what he saw, and the act of hiding leaves its traces. The silence, covered up by the words of the story, speaks, although it speaks as the absence of what the father saw.

The realization of the ten-year-old that he "will have to discover them all" is no match for the power of repression in the older genera-

tion, and for their evasions and denials when the young ask questions. This becomes evident to the son as he grows older. In *Hedges*, Henner had been a surveyor for the railroads. In *A Farewell to the War Veterans*, the father has been promoted to *Reichsbahnrat* (a civil servant in the higher echelons of the German railway system) (100) and in the early months of the war has been sent to Katowice to lay railroads for "military transports" (100). His wife, left in Berlin and traumatized after the stillbirth of her first son, visits him there, since he is no longer granted extended weekend furloughs, and they go hiking in the Beskid mountains, south of the "Silesian" Katowice, and in the High Tatra (103). The father also visits, on several occasions, nearby Cracow, which he likes better than any other city in the region. Not mentioned is the fact that Auschwitz lies between Katowice and Cracow, at one point of a small triangle, about 20 miles from Katowice and not 40 from Cracow so that the father was in the immediate vicinity of the death camp and had to pass it on the way from Katowice to Cracow. As if to focus on a relatively less horrific aspect of the Holocaust, the text mentions the ravages of Cracow: "In Cracow . . . there had lived many Jews, and after the invasion of Poland by the German army, SS units had soon thereafter begun to expel the Jews from their apartments in the city and in the old Jewish quarter. The old synagogue was burned to the ground." (104). Yet this passage is curiously vague. "Many Jews" does not suggest as large a number as the 60,000 Jews who lived there; expelling them from their apartments leaves unstated the horror of deportation, ghettoization, and eventual annihilation;[12] singling out "the old synagogue [. . .] burned to the ground" suggests that this was the only act of vandalism; and the activities of the army (invasion of Poland) and the SS (expulsion of the Jews) were strictly separated—a separation that did not seem to hold when they shared living quarters as he states elsewhere. There is furthermore in this passage an absence of a clear narrative perspective: one cannot be sure who recounts this passage. Is the son paraphrasing the father or does he provide his own information? It appears that the son wants this information to be known but does not want to implicate his father, and he accepts his father's denial without commenting on its ambivalent nature when he states: "For my father it had always been a fact that he was not implicated in the persecution of the Jews, he had maintained that he could not remember ever having encountered Jews during the war years" (108). The smudgings and silences of this sentence involve the son as much as the father, since the son repeats uncritically what the father has presumably told him. Clearly, "not implicated in the persecution of the Jews" leaves much room for tacit knowledge of the atrocities, and maintaining "that he could not remember ever having en-

countered Jews" can be read as a statement of repression on the father's part (for "not remembering" leaves the door wide open for any number of "unremembered" encounters),[13] as a sophistic hiding behind the word "encountered" (if he had not actually "encountered" Jews, he may nevertheless have heard about their fate), or simultaneously as a thoughtless admission of their ghettoization and annihilation (since indeed, once ghettoized, they could no longer be openly "encountered"). Alert to his father's "secrets," the son reads his father's increasingly frequent daydreaming and brooding as signs of a repressed memory and of continual attempts to reconfigure the past.

The ambivalence of narrative perspective persists in key passages and invites several possible interpretations; it suggests the son's conflicts as much as the father's exculpatory stance. "My father cursed the war and all that the war wrought among people, nothing but death and despair. Yet once again, my father had to depart for the East, had to live in Katowice, while my mother had to start anew in Berlin . . ." (102). Is the son here repeating what the father had told him, does he believe him and show his empathy with him, or do we read the son's desire not to accuse his father as demonstration of filial attachment and the difficulties of freeing himself from these bonds? The passive obedience, shirking of responsibility, and touches of self-pity in this passage are familiar from earlier texts. Here again, language operates with silences. Why does he not say why it is so unpleasant to live in Katowice, as the phrase "he had to live in Katowice" implies? The ambivalent narrative perspective does not exonerate the father so much as show him as careful, even afraid. Cursing "the war"—an abstract concept impervious to curses—had already indicated this fear, which is personalized when he does not speak in front of an SS man with whom he shares quarters but simply changes his living arrangements (102). How does the son know this? Surely the father must have told him about the incident, but from whose point of view is it narrated?

As so many members of the successor generation before him, the narrator eventually realizes that there will be no answers and that in any case they would have to be given freely in order to be valid.

> I had wanted to coerce my father to comment on the persecution of the Jews, but the more I insisted, the more he withdrew. I realized myself that this court trial taking place between us stood on shifting grounds and the only correct thing would have been for my father—even without my questions, of his own free will—to speak about the time in Katowice and the region around Katowice (106).

In all these "novels about fathers and mothers," the children, whether respectful or resentful, loving or hating, confront their parents

in order to be informed—and to judge; but they never demand that the parents, out of love and respect for their children, conquer their shame, admit their lies and denials, and speak about their own failures and worse. By remaining frozen in their denials, the parents show a self-love greater than their love for their children. This withholding in turn vindicates the children's harshness.

In the end, Ortheil's narrator arrives at a rather speculative conclusion about his father; the conclusion reflects his frustration over how little information he has gleaned, and it shows that "the fate of the Jews" is at the core of the father-son confrontation. "My father—I never found out whether due to ignorance, lethargy, or fear, not even this I found out—was not concerned about the fate of the Jews, and it is precisely this, this lack of concern or position, that I reproached him with" (108). Yet despite the narrator's unambiguous acknowledgment of the Holocaust and his explicit desire to have his father speak about it, he himself betrays a certain unease that shows in circumlocutions. When one analyzes the narrator's account of his father's evasive answers in relation to Auschwitz, one sees that the father's evasions have spawned an equally evasive language in the son. He says:

> But it was totally impossible not to have heard about these pogroms and the expulsion of the Jews, I was never able to understand that such ignorance was possible, and above all I could not imagine that nobody knew about the camp at Auschwitz, which was midway between Katowice and Cracow. . . . How often had I asked my father about the camp Auschwitz, near Katowice, near Cracow, and how often had we started to argue over his answers! For my father gave different answers every time; one time that he knew nothing about Auschwitz, then that Auschwitz was a work camp like other work camps. But these answers my father gave only after I had pressured him vehemently, and most of the time he then fell into a kind of silent, defiant absence which was often taken for dreaming (104–5).

Despite his ardent desire to find out the truth, the son observes linguistic taboos, thereby signaling an impeded access to the very truth he is trying to uncover. He speaks of "pogroms" and "the expulsion of the Jews," which suggest a different historical context: "pogroms" were not systematic genocide and the Jews were not "expelled" but murdered. Focusing on the expulsion of the Jews from Cracow avoids confronting their annihilation in nearby Auschwitz. The phrase "the expulsion of the Jews" is a euphemism that camouflages the full horrors of the Holocaust. He also seeks to defuse the horror that imbues the word "Auschwitz" when he refers to it merely as a "camp," not as the extermination camp

it was. And he never asks his father, or even wonders to himself, whether or not his father helped to construct the very railroads that carried human beings to their unconscionable death.

Nevertheless, in yet one more aspect, Ortheil goes beyond other authors of "literature about fathers and mothers" when he shows the narrator's own efforts to come to terms with this past.

> In bad moments it appeared to me as if human history, with these persecutions, had come to its end. After these persecutions and murders I often thought of a new beginning not only as a big lie but also as something impossible. I could not even understand how one could once more gather enough courage and start from scratch, in the realization that something like this had once happened. In bad moments I believed that the history of this country, in which I was born after the war, was once and forever done with, while on the other hand my birth was a visible indication that history continued. I myself could not possibly day after day and week after week live with the thought that history had come to an end, however, neither could I liberate myself from this history by pretending that nothing of importance had happened (107).

The narrator's suggestion that "these persecutions" indicate the end of history resembles Dan Diner's dictum of the Holocaust as a "break in civilization." But by 1992, when the novel was published, thoughts about continuity had begun to surface everywhere. Ortheil couches his proposition in practical considerations that ensure a pained, polarized continuity. Post-Holocaust history is marked by the events of the Holocaust, just as, on the personal level, the narrator's "post-fascist life" is marked by how his parents coped with "fascism." Affirming the continuity of history means, for Ortheil and his narrator, not historicizing the Holocaust by allowing it to recede into the past but acknowledging the crimes committed and recognizing their legacy as an ongoing, unsettling continuity.

Through his protagonist's labor of mourning, Ortheil raises another significant question. The Mitscherlichs had posited that the Germans' "inability to mourn" related to the perpetrators as much as to the victims. Is the successor generation, as exemplified in Ortheil, beginning to work its way toward an "ability to mourn?" If the completed mourning process for the father promises closure and the possibility of moving on, what bearing does this completion have on a mourning for the victims? Ortheil has made an important step in mourning his father (and in him the members of the perpetrator generation), but this mourning is still an intrafamilial affair. For the son, as for the father, "the Jews" remains an abstract concept, although they arrive at opposite positions in relation to it: the father's position is that of denial, the son's that of acknowledgment.

The collective term points to an indistinguishable mass of people and thus avoids the painful recognition of Jews as individuals. As long as "the Jews" remains an object of intra-German discourse that excludes Jews as sentient human beings and does not see them as individual victims of the perpetrators' deeds, the labor of mourning does not extend to them.

Ortheil's narrator had the courage to engage in the full and painful labor of mourning in relation to his father, and through a personal journey of growth has laid to rest his need, as a member of the successor generation, to hear the parental confession. This closure does not extend to the Holocaust, which he recognizes as an irrevocable rupture, with continued impact in the present. But where sorrow over the crimes committed and mourning for the victims who suffered them should be voiced, there still reigns silence.

The War on the Eastern Front

Hermann Lenz

> The convenient working distinction between cultural texts that are social and political and those that are not becomes something worse than error. . . . There is nothing that is not social and historical—indeed . . . everything is "in the last analysis" political.[1]

> But then the question is, of course, are we dealing with the past or with its memory?[2]

Born in Stuttgart in 1913, Hermann Lenz was twenty years old when Hitler came to power, and he was in the preferred age group for enlistment when preparations for World War II started. In 1938, he went through military training. He was called to active duty in the spring of 1940 and participated in the invasion and occupation of France. In late October of 1941, in the wake of the German invasion of Russia, he was shipped to the Eastern front. Here, he was part of the military units laying siege to Leningrad and served in the trench warfare in the Volchov swamps. Retreating with the German army along the Baltic coast, he spent the last few months of the war fighting the American invasion in the Mosel region, where he was taken prisoner and sent to a POW camp in the United States. In the winter of 1946, he returned to Stuttgart, his native city.

The novel in which he writes about his participation in the war he called, with a tinge of irony and much critical acumen, *New Times (Neue Zeit)*. Apart from flashbacks, the novel spans roughly the decade from 1937 to 1946, covering the last two years before the outbreak of the war, when the protagonist, a student at the University of Munich, meets

Hanni Treutlein, a fellow student who is, after the war, to become his wife. It chronicles his time as a soldier on the Eastern front and ends with the protagonist's return from a POW camp in the USA. The novel was published in 1975, thirty years after the war's end, and is the third volume in a series of nine autobiographical novels that Lenz began to publish in 1966. They cover his entire life, even tracing his ancestry back to the great-grandparental generation, and have slowly caught up with his present: the last novel to date, *Friends*, was published in 1997 and relates the most recent events his life.[3]

After Lenz returned from World War II, he refused to integrate into the oblivion- and success-driven postwar society. He held minor positions as the secretary of a cultural society and of a writers' association and directed all his attention to meticulously keeping a diary, as he had at the front, and on "inventing stories" which he published. As exemplified in his fictional alter ego, Eugen Rapp, writing had always been for him not just a *Flucht* but a *Zuflucht*, not only a flight from the present but a refuge in a counterworld where he could concentrate on the experiences essential to him alone. His fictional world was far from idyllic, but it did explore retreats into the past—mostly to the Biedermeier period or turn-of-the-century Vienna—or created surrealistic alternatives. In the society of the economic miracle, his "invented stories" did not meet with great acclaim, although he found a small circle of constant readers. By the early 1960s, around his fiftieth birthday, he had arrived at a literary form that allowed him to merge the two activities that had consumed his life: the "invented stories" and the diaries fused into the autobiographical novels.[4] The insight that his own life was the material out of which to create his fiction has been compared to the Proustian *Recherche*, as indeed other similarities with Proust have been identified.[5] Although there are no major epiphanies to parallel the famous madeleine episode in *Remembrance of Things Past*, Lenz's novels are a string of minor epiphanic moments of *temps retrouvés*—instances of time recovered from oblivion. In Lenz's case, memory may be helped by the diaries, but memory goes beyond re-recording these notes to highlight scenes, to expose gaps of forgetfulness, and to provide a context for what was experienced. The novels, and in particular *New Times*, are as much about the workings of memory and what is forgotten as they are about specific events.

Over the last three decades, concurrent with the autobiographical novels, Lenz has continued to "invent stories," and he published a major trilogy, *The Inner Realm*, on the Nazi period.[6] In it, some of the principal figures of the autobiographical novels (Eugen Rapp, Hanni Treutlein) appear as peripheral characters, just as the central character of *The Inner*

Realm (Margot von Sy) has, under a different name, a few scenes in *New Times*. The trilogy is an expansive exploration of various modes of behavior within Germany, while *New Times* focuses primarily on the war front. Together, they document Lenz's ongoing and deep need to work through the Nazi period from diverse angles.

The first autobiographical novels, published during the turbulent and politically active late 1960s, did not find a wide audience. This early lack of interest in Lenz's work has been imputed to his rigorously subjective style and to thematics that were not in touch with the prevalent literary trends. But in late 1973, Peter Handke, the widely recognized Austrian writer and representative of the postwar generation, "discovered" Lenz, who was then sixty years old, and published an appreciative essay that catapulted Lenz to recognition and prominence.[7] Yet it would appear that this recognition was not uniquely due to Handke; or rather, one could say that Handke "discovered" Lenz at the appropriate moment, when the intellectual climate had shifted from leftist political and literary activism to the introspective scrutinies of the New Subjectivity. Hermann Lenz had always resided in "the inner realm," so one might say that his time had finally come.

His novels gained wider recognition at the same time as the wave of autobiographical novels gathered momentum. Yet Lenz's novels are more radical in their subjectivism and introspection than those of the younger generation. His self-exploration is motivated by a different impulse: an examination of his own experiential faculties, not a search for a social and personal identity in the face of a problematic national identity. It is a philosophical and existential search under the guiding hand of Marcus Aurelius, Epicurus, and the Stoics, and from the beginning marked by what the literary scholar Hans Dieter Schäfer has identified as "the crisis philosophy of existentialism . . . before the outbreak of World War II."[8]

Lenz's autobiographical novels, like most postwar literature, are a hybrid literary form. He uses the "documentary" material of his diaries (with the diaries themselves constituting a highly subjective creation of "documents") and transmutes this material into a narrative. The novels chart his life story, but they are also the repository of his observations and reflections. In all of them, the near congruence between fiction and "reality" is most striking and, as with other literary hybrids, gives rise to a renewed inquiry into the boundaries of literary discourse, in this instance between autobiography and autobiographical fiction. While the material out of which Lenz fashions his novels is clearly autobiographical, the literary techniques and perspectives transcend autobiographical writing. The third-person-singular narrative stance, which is meant to create a distance between author and protagonist, and the protagonist's

name—Eugen Rapp—are the first and most obvious indications that this is not autobiography. Lenz has been viewed as a literary "modernist"—that is, as imprinted with Hugo von Hofmannsthal's skepticism about the viability of language, and, in the words of the scholar Birgit Graafen, as situated "in the vicinity of those authors who at the turn of the century gave voice to the crisis of realistic narration by turning to the subject of perception."[9] The split of narrative consciousness into dialoguing voices; the displacement of events as if seen through the wrong end of a telescope and, alternatively, the magnification of certain moments into epiphanies of exquisite simplicity or shocking horror; and the tensions created between subjective experience, intense remembrance, and a distanced, becalmed narrative all suggest the deliberations of a literary practitioner. In particular, the reconstruction of time lost, the documentation of the way memory works, the demonstraton of its fallibility in gaps and omissions and in the speeding up and slowing down of the narrative flow confirm these writings as fiction. All this is particularly evident in *New Times*, which is thus not merely an autobiography or even a "war novel" but a literary work as self-reflective as it is intent on recapturing the moments and the flavors of past experience.

Lenz's radical subjectivism and absentmindedness in relation to the stream of daily life marked him from his youth as an "outsider" or a "loner." Yet this withdrawal into himself does not seem to have had external causes, such as the impatience of his father or the brutal beatings administered by an elementary school teacher.[10] Quite the reverse: these rough dealings were more likely provoked by Lenz's manifest disinterest in the world around him. In her study on Lenz, Graafen suggests that this "absentmindedness" was an integral part of his personality: "Especially striking is the absentmindedness of the young boy, which is accepted by the grandmother as part of his personality—'these absences were part of him'—but met with incomprehension on the part of teachers and parents."[11] Graafen traces this absentmindedness back to Lenz's maternal grandfather, noting that "in the portrayal of the grandfather, an intra-familial tradition of sensitivity is laid down that contrasts the inner agreement of grandfather and grandson with the father figure, who is experienced as alien." One wonders whether Lenz is not also heir to secular vestiges of a Swabian pietism that was a pervasive spiritual attitude several generations before him.[12] His inner-directedness, his rejection of intellectualism, his taste for experiential immediacy, his intense focus on indifferent, quotidian objects or events, and his slightly defensive (and rather mannered) overemphasizing of a humble, petit-bourgeois background that attaches great value to formal education (*Bildung*) would all corroborate this point.[13] Clearly, Lenz's apathy toward politi-

cal engagement and his noninvolvement in current political debates, combined with his flight into literature, characterize him as one of the disastrously many "unpolitical Germans" who date back to the mid-19th century. One important aspect of Lenz's oeuvre is his effort to find a voice for the unmitigated confrontation with the self as it seeks to account for this passivity. He acknowledges it and suffers its consequences without being able to shed it. In this respect, the "political" novels, above all *New Times*, bear in their scrupulous honesty the marks of a confession. No other postwar author has scrutinized this passivity as unremittingly as Lenz. His alter ego, Eugen Rapp, is aware that, as the historian Fritz Stern has remarked, "to pretend to be unpolitical at a time of violent social change and unrest is in itself a support of the existing order."[14] Yet he does not find it in himself to act.

Just as the double focus of the invented stories and the diaries fuses in the autobiographical novels, there is a fusion, in Lenz's creative repertoire, of an introspective withdrawal into a self-created world on the one hand and sharp and penetrating observations of the surrounding world on the other. These are in fact the distinguishing characteristics of Lenz's artistic universe. Eugen Rapp sees the process of intense observation as a means of gaining an inner clarity, but it is also necessary to the artist's mission as he conceives it: "To see everything, to hear everything, to feel everything, to smell everything that shows itself to you, here. Let it penetrate you, participate in it, then it will become clear to you."[15]

Hitler's coming to power in January 1933 roughly coincided with young Lenz's starting his university studies. His desire to withdraw from mundane contacts, the resultant sense of isolation, and the anxieties and unease connected with being in the world and exposed to its demands, all were exacerbated by the pull of political developments. How did an introvert who preferred the *vita contemplativa* to the *vita activa*, an "unpolitical German," respond to times in which the majority of the population (including his own father) was caught up in a euphoric optimism and had no patience for those who foresaw catastrophe? Passivity, even passive resistance, and a sense of fatalism were not uncommon among Germans during the Third Reich, and Lenz depicts Eugen Rapp this way—as an intelligent (though not intellectual) observant individual who cannot abandon his protective shell in order to take a stand. Eugen Rapp does not represent the "good German" of the so-called "inner emigration" who did not dare speak out. He is not the retroactive voice for those who were too intimidated or paralyzed and who now might think they had found an apologist. He is too much of an individualist and a loner—someone whose thoughts and observations are uniquely his own and who is recognized by his peers as someone apart.

But Lenz gives voice to what was for a long time committed to silence. (In the trilogy *The Inner Realm*, Lenz's protagonist, the diplomat von Sy, is for a while actively engaged: he participates in a conspiracy against Hitler. But when these plans fizzle, von Sy is relieved.) The political events may have provided Lenz with a good reason to be an outsider and to reject any worldly ambition, but his predilections antedated the Nazi regime and continued after its collapse.

Lenz's subjectivity, his passivity vis-à-vis current events, and, in many of his literary works, the withdrawal into the Habsburg past have all gained him a reputation as a conservative writer. Lenz's conservatism is characterized by an orientation toward a past that is not so much idealized as marked by a stability and order clearly missing in the present. The past is not blindly and unhistorically glorified but seen as a refuge from the present, or rather as a refuge that makes the present bearable. At the front, Eugen Rapp seeks refuge not just in writing, but in writing about Habsburg Vienna, "because you keep tumbling and thinking of the old Vienna, and taking refuge in past times. Good, because otherwise you could not bear it. . . . You could not bear the new times without the old ones" (177). Eugen is fully aware of the disparity between his surroundings—the detritus of a battlefield—and his writing: "A machine gun salvo blasted into a human head, the human head lay next to his feet, he saw it from above and very close; and yet, a little while later he wrote verses in which there was only brightness and light" (196). *New Times* fell short of the demands of those critics who expected from the novel open criticism and penetrating analysis of the war and the Nazi regime and the profession of newly found political commitments. Lenz's registration, without editorial comment, of his hero's intense daily experiences, including the boredom of continual trench warfare, suggested a passive acquiescence to events. However, if one reads *New Times* as a testimony and as a confession culminating in the remark "but he was guilty anyway, and as a soldier you are guilty of Hitler" (381), then the entire account is not just a document of what happened but also the confession of an "unpolitical German" who could not find it in him to act otherwise. In its apolitical and nonanalytical stance, *New Times* is a political statement precisely because it eschews politics.

Lenz must have been aware of this general criticism of his work, because he thematized it in a brief scene in the novel. During the retreat through Poland, Eugen is asked one evening by a young officer and his wife to read from his work-in-progress, a novel.

And he read from the experiences of a young man in the Vienna of the turn of the century, which had vanished, had disappeared into nothing,

and he noticed that what he read seemed to the two others weird, strange, or curious. . . . And again he read his descriptions of feelings, light reflections, which she must have disliked, which must have annoyed her (it was in the air) (343).

The officer's wife then voices the position of many Lenz critics when they find fault with Lenz's withdrawal into his self-created world: knowing that Eugen Rapp comes from Stuttgart, she refers to the heavy Allied bombardment of that city and demands directness instead of evasion: "Today, someone ought to describe *that*. Just the way it is" (343). The description of "*that*" is, of course, exactly what Eugen covers with silence. For those who demand a description of "*that*" in all its horrifying aspects, Lenz will fall short, for he is not a chronicler of events but a chronicler of how the events affect the individual. His chief concern is to harness memory to show what eludes memory or is repressed for reasons submerged in silence. Memory is acknowledged as selective and subjective, but it also speaks in what it omits or is silent about.

Lenz's conservatism is never driven by aesthetic considerations, as is the case, for example, with the writer Ernst Jünger.[16] Lenz cannot wax ecstatic over the glow of battlefields or the heroic posture of various German elite. His aesthetic sensitivities are shaped by ruptures and fissures, by abysses exploding continuity into fragments, by splits in time and consciousness, by black holes that swallow up the most crucial of events. His narrative techniques reflect both the exploded continuities and the desire to calm these nightmares. Peter Handke has commented on Lenz's unfinished sentences and on *New Times* in general as "contorted, magnified in details, with gaps in time, alogical juxtapositions of changing human faces, of living and dead ones [which] he DREAMS once more in front of us and for us. . . . In the middle of sentences time switches, locales change, faces are transmuted, a glance disappears in favor of a memory, the memory vanishes at a threatening noise, the noise is pushed aside for absorption in a photograph."[17] In the discontinuities, shatterings, and fragmentations, and the techniques used to express them, and in the careful registration of memory and its elisions, Lenz is in fact an author with post-Holocaust sensitivities. He knows that he cannot describe "*that*. Just the way it is" and continually alerts the reader that his (and his protagonist's) position is one of subjectivity. The gaps and holes in Lenz's "subject-position"[18] are not denials or circumventions; his text "performs" the silences and in this performance reveals the traumas that cannot break through the wall of silence. *New Times* feeds on the tension between the recovery of burdening memory, punctuated by the black holes of silence, and the "invention" of dreams

and stories as palliatives. Lenz tries to manage the traumas and night-
mares of the unbearable present of *New Times* by invoking, mantra-like
and in soothing repetition, certain key phrases, such as "act as if nothing
were happening" (151, 146, 161, 216); "duck down" (34); "make yourself
small" (257, 297, 301); "cut yourself off" (201); "push it away" (337); "be-
cause you are not being asked" (78); "because you cannot stop it" (238).

Eugen Rapp's passivity and sense of powerlessness as the decrees of
the Nazi regime took their course is not meant as an appeal to the
reader's sympathy, much less a suggestion of collusion or a plea for exon-
eration. Rather, the novel presents a constant challenge, urging the
reader to ask the very questions that the protagonist has already an-
swered with his (passive) behavior. What, except passive resistance, was
possible under Nazism for someone already marked by withdrawal from
the world into an inner-directed counterreality? This challenge is all the
more pointed when one compares *New Times* with, for example, a war
novel of Heinrich Böll's, such as *And Where Were You, Adam?* In Böll's
novel, the third-person-singular narrative perspective is presumably
"objective" in its presentations, although tinged with sympathy for the
travails of the "little guy," the common soldier. As the reader is drawn
into the story and invited to identify with the protagonist, the elitist in-
equities within the *Wehrmacht* are critically presented and the insanity
of the war is clearly addressed. Nevertheless, this criticism crowds out
the larger context: the very cause of the war—namely, Nazism—and
the role of the individual and of the military in implementing it and in
protecting the implementation of Nazi genocide. Despite its critical
stance, Böll's novel is no less fatalistic than Lenz's. In contrast to *And
Where Were You, Adam?* the third person singular in *New Times* does
not offer an "objective" presentation of the war or attempt to elicit the
reader's sympathy; instead, it presents the protagonist in interaction
with his surroundings. The reader sees only what the protagonist regis-
ters. This nonomniscient third-person perspective constantly prompts
the reader to supplement the information offered, and in so doing to in-
terpret the protagonist and draw conclusions about the significance of
the scene described, about the blind spots glaring in the text, about the
protagonist's condition at the moment he registers the event.

Lenz's third-person-singular perspective is moreover constantly broken
by a dialoguing second-person-singular "you." This break in narrative per-
spective affirms the subjective mode of the protagonist's exclusive and
limited perspective. He offers not a complete portrait of the war, much
less an authoritative one, but one individual's way of coping—with
other alternatives possible and suggested in the portrayal of other char-
acters. Eugen Rapp's consciousness splits in two, so that he can in effect

talk to himself at moments when he needs the reassurance of a steadying "other" or an other with whom the horror of the situation can be shared. At such times, he steps outside of himself, so to speak, and watches himself from a distance. After a brutal battle, he muses not on the events of the battle but on his manner of coping: "You cannot stop anything, but you can watch yourself and observe how you behave in whatever is coming at you" (238).

Another striking idiosyncracy in Lenz's artistic vision is the extraordinary attention given to details. In these chiaroscuro presentations, fragments and moments are briefly illuminated and submerge again quickly into a sea of darkness and silence, so that no scene is completely executed. The details, fragments, images, moments on which Eugen Rapp fastens his attention become focal points for what is not stated at all. Eugen does not articulate what he thinks or feels, nor does he comment on what he experiences. Instead, his responses can be "read" from the (diversionary) attention he directs to details and moments at hand, and he speaks of these moments self-reflectively as the quintessence of life. "All kinds of moments: Only out of those, then, grew a composition; accumulated, sedimented, gathered. . . . And what will you know about it in thirty years? Hopefully everything down to the last detail. . . . Because such details sharpened the sentiments; and it was those that mattered to him" (41).

Attention to details also contributes to losing the larger overview. Here, Lenz's techniques, like Böll's, express the short-range goals of surviving in war, the moment-to-moment existence that does not demand, and does not allow for, longer vistas. But in Lenz, the focus on existence is experienced as a series of illuminated, epiphanic mini-explosions that highlight moments but lack context, so that their sequence becomes irrelevant. Time as an ordered, logical sequence directed toward some goal ceases to exist. This perception works extremely well in the novel, because once Eugen Rapp is settled in the swamps around Leningrad, time indeed no longer exists, even though the seasons roll by. Time is reduced to discrete events in space. In this narrative universe, the use of sequential time designations such as "and then," "later," and the like does not indicate the orderly passage of time from one event to the next but simply the closure of one scene and the introduction of another. The time designations "and then," "and later" rather obliterate orderly sequence, since they can mean anything: they can imply jumps of time ranging from hours to days or weeks. Far from providing continuity, they highlight the disorienting gaps, the destruction of continuity. The reader (if so inclined) must reconstruct chronological time either by noting the passing of the seasons or by comparing the narrative with historical timetables.[19]

The focus on details serves two seemingly contradictory psychologi-
cal functions: focusing on a detail prevents one from contemplating the
larger scene, while simultaneously registering it instead of repressing or
"forgetting" it altogether. An example may help to illustrate this point:
one of Eugen Rapp's acquaintances has been killed by the explosion of
his own grenade thrower (189); Eugen is so affected by this death that he
cannot go to the funeral, but he is told that after the man is buried in a
swamp, his boots keep rising to the surface of the swamp (190). This
image of the boots rising out of the swamp focuses Eugen's mourning.

A recurring theme throughout the novel is that Eugen does not hear,
does not see, does not know what is going on even as he participates in
events. At one point he is nearly run over by a German tank because he
does not hear and does not see it, caught in his absentmindedness (240).
At another point, after the unit has engaged in battle to secure its re-
treat, he hears the men talking about what happened. He asks one of
them: "How do you know all that?" and the man answers: "For crying
out loud, didn't you notice? You were in it, too!" Eugen ends by musing:
"And again it seemed strange to him that everyone who became in-
volved in something like this saw and experienced something different"
(294). Yet the reason for this absentmindedness at moments that would
appear to call for the highest concentration is the same that induces him
to focus on details: it is an attempt to block out the horror of the larger
scene, to cope with trauma. Absentmindedness constitutes a protective
shell. The ubiquitous use of verbs like *gliding, sliding, tumbling,* and
stumbling to describe how Eugen goes through the war enhances this
picture of him as a dreamer and a sleepwalker. His wonderment that
"everyone . . . saw and experienced something different" relativizes and
limits the war experiences to what he alone went through, and he makes
a point of stressing that this is all he can say. The following passage is a
good example.

Again they came to another village, and there was still a farm woman in
one house. When Eugen remained alone with her in the sunlit room,
she said: "You go away and . . . set fire to the joint." She laughed and
swept an arc in the air with one arm. Eugen looked at the floor and
shook his head. So now the Russians already knew of the "scorched
earth" command. You haven't seen any signs of it yet, but you just wait.
 The woman brought him a cup of milk that had specks of cream in
it. On the rim of the cup, hay fibers were stuck, and he brushed them
aside; then he drank quickly and bravely. A vat stood next to the tiled
stove; on the stove lay a naked girl who looked at him with dull eyes.
The woman talked with the girl, who did not move and let her arm

dangle as if she were lifeless; she lay there with extinct eyes. And still the woman kept talking, reached for the naked legs of the girl, pulled her body down, pressed this beauty to herself; for the girl was beautiful and blond, the face broad, snub-nosed, but without any expression; she was someone without emotions [*eine Gemütslose*] or a melancholic [*eine Gemütskranke*], an eighteen-year-old who had been worn out (but how it is truly, you don't know).

The woman stood the girl before the tiled stove, as if she were a doll made of fine-skinned white flesh, a doll with dangling arms that she stuffed in her dress, while she looked over at Eugen and smiled.

He walked outside, waited for the others (298–99).

"Again they came to another village" establishes a repetitiveness so sweeping that the "again" encompasses the "another." Yet as soon as the monotonous repetitiveness has been established, a singular occurrence disrupts it: "there was still a farm woman." This break suggests that all the villages the army has so far passed through have been devoid of people. The presence of the single farm woman implies the absence of the other villagers, and it raises the question of why there were no other villagers left. "In one house" conjures up images of desertion, even though Eugen Rapp does not think about why the villages were deserted. Then, between the first sentence and the second, there occurs a glaring gap: "When Eugen remained alone with her" indicates that previously others had been there with him, reinforcing the impression that every house in the village is being searched by soldiers. Just as the presence of the single woman reveals the absence of the other villagers, so Eugen's presence in her house reveals the absence of other soldiers. Why did Eugen not leave with the others? The scene that follows is a tightly compressed moment of illumination (underscored by the "sunlit" room). It is a moment of memory retrieved in all its observational intensity and in all the unacknowledged trauma lurking beneath the surface of nonarticulation. When one "reads" Eugen's behavior and response to the situation in this scene, one reads the response of one absentminded out of self-protection. Memory recovers fragments of the situation and the cause of repression. Memory does not illuminate or release the repression but includes it as part of the scene. It would have been possible for Lenz to have his alter ego retrospectively "understand" his response to the situation and comment on it, but this would bring hindsight to a situation Lenz wants to present as the recaptured memory of a moment as it was then constituted.

As Eugen lingers in the room, the woman speaks her only words, in broken German: "You go away and . . . set fire to the joint" ("*Ihr wegge-*

hen und . . . Bude anzünden") and she laughs. Does she laugh out of despair? Is she covering up her fear? Is she appealing to Eugen to contradict her or to protect her from what she expects to happen? The surrounding devastation, at first only suggested by her solitary presence, is now confirmed by her remark and its accompanying gesture. In response, Eugen looks down at the floor. Does he do that because there is no reassuring resting place for his eyes in this universe? Does he look down because he does not want to look at the woman? Is he ashamed? The shaking of his head is similarly inscrutable: is he honest or consoling? Does he look down because he cannot look at her and lie? While his body responds in its own ambivalent way to the woman's statement, his thoughts clumsily take an evasive turn, registering with seeming surprise a well-known fact. Why should he be surprised that "now the Russians already knew" what was the common practice of the retreating German army and was, as an order, no longer a surprise to him?[20] Is he avoiding the immediacy of a confrontation with the farm woman by pondering the obvious? Is his reaction to the "scorched earth" policy limited to a simple glance at the floor? Clearly not, for now Eugen's focus splits. He seeks distance and support in dialogue with the second person singular and its calming message: "you haven't seen any signs of it yet." The split of narrative perspective is repeated in the split between the immediacy of the situation and the evasiveness of his response. As he has "not yet" seen any evidence of the execution of the "scorched earth" policy, there is a moment of hope, which the "but you just wait" immediately undercuts. But how can he be so sure that the "scorched earth" command will indeed be executed? What has he seen or heard that persuades him that this order will be followed? The gap between the "not yet" and the "but you just wait" constitutes an admission of knowledge even as it refuses articulation.

There is nothing so far in the scene to explain why "Eugen remained alone with [the farm woman] in the sunlit room" after the others had left. Why did Eugen stay? The silence on this point indicates his own lack of awareness as to why he stayed, allowing the reader to guess that Eugen, perhaps unconsciously, did not want to leave. The first part of the scene is a screen that blocks out why Eugen stays. There are sensory images in this brief introduction: the room is sunlit, the woman laughs and gestures as she speaks. This sense of vividly registering sensory impressions combined with an absentmindedness that "forgets" to ask after the implications of what is being observed is even more pronounced in what follows. The farm woman brings him a cup of milk. Did he ask for it? Did she offer it without being asked? Why did she offer it? What did she expect from him, or hope for, when she offered it? Did

she think that Eugen's remaining in the room indicated an interest on his part that she wanted to turn to her advantage? What does he want to block out as his attention contracts to the smallest point in front of his eyes: the specks of cream swimming in the milk? From this point of ultimate reduction, his vision then slowly widens, at first just enough to encompass the rim of the cup, where he sees (again in close-up) hay fibers, which he brushes away; then he drinks "quickly and bravely." Why "quickly?" To get a disagreeable task behind him? Because he does not want the milk but prefers not to offend the woman? What is it that he wants to get to, so that he has to drink "quickly?" And why does he drink "bravely?" Surely he cannot be disgusted by hay fibers on a cup, after he has survived the mud and vermin of the swamps? Is he afraid of being poisoned? Is he "brave" to drink because the situation is unpleasant or unbearable? Only as he drinks—or after he has finished drinking—does his glance expand further. Or perhaps only now does he acknowledge what he must already have registered earlier in that sunlit room. As if his eyes had to work their way slowly to the center of the scene, his glance goes from the specks of cream to the cup to a vat, from there to a tiled stove, and finally to the naked girl on top of it. Why does she lie there, naked, in winter? After all the diversionary gestures and glances, Eugen Rapp finally steadies his gaze and observes the woman and the girl—there are now repeated and detailed references to them: "The woman talked with the girl, who did not move and let her arm dangle as if she were lifeless; she lay there with extinct eyes. And still the woman kept talking, reached . . . pulled . . . pressed." The woman stands the girl on her feet and dresses her. But the girl remains lifeless. Why does the woman look over at Eugen and smile as she pulls the girl down from the stove and dresses her? Is the woman offering the young girl to a soldier in the hope of being spared looting and raping and any of the many other brutalities perpetrated on the civilian population by the military? Is she trying to bribe him into protecting her from the other soldiers? And why is this eighteen-year-old beauty "lifeless . . . with extinct eyes?" Has she been used this way many times? Is this a mother sacrificing her daughter to protect whatever she thinks can be protected? The scene is not particularly shrill; the horror of it sinks in only when one contemplates and interprets the carefully noted details. To describe the young woman as "without emotions or a melancholic" is presumably correct but certainly an understatement, necessary to protect Eugen from the full realization of what he sees. When Eugen ventures an opinion—"someone without emotions or a melancholic, an eighteen-year-old who had been worn out" (*die sich abgestumpft hatte*)—this opinion is immediately taken back and, as a signal that this is a traumatic situa-

tion, his consciousness splits, so that he can reassure himself in dialogue: "but how it is truly, you don't know." The technique of dialoguing has a soothing effect, and the content of the dialogue defuses the acuity of the observation. Withdrawal from his opinion is bolstered by an explicit admission of ignorance ("you don't know"), while the parenthetical nature of the comment heightens the ambivalence: as a statement in parenthesis it signals its own relative unimportance, but as a statement important enough to be made at all it challenges the reader to an opinion of his/her own. Whatever knowledge forms the basis for Eugen's tentative opinion is shrouded in silence, but this knowledge lives in the cracks and fissures that surround the illuminated moment of perception and it blasts its way to a surface corroded with ambivalence.

With the woman still smiling at him and manipulatings the girl, Eugen walks outside and waits for the others. The absence of an emotional response to what he witnessed in this scene and the immediate cover-up of a possible opinion make a statement about Eugen. An inner self-protective mechanism allows him to register the scene without an affective response. There is no shock, no sorrow, no compassion, but an arsenal of defense mechanisms that prevent these emotions from emerging. The absence of an affective response is hence not obtuseness or callousness, and the impact of the scene must be read through this absence, through its silence. The strength of the defense mechanisms that prevent an affective response is a precise gauge of the strength of his emotional turbulence. The fact that Eugen can walk out, that the defense mechanisms do come into play, says something else about Eugen: he has learned to survive by the filtering and repression of knowledge. No other postwar writer has had the courage to admit to and to demonstrate this process.

How does someone like Eugen, who gropes his way across abysses of absentmindedness from one illuminated fragment to another, who excises radically all that is not part of his subjective experience, and who makes these excisions the silent partners of his witnessing, take account of the Holocaust? During his days as a student at the University of Munich, he falls in love with Hanni Treutlein, like him a student of art history. In Nazi terminology, she is a *Mischling*: her mother, although of Catholic faith, is Jewish; her father is not. It is perhaps too strong an expression to say that he has "fallen in love," since their relationship is from the beginning dampened by the rabid anti-Semitism of the Nazi regime, which would in any event prohibit their marriage and allows for no hope in a constructive future. The only reference to Hanni's sexual attractiveness comes when they go swimming and Eugen sees that ". . .Treutlein Hanni was surprisingly nicely curved. Why didn't she show this at other times? Well, just because; and she should do exactly as she wanted" (46). Since

the relationship is presented from Eugen's perspective, the reader never knows how much Hanni loves Eugen, but she is presented as deeply caring for him. Eugen feels that Treutlein Hanni senses "the structure of his inner life" (52), and he shows his deep involvement with her in his awareness of her moods and sensitivities. Thus, for example, he records the instance when she catches herself in the middle of a sentence describing her joy and triumph at having passed the Ph.D. oral exam at extremely short notice, right before the deadline after which *Mischlinge* would no longer be granted degrees; in her joy, she forgets momentarily that Eugen, under much more propitious circumstances, had not qualified. She says to Eugen: "You wouldn't believe how I crammed for the oral! What others could take half a year to do, I had to . . . but you know anyway" (210). Hanni's self-interruption and subsequent silence illustrates her sensitivity toward Eugen; his recording of it is in turn evidence of his sensitivity to her every word and silence; but it also implies self-criticism, since he caused her to interrupt the account of her moment of triumph.

Some critics have complained that Eugen consistently and "irritatingly" refers to Hanni as "Treutlein Hanni," implying a certain distance.[21] Yet using the last name before the first name is a widespread habit in southern Germany and may, for Eugen, have carried connotations of *Heimat*, of familiarity, even intimacy, and a rootedness he did not otherwise feel. When he refers to Hanni's friend Helga Wendlinger (218), someone he does not feel close to, the first name is mentioned first. Lenz's frequent use of dialect in the conversations of his characters serves a function similar to the "Treutlein Hanni" inversion. The various dialects, which Lenz registers with a fine ear, identify a speaker and document the deliberate creation of group identity at the front, where soldiers in the same company or division originally came from the same region. Eugen is most deeply affected by the Swabian and Bavarian dialects—Hanni speaks Bavarian—and their use at the front evokes a sense of familiarity and of "back home," of *Heimat*.[22]

Through the relationship with Hanni, Eugen is constantly aware of the escalating harrassment and persecution of the Jews. For a period of time as a student, Eugen rents a room in the Treutlein household, and he keeps this address as his official residence throughout the war. While he would never dream of changing his address, it also causes him concern. Since the regime's legislative maneuvers are designed to sever any connection between Aryans and Jews, including *Mischlinge*, the Gestapo could easily construe this stubbornness as a political act of resistance. Even before he went to study in Munich and learned that Hanni's father had lost his position as a university professor because he was married to

a Jewish woman, Eugen was aware of this harrassment with respect to
the professors at Heidelberg (47). In a novel that is particularly vague on
specific time assignations, a few dates are precise, indicating that Eugen
is shaken out of his general state of absentmindedness. One is "Friday,
August twelfth, nineteenhundredthirtyeight," a day on which "many
synagogues were destroyed and on the day before, August eleventh,
nineteenhundredthirtyeight, the synagogue of Nuremberg had been torn
down" (69).[23] As is usual for Lenz, there is no comment or expression of
outrage over this destruction; however, the singular date seems meant to
burn the events of this day as recorded history into the reader's con-
sciousness. That the dates are written out in letters and the year is re-
peated in the reference to the day before only heightens their
importance. It also suggests that Lenz wants to slow time down to better
impress and remember; it takes trouble, time, and attention to read
these dates spelled out in letters. They carry the weight of the events,
the memory of the events and of the buildings destroyed, and the silent
and powerless outrage.

Another clearly identified date is that of November tenth, the day
after *Kristallnacht*, the "night of broken glass," in 1938. On this day,
Eugen is released from military training. Lenz describes Eugen's renewed
contact with civilian life with a rare ironic undertone; but then (as if try-
ing to cancel what could be construed as a possible comment on the van-
dalism) has him immediately retreat into his shell:

> Then he left. And already on the platform of the streetcar nobody from
> the Dom-Pedro-School could any longer be seen, but instead other
> things could be seen. Shards of shop windows, for example, bashed-in
> doors and looted stores. In front of a store, a new handbag on the side-
> walk. At least nobody took this handbag. A woman in a housecoat cir-
> cled it.
>
> They had had all Jewish stores plundered; to be impotent and to re-
> main paralyzed, that is what it amounts to for you.
>
> On November tenth, he went to the house number five Mannheimer
> Street. Treutlein Hanni pointed to all the coats . . . (81).

Hanni's relatives are at the house to discuss whether and how they
should leave Germany. The sentence that speaks of the vandalism, and
of Eugen's paralysis, is visually highlighted: the two lines form a para-
graph. For Eugen, the two parts of the sentence belong together in the se-
quence indicated: vandalism elicits paralysis. It is significant that Eugen
refers to the perpetrators of this pogrom as "they" and chooses a variant
of the passive form—"they had had all Jewish stores plundered" (*sie hat-
ten alle jüdischen Geschäfte plündern lassen*), thereby erasing any iden-

tification of those who ordered the plundering as well as of those who actually carried it out. The anonymous commanders and the equally anonymous executioners formed a hierarchy of perpetration that allowed, in the postwar years, all of "them" to deny responsibility for the crimes. Those who had ordered the crimes had not actually committed them, while those who committed them could hide behind a chain of commands that they said they had to obey. As is characteristic of Eugen, his response in this instance, too, lacks overt outrage or emotional investment. The anonymity of the perpetrators stands in direct relation to the powerlessness of the victims and those on their side. The second part of the sentence offers then an excuse for the absence of a strong response—a response that must nevertheless have been felt and repressed in the withdrawal into paralysis. Fallen into the gap between the first and second parts of the sentence—between noticing the vandalism and acknowledging the paralysis in response to these acts—is the expression of affect, of revulsion and outrage, tied perhaps to shame and perhaps to fear of further violence. The response of Hanni's relatives shows the reaction to these destructions much more forcefully. By including their response, Eugen corrects his own toned-down version of events.

The obliteration of distinct time indications and a blurring of chronology that was noted with respect to Eugen at the front, similarly holds at home. With the exception of these two examples, the chronological sequence of the escalating persecution and deportation of the Jews is blurred and must be read against a knowledge of history. Eugen's concern and fear accelerate and intensify, but without reference to events in specific time these fears become the underlying, permanent condition of existence. The information in the novel is anecdotal and, as usual, confined to specific scenes. Thus, Hanni receives her Ph.D. in art history barely before the deadline excludes Jews from being granted degrees. The novel states only "July 1" (210) but omits adding the year 1942, which the reader must provide him/herself in order to situate the event correctly. Hanni's professor, whose VW ostentatiously displays the Nazi flag, lets her know that he had not been aware that she would fall under the ruling, and speeds up her exam. Hanni then finds work in the auction house of Weinmüller, a prominent member of the Nazi Party. In both instances, party members come to the support of a "half-Aryan" (211), apparently because they see Hanni as an individual whom they like and because their action involves no danger to themselves. Hanni is not yet caught in the machinery of annihilation, although her situation is steadily worsening and there can be no doubt that *Mischlinge* of the first degree will eventually be sent to extermination camps.[24] This is made clear to Eugen presumably in the fall of 1944, when a young

woman who is aware of his relationship with Hanni, coolly and cruelly informs him that now "even half-Jews are sent to camps" (342). Indeed, shortly before this comment, Hanni has been sent to forced labor (she has to wash streetcars in a streetcar depot), while Weinmüller, "nearly crying," can do nothing to help.

The course of the war accelerates the persecution and destruction of the Jews. Any contact with them becomes a highly political statement. This is evident when, in late 1942, Hanni's mother dies "a painful death" (212). The cause of her death is never mentioned, but one is tempted to say that it was a timely death, since a few months later, in the summer of 1943, the deportation of Jewish partners of mixed marriages began and forced divorces were contemplated.[25] The priest who is supposed to bury Hanni's mother, the woman of Jewish race but of the Catholic faith, refuses to do his duty and instead "carefully dodge[s]" the issue. However, "a tiny old colleague did it then anyway" (212). The matter-of-fact (indeed, callous) description of the burial as "he did it then anyway" and reference to the priest as a "colleague" reflect not just the painfully unceremonious act but also a blunting of sensitivities. The reader cannot be sure of the identity of the narrative voice in this part of the account: is it Eugen's voice or is Eugen reporting what he was told, and if so, by whom? (Hanni and Eugen are in an antique store, surrounded by Hanni's friends and co-workers, when this account of her mother's death is inserted.) Hanni rights the burial situation as best she can when she finds an antique wrought-iron cross for her mother's grave. The distress caused by the behavior of the two priests and Hanni's pain are never mentioned. However, Eugen is disturbed enough to shift his reaction to a different level, where he can express his emotions in a manner typical of his general style of coping—through displacement and focusing on peripheral details. Standing in the antique store, surrounded by objects, he muses: "The cracks and fissures, the knocked-off corners on old desk sets or vases, were carefully glued so that it would look smooth and clean on the outside. A connoisseur, however, would see how it truly was; although you wouldn't dare call yourself a connoisseur" (212/3).

Perhaps being old, the tiny priest thought he had less to fear? The "dodging" of the other priest bespeaks a cooperation with the Nazis that was only too prevalent. In his small gesture of "dodging" are contained in nuce many of the larger instances of a cooperation not explicitly demanded but on which the regime could rely. This minute scene raises the very question that has haunted postwar attempts to look at the German past: why were so many people so prepared to cooperate with the Nazis even when they were not coerced? Or, inversely: why were there

so few who were even moderately decent, as the tiny old priest seemed to be, and as the professor and Weinmüller could afford to be?[26]

Eugen tries to contain his increasing fears in impersonal references to the deportation and annihilation of the Jews in extermination camps. The word "Auschwitz," for example, and the genocide for which it stands remain a distant, abstract entity. Only when the personal element is introduced and Hanni is thought of in the context of Auschwitz is there an affective response, and then the thought is so devastating that it is deliberately broken off: "One knew from the London broadcasts the name Auschwitz and what happened there. This will be revenged on all of us, just wait; and when you think of Treutlein Hanni . . ." (307). As in so many other instances, it is the silence that conveys the affect. Only on rare occasions is affect expressed, and then only in relation to Hanni. Eugen's reaction in the fall of 1944 when he hears that now "even half-Jews are sent to camps" is visceral:

> Like a millstone it was thrown into him, although he had already and always counted on it . . . ; but it did not serve any purpose if he only thought it, imagined it. Only when it happened or, like now, was close, in the face of the beautiful lady, did he feel it cut sharply into his bowels; because it was obvious that it would not take much longer (344).

Eugen's physical reaction in this brief scene ("he [felt] it cut sharply into his bowels") is as strong an affective response to the threat of deportation and annihilation as one can find in the literature of the perpetrator generation, but even this reaction is couched in passivity.

In another instance, one of the most horrifying (though not persuasively documented) practices in the death camps is mentioned—namely, that the bones of human beings are made into soap. As in all literature not written by survivors, mention of this and similar practices is couched in layers of distancing. Hanni Treutlein's father hears it on a Swiss radio station he listens to illegally, and mentions it to Hanni and Eugen. While the father, although predisposed to believe anything heinous about the Nazis, cannot, "despite everything," quite believe this, Eugen, perhaps speaking from his experience at the front, affirms that "I believe them capable of anything" (257). Hanni, the one most personally affected, remains silent, but she looks "through the open door of the balcony out at the neighbor's house, where a sculptor had set out bronze-colored Hitler busts to dry." Hanni's silence speaks clearly: she believes the report. Her glance out the open door may be a diversion from the immediacy of the confrontation, but it also suggests a search for an escape, blocked by the cheap Hitler busts. Even with the door open, there is no escape. As if ac-

knowledging this fact, but with a psychologically delayed response that indicates that she needs time to let the enormity of her father's statement sink in, Lenz's next sentence reads: "Later, she mentioned that her relatives Ada and Olga Reé from Berlin had now also been deported and the two have last been seen east of Riga" (257).

Here and in similar scenes, Lenz addresses, even though he does not enunciate, the enormous fears, anxieties, and pain of the Jews, *Mischlinge*, and all those living in the *univers concentrationnaire*.[27] He is unique among West German writers in that he has his alter ego admit, albeit in circumlocutory and "silent" language, clear knowledge of the Nazi crimes, and that he documents not only that knowledge but also the fears associated with it—that is, the affective context. But he is able to do so only when the personal dimension is involved.

It is therefore all the more interesting to see how Eugen Rapp copes with impersonal knowledge—with the knowledge he acquires as a soldier on the Eastern front. According to the information provided in the novel, Eugen Rapp is shipped from southern France to the area near Leningrad toward the end of October 1941, at a time when the "Barbarossa" campaign had come to a standstill and it had become obvious that neither Leningrad nor Moscow could be overrun before winter. Eugen serves variously as a common soldier (a *Gefreiter*) in the 5th and 6th infantry regiment and is intermittently a writer for the division staff. He is part of the military that lays siege to Leningrad and he remains at that part of the front until the retreat through Lithuania, East Prussia, and Poland. Except for brief interludes at the division staff and some trips to the units behind the lines, he serves in the front lines. Upon arrival, he is stationed near Peterhof, from where he has a view, across the frozen Gulf of Finland, of Kronstadt and Leningrad. Sometime during the summer of 1942, his unit is sent to the Volchov swamps, eventually, in early 1943, to Lake Ladoga, and later in the year to the Malukssa swamps. From there, the retreat is studded with many small battles (or at least they appear small from Eugen's limited perspective) in many small villages and hamlets.

Just as time ceases to exist for him and the seasons merely mark an ever recurring cycle, place loses its definition. Upon arrival at Peterhof, he remarks on the badly damaged castle, but soon thereafter "place" shrinks to the geographic formations of soil, swamp, and the impact of the seasons—hot, mosquito-ridden summers and unimaginably cold winters. Rapp names a few towns he has to pass through when he goes on furlough, but the battles that imprint themselves on his memory are fought in places like "Posselek Seven," which he explains means "workers' settlement seven" (260), or in Vashkovo, which "means in German

bug-infested village" (*Wanzendorf*) (311), or near a château in a forest, called "Lissino Corpus, i.e., fox's lair" (290). These places could be anywhere, but they stand out for the events that take place there. At the front he begins to lose some of the passivity and resignation he had shown toward the political developments at home. He still repeats, like bits of hypnotizing prayer, the litany of "make yourself small," "duck down," "because you are not being asked," and the like. But his passivity escalates to passive resistance when he does not shoot at the Russians or when he merely "tumbles along" (240), "stumbles forward" (242), or "gropes along behind the others" (235). After a fierce battle, he receives the Iron Cross second class, like "everybody who is still left over" (237), and on other occasions (he does not say when), he receives the Storm Medal and the "Order of Frozen Flesh" (*Gefrierfleischorden*) (262).

There are incidental descriptions of the conditions at the front, which range from the lack of ammunition, equipment, and clothing to the frequent denunciations of soldiers by other soldiers. Some of them die in "friendly fire" or when their own weapons explode, or they are sent into investigatory detention and to penal battalions.[28] In the last year of the war, Eugen himself is in danger of being court-martialed for a comment he made to a soldier who later defected to the Russians, to the effect that the Russians would reach East Prussia by the end of 1943 and the war would be over in half a year; the Russians then reprint this comment in leaflets and shower them on the German positions (309–12).

The assumption that the rank and file of the German army was honorably fighting a war and was not implicated in the mass murders and atrocities on the Eastern front has, in a number of historical studies published in the last few decades, been proved wrong. As one among several, the German historian Christian Streit states: "In West German historiography it was until the middle of the 1960s nearly an article of faith that the German army had nothing to do with the National-Socialist crimes, which were essentially reduced to the murder of the Jews."[29] Acts of the most heinous barbarity, committed by an increasingly brutalized military, are now abundantly documented, as is the more or less willing cooperation of the military leadership with the SS in implementing these political "directives," often for reasons of personal advancement or bureaucratic rivalry. To what extent was Eugen Rapp involved in or did he have knowledge of these brutalities and killing missions, and how did he cope with this situation? He describes some instances in which alleged Soviet commissars are taken prisoner and sent to the division for trial; he meets partisans, knows that they will be shot, and gives one of them a chance to escape (334); he sees the raped corpse of a Russian woman (156–8). He knows of the "scorched earth" policy. The

shooting of "partisans," of "commissars," of Jews, or of any civilian al-
leged to belong to any of these groups, was condoned and even sanc-
tioned by directives such as the "Barbarossa" decree or the "commissar"
order. In Lenz's text, there is no indication that these acts were anything
more than individual occurrences.

Eugen Rapp also comes in cursory contact with members of the SS. In
one instance, he watches SS men guard Russian prisoners of war, who
are pulling tanks and corpses out of the swamps. The SS carry whips
with five tails on which steel balls are fastened, and Eugen, the passive
resister, asks one of them in a tone more matter-of-fact than judgmental:
"So this is what you use to beat [them] with?" (181), to which the SS
man, seemingly embarrassed, gives the vague reply: "Well, we just have
them like that . . . " ("*Das brauchen wir bloß so . . .* ") (181). Estonian
soldiers and Estonian SS, in new and warm coats, arrive to relieve them
(234), but in general—and contrary to historians' reports[30]—there seems
to be no fraternizing between the SS and the military. Eugen remarks
that a certain officer "could not tell the Bavarians anything, because he
belonged to the SS" (182). Eugen is aware of the many spies and snitches
in his unit, and of the convinced fanatics and opportunists, and he tries
to limit his contact with them. Does that mean he had no knowledge of
the crimes that were being perpetrated around him?

In stark contrast to his fears about Hanni and his knowledge of the
persecution of the Jews at home, he expresses no concern about the fate
of the Jews in Russia, nor does he ever mention encountering any of
them during his whole stay on the Eastern front. This is all the more
surprising as he repeatedly mentions the town of Krasnogvardeisk, some
25 miles south of Leningrad, which he passed on his way to the front
lines. Krasnogvardeisk was, as of October 1941 (around the time of
Eugen Rapp's arrival in the area), the seat of *Einsatzgruppe* A. *Einsatz-
gruppe* A and its various *Einsatzkommandos,* or mobile killing units,
had come on the heels of the advancing German army through Latvia
and Estonia and by fall had established itself in Krasnogvardeisk.[31] In
Krasnogvardeisk, Eugen Rapp is aware of the hostility of the Russian
population, and in a brief sentence—"In a tree hung a hanged man"
(139)—conjures up the many scenes of savagery perpetrated by the Ger-
mans.Yet, as the noted historian of the Holocaust Raul Hilberg has re-
marked, it was also the case that

> [t]he Einsatzkommandos that moved with the armies farther to the
> east encountered fewer and fewer Jews. The victims were thinning
> out for two reasons. The first was geographic distribution. By October-

November 1941, the largest concentration of Jews had already been left behind. [. . .] The second reason was the decreasing percentage of Jews who stayed behind. With increasing distance from the starting line, the Soviet evacuation of factory and agricultural workers gained momentum. Many Jews were evacuated, and many others fled on their own.[32]

Hilberg stresses that "in the frozen areas near Leningrad, *Einsatz-gruppe* A caught only a few strayed Jewish victims" and the *Einsatz-gruppen* Reports reflect that situation.[33] But even if the *Einsatzgruppe* did not find many Jews to murder, the unit was there trying to find them, and Eugen must at least have heard of their presence and their objectives.

Eugen also passes on several occasions through Narva, an Estonian town on the Russian border which had had one of the larger Jewish communities in Estonia. An *Einsatzgruppen* Report dated October 12, 1941, shortly before Eugen Rapp's division passes through on their way from France, describes the persecution (which includes wearing the Jewish star) and murder of the Estonian Jews as not yet completed. As late as 1943, the Vaivara concentration camp was organized, with one of its branches in Narva. Could Eugen really not have been aware of this? He noticed the wearing of the Jewish star in Germany—as in this scene, which is also an illustration of silence as a highly explicit language. In the entire scene, not one word is spoken, yet there is an intense flow of communication: On the way from southern France to Leningrad, the troop train passes through Berlin, and Eugen notices from the train "apart from the others, a girl with the yellow Jewish star next to the rusty steel beam of a waiting room with the sign 'Berlin-Moabit'" (138–9). Some of the other soldiers, who know of his liaison with Hanni, also see the girl and respond, although in a nonverbal way. "Hochreither nodded and looked at Eugen out of his light-blue eyes. Goeser bit into his lower lip. The others looked straight ahead" (139). If one Jewish girl in Berlin elicits this kind of recognition and response, why does Eugen not notice the persecution and decimation of the Estonian Jews, or see the mistreatment and starvation of Russian prisoners of war (he sees only that they are guarded by sheepish SS with five-tailed whips), or register the devastation and killing of the civilian population under the flimsiest of pretexts? Is it really credible that he continually experiences, at the front, horrendous hardships but that the atrocities he witnesses are confined to a few highlighted scenes devoid of any larger context? In one instance, Eugen reveals *that* he knows, but not *what* he

knows, about the persecutions in Vilnius. He mentions that Wieland, a friend of his and Hanni's "was in the military hospital near Vilnius (also not a pleasant area) [*auch keine erfreuliche Gegend*]" (214). The colloquial *auch* in *auch keine erfreuliche Gegend* appeals to an unstated common knowledge and suggests that there are still other, similar areas; *erfreulich* carries moral overtones; negated and juxtaposed with *Gegend*, it suffuses the entire area with a sense of doom. Hidden behind the parenthetical comment "also not a pleasant area" lies the fact that in and around Vilnius, the "Lithuanian Jerusalem," roughly 70,000 Jews were killed between early fall of 1941, when the German armies invaded and *Einsatzgruppe* A arrived, and December of the same year.[34] How much does Eugen know about these atrocities? Perhaps his knowledge—based on rumors and whispers that have to bypass spies—is as vague as his manner of expressing it is cryptic. However, he seems to have no doubt about what he has heard; his parenthetical comment may keep silent on specific details, but it is straightforward. On a later furlough, a similar pattern is observed: he meets a friend and describes how she responds to his reports, suggesting that he gave her information that is withheld from the narrative.

> And Helga, one who loved to talk tough [*die gern saftig schwätzte*], one who looked durable and didn't want to know very precisely a lot of the details that Eugen was describing—"Oh well, it will always keep going and I couldn't care less; I live now!" she said, and followed her words with a robust laugh—she couldn't stand Eugen's burdening talk [*Geschwätz*], he felt that (255–6).

Twice in this disjointed sentence there is reference to Eugen's "talk" (*Geschwätz* carries a derogatory connotation, talk not to be taken seriously), but Helga's aversion to the *content* of the talk serves as a screen behind which the information remains hidden. The reader never finds out about "the details that Eugen was describing." Lenz simultaneously offers and withholds information but the silence does not deny knowledge.

Performing what becomes, toward the end of the novel, almost a ritual of speaking silence, Eugen has during this same furlough yet another "talk." This time, it is an "unequivocal discussion" (*eindeutiges Gespräch*) with his father, the Nazi admirer. The significance of the event is highlighted in that once more a full date is spelled out: " [I]n the third year of the war; to be precise: on May fifteenth anno fortythree . . ."[35] But the content of the "unequivocal discussion" is left out. Instead, as on other traumatic occasions, the thought is broken off and Eugen's focus shifts to self-observation, to registering his reactions to what is talked about.

Unequivocal discussion between father and son in the third year of the war; to be precise: on May fifteenth anno fortythree. . . . And you perceive everything rather hazily [*arg verschwommen*]. As if the house, the room [*Stube*; an anachronistic term to indicate a sense of withdrawal into a different era] under the roof in the attic where his books were lined up and the desk was polished by his mother, were of gray material; hence just about like wasps' nests; this softness, which felt velvety to the fingertips, like powder or ashes (254–5).

Is the fact that he perceives everything through the hazy filter of a grayness that feels like powder and ashes a metaphor for what he knows? Under the impact of the "unequivocal discussion," Eugen Rapp's mind, so responsive to concrete details and so adept at shifting his attention away from traumatic confrontation even while maintaining a traumatized focus, in this instance dematerializes the solidity of the house, the room, the books, the desk, as if some lethal rays had penetrated their solidity and transformed them, while maintaining their shape, into powder and ashes. The discussion with the father not only transforms reality but transforms it according to the unstated subject of their discussion. The gray softness of powder and ashes are not arbitrary random images to which Eugen flees but very precise displacements. Where Eugen's thoughts refuse to record, his senses step in and "talk." Or rather: Lenz records how Eugen transforms his reality as a way of speaking while not speaking about what he and his father talk about.

Eugen Rapp enacts in the novel an absentmindedness punctured by salient highlights; he enacts the silences into which memory falls and the silences that shield without repressing. Lenz portrays in his protagonist how the mind copes with shock events and sustained traumatization, where it finds its limits to what it can say, how memory selects and subjectivizes. In this landscape of the mind and of memory, the narrated events emerge like islands in a sea of silence, but they are connected at their base by a memory averse to surface. The French philosopher Jean-François Lyotard has argued this precise point:

Whenever one represents, one inscribes in memory, and this might seem a good defense against forgetting. It is, I believe, just the opposite. Only that which has been inscribed can, in the current sense of the term, be forgotten, because it could be effaced. . . . One *must*, certainly, inscribe in words, in images. One cannot escape the necessity of representing. It would be sin itself to believe oneself safe and sound. But it is one thing to do it in view of saving memory, and quite another to try to preserve the remainder, the unforgettable forgotten, in writing.[36]

Lenz's careful charting of the way memory constitutes itself (what it singles out, how it operates, what it "forgets"), his representation of silences and absences, and the gaps and fissures that constitute a vital part of the text, speak of the trauma that some members of the perpetrator generation undergo as they confront the crimes of the Nazi regime. Here, the language of silence preserves and reveals what it cannot speak about.

Ruptures and Displacements

Gert Hofmann

We have no standard anymore for anything, ever since human life is no longer the standard.[1]

Until recently, the prevailing opinion was that most Germans who lived through the Hitler regime were immobilized by fear of Nazi brutalities and were therefore silent, passive, and not involved. This assessment has been challenged most notably by Robert Gellately in his 1990 study *The Gestapo and German Society*, in which he concludes that "the regime's dreaded enforcer would have been seriously hampered without a considerable degree of public co-operation."[2] Considering the enormous brutalities it perpetrated, the number of the Gestapo—the Secret State Police—was relatively small;[3] Gellately holds that the Gestapo, rather than being "an 'instrument of domination,'" was "to a large extent a reactive organization . . . structurally dependent on the continuing co-operation of German citizens" (136).

This cooperation manifested itself most frequently in denunciations. Gellately suggests that "denunciations from the population were the key link in the three-way interaction between the police, people, and policy in Nazi-Germany" (136). Although anti-Semitism figured in these denunciations, the motives were "usually determined by private interests and employed for instrumental reasons never intended by the regime" (147);

they were motivated by "resentment and spite," based on "personal arguments, enmities and aversions of all kinds" (144) and even included "denunciations of one spouse by another" (148) for purely personal reasons, such as obtaining a divorce. Gellately notes that the number of denunciations for activities such as "malicious gossip" at times threatened "to overload the system" (153–4). The dreaded brutality of the Gestapo and of their methods of intimidation and extortion created an atmosphere of suspicion, anxiety, and fear, and suicide was not an uncommon response among those who were denounced. In the postwar years, none of the denouncers were ever tried or held responsible for their deeds.

Postwar West German literature dealing with the Third Reich has commented on these practices. The references to denunciations, however, are generally used to set a scene or create a mood; they are presented as "givens" in no need of analysis, and only rarely are they of central concern. Scrutiny of the personalities and motives of the denouncers, of the mechanisms that promoted active cooperation of vast segments of the German population, or of the manifold effects of denunciations on the victims is lacking, as if such topics did not merit exploration.

Rolf Hochhuth's 1978 *A German Love Story* is a rare exception.[4] It reconstructs in documentary style the effects of one such denunciation on the lives of an adulterous couple who defied the racial laws of Germanic purity. The young Polish lover is hanged; the German wife is sent to a concentration camp. Hochhuth interviewed—and integrated the interviews into his narrative—the denouncers and those instrumental in bringing about the death by hanging of the young Pole as they prospered into the 1970s. All denied any wrongdoing and insisted that they had acted "only" in accordance with then-valid laws, but Hochhuth makes it clear that the Pole's death could have been avoided. Why weren't the love letters destroyed instead of being handed over to the Gestapo? The answer is that the woman who handed them over hoped to come into possession of the grocery store owned by the errant wife. Hochhuth asks a retired forest ranger who had helped to build the gallows whether or not it was "difficult" for him to do so. The retiree, "irritated by [the] stupid question," answered: "Difficult? Any child can do it! Here a post, there a post—and a beam over it!" (194) Hochhuth illustrates the amnesia, repression, denial, the self-serving lies, and the zeal to execute orders which outweigh any human concerns. He uncovers the breathtaking magnitude of a moral obtuseness that ignored any human emotion and took great pride in technical efficiency—an obtuseness that was a major contributing factor in the prompt execution of the deadly commands of the Holocaust. Even the German wife, who survived the concentration camp, who still cries when she thinks of the young Pole and admits that

she caused his death, wants to remember as little of that catastrophe as do the perpetrators.

In his summary indictment of the entire community, Hochhuth ignores more nuanced positions and does not show much interest in exploring what must be extremely complex thought processes in the surviving victim. His is a journalistic approach, backed by extensive documentation and avoiding any imaginative projection. It focuses mostly on the glaring discrepancies between the perpetrators' documented behavior and what they admit they did. By contrast, Gert Hofmann burrows deeply into the consequences of denunciations as they are inscribed upon the victims and as they destroy not just individual lives but the very concept of a common humanity.

Gert Hofmann was born in 1932 in Limbach/Saale in Saxony, and died in 1993 in Erding, near Munich. He became a novelist late in his career, after he had established his reputation as a writer of radio plays. His novella *The Denunciation* is his first major prose narrative and was published in 1979, the same year that the American TV series *Holocaust* was aired in West Germany and one year after Rolf Hochhuth's *A German Love Story*.[5] From then until his death in 1993, he published roughly one prose narrative per year. While his emphases vary, all his work portrays deeply traumatized characters. Several of these narratives are set in the years of the Hitler regime or recall those years, and the traumas lived in the present are clearly related to events that occurred back then.[6]

The Denunciation is a "classical" novella, in the sense that it conforms with the criteria established over nearly two centuries. Some of these criteria play crucial roles in *The Denunciation,* and must be identified so that it is clear where Hofmann uses and where he transgresses traditional narrative boundaries. One of the key elements of a novella is the central importance of a singular, "unheard-of event" (*die unerhörte Begebenheit*); another is a sudden, elemental shock, understood as fate, severed from any logical or psychological explanation, occurring abruptly, "one day," out of nowhere.[7]

The Denunciation concerns the destruction of the Hecht family in the last year of the war. Because of a denunciation, the father is sent to a penal battalion on the retreating Eastern front and is killed within a month; the mother soon thereafter commits suicide by drowning; and their fourteen-year-old twins, Karl and Wilhelm, are separated. The actual subject matter of the denunciation cannot, of course, be found out in the postwar years, but one of the brothers (Wilhelm) wonders whether it had to do "with the fate of our half-Jewish neighbor L. Silberstein, who for such a long time and in such a miraculous manner had evaded

the attention of the bureaucrats and who around this time had been re-
moved from our city for the purpose of liquidation" (16). The narrative is
triggered when one brother, Karl Hecht, now a successful lawyer in the
same small town he grew up in, receives one night in the mid-1970s,
suddenly and unexpectedly, the news that his twin brother Wilhelm has
died at Bellevue Hospital, in New York City. Wilhelm, who has gradu-
ally gone insane over the ruptures in his life caused by the denunciation,
and over his failure to identify the denouncers, has bequeathed to Karl
his notes, bills, letters and drafts of letters, prescriptions, and notebooks.
On the night he receives the news and the package with his brother's
notes, Karl reads and quotes from these notes, and Wilhelm's voice
serves as a counterpoint to Karl's, who in contrast to his twin has em-
braced the economic miracle with all the attendant repression, denial,
and deliberate effort to forget the Nazi past. During the same night, Karl
is supposed to prepare for the next day's trial, in which a teacher, Wil-
helm Treterle, is being sued for having assaulted a citizen whom
Treterle has accused of denouncing him. The narrative perspective
seems to be that of Karl, but with a twist: Karl's thoughts and observa-
tions, and even the descriptions of his actions throughout the night, are
recorded in the form of a letter-in-progress to a mysterious colleague
named Flohta, who functions as Karl's externalized partner in an inner
dialogue, since he seems to present and restate, as well as comment on,
the content of Karl's letter.[8] Space and time of the narrative are tightly
controlled: Karl does not leave his room (except once to brew some cof-
fee in the kitchen), wandering mostly between his desk, the window,
and the bookshelves, which hide a bottle of whiskey; he starts to register
his thoughts and actions around eleven o'clock at night and is done by
early morning.

Karl's letter to Flohta seems motivated by self-serving rationalizations.
In involuted comments, Karl defends his adult life: the desire and even the
pride he takes in being able to forget his traumatic childhood; the self-
righteousness of the economically successful; his need to belong to the
town's establishment; his lack of patience with those (like Treterle) who
threaten this carefully groomed order. But he also betrays a bad conscience
over his abandonment of principle and a need for confession and exculpa-
tion. His persistent protestations to the contrary, Karl seems to harbor
doubts about himself. He needs Flohta to function as a moral arbiter.

In distinction to writers who use multiple perspectives to make the
point that "truth" is elusive and cannot be ascertained, Hofmann uses
multiple perspectives to indicate profound disorientations and ruptures
in the perception of reality itself. In agreement with an important defin-
ition of the novella—that the "unheard-of event" arises suddenly, as a

stroke of fate—the ruptures in *The Denunciation* are caused by events beyond the victims' control. Yet the defining moment—the sudden, unexpected rupture—is curiously out of focus.[9] While the denunciation is the primary "unheard-of event" that shatters the lives of the twins, the truly "unheard-of event" in their lives is its consequence: after the father's death and the mother's suicide, the twins are separated. This rupture is so devastating that it affects the twins' psychological, perceptual, and intellectual development. In its narrative impact, it distinguishes all levels of the narrative discourse—the level of plot and character development, the level of structural and syntactical organization, the narrative voice itself. Ellipses, as marks of interrupted thoughts or uncompleted, ruptured sentences, are an integral part of the text.[10] This rupture also has an impact on the handling of time, where frequent interspersions of adverbs like "suddenly" and "immediately" break the flow and reinforce a gasping, staccato rhythm, as in the following passage.

> The news of the sudden passing (on September 8th) and the immediate cremation (on September 9th) of my twin brother Wilhelm, age forty-five, of whom, as you perhaps remember, writes the lawyer Karl Hecht, I had not heard anything in almost fifteen years and which reached me this very moment from the administration of Bellevue Hospital in New York in English, together with the consoling, although probably untruthful, addition that he had died "peacefully and composed" and that in accordance with his wishes his earthly remains were immediately (on the 10th) shipped here and their arrival (airfreight, express) could be expected as early as the 12th, which, as I quickly calculate, is already tomorrow (5).

This is the first sentence of the narrative, or rather, it is not a sentence at all. Its presumed subjects—"the news of the sudden passing" and "the immediate cremation"—are not followed by verbs, an omission that is not at all obvious in the mass of interrupted, chopped-up sentence fragments. (The missing verbs should have anchored the sentence; instead, the fragments drive forward in a heaving rhythm, out of control.) Two relative clauses are loosely attached to the first shattering bit of information; this shattering then reverberates throughout the text, most immediately in the highly unusual (indeed, confusing) sequencing of the relative clauses. "The news of the sudden passing [. . .] and the immediate cremation . . . of my twin brother" is followed by a relative clause that refers to the brother ("of whom [. . .] I had not heard anything") and then, in a crossing back to terrritory already left behind, by a second relative clause that refers to the first words of the sentence ("the news [. . .] which reached me"). The rupture between noun and relative

clause is compounded by the displacement of the sequence and enhances the sense of fragmentation and dislocation. The urgency of the tone, the injection of the many dependent clauses and parenthetical phrases, and the cramming of an overwhelming amount of information into one incomplete sentence give the text a heaving rhythm that suggests a shock—presumably stemming from the "suddenness" of the news—which is stabilized by attention to mundane detail.

But not only grammar and syntax are at odds in this fractured, gasping sentence fragment. There is also a psychological displacement that shifts attention away from the "unheard-of event" to a slightly more bearable reality. The very first words of the text show this curious displacement, for it is actually the news that arrives "suddenly," not the death of the brother. Karl Hecht has not heard from his brother in nearly fifteen years; he would have no way of knowing whether or not his brother's death was sudden. In fact (as he will find out in the course of the night as he reads the notes), his brother deteriorated slowly, not suddenly. Characterizing his brother's death as "sudden" shows us that he was not prepared for it. The displacement of the "suddenness" from the news to the brother's death, followed by the stream of technical data, is an illustration of Karl's need to alter reality and an indication of a deep-seated and as yet undisclosed trauma.

In the next sentence, the fracturing continues, although now it occurs in a shift from direct to indirect discourse which deliberately undermines narrative authority and blurs the narrative perspective.

> Well then, although he was the older and the stronger one, he died before you, Hecht presumably thought and refolded the letter from New York. *(Da ist er also, obwohl er der Ältere and Kräftigere war, vor dir gestorben, habe Hecht gedacht und den New Yorker Brief wieder zusammengelegt).*

The first half of the sentence ("he died before you") is in the indicative. Yet it must be an indirect quote of Karl Hecht by the recipient of the letter—a quote in which Karl refers to himself in the second person singular. The second half of the sentence, in German in the present perfect subjunctive *(habe Hecht gedacht)*, seems to be the recipient's own statement— but is it commentary or a rephrasing of Hecht's words? In any event, the reader is not reading what Hecht wrote but instead what the addressee chooses to communicate. The content of the sentence reveals Karl's rivalry with his "older and stronger" brother, again bending facts, since one must wonder how much older and stronger Wilhelm as twin could have been.This rivalry is also suggested in the "well then, although" and can be heard as Karl's satisfaction in having outlived his brother.

A few lines farther, it is not the shifting from indicative to subjunc-
tive that breaks the continuity, but the switching of the point of view:

> And I think immediately: good grief, will you have to study all this, too,
> tonight, for he is more than occupied and the night is extremely oppres-
> sive and I have never had much interest in the writings of my brother
> but with his handwriting, in contrast, always the greatest difficulties.

With exception of "the night," all subjects are personal pronouns and
all refer to Karl Hecht. The I-you-he-I-sequence betrays a narrative rest-
lessness and an inability to establish continuity or a unified focus. Karl
Hecht's narrative personality begins to split into dialogic or trialogic dis-
course. This split points up his essential fragmentation and in the course
of the narrative is shown to be part of his constitution.

Denunciation is not only a violation of privacy. It relies on an aura of
authoritarian surveillance and deprives the individual of a basic trust in
the world around him. After the denunciation with its consequences, the
world as a taken-for-granted, recognizable, and ordered universe has
ceased to exist, a cataclysm most poignantly reflected in the separation of
the twins. In a photograph found in Wilhelm's notes, dating from a time
"shortly before the disaster" (6), the twin brothers are of "equal height"
(no rivalry here!) and look with equally "defiant and unbroken glances"
into the camera. They are so intertwined that Karl Hecht cannot tell
whose hand it is that shows so clearly in the picture (7). The separation
has destroyed this cohesion forever. The vertiginous juxtaposition of frag-
mented bits of time in an undated draft of a letter addressed by the dis-
traught Wilhelm to an unknown recipient expresses his lament at the
same time that it circumvents direct articulation.

> We are supposed to get separated. How so? We are supposed to get sep-
> arated! The books are suddenly as if extinct, the toys are immediately
> dead. . . . For how could that be conceivable? We think about it. So far,
> we have experienced everything together, shall that now be divided?
> And the talks that we have had? Shall the individual sentences and
> words that we have uttered now become divided? Dear Sir, but we are
> constructed in such a way that everything happens to both of us and
> everything, that happens to us . . . by both of us. . . . First they pushed
> us into each other, now they want to pull us out of each other. . . . That
> would necessitate a new construction, each of us would have to be re-
> assembled in a totally new way, with totally new parts . . . (62–3).

The shock over the impending separation is so great that the intensity
of the lament can, even in retrospect, be expressed only in the subjunc-
tive, as a possibility. Neither the actual separation nor the consequences

of this separation in the lives of the twins are ever directly stated in Wilhelm's notes or Karl's recollections. Instead, the entire document—the letter that Karl writes to Flohta; the fragments of Wilhelm's notes that he chooses to include; and the report that Flohta gives of Karl's letter, with all the quotes and paraphrases—is an expression of the trauma of that separation, down to "the individual sentences and words." The broken language embodies the rupture, its effect on the twins' emotional and intellectual makeup, and Karl's efforts to forget the trauma. One can conclude that just as "the news of the sudden passing" was a displacement in aid of self-protection, so emphasis on the denunciation displaces the traumatic impact of the separation. The title of the novella itself is then an instance of displacement.

Once internalized, the ruptures and disjunctions form the basis of each brother's variously "reassembled" self: the discontinuities are contextualized and accommodated according to each brother's way of coping with the original severance. For Karl, the inexorable quality of that break is expressed in his own sense of powerlessness vis-à-vis forces that can destroy him. Overcome by panic, he writes to Flohta:

> Something goes its own path, follows its own law. But I don't want that, I think, and once again want to jump up, but then remain seated and want to replace the thought that there might be something going along inexorably, and *rolling over me*, with a different thought, one more appropriate (47).

Karl wants to interrupt the sense of being overrun by "once again" jumping up from his chair, disrupting a perceived threat with yet another disruption, but he switches from physical to mental displacement: he wants to take refuge in a "more appropriate" thought, which means he avoids confronting his fears. Wilhelm responds to the trauma in a very different manner: he wants to find the truth behind the denunciation, and in this attempt would dismantle Karl's mythization of history. In words that are very similar to Karl's, yet in their context clearly opposite to Karl's frame of reference, he writes in an abandoned draft (as quoted by Karl):

> Dear Sir, you hold against me that where the sucking undertow of history is concerned, which cannot be resisted, I simply look for base characters and *guilty persons* and therefore try to simplify matters for myself . . . (57).

There is no way of knowing whether Wilhelm's fragment (the quote cited constitutes the entire passage) was drafted in response to a letter

he received or is simply an imaginary exercise. Nor can one ascertain whether the "sucking undertow of history . . . which cannot be resisted" is perceived as such only by the person to whom the fragment is addressed, or whether it is a perception shared by Wilhelm. One may be inclined to interpret the "is concerned" and "cannot be resisted" as the opinion of the draft's intended recipient, who apparently took issue with Wilhelm's search for "base characters" and "guilty persons" and pointed instead to the "sucking undertow of history" as the culprit. Karl feels that an inexorable "something [that] goes its own path" may "roll over" him, while the "Dear Sir" of Wilhelm's fragment, similarly impressed by the inexorability of the "sucking undertow of history" but apparently not traumatized by it, uses it as an exculpation. Wilhelm alone does not hide in mystifications or look for excuses, and though clearly as traumatized as his brother, wants to track the culprits.

One of the more startling aspects of *The Denunciation* is the violation of the time element in its narrative probability and verisimilitude. As is the case with the narrative voice, abrupt and complex shifts in time pervade the entire narrative and wreak havoc with any sense of continuity. Like fragments of tectonic plates, they pile up on top of each other. The reduction of continuous time to unhinged points of time and the near chaotic overlap of discontinuous time bits violate the narrative time frame—Karl Hecht's writing his letter to Flohta in a period of approximately six hours. Karl reads his brother's notes, ruminates, and ponders them; he makes several efforts to work on the next day's trial brief, and he spends time thinking about the court case; he goes downstairs into the kitchen to brew some coffee; he walks up and down in his study and pours himself several whiskeys; he stands by the window a number of times and looks out into the night and the town; and, commenting on his actions and thoughts, observing and describing his thoughts and the material he peruses, he writes everything down in the letter to Flohta. The letter is roughly one hundred pages long. Karl cannot possibly have done all these things in one night.

The very cramming of scenes and bits of events into a time frame so tight that it cannot possibly accommodate them all undermines any sense of time as imposing order. In an outstanding characteristic of Hofmann's text, specific words used on the narrative level by the protagonist also describe the narrative techniques used by the author. The language of this highly self-reflective narrative provides the language with which to interpret the narrative. In an example of how Karl's language mirrors the narrative technique and provides the tools to interpret the narrative, he observes, with respect to time:

> And I admit that in history as a whole [. . . .] always as a whole, you
> understand, I see no meaning but a chaos of forces and that everything
> is tight to burst [*zum Reißen gespannt*] and of course ruled by acci-
> dent (84–5).

The overabundance of "chaotic forces" and fragments jammed into a
time frame that is "tight to burst" enacts Hofmann's stringent subordi-
nation of phenomenal reality to the demands of artistic autonomy. The
work of art creates its own universe, including elasticity of time, and de-
fies the very standards of time and space coordinates on which it seems
to rest. The shock of incongruity—that is, the lack of congruence be-
tween the narrated activities and the narrative time frame—evokes the
disorientation and ruptures attendant on the original trauma. Reality it-
self, in which these ruptures occurred, has shattered. The "sucking un-
dertow of history" and the "something" that "goes its own path, follows
its own law" have violated and distorted all frames of reference in which
one was once accustomed to organize and experience reality. A reality in
which denunciations and other forms of destruction obtain, and in
which culprits are never brought to justice, can no longer be gauged by
the coordinates of earlier human discourse and existence. This new uni-
verse is a "chaos of forces" where there can be no trust in the senses and
no reliance on previously held basic assumptions.

A universe in which narrative and interpretive discourse coincide and
mirror each other suggests a closed universe. That the universe of *The
Denunciation*, ready to burst with "chaotic forces," is a closed universe,
one without exit, is substantiated in the many examples of mirrorings.
These mirrorings show up as complementarities and in double and triple
correspondences between persons and between events. In all instances,
the mirrorings lack reference to an orienting source. On the most obvi-
ous level, the two brothers mirror and complement each other. In a weak
moment, Karl admits to their reciprocal relation when he writes to Flo-
hta: "For I read [in Wilhelm's notes] *my* memories too, even if so-to-
speak from the other side" (37). The twins also complement each other
in the sense that Wilhelm's mental breakdown finds its analogy in Karl's
physical breakdown, his heart trouble. One may even wonder whether
Wilhelm's death is not a prefiguration of Karl's: throughout the night,
Karl provides detailed information on an apparent heart-attack-in-
progress. He speaks of "pains in his chest and his left upper arm" (24)—
pains that earlier made him consult three physicians and that spread
during the night "to his left elbow." Karl does not want to know—not
about his current physical condition and not about his ruptured past.
Wilhelm, on the other hand, was apparently only too aware of his frac-

tured existence and struggled in vain to restore a reality that had been destroyed along with his own existence.

> Dear Sir, for personal reasons I need to know to whom our family . . . its extinction and I myself, who due to this extinction now lead a life divided over several continents, but equally miserable everywhere, . . . my shattering . . . [. . .] Because I don't know whether you were in on, were perhaps part of, perhaps even *significantly* part of the history of our double mutilation, which is supposed to have occurred due to a double denunciation of my parents . . . (14).

The mirrorings become more complex when one considers that Wilhelm has two namesakes. First, there is the teacher Wilhelm Treterle, who in the narrative present has recently sought Karl Hecht's counsel in a case of denunciation and character assassination (7). Karl inadvertently but significantly confounds Treterle with his brother Wilhelm as he admits: "I make a big mistake and in my absentmindedness slide everything [i.e., Wilhelm's notes] in among the case documents that lie before me, mix everything up" (6). Treterle showed up one day, "suddenly," in Karl's office, dressed according to the style of the counterculture of the 1970s. His sudden appearance profoundly disturbs Karl, who dates the beginning of his heart ailment to Treterle's first visit to his office (25–6). Treterle is clearly a victim of the "decrees against the radicals," which the West German government began issuing in early 1972; they are referred to in the narrative, with echoes of the legalistically minded Nazi language, as the "ministerial decree of 2/8/72" (19). Hofmann must have seen in these decrees a revival of Nazi tactics, since he suggests parallels between Treterle's situation and that of the twins' parents. In a mirroring of the past and the present, the mechanisms of persecution—the impossibility of identifying anonymous letter writers or Treterle's inability to prove that his telephone is tapped and his luggage was searched—which the twins did not grasp when they were young and which Wilhelm unsuccessfully staked his life on uncovering are now detailed for Karl as Treterle presents his case as a stigmatized and hunted outsider. The political predicament of the radicals mirrors the situation that led to the death of the twins' parents in the Nazi period when Treterle says of his "comrades": "[A] disproportionately large number of them either kill themselves or die in other ways, 'but always in an *unnatural* way, Mr. Hecht'" (48). In a *tour de force* of repression, Karl tries to make fun of Treterle's fears by pointing out the irrational nature of his accusations (49); he does not want to make the connection between the "act of desperation" (*Verzweiflungstat*) (64) that was the suicide of his mother (and, before her, of Frau Silberstein and "the others ") (30) and Treterle's "comrades".

The adult Karl Hecht, lawyer and respected citizen, has to prove his loy-
alty "toward half the town, indeed toward *the better half* of it" (24), and
cannot afford to show sympathy with people like Treterle. (The split of
the town into two halves again conforms with the many other splits.)

The "Treterle case" mirrors what happened thirty-one years ago to
the twins' parents and illuminates the process of terrifying and destroy-
ing targeted victims. It makes clear that though the culprits of the past
era may no longer be alive, their practices—and with them the attitudes
and values on which these practices are based—have survived into the
present. Wilhelm did not have to search the past to find culprits. The
verdict on such a world is radical and echoes the verdict expressed in the
shattered time coordinates: the world of denunciations is a world in
ruins, a world destroyed. Karl again enunciates what the novella "per-
forms": just as he recognizes his own memories in those of his brother,
but "from the other side," so he recognizes toward the end of the night
that the world as previously understood—the world of which he is a re-
spected member—has ceased to exist and can be comprehended only
"from the other side," as an apocalypse that has already occurred. Lean-
ing out of the window into the dark night, he realizes:

> I have suddenly the impression that the lantern and therefore also my
> house and therefore also the city and therefore probably the entire
> earth lie deeply underneath water and that the flood, dear Flohta, the
> end of the world, which has been secretly expected, indeed *longed for*
> by all of us, has already occurred and that the world has already per-
> ished. It has just gone unnoticed! That the extinction of mankind in an
> element inappropriate for it has already occurred, it has just gone un-
> noticed! (94)

The third Wilhelm of the narrative is Karl's twenty-one-year-old son,
named after his uncle. Karl's reflections about his son are elicited by the
noise the young man makes as he comes home around two in the morn-
ing. The relation between father and son is one of open hostility, not un-
usual as an expression of generational conflicts that, for these postwar
generations, focus on the Hitler regime and on the continuation of some
of its personnel and practices into the present. The relation between father
and son has been abruptly and suddenly broken, at a specific and identifi-
able point in time. Karl remembers the rupturing event but represses the
most important aspect of it—namely, the cause. He states to Flohta:

> Yet, as you know, there was a time when we got along quite well. Up
> to *that point.* Once, on a summer day, I don't remember how many
> years ago, in the garden, on the terrace, we were drinking coffee, then

this conversation, this conversation. . . . I have often tried to remember what was actually said in this conversation, but I must have forgotten it. However, I don't believe that *anything special* was said (76).

It appears that the son espouses a worldview directly opposed to that of the father, yet responds to it in significant ways. Karl has concluded that the apocalypse has already taken place and sees this as an event that was secretly longed for (without pausing to wonder why it should have occurred or why it should have been longed for). However, he does not notice any inconsistency when he accuses his son, apocalyptic thinker like his father, of wanting "the fastest and most thorough destruction of our obscene social order, as he puts it" (83).

Karl feels himself as powerless, at the mercy of forces that grind away like inexorable machines. He notes that "we have always lived in a world subjected to boundless forces and dark laws, you must imagine an enormous machine whose wheels move for a purpose unknown to us and in a rhythm we cannot comprehend" (84). Yet he ridicules his son's attempts to master the world with the same key phrases that he uses to describe his own malaise: "But my son, he will soon be twenty-two, and now listen to what I am about to say: he comprehends the world machine, he knows the laws!" (85).

Where brother Wilhelm knows Karl from "the other side" and is disappointed in him, son Wilhelm knows the father "from inside out" (76) and despises him. His rebellious protests (82–3) connect the son, in Karl's mind, with Treterle, just as Treterle reminds Karl of his brother (78–9), and all three Wilhelms have entangled Karl in a maze from which he cannot extricate himself.

> When I think of my son, Treterle immediately comes to my mind [. . .] And when I think of Treterle, my twin brother comes to my mind, dead now, but still highly effective from inside his urn, and he then, naturally, carries me back to my son with his noise pouring down from his room. Or to Treterle, similarly making noise in my office. Or to both. The point, dear Flohta, is that despite my exhaustion I am constantly driven back and forth between at least three difficult cases (78/9).

The elder Wilhelm has gone insane, and the younger Wilhelm, too, seems to be unwell, as his father almost gleefully notes (demonstrating the same sense of competitive satisfaction as when he noted that his brother, though "older and stronger," had died first). "Allegedly he perspires constantly, constantly . . . from nervous stomach troubles, sickness, even *spasms*, as I heard recently" (77). These "spasms" are symptoms he shares with Treterle, of whom Karl notices: "And I see that he is under

much pressure, makes jerky movements, fidgets spastically, as if he had a tick, without control, a great unrest, dear Flohta" (24). The "jerky movements" are in both cases the physical manifestation of a shattering and mark Wilhelm Treterle and young Wilhelm Hecht as fearful rebels and members of a troubled postwar generation living after the Holocaust and the apocalypse have destroyed the coordinates of a humane world. The attempts of all three Wilhelms to "right" the world by changing it are obsolete, since the world they want to change has ceased to exist. Yet Karl, the gleeful survivor, is also in bad health and suffering from a "life disturbance" (Lebensstörung) (25) that culminates, during the narrative, in a heart attack. The cause of the suffering of all four of them is the German past and its continuation into the present. For this world, the closed world after the end of the world, there is no hope in a "righted" future.

There are still other sets of correspondences and mirrorings that reinforce the sense that there is no exit: these are clusters of correspondences between dates and events. One such cluster groups around "early September 1944," and is mirrored in the narrative present. Joseph Hecht, the father of Karl and Wilhelm, was denounced in early August 1944 and, as expected, he was killed at the front in "early September." On September 8, the mother commits suicide by drowning, but her body is not retrieved until September 11. Thirty-one years later to the day, Wilhelm dies, on September 8, in New York City. Karl receives the news of Wilhelm's death and of the arrival of the urn on September 11. This transit parallels the three days the mother's drowned body floated in the river. Karl has a sensation of his brother's physical presence in the room, carrying an armful of gladiolas, which Karl can actually smell (7–8) and which recall the gladiolas on the mother's grave in 1944 (65).

The second cluster centers on "early May" 1944, when "one morning" the "half-Jewish" tailor Silberstein is arrested and deported. This event, which breaks the bonds of a common humanity, is expressed in the language of tectonic shifts, of Schübe (shifts, pushes, thrusts); in the street, Silberstein is being hinaufgeschoben (pushed up) to a waiting car, which he is then hineingeschoben (pushed into); and Wilhelm remembers the event in a fragmented, broken thought: "An event, which in ever new thrusts . . ." (Ein Ereignis, das in immer neuen Schüben . . .) (27). Thirty-one years later, on May 4, Treterle strikes a respected citizen of the town who he feels has maligned and possibly denounced him (85). When Silberstein was deported, he suffered a head injury (42). In the 1970s, it is Treterle as potential victim who inflicts the "physical injury" on a respected citizen. Wilhelm follows his mother into death on the anniversary of her drowning; timid Treterle lashes out against his victimization on the anniversary of Silberstein's deportation.

The two clusters also show cross-references. Treterle's "performance" (*Auftritt*) occurs in an "atmosphere of animosity and tension" and "before at least six witnesses" (85). Karl's mother, too, had physically assaulted an unidentified maligner in an *Auftritt* conducted "with greatest vehemence, even ruthlessness" (15), and on another occasion had made some comments "before four witnesses" (56) which entailed, as punishment, the twins' expulsion from school and their stigmatization as "other."

There are further parallels in the suicide by drowning of the mother, of Mrs. Silberstein, and of "others." But while the exact date of the mother's suicide is indelibly imprinted on the minds of her sons, the date of Mrs. Silberstein's death is equivocal. She commits suicide before the deportation in early May of her husband, yet the mother's death in early September is said to have occurred only "a short time afterwards" (33). There are similar lapses when an uncle steps in to help Mrs. Hecht sort her estate, arrange her affairs, and sell some of her furniture (59), and he does so over what seems to be an extended period of time—"every time the uncle came" (59) or on the various "visits of the uncle in the city" (62). Yet the uncle would not have stepped in before her husband's death, and between his death and hers one week at most could have elapsed. These discrepancies highlight the broken time sequences, but they may also indicate the psychological dimension of memory, which arranges events according to their subjective magnitude. The events as fragments torn loose accumulate in ruptured memories.

In a text that is constituted of ruptures, fragments, "chaotic forces," "and of course ruled by accident" (85), the carefully manipulated correspondences and "accidents" demand an explanation. In distinction to random occurrences, "accidents" and "coincidences" are characterized by repetition and/or synchronicity. At the same time, in accidents only the effect is registered, never the cause. It is the absence of causality—the absence of discernible reason, juxtaposed with a clearly recognizable repetitive pattern—that is highlighted in these instances. In a universe of accidents, events cannot be experienced (and experience cannot be organized) according to preestablished rules. Like the incomprehensible and inconceivable denunciations, the entire universe is beyond comprehension. The invisible powers of anonymity, the impossibility of tracing the denunciations, the inscrutable cooperation of those who condone denunciations, all create a world comprised only of effects, with no organizing principles. The coincidences and accidents reveal a universe without orienting coordinates. Ultimately, every level of discourse repeats and reinforces the realization that such a world is a world destroyed in the apocalypse, no longer a world of humans.

On the larger scale, denunciations have destroyed the world as a universe functioning because of and for humans. On the individual scale, denunciations have destroyed human lives. As in a photograph with a strong depth perspective, the two brothers loom large in the foreground, demonstrating, in their opposite and complementary ways, how they evolved from young boys who looked into the camera with an "unbroken" glance, united and self-reliant in their ignorance before the "disaster," into two "broken" adults, one of whom tries to ignore the fragmentation and repress its cause, while the other disintegrates completely as he tries to heal the fragmentation by uncovering its cause. In the middle distance of this portrait are the parents, both of whom die as a consequence of "a double denunciation directed against our parents" (14). The father's death on the Eastern front and the mother's suicide at home suggest, in their opposite yet complementary ways, the brothers' dual responses. At the vanishing point in the background, small and seemingly distant, yet located at the very point that organizes the perception of the entire arrangement, are "our half-Jewish neighbor L. Silberstein" and his wife. Mrs. Silberstein's death by drowning prefigures that of the mother, while Mr. Silberstein's transport to an undisclosed destination, where he will die, prefigures the father's death at the front.

In one of the fragments, Wilhelm connects his mother's suicide with Mr. Silberstein's "liquidation": Mr. Silberstein had "for such a long time and in such a miraculous manner eluded the attention of the bureaucrats or had been suffered by them" (16), but now, due to the "betrayal," he "was removed from the city for the purpose of liquidation" (16). Wilhelm wonders whether her altercations with the person whom he addresses in the fragment as "Dear Sir" and whom he recalls as someone who at that time was wearing a uniform (one can assume that it was the uniform of the Nazi Party, for only party members were not at the front) had to do with Mr. Silberstein's deportation. What in their "vehement argument" did the mother so much "take to heart" that two or three days later she committed suicide?

The displacement in the novella's title now gains an additional dimension: the title is a singular noun, but the narrative suggests several denunciations. There is the denunciation of Mr. Silberstein, or of Mr. and Mrs. Silberstein; there is "the double denunciation" of the parents; and there is the "document or piece of paper" (15) that is the cause of the argument the mother has with the man in uniform, and that she waves in front of his face as she screams at him.

One can assume—the text invites this assumption, but nowhere confirms it—that the mother's participation in two of Mr. Silberstein's lessons in tailoring and the father's possible comments or behavior sub-

sequent to Mr. Silberstein's deportation caused the parents to be denounced and punished. If one is guided by the dates—Mr. Silberstein is deported in early May while the father is not sent to the penal battalion until August—the harrassment and persecution of the Silbersteins is the primary and triggering event for all further disasters. The profound violation of the Silbersteins' humanity catapults the entire universe into perdition. The Holocaust as the annihilation of the Jews is thus the central point of the narrative, from which all subsequent catastrophes radiate. Or (to invoke an earlier image) the persecution of the Silbersteins can be seen as the vanishing point that determines the entire perspective of the narrative. The closed universe of Hofmann's text and the endless mirrorings without an exit all point to the radical conclusion that neither repression and denial nor self-absorbed explorations can provide a resolution to a past that continues its heinous practices in the present. The treatment of Treterle, who stands in for all those who are stigmatized by the majority as "other," shows clearly that no change of mind has occurred, that indeed the universe is closed. Published at the height of the outpouring of the self-exploratory "literature about fathers and mothers," *The Denunciation* goes beyond the hopes that nourished those novels—namely, that psychological and political explorations of the past would allow the individual to come to terms with it. As Wilhelm's fruitless efforts show, Hofmann demands more than an exploration of the past and the identification of culprits. He demands implicitly that old practices such as the violation of another person's humanity should cease, but he gives no glimmer of hope that this will occur. His verdict is therefore the starkest one imaginable: with the Holocaust and its manifold practices of destruction beginning with the most insidious denunciations, and with the continued violation of another person's humanity in the present, the world as a human universe has ceased to exist.

The apocaplyptic mood evident in West German thinking at the time *The Denunciation* was published was one that Gert Hofmann shared. Anton Kaes, a scholar of German postwar film, sees in this concern with the apocalypse an expression of hope for a fresh start.

> It would be worth speculating whether the obsessive preoccupation with the apocalypse and the imaginary anticipation of the end of the world in the 1970s and 1980s does not express Germany's subconscious wish to eradicate its traumatic past once and for all. The longing for the apocalypse and the end of history may be provoked by the utopian hope to begin once more, to create a pure moment of origin that is not contaminated by history.[11]

For Gert Hofmann, such a hope does not exist.

Restitution of Personal Identity?

Alfred Andersch, Peter Härtling, and Gert Hofmann

Germans cannot think of anything to say with respect to the victims.[1]

In *weiter leben,* an account of her youth (which included deportation to Theresienstadt and Auschwitz), the literary scholar and Holocaust survivor Ruth Klüger points to a particular aspect of the huge gulf separating Jews and the perpetrators of the Holocaust. She says:

> As so often happens when several Jews sit around a table, we started to speak about the great Jewish catastrophe. It strikes me that the questions Germans discuss in such conversations concern the perpetrators, while Jews want to know more about the victims. Germans cannot think of anything to say with respect to the victims, except that they were at the mercy [of the Nazis] (96).

When one looks at postwar West German literature, including the examples so far discussed in this study, one finds, in apparent contradiction to Klüger's observation, various references to Holocaust victims. In these instances, it is important to take note of the narrative strategies: How are the victims portrayed? What events have the authors chosen to depict? What perspectives predominate, and where, say, does the text contradict itself? Then the German silence that Klüger takes note of begins to resonate with complexity.

Postwar German literature does not lack for Jewish characters. In fact, there are enough to have prompted overviews and even arrangements into typologies. In an article based on her dissertation, the literary scholar Nancy Lauckner classifies Jewish characters into such categories as "the refugee," "the victim," and "the child as victim."[2] In relation to "the victim," she observes: "Many authors react philosemitically to their Jewish victims, which frequently causes such characters to be idealized, unrealistic and out of character [*verfremdet*]," but notes that "the best novelists avoid such idealization and melodramatization by combining literary realism and symbolism; they create credible figures and situations yet endow them with some symbolic value." But "symbolism" and "symbolic value" are precisely what obfuscate the specificity of Jewish existence, circumventing it as carefully as does philo-Semitism. When the prominent scholar of Jewish studies Sander Gilman writes about "Jewish Writers in Contemporary Germany," he includes in his assessment the critical examinations of these works and dismisses as "hopelessly utopian" two studies that analyze Jewish characters in postwar fiction.[3] In a different context, Ruth Klüger, writing under her married name of Ruth K. Angress, concedes rather caustically that "Jewish characters occur in German post-Holocaust fiction more frequently than one would expect, considering the dearth of actual Jews in Germany,"[4] and follows this comment with a pithy analysis:

> [These characters] are derived not so much from observation or a study of Jewish history as from two sources, the tradition of anti-Semitism on the one hand and unresolved guilt feelings about the Holocaust on the other. The two trends seem to be opposite, but they are really two sides of the same coin, as brutality is so often the flip side of sentimentality. And they can both serve the same function of self-gratification by providing a sense of superiority towards those who are presumed to be weak or morally deficient (215).

What criteria then should gauge the assessment of whether or not a Jewish character has been presented by a non-Jewish German writer in a manner that avoids "self-gratification" or circumvention through "symbolic" representation, or uses narrative strategies ranging from obfuscation to wishful or "utopian" thinking? The literary critic Klaus Briegleb offers this list of specific questions:

> [W]here do the Germans draw the line between a nonchalant politics of language (pacification, role reversal, laziness in investigating problems, historic lie) and literary quality (making the Shoah present through the physical embodiment of characters and through alerting consciousness to the problems based on language and literary method-

ology instead of a falling silent exactly when Jews and their annihila-
tion are concerned)? Where, in German texts written by Jews and Ger-
mans, lie the differences that thematize the Shoah? . . . To what extent
is it taboo for a German to fantasize a Jewish existence, during and
'after' annihilation?[5]

Some of Briegleb's questions go beyond the limits set for this study.
But his demand to make "the Shoah present through the physical em-
bodiment of characters" is relevant to our inquiry and relates to
Angress's comment on the absence of Jewish characters based on "ob-
servation or a study of Jewish history." And Briegleb's last question—
ought a German author to "fantasize" about Jewish sufferings and to
what extent is a German author able to imagine such an existence—
will need a specific answer.

A related demand was voiced earlier, in 1980, by the literary scholar
Andreas Huyssen, who called for an "emotional identification with the
victims as Jews," and held that emotional identification would elicit true
"mourning."[6] Without such mourning, Huyssen observed, even "genuine
attempts to come to terms with the past" would feed into "facile breast-
beating . . . often coupled with denials of personal guilt or shame" (112).
The call for an emotional identification with the victims *as Jews* was reit-
erated by Eric Santner, who insisted that "the capacity to feel grief for oth-
ers and guilt for the suffering one has directly or indirectly caused depends
on the capacity to experience empathy for the other *as other*."[7] This is a
radically different position from the one adopted by perpetrators who have
tried to identify with the victims because they see themselves, too, as
having been "victimized" by the Nazi apparatus; instead of grieving for
the other, they feel sorry for themselves.

In his discussion of American postwar literature, the noted literary
historian Guy Stern establishes the absence of empathy with Holocaust
victims as a significant expression of a persistent anti-Semitism—one
that holds equally for postwar German literature:

> Silent literary anti-Semitism is therefore—at least to my mind—de-
> fined by an omission of a declaration of sympathy for Jewish suffering.
> The Jewish suffering should at least be mentioned in passages where
> an omission would strike a neutral reader as a palpable gap in a liter-
> ary work.[8]

The historian Robert Moeller takes issue with the depiction of Jewish
victims as "objects, not subjects, of their own history, a history never
told from their perspective." Alluding to the Germans' "inability to

mourn," Moeller notes that their historical memories are "selective"—
or, rather, operate on two tracks: echoing Ruth Angress's earlier observa-
tion, he finds that Germans have little to say about those parts of the
"horrifying totality" of the Nazi regime in which they were perpetra-
tors, but are quite forthcoming about their own experiences as victims.[9]

Yet another point of view is voiced by the historian Eva Kolinsky in
discussing a survey of German history textbooks. While the writing of
history and of fiction take different narrative approaches, Kolinsky sees
the goals of both in similar terms. Her primary concern is the appropri-
ate manner of remembering the Holocaust. She states flatly that "men-
tioning Auschwitz cannot be equated with remembering" and believes
that "teaching about the Holocaust and about Auschwitz needs to go be-
yond the facts and figures of conventional historiography and generate a
sense of personal relevance."[10] One must find words that "communi-
cate something of the suffering inflicted by that system on the human
beings it branded as victims." Kolinsky approvingly quotes the scholar
Werner Habel and his call for "a restitution of personal identity" to the
victims of Nazism, since "National Socialism . . . extinguished the indi-
viduality of its victims." And she agrees with him that as "a prerequisite
of remembrance, the collective reference to Jews and other social groups
deemed separate from German society has to be reversed by rescuing in-
dividual life stories from the nameless millions of victims." "Making
present" or "making relevant" this suffering, feeling grief, and returning
to the victims their status as subjects of their suffering and of their his-
tory are prerequisites for an appropriate remembering.

Fiction as the proper province of the imaginatively projected lives of
individuals gives wide berth to "rescuing individual life stories." Are
there works in postwar German literature that attempt a "restitution of
personal identity" based on, in Huyssen's words, "an emotional identifi-
cation with the victims as Jews?" Does the literature portray instances in
which the victims are subjects, not the objects of their own suffering?
Can it "fantasize a Jewish existence, during and 'after' annihilation," as
Briegleb asks? Is there indeed, as Briegleb states, "a falling silent exactly
when Jews and their annihilation are concerned?" and can the silence ex-
pressed in the "omission of a declaration of sympathy for Jewish suffer-
ing" be seen as Guy Stern sees it—as a form of literary anti-Semitism?

Three postwar German novels that have Jewish protagonists and are
written by non-Jewish authors will be discussed in the light of these cri-
teria. Common to all three is the fact that the Jewish protagonist gives
the novel its title. One may therefore infer that the three authors strove
deliberately to "restitute personal identity."

Alfred Andersch

Born in 1914, Alfred Andersch spent as a young man, in 1933, six months in the concentration camp at Dachau for his Communist leanings; opposed to the Nazi regime, he deserted from the German army in 1944 and became a U.S. prisoner of war. In the immediate postwar years, he was a prominent literary figure, co-editor of the important but short-lived periodical *Der Ruf (The Call)* and cofounder of Group 47. Disillusioned with postwar Germany's exclusive focus on economic reconstruction, he left Germany in 1958 and moved to Switzerland. He began to write *Efraim's Book* at the start of the Auschwitz trials, in 1963, and published the novel in 1967, two years after their conclusion.[11] The narrative time stretches from the fall of 1962 to the summer of 1965. The Jewish protagonist and narrator, George Efraim, born in Berlin in 1920, was able to flee the Nazi regime for England in 1937 and live with his uncle, while his father perished at Theresienstadt and his mother at Auschwitz. After the war, Efraim travels the world as a reporter and at the beginning of the novel is on assignment to investigate the mood in Berlin in the wake of the Cuban missile crisis. This is Efraim's first return to Berlin since his departure as an adolescent a quarter of a century earlier. He decides that this assignment is only a front, since Keir Horne, his editor, who recruited him as a journalist in Italy during the war, has charged him with a personal mission: Efraim is to discover the fate of Keir's natural daughter Esther, who was Efraim's childhood friend and whose mother, the Jewess Marion Bloch, died in Auschwitz.

Critical reception of Andersch's novel was divided into two camps, and this division is itself of interest. Hans Schwab-Felisch of the periodical *Merkur* gave it an existential, largely positive reading, seeing it as centered on "a major theme of contemporary literature—the problem of identity."[12] Ignoring the specific identity and situation that Andersch had created for his protagonist, Schwab-Felisch concentrated his musings on concepts such as "freedom, chaos, fate or accident, truth or puritanism." The fact that Andersch wanted to situate Efraim in the problematics of a post-Holocaust Jewish existence was not acknowledged—though it was for this very reason that Andersch was awarded the Nelly Sachs Prize of the city of Dortmund in the year the novel was published, at the suggestion of the poet and Jewish refugee from Nazi Germany, Nelly Sachs.

Alluding to other reviewers' avoidance of discussing the Jewishness of Andersch's protagonist, the prominent literary critic Marcel Reich-Ranicki began his devastating review of the novel by asking why so many of the reviews were so "very friendly, decidedly respectful, in part enthusi-

astic" and why those who felt otherwise kept silent.[13] He suggested the answer lay in the fact that "Andersch has a German Jew tell the history of his life." After indicting the reviewers, Reich-Ranicki takes Andersch to task for bathing his protagonist in an "unfortunate, sticky-sweet philo-Semitic aura" and for trading in clichés and "pure Kitsch." He sees the novel as "insignificant," "frighteningly poor," "actually embarrass-ing," and bluntly asks whether Andersch had the right to "judaize" his protagonist. (He answers his own question by saying that novelists are allowed to do anything they can pull off, but that Andersch did not suc-ceed in pulling it off.)

Almost two decades later, in her article of 1985, Ruth K[lüger] Angress surmises that the novel, coming after the Auschwitz trials, "is itself an act of restitution" and was "almost certainly conceived as a gesture of philo-Semitism." She concludes that "it is probably fair to say that this novel exemplifies serious and superficially conscientious German ef-forts to come to terms with what the previous generation inflicted on their Jewish fellow citizens" (219–20). The combination of "serious" (which acknowledges the intent) and "superficially conscientious" (which comments on the manner of executing the intent) identifies more persuasively than Reich-Ranicki's remarks the spirit in which the "efforts" were carried out. She takes issue with the fact that the "vil-lain" of the story—Efraim's editor, who did not save the life of his half-Jewish daughter when he was urged to do so by bringing her to England—was an Englishman, while those who risked their lives to help the young girl were German nuns. She faults the presentation of all Ger-mans in the novel as concerned with the Nazi past "in an appealing, soul-searching and intense way;" she comments on the absence of "for-mer Nazis or sympathizers" (220) and on instances in the novel that "serve to deflect from the fact that Nazis were real people and real Ger-mans" (222); and she devotes particular attention to Efraim's confused "philosophy" that inquires into fate versus accident as determining fac-tors in a person's life. Angress is right when she objects to "Efraim's as-sertion that all groups are equally vulnerable" to blows of fate, since "Andersch thereby blurs the circumstances [of the Jewish catastrophe] and diverts from the rabid anti-Semitism, that caused Jews to be . . . de-ported" (221) and she passes a final judgment on the "superficially con-scientious . . . efforts" in her verdict that the "very evasiveness of Andersch's novel seems to me open to censure" (222).

Yet why would a "serious" effort undertaken by a presumably serious writer so spectacularly misfire? Is the novel, despite its "serious" and "conscientious efforts," a "superficial" document of goodwill and moral commitment that, "considering the dearth of actual Jews in Germany,"

can only indicate the author's ignorance of the history and suffering of the Jews? Did Andersch assume that as an alienated intellectual he had the necessary empathy to create a more profoundly uprooted and exiled intellectual? What blind spots on the map of the author's unconscious assumptions are revealed in these "superficially conscientious . . . efforts?" Or what does it say about the author if his character remains a construct, devoid of personal dynamics, a subject speaking about the events in his life as if they belonged to an object? All these objections to the novel are valid and cannot be argued away; but a different approach may show not what Andersch wanted to do—namely, to present "the theme of a German-Jewish intellectual," an attempt in which he failed—but what he in fact accomplished.

The structure of *Efraim's Book* is extremely complex. The beginning of the narrative, Efraim's arrival in Berlin on October 26, 1962, coincides with his decision to take notes. The narrative time frame of the novel encompasses the period from the Cuban missile crisis of October 1962 to the summer of 1965. Inscribed in this time frame are the situations and events that Efraim experiences and comments on. There are also many flashbacks into the deep past and from these vantage points there occur further flashbacks and occasional flashforwards.The remembered time extends in a sweep back to his childhood and encompasses significant way stations of his life, but the scenes are not recalled in their chronological order and are often interrupted, although ultimately the fragments fit together like pieces of a puzzle. After the initial arrival in Berlin, narrative time and narrated (that is recaptured and interpreted) time diverge. Inscribed in the narrated time, which encompasses the momentous events in Efraim's life, is yet another circle of time, representing the core of the novel: it is Efraim's brief sojourn of about a week in Berlin, during which time he tries to find out what happened to Esther. It takes Efraim the entire length of the narrative—some three years—to recount with many starts and interruptions this core period. One could say that Efraim had to write all the notes that constitute the novel before he could articulate what he learned during this week, and that he postponed saying something he knew from the beginning—from that early week in Berlin.

The apparent narrative chaos (in the form of frequent diversions, interruptions, ruminations on accidents, withholdings of information, manipulations of time, changes of locale, and so on) embodies the author's reflections of the narrator's shattered life. (The discontinuous episodes are, however, not presented as flotsam pieces of an inner self; they show Andersch's struggle to endow his character with personal dynamics.)

The apparent narrative chaos can also be read as the narrator's evasive tactics, designed to postpone addressing the core event. But a closer look at the deep structure underlying these diversions reveals yet a different pattern: the concentric circles of a descent into an inferno that at its nadir is shrouded in a silence from which haunted voices escape.

The novel begins and ends with phone conversations between Efraim and Keir Horne, which constitute the perimeter of the innermost circle—the Berlin episode—and are separated by roughly a week of the narrated time. Efraim has met Anna, an aspiring East German actress, the night before the first phone call (although he chooses not to recount this episode until later), and she suggests that Efraim visit Esther's former school for possible information. Esther becomes the central character, but as absence and silence.

Five years younger than Efraim, Esther was thirteen years old in 1937 when she disappeared (315). The choice of a child as principal victim lends itself easily to accusations of sentimentalizing (and leads to Reich-Ranicki's indictment of the novel as "pure Kitsch"), because it is no longer the horror of the situation that elicits (or should elicit) sympathy and identification but the fact that a child is made to suffer.[14] Andersch tries to avoid this sentimentalizing by working with the paradox that Esther's presence is more palpable through her absence. In Efraim's conversation with Esther's former schoolmistress, Mother Ludmilla, Esther comes alive as a refracted presence, not as a presence in her own right. Andersch can portray Esther and her predicament with an intensity that would indeed be sentimental if it were not filtered through this distancing device. In the conversation with Mother Ludmilla, Efraim even invokes Esther's little dog: "It's not possible that you didn't help a thirteen-year-old child who came to you with her little dog" (275). When Mother Ludmilla equivocates, he escalates the sentimental appeal, hoping she will contradict him: "You looked on as a child in tears, a child you knew well, walked along talking to her dog?" But Mother Ludmilla will not be pressured into giving him an answer. This image of the child and the open-endedness of Esther's fate beckon for an affective response. The very absence of an answer invites readers to provide their own. The length of narrative time it takes Efraim to articulate what he has found—namely, no information about Esther—serves to intensify their emotional investment in this search.

As a counterpoint to the affective if sentimentalized investment in Esther, Efraim includes in his notes two brief excerpts from testimonies made by witnesses during the concurrent Auschwitz and Treblinka trials. They occur in the very center of the novel and raise the question of

whether or not the novel was written just because of them. They are the only documentary excerpts in *Efraim's Book*, and must therefore be assumed to speak where the author's voice fails. The first statement, made by the witness from Treblinka, reads: "On at least one occasion SS-Man Küttner, known as Kiewe, flung a baby into the air and Franz killed it with two shots" (150). The second statement, made by the witness from Auschwitz, reads:

> We saw an enormous fire and men were throwing things into it. I saw a man who was holding something that moved its head. I said: "For the love of God, Marusha, he's throwing a live dog into it." But my companion said: "That's not a dog, it's a baby" (150).

In both statements, the horrifying acts are committed on children; in the second statement, there is also a connection between a child and a dog. There can be no doubt that Andersch chose these excerpts because they underlined his intention to speak out on this most sentimental subject: children. The laconic testimony abolishes the narrator so that the text can have its own devastating impact. Where Efraim is searching for one young girl with her dog and tries to individualize the despair of her situation, the testimonies describe abhorrent practices inflicted on the anonymous many. They speak with an authority and authenticity that are beyond Efraim's experience. They are the voices that cry out from the silence at the nadir of the inferno.

Efraim's Book is not a "restitution of personal identity." For that, it is too deliberate a construct. The heavily intellectual intent precludes emotional identification with the protagonist. The many ruptures and disjunctions seem artificial, because in the end the novel as it portrays Efraim attains resolution and closure. (Only Esther's fate is left open.) But if the focus is shifted away from Efraim to Esther as the central character of Efraim's undertaking, the different emphasis calls for a different interpretation. Then the novel is not an attempted—and failed—effort to restitute the personal identity of the protagonist, but addresses the crimes committed against the silent, absent children. In reaching out to the testimonies of the trial witnesses, Andersch suggests an image of abhorrence that reaches beyond the author's willed efforts and intention to write about "a German-Jewish intellectual." The critical assessments of *Efraim's Book* are not invalidated by the inclusion of these excerpts, but the enormity of silence these excerpts represent and the power of that silence add a dimension that leaves cliché, sentimentality, and philo-Semitic gestures behind and penetrates to a level of shock and horror for which Andersch had not found a language.

Peter Härtling

Peter Härtling is a prolific and well-respected writer and essayist who has also published children's books and poetry. He was born in Chemnitz in 1933; during the war the family relocated and then had to flee from what is now the Czech Republic. In the course of these dislocations, his mother was raped by a Russian soldier and later committed suicide and his father, a lawyer, died in a Russian prisoner-of-war camp. In novel after novel, Peter Härtling has almost obsessively been preoccupied with rewriting these traumatic events of his teenage years. In 1985, almost two decades after Andersch's *Efraim's Book*, he published *Felix Guttmann*. 1985 was a politically turbulent year. It marked the 40th anniversary of the end of World War II and the Nazi regime and, connected with its commemoration, the "Bitburg affair," in which President Ronald Reagan agreed, over much protestation in the United States, to honor with Chancellor Helmut Kohl a German military cemetery at Bitburg that also contained the graves of members of the Waffen-SS. By the time *Felix Guttmann* was published, the wave of autobiographical fiction had crested—a wave that included Härtling's own *Belated Love (Nachgetragene Liebe)* of 1980. The avalanche of autobiographical fiction again had proved Ruth Klüger's point: German writers were preoccupied with the perpetrators, but as far as the victims were concerned they could not "think of anything to say." Would the publication of *Felix Guttmann* serve as an exception to the general tide? Would it restitute personal identity?

Felix Guttmann is the story of an "unknown Jewish lawyer, born in 1904 in Breslau, who went in 1922 to Berlin to study law, could not practice after 1933 when the Nazis passed the law disbarring Jewish lawyers, who emigrated to Palestine in 1937 and returned, in 1948, with an Israeli passport to Germany."[15] The critic Wolfgang Pohrt, who reviewed the book for *Konkret*, took issue with this announcement, arguing that it promised a "juicy shlock novel along Holocaust lines and according to the principle of one-made-it-through."[16] (What is remarkable in this statement is not so much Pohrt's assessment of the novel as the tone of cozy familiarity with the Holocaust.) The novel's narrative structure is much less complex than that of *Efraim's Book*. There is a narrator (the author) who tells the partly fictionalized life of a German Jewish lawyer whom he meets in the postwar years and whom he names Felix Guttmann. The name casts the bearer in a very specific light: "Felix" means "the happy one," "Guttmann" is "a good man." The author's narrative time is 1984–85 and progresses in a linear fashion with only occa-

sional flashbacks to the author's own past. The narrated time, by con-
trast, spans Felix Guttmann's entire life, from his infancy in 1904 to his
death in a streetcar accident in 1977. In a coda the end of the narrative
and the narrated time coincide. Structurally, Härtling follows narrative
principles also employed in some of his other novels: he constructs from
the I-perspective of the narrator the life of a protagonist; as he reflects on
these constructions, he introduces a sense of uncertainty. Consequently,
the novel "plays" with the unreliability of memory; it constructs and
hypothesizes, and intertwines historical realities with those of fiction.
Thus, Härtling titles his first chapter "Remembrance of a figure which
he will not be." This ambiguity allows him to affirm what he states and
at the same time question what is said.

Up until 1933, Felix's life as a German Jew is unremarkable and, as an
example of German prewar novels of male adolescence, fairly pre-
dictable. He is a single, pampered child surrounded by attentive adults;
in high school he finds a best friend and has his first sexual encounters.
There are hardly any contretemps in this pleasant life, but those that do
occur serve to establish his "otherness." In one instance, little Felix de-
fends the possession of a grassy "island"—a strip of grass in a backyard
that serves surrounding apartment buildings; the other children grant
him the space, but they do not join him there. Indeed, one can read this
childhood as a subtle study in an almost imperceptible exclusion, which
makes of the child, who wants to play with all the children in his neigh-
borhood, a rather reclusive adolescent. By the time he has become a law
student in Berlin, his contacts are almost all with fellow Jews. The ex-
ceptions are two rather unsavory gentiles: one is his first love, an aspir-
ing and opportunistic actress; the other is an officer of the right-wing
militaristic *Freikorps*. The philo-Semitism in this arrangement is unmis-
takable. Felix's "otherness," which as a young child he does not compre-
hend, is never articulated; it is rather expressed in the silences and
distances of those around him. Here, Härtling shows great sensitivity to
the subtle and not so subtle manifestations of prejudice, and above all to
its effects on the psyche of a child in the formative years. Long before
the belligerent anti-Semitism of the 1920s, and at a time when German
Jews were proud to fight for the Kaiser, this childhood and adolescence
demonstrate the failure of German Jewry to become integrated into the
population as a whole—a failure due not to the Jews' reluctance to as-
similate but to the refusal of the dominant culture to accept them. In the
early childhood experiences of Felix, Härtling demonstrates that the
much-vaunted symbiosis between Germans and Jews did not exist and
was "never anything else than a fiction."[17] In Felix's adult years, this oth-
erness keeps him from joining any organizations (whether Communist or

Zionist), from establishing many close friendships, and from committing himself to long-term relationships such as marriage. As Mirjam, his lover and friend but never his wife, remarks: "You cannot get over the fact that you are a Jew" (132).

The advent of the Nazi regime and its anti-Semitic laws decimates the small group of friends Felix had been part of. As a lawyer forbidden to practice, he advises prospective German Jewish émigrés at the *Palästinaamt* (Palestine Office) in Berlin, and Härtling here offers distressing glimpses of Jews trying to leave Germany, of the panic and chaos of their lives, and of their occasional despairing efforts to drown their overwhelming anxiety in a hyperactive search for pleasure or some other form of distraction. One day, the ominous SS functionary Adolf Eichmann summons Guttmann to his office and interrogates him about his friend Casimir, a Communist. This is a clear warning and Guttmann leaves precipitously for Palestine.

At this point in the novel, the increasing horror of the political situation is matched by a growing delusive optimism. When he visits a Zionist camp near Berlin, Guttmann, according to the narrator, thinks: "He found himself at a place where Hitler did not rule, where fear was driven out and hope was inculcated, where young women and men learned in workshops and in the fields for a future they called Palestine" (259). Similarly, there are no problems with Guttmann's papers, transit visa, and the like, and in no time at all he finds himself on a boat bound for Palestine. The boat is old, but his flight is without obstacles.

The years from 1937 to 1948 are omitted from the narrative, since the narrator/author professes to know little about Palestine. He says: "Before he enters his country, I leave him. I do not know it well enough" (284). This sentence is astonishing in its colossal obtuseness. Why should Palestine and not Germany be Guttmann's country? In his review, Pohrt singles out this "scandalous sentence" for legitimizing "persecution and expulsion by turning the refugee into someone returning home." The same thoughtlessness and lack of sensitivity are evident when the author has Guttmann wonder: "Why must we pay for the fact that we are leaving a country in which we were born and raised, worked, lived and loved, and brought up our children? Simply because there are some who suddenly understand themselves as a race" (262). The question is doubtless meant to be incisive, but it is curiously mellow. "Why must we pay" hardly expresses the sense of outrage and indignity and very real impoverishment that the escaping Jews must have felt. "We are leaving" conveys none of the panic or the absolute necessity of flight, to say nothing of the difficulty of getting out at all. And only a non-German would refer to Germany as "*a* country," instead of "*my* country."

Putting this locution in a Jew's mouth portrays him as having no allegiance to his country and reinforces the stereotype of the Jew as eternal wanderer. "A country in which we were born and raised, worked, lived and loved, and brought up our children" is a long circumlocution that avoids the obvious "our country," and underscores the temporary quality of the stay; and "simply because" carries no sense of the viciousness and magnitude of an officially instituted anti-Semitism.

When the narrator/author tries to explain why he skipped over the decade that Guttmann spent in Palestine by saying "I do not know [his country] well enough," he undermines the authenticity of Guttmann's life story. If the narrator meant to transcribe Guttmann's account, surely he would write down whatever Guttmann chose to tell him about Palestine, just as he wrote down what Guttmann allegedly told him about Berlin. If Guttmann did not tell him anything, then that ought to be part of the narrative. The narrator makes it too easy for himself when he simply says: "I have never asked him about it" (255), or "He avoided speaking about it" (255), or when he says: "Before he enters his country, I leave him. I do not know it well enough, and whatever he experienced in the ten years he spent here, I know only in pieces and I cannot imagine it" (284). The omission of the ten most crucial and painful years in the history of the destruction of the Jews demonstrates what Klaus Briegleb meant when he spoke of "a falling silent exactly when Jews and their annihilation are concerned" and convicts the novel in Guy Stern's definition of literary anti-Semitism as "an omission of a declaration of sympathy for Jewish suffering" when such an omission "would strike a neutral reader as a palpable gap in a literary work."

In 1948, Guttmann comes back, in American uniform, to a "destroyed" Germany.[18] He settles in Frankfurt and reopens his law practice. He remains an Israeli, but applies after a few years for German citizenship; he marries a woman from Berlin and dies in a street accident in 1977. His return to Germany suggests that Israel is to be understood as a place of exile, in apparent contradiction to the earlier statement that Palestine was "his country." There is no explanation for this highly unusual return to Germany, except that Guttmann longed for it (es verlangte ihn, 286). The passive verb form in German indicates not so much that it is Guttmann who makes the decision but that something in him "longed for it." Presumably his attachment to Germany (not to Germans, since he hardly knew any) overruled any other considerations. Even more curious is the comment that Guttmann "raved" about Germany on occasion "as if it were Atlantis" (10). Could it be that Guttmann suffered from a homesickness more powerful than a natural revulsion against a nation of Holocaust perpetrators? The narrator/author does not say, nor

is he interested enough in Guttmann to guess at his motives. Guttmann is similarly taciturn with respect to his impressions of life in postwar Germany. The author simply "assumes" (255) that Guttmann returned without fear of meeting those who had persecuted him and tortured and murdered his fellow Jews. Guttmann is "pained by the missed opportunities" for justice (255), although he "avoided debating the issue" (255). (One wonders what sort of debate there could be on this issue.) Is Guttmann's "avoidance of debate" a sign of resignation? Is his silence an admission of defeat on the part of Jews returning to Germany in the midst of the burgeoning Adenauer restoration? Or is this silence a silence imposed on him by the author, who does not care to "debate" the issue?

Why does Härtling want to write about a German Jewish life, when he recoils from the pain lived in such a life? In the opening page, he explains his attachment to Felix Guttmann: "I would never have admitted to him what I now say as an obituary: that he was my friend, even more, that after I went a long time without a father, he replaced my father" (9). Härtling creates in Guttmann the father he lost at the end of the war. His desire to fashion an ultimately harmonious world with a father in it is so overpowering that it can accommodate reality and historical events only selectively. The "truth" of *Felix Guttmann* lies not in the account of Guttmann's life but in the strength of the author's desire to fashion an acceptable world. This desire (or rather, need) is not simplistic enough to falsify facts outright; it is dressed in the cloak of memory and as such wanders freely across the terrain of uncertainties, reconstructions, fragments of a past long gone. The absence of painful events or their quiet, almost lyrical recounting stem from the author's overwhelming need to keep suffering at a distance. Thus, when he summarizes in one brief paragraph toward the end of the novel what happened to the people close to Guttmann, the tone is calm and the language full of softening euphemism.

> Mama died in 1939. Jona and Elena were brought to Theresienstadt in 1940 and from there deported to Auschwitz. They died in the gas. (*Im Gas kamen sie um.*) As did Olga. As did Miss Esther. Casimir took his own life in an internment camp in Southern France in 1940. The others escaped: Aunt Betty, Katja, Mirjam, Aaron Weiss, Sommerfeld (285).

Härtling's presentations are shallow because deeper probings would destroy his construction of a reasonably intact world. Surely Härtling knows that the Holocaust was more horrible than he intimates in *Felix Guttmann,* and perhaps for this very reason he is compelled to create a counterworld in which one dimly recognizes markers and pointers but is spared a fuller and more direct gaze. When Härtling commits Guttmann's

Palestine years to silence, he invalidates his own efforts to reconstruct a Jewish life and signals that his interest lies elsewhere. Since he wants to becalm the horrors of the Holocaust, a Jewish father-substitute is more effective than a non-Jewish father-substitute. The Jewish father's presence keeps the knowledge of the Holocaust alive, but since the father survived and returned, there is no need for unsettling information. The crimes of the Holocaust have been "forgiven" when Guttmann returns; and Guttmann's act of sharing, of telling the narrator sufficient details about his life so that the narrator can write them down, constitutes yet a further act of forgiving. The immensity of the Holocaust serves in this novel to show the miracle of the father's survival and the magnitude of his forgiving. Guttmann matters *because* he survives, returns to Germany, befriends the author, becomes his surrogate father, and forgives whatever needs to be forgiven.

The novel, then, is not a "restitution of personal identity" but a peculiarly fantasized account of Jewish survival, acceptance, and forgiving. In its expression of the need for a harmonious world with a surviving, forgiving father, it shifts between philo-Semitic portrayals and an underlying lack of interest that can be viewed as anti-Semitic. In his overriding desire for a Jewish father and his forgiving, Härtling insults Jewish suffering; his omissions and euphemistic evasions speak loudly of his own interests and the purpose for which he invented a Jewish existence.

Gert Hofmann

Like Peter Härtling, Gert Hofmann reenacts the trauma of his wartime childhood and adolescence in many of his novels. They were born within a year of each other (Hofmann in 1932, Härtling in 1933) and in close geographical proximity (Härtling in Chemnitz, Hofmann in Limbach, not even 15 miles distant). In novel after novel, both go back over the same nightmarish terrain, but where Härtling needs to fabricate a counterworld of wish fulfillment, Hofmann allows the trauma to emerge in all its devastating force.

In distinction to *The Denunciation, Veilchenfeld* widens the perspective to examine the genesis of postwar denial and silence, and includes a whole range of collaborative behavior, extending from shamed resignation and unadmitted knowledge, through indifference and silent complicity, to opportunistic kowtowing to the Nazis and vicious harrassment of the Jews.[19] Whereas in *The Denunciation* a fragile, elderly Jew was a background figure that nevertheless determined the perspective, in *Veilchenfeld* a similarly fragile, elderly Jew occupies center stage. As in

The Denunciation, ruptures, fragmentation, silence, and the victims' presence-as-absence dominate a complex narrative.

The protagonist in *Veilchenfeld* is "Bernhard Israel Veilchenfeld," professor of philosophy at the University of Leipzig. After his dismissal from the university, Veilchenfeld "retires" in the narrator's small town. With few and carefully arranged exceptions, Veilchenfeld never acts or speaks directly: he is presented only as perceived by others; when they "forget" him, he does not exist. The narrator is a young boy named Hans, who observes Veilchenfeld with voyeuristic curiosity. Hans is intelligent, coolly detached, minutely observant, and from a child's naive perspective uncovers the inconsistencies and lies in the adults' lives. His narrative voice encompasses the voices of those around him; he combines their opinions and silences with his own observations, misunderstandings, and misinterpretations, and with his own versions of what he is told to do, to think, to feel. Since Hans does not witness all that he tells us, but repeats (most frequently) his father's accounts of what the father has heard or witnessed or is thinking, there are many levels of "stacked" discourse—discourse within discourse, discourse grafted onto discourse, frequently open-ended, unfinished. His voice is the accumulation of fragments and disjoint pieces of information from his parents and the townspeople, adding up to a sea of contradictions that he learns to navigate. Disingenuously, he repeats whatever he hears, all the while attentively watching the adults' unease, their mistakes, the instances that occasion their silences. Hans is shrewd and precocious but he is also a child who is receiving an education in duplicity, fear, and brutalization.

The profound and bitter irony in *Veilchenfeld* stems from the discrepancy of what Hans observes and reports and what the reader understands is happening. Veilchenfeld is a concern and frequent topic of conversation in Hans's home and among the other adults of the town. As they form an increasingly threatening and impenetrable circle around him, Hans registers Veilchenfeld's gradual diminution: the space in which Veilchenfeld can move is increasingly constricted; he is losing weight and his body is shrinking; he is subjected to cruel practical jokes; he is physically abused by Nazi hoodlums, and by the police when he complains; his apartment and his books are vandalized; his passport is torn up; and finally he commits suicide, for which Hans buys the poison. As Veilchenfeld shrinks, his appearance deteriorates, as does that of his apartment (first through lack of a housekeeper, then through vandalism). Hofmann is careful to show that in this deterioration the victim is blamed for the damage. He is to blame for the hoodlums' attack on him, since he should not have been out at midnight (though midnight seems the only time safe for him to walk to the mailbox). His scars and wildly

cropped hair, the result of the hoodlums' attack, make him look violent, so that the townspeople can now say they are scared of him and can further ostracize him. Confronted with the animosity and indifference of an entire town, he still wants to restore a measure of order to his life and maintain his dignity. He fights back with the actions available to a believer in the inviolability of the law: he goes to the police to complain about the assault, only to be further abused.

The narrated time of *Veilchenfeld* extends, with a few flashbacks into a deeper past, from winter of 1936 when Veilchenfeld arrives in the small town in Saxony to his suicide on September 18, 1938. While the child's time is subjective, highlighting only the overheard conversations and the infrequent contacts with Veilchenfeld, the events occur chronologically in a merciless sequence determined by the Nazi laws designed to ostracize, humiliate, and, in Jean Améry's anticipatory sensitivity, to murder the Jews. Hofmann, with precise knowledge of their issuance, uses them as the invisible grid on which to chart Veilchenfeld's demise. These laws also make clear that the attacks on a single individual can be seen as emblematic of the ostracism and barbarities visited on all Jews.[20] This general validity is stressed when names are mentioned of citizens who have already left or are trying to leave the country.

Hans's father is a physician and World War I veteran. Despite many good efforts on his part, his attitude toward Veilchenfeld is ambivalent. He speaks up for the professor when an acquaintance wants to "blame the victim"; he walks home with Veilchenfeld when he encounters him in town, although they take side streets; he seeks out and reprimands the head of the town's waterworks, who as a "joke" has turned off Veilchenfeld's water in the heat of August; he is not intimidated by the racial laws and continues to treat Veilchenfeld for a heart ailment even after he receives an official notice enjoining him "no longer to take care of the patient Veilchenfeld, because of assumed hereditary diseases" (118). But he is pessimistic about Veilchenfeld's chances of being able to leave Germany, and there is a deep irony in the fact that as a physician he treats Veilchenfeld for his heart condition but that as a citizen he sees suicide as Veilchenfeld's only option left. Early on, he invites Veilchenfeld to his house for dinner. During the dinner, the boy notices that

the good stew that Mother had fixed steams into his face, so that beads of sweat run down his cheeks, which he wipes away with the back of his hand so that they do not fall into his plate. Until I suddenly realize that these are not beads of sweat at all, but tears. Indeed, here sits Mr. Veilchenfeld and cries into his soup! (24)

The child is astonished but spends no time wondering why Veilchenfeld is crying. He registers his mother's embarrassed reaction to Veilchenfeld's tears, and he understands that she does not want to know the reason for the tears:

> But Mr. Veilchenfeld, there is no need for you to get so excited, said Mother and wagged her finger at him. Wouldn't you rather tell us: How did you spend the winter?
> Well, somehow, says Mr. Veilchenfeld and wants to add something, but then there is nothing.
> It is completely natural that we invite you, says Mother and puts her hand on his arm. And it will not be the last time either. Right? she asks Father.
> No, not the last time, says Father, who has folded his hands in front of the good stew and wants to continue eating (24).

The abyss between the mother's clumsy, bright patter and Veilchenfeld's reality cannot be bridged by polite small talk. In this nonconversation, Hofmann shows how language amounts to silence. Does Veilchenfeld not want to burden his hosts with the knowledge of his situation? (But his hosts must know about his ostracism—why else would they invite him?) Avoiding an answer, Veilchenfeld spares the family a direct confrontation with his situation (which they, in all likelihood, would have denied anyway); he allows the mother to act as if "there is no need . . . to get so excited," and his hosts can go back to dinner as usual. When hoodlums smash one of the windows, the father breaks off the evening. He makes a show of searching his yard for the criminals, but (as Hans notices) avoids looking where he knows they are hidden.

The mother suffers from frequent colics that seem related to shame and concern for Veilchenfeld as much as to fear over contact with him. Out of fear she turns against him. Hans relates a conversation in which he indicts his mother simply by repeating what she says to him and his sister Gretel:

> As things are, you two should rather not speak with him anymore in the street, Mother always said when we had passed him.
> And to say hello, we asked Mother, should we still say hello?
> No, said Mother, not even hello. Rather we should act as if we did not know him, as if he no longer existed.
> And if he says hello?
> Dear Lord, cried Mother and threw her arms up in the air, he cannot be that tactless (9).

Hofmann here makes it clear that when people act "as if he no longer existed," soon thereafter he indeed will cease to exist, and he shows how

quickly the victim gets blamed so that the culprit can feel blameless. Here as throughout the narrative, the duality of "we" and "other" is maximized, yet in the entire narrative, the word "Jew" is never mentioned. This could be considered an avoidance of a clear mention of the Holocaust were it not for the constant, oblique references to the persecution of the Jews. There are stereotypical anti-Semitic invectives, as when the laborer Lansky complains that Veilchenfeld's nose is too big (131), and there are loaded and discriminating euphemisms, as when the question arises of whether or not a housekeeper can be found to "do the dirty work for *someone like that*" (94). When Hans's little sister wants to know how Veilchenfeld thinks, Hans again coolly indicts his mother by quoting her prejudices: "He simply thinks differently, she says. And how, asks my sister, how do we think? Like everyone else" (15). When another family, the Hirsches, have left, it appears that "soon we will be among ourselves" (100). When "relocation" is imminent, those identified as "others" lose even that designation and vanish into utter namelessness before they are murdered. As the whole street wonders why Veilchenfeld has not yet been "relocated," Hans slips into his neighbors' language and repeats the testimony to their inhumanity when he explains: ". . . because they don't have enough of them together yet so that the load pays off" ("*weil sie . . . noch nicht genug zusammenhaben, damit sich die Fuhre auch lohnt,*" 146). By not using the word "Jew," Hofmann shows how Jews have become nonpersons even before they are annihilated; he also forces the reader to pay attention to the victim's humanity rather than his ethnicity, and thereby emphasizes the utterly arbitrary and irrational manner of mistreating the victims.

Veilchenfeld is the increasingly silent and increasingly absent center of the town, which moves around him in a choreography of hunters out for the kill. Hofmann introduces a cross section of the town's population as they ostracize Veilchenfeld. He gives most of the people names and introduces them with brief biographical sketches to identify them as individuals responsible for their words and actions, so that they cannot disappear into the anonymous crowd of those who would later plead ignorance about the annihilation of the Jews. Their attitudes range from the most vituperative and vicious anti-Semitism to a pained avoidance of Veilchenfeld induced by fear. In line with earlier theses on anti-Semitism, Hofmann locates the most pernicious anti-Semites in the lower classes, particularly among lower-class young men, who despise Jews in order to buttress their own superiority and are secure in the knowledge that their harrassment and assaults and vandalism will not be punished, and he shows the collusion of low-level bureaucrats with the Nazi regime. But neighbors, too, participate: When the adolescent criminals

come to destroy Veilchenfeld's apartment, the neighbors accost them, but mostly to make sure that the target is Veilchenfeld and not themselves. Some of them even start to argue the next morning about exactly what time Veilchenfeld's apartment was vandalized, indicating that they all knew what was going on and watched it (130–1). At numerous points in the narrative, people could have stepped forward in support of Veilchenfeld or to protect him, and Hofmann makes sure that these inactions and omissions are noted. But he also shows how fear begins to assert itself, imposing silence on those who are not supporters of the regime. Hans witnesses a scene in the milk store, where Mrs. Schellenbaum speaks of the sleepless nights in which she hears screams coming from the cellar of the town hall, where people are locked up and beaten. When Mrs. Übeleis counters that "nobody here gets locked up on suspicion only," Mrs. Schellenbaum immediately backs off, murmuring: "Well, perhaps I am wrong, perhaps I only imagine it," whereupon Mrs. Übeleis presses her point even further: "One should not imagine something that horrible" (52–3). On a different social level, there are Veilchenfeld's former colleagues and acquaintances from the university, and the "hundreds of students" he taught in a career that lasted over forty years (25), all of whom have discontinued their contact with him. There is a distinction between the vociferousness of the thugs, who in the postwar years will hide behind denial or a profession of obedience to orders, and the language of other groups, where silences, evasions, and fear-induced euphemisms are the norm, but who were just as instrumental in delivering the "other" into the hands of the Nazis. Here, Hofmann exposes the roots of the different kinds of silences in the postwar era: the recalcitrant silence of the perpetrators and fervent followers, and the shamed silence of those who knew all along but did not help, out of "too much obedience and too little civil courage."[21]

When Veilchenfeld learns that he has no recourse to legal or official means, he asserts the only values that under the present circumstances cannot be taken from him: his self-esteem, his dignity, and control over his own life. Yet the two examples of this assertion are symbolic prefigurations of the Holocaust and are loaded with profound ambiguity. After Veilchenfeld's abuse, he burns his soiled clothes in his kitchen stove (66). Since the clothes are wet and the air is sticky, the fire does not catch but only smolders, "so that suddenly, by the end of the night, an enormous dark and foul-smelling cloud stood above the house of Herr Veilchenfeld" (66). The "stink" (*Gestank*) of this cloud hovers over the town and can be read as an indictment of the town's acts toward Veilchenfeld, obvious to all. But this image is also an ominous prefiguration of the chimneys at the death camps, where not the clothes (those

would be saved) but human beings will be burnt. The ambiguity of this scene lies in the fact that it is Veilchenfeld, the victim, who stokes the fire as an act of purification and to destroy the vestiges of his degradation and humiliation. The second example builds on a similar ambiguity and occurs when all venues for Veilchenfeld's departure to Switzerland have been blocked and deportation is the only exit left: at this point, Veilchenfeld takes control of his life away from the executioners by committing suicide. Yet like the burning of his clothes, where the act of purification necessitated action on the part of the victim and foreshadowed a much greater catastrophe, his suicide as an act of control over his life destroys him and realizes his executioners' goal. In both instances, destruction by his own hand is his only option. The ambiguity of a situation in which the victim, in ostensible opposition to the persecutors, preempts the executioners' acts and has only one recourse—self-destruction—begs an enormous question which the book is not prepared to examine. Veilchenfeld's individual self-destruction as prefiguration of anonymous mass destruction builds on the realization that there were no alternatives for escape and survival.

At this point we come back to the initial question. Beyond any doubt, Hofmann has, in *Veilchenfeld*, restituted personal identity to a degree neither Andersch nor Härtling could manage. This is accomplished in the dual perspective that underlies Hans's intimate observations: guided by his contacts with his parents and the townspeople, he sees Veilchenfeld as "other," but he also, unknowingly, portrays Veilchenfeld's humanity and shows in concrete scenes what it meant to be a Jew in Germany at that time. Hans records Veilchenfeld's gestures and traces his movements. These movements are the subjective responses (for example, his tears at the dinner table or blinking at Hans when Hans is no longer allowed to speak to him) of an individual who gradually understands the inescapably deadly situation in which he finds himself. Hofmann shows that being treated as an object and an "other" is part of Veilchenfeld's subjective situation as an individual. The accuracy and poignancy of the details and the intensity of sympathy generated in witnessing the humiliation and crushing of an individual is in my opinion unique in West German literature.

Yet Hofmann has created as protagonist a kind, elderly gentleman who can easily generate sympathy; the protagonist is also unmarried and therefore relieved of the great burden of worrying about family and children. Even though suicide was a frequent occurrence, Veilchenfeld's death was for most Jews not an option, so that Veilchenfeld withdraws into himself at the very point where his relevance for the many should be stated.[22] He is an early victim, who dies during the *Sudetenkrise* and

before the Munich agreement in September of 1938. He does not witness the pogrom of *Kristallnacht*, the mandatory wearing of the Jewish star, or the implementation of the Final Solution. He dies during the town's folkloric festival (*Heimatfest*), whose fireworks Hans describes in a language that anticipates the disaster of war. Hofmann has, with fine-tuned sensitivity, answered Klaus Briegleb's question as to whether or not it behooves a German "to fantasize a Jewish existence, during and 'after' annihilation." He focuses on one individual victim's life and death in which suicide is still seen as a personal choice—removed from the anonymity of mass annihilation, though clearly foreshadowing it. He shows us the last gasps of self-defense, followed by a situation of utter hopelessness for the Jews; in his depiction of the population, Hofmann lays the groundwork for all the brutalities and atrocities to come; he reaches with symbols and prefigurations across the threshold into annihilation. But he does not cross the threshold. That is where the silence of the victims reigns.

Speeches and Controversies

On the one hand [is] the Jewish tradition that to remember is the secret of redemption and Santayana reminding us that to forget the past is to be condemned to repeat it. On the other side stand Cicero, Renan, Gladstone, and Churchill, who think that to forget should be as much a part of a nation's tradition as its memory of past glories.[1]

As the 1980s wore on, the prominence of literature in attempting to work through the Holocaust was challenged by more public expressions: political speeches on the anniversaries of events that occurred in the Nazi regime, academic controversies conducted in the media, demonstrations and protests. This chapter presents some of the political, academic, and literary debates; they demonstrate that the strategies of the language of silence continued to prevail even when the Holocaust was at the center of attention.

In the early 1980s, the last years of Chancellor Helmut Schmidt's Social Democratic government, a new *Tendenzwende* or change of tides started to take shape, gaining momentum with the election of the Christian Democrat Helmut Kohl in 1982. In fact, Kohl's election as chancellor was in itself an expression of this change, and inaugurated a more conservative period in which politicians and intellectuals began to speak publicly in terms of national pride. Kohl, a historian by training, wanted to establish historical continuity with a German pre-Nazi past, and two new museums were to be the visible symbols of this goal: the German Historical Museum in Berlin would present the national past; the House of History in Bonn would focus on the forty-year history of West Ger-

many. In his desire to encourage a more positive historical conscious-
ness among Germans, Kohl also sought to "normalize" and "relativize"
the Holocaust.

Although Chancellor Kohl never prevaricated on the Holocaust, his
public recognition of it was far less impressive than that of Chancellor
Willy Brandt, who had made an act of public contrition in 1970, when
he knelt at the site of the Warsaw ghetto uprising. Willy Brandt had, as
a young man, been a refugee from Nazi Germany. Helmut Kohl, born
in 1930, saw himself as the first federal chancellor of the post-Hitler
generation. In a breathtaking gesture of insensitivity and self-assertive-
ness, he chose Israel and a speech before the Knesset on January 25,
1984, to identify himself as one who "had the grace of late birth and
the fortune of a special family" and thus "could not be guilty"[2] of im-
plication in the Holocaust—an astonishing and ambiguous phrase,
since it stressed his noninvolvement while simultaneously suggesting
that he might well have been guilty had he been born earlier and that
he felt a certain solidarity with those who were not "graced" by such a
"late birth." In other words, it was chance, not choice, that had al-
lowed him to remain untainted by Nazism. He seemed to be saying
that no moral stand was possible for those not so "graced," thus im-
plicitly exonerating them. Moreover, the "grace of late birth" implied
that only the perpetrator generation had to confront the Nazi past and
the successor generations were mercifully exempt from it. Ironically,
this statement did not appear to bother surviving members of the per-
petrator generation; those who spoke out against it were of the succes-
sor generations.

Bitburg

For all his desire to create distance between his government and that of
the Nazis and to have West Germany recognized as an accepted member
of the world community, Chancellor Kohl was barred from participating
in the Allied ceremonies commemorating the 40th anniversary of the D-
day landings in Normandy. He was thus especially eager to welcome
President Ronald Reagan to West Germany on May 5, 1985, to com-
memorate the 40th anniversary of the defeat of National Socialism and
the end of the war in Europe. President Reagan's visit to Europe and
West Germany for these commemorations was a symbol of the Western
Allies' acceptance and acknowledgment of West Germany as a reliable
partner. The proposal that President Reagan visit the military cemetery
at Bitburg, which contains the graves of members of the Waffen-SS, pro-

voked many protests and petitions, largely from the Jewish communities in America and Germany but also from Congress. However, President Reagan did not bow to public and political pressure. As a concession, he went with Chancellor Kohl to lay a wreath and to speak at the concentration camp of Bergen-Belsen—a visit he had formerly declined—and then went on to visit the military cemetery at Bitburg.[3]

In the middle of the uproar over President Reagan's proposed visit to Bitburg and during debates in the West German Bundestag, Chancellor Kohl, in an effort to encourage the visit, thanked President Reagan for his "noble gesture" and said: "Reconciliation is when we are capable of grieving over people without caring what nationality they are."[4] Undeterred by the difficulties over the visit, he revealed his intention to obliterate the horrendous uniqueness of the Holocaust: the inclusiveness expressed in "grieving over people without caring what nationality they are" abolishes the distinctions between victims (of any nationality or ethnicity) and victimizers. In this statement, the Chancellor anticipated by a year the so-called Historians' Controversy of 1986, which would focus precisely on whether or not the Holocaust ought to be seen as an event unique in history.

There were, however, counterpositions. On May 8, three days after the Bitburg visit, Richard von Weizsäcker, President of the Federal Republic, delivered a speech to the Bundestag during the continued ceremonies commemorating the 40th anniversary of the end of the war in Europe and of "liberation . . . from the inhumanity and tyranny of the National Socialist regime."[5] This speech amounted to an unusually clear and direct public confession of the crimes of Nazism. The invocation was all-inclusive:

> Today we mourn all the dead of the war and tyranny. In particular we commemorate the six million Jews who were murdered in German concentration camps. We commemorate all nations who suffered in the war, especially the countless citizens of the Soviet Union and Poland who lost their lives. As Germans, we mourn our own compatriots who perished as soldiers, during air raids at home, in captivity or during expulsion. We commemorate the Sinti and Romany gypsies, the homosexuals and mentally ill who were killed, as well as the people who had to die for their religious or political beliefs. We commemorate the hostages who were executed. We recall the victims of the resistance movements in all the countries occupied by us. As Germans, we pay homage to the victims of the German resistance movement in the military, the churches, and trade unions, among others, communists and the public at large. We commemorate those who did not actively resist, but preferred to die instead of going against their conscience (59–60).

In distinction to Chancellor Kohl's efforts to situate the Holocaust within "the history of this century," President von Weizsäcker clearly argued for the uniqueness of the genocide; and though he thought that the execution of the crimes was restricted to a limited number of people, he suggested that there was widespread knowledge of the persecution of the Jews and apathy in the face of this knowledge:

> Hardly any country has in its history always remained free from blame for war or violence. The genocide of the Jews is, however, unparalleled in history. The perpetration of this crime was in the hands of a few people. It was concealed from the eyes of the public, but every German was able to experience what his Jewish compatriots had to suffer, ranging from plain apathy and hidden intolerance to outright hatred. Who could remain unsuspecting after the burning of the synagogues, the plundering, the stigmatization with the Star of David, the deprivation of rights, the ceaseless violation of human dignity? Whoever opened his eyes and ears and sought information could not fail to notice that Jews were being deported. The nature and scope of the destruction may have exceeded human imagination, but in reality there was, apart from the crime itself, the attempt by too many people . . . not to take note of what was happening (61).

Von Weizsäcker also broached the problematics of a legacy of guilt as it affected subsequent generations; harking back to Karl Jaspers's early considerations in *The Question of German Guilt,* he spoke of historical liability for all Germans and stressed the importance of remembering.

> The vast majority of today's population were either children [during the Third Reich] or had not been born. They cannot profess a guilt of their own for crimes that they did not commit. No discerning person can expect them to wear a penitential robe simply because they are Germans. But their forefathers have left them a grave legacy. All of us, whether guilty or not, whether old or young, must accept the past. We are all affected by its consequences and liable for it. The young and old generations must and can help each other to understand why it is vital to keep alive the memories. . . . We seek reconciliation. Precisely for this reason we must understand that there can be no reconciliation without remembrance (62).

As a public confession, the speech had a resounding impact. The crimes of the Holocaust were admitted, the burden of the legacy for the successor generations was acknowledged, and remembrance was instituted as a path toward reconciliation. However, the question of whether or not reconciliation was feasible—since reconciliation requires two

parties to agree—was not addressed. The Jews were not recognized as the partners who must be asked whether or not they are prepared to agree, and when von Weizsäcker said "we," he clearly did not think of the German Jews; his speech skirted the issue of the "inability to mourn"; the charge to remember was an exhortation rather than an affective undertaking.

Perhaps in response to the unfavorable international attention given to the Bitburg affair, the West German parliament passed barely a month later the law against the so-called "Auschwitz lie," which made it an offense to deny that persecution was suffered "at the hands of the Nazi regime, or at the hands of another system of violent and arbitrary domination."[6] The addition of "or at the hands of another system of violent and arbitrary domination" again draws attention away from the singularity of the Nazi perpetration of the Holocaust and relativizes it, but the very passage of the law is also evidence of the widespread attempts to deny its reality. The perceived need to respond with laws to situations that could perhaps be better handled by setting unambiguous examples savors of authoritarianism and recalls the ease with which laws were passed during the Nazi regime to harrass and decimate the Jews and, in the postwar period, to combat the terrorists and punish former "radicals."

Literary Disputes

In contrast to the Federal Republic's politicians, writers were free to express themselves unencumbered by concern for an electorate. It is therefore interesting to note that neither Günter Grass nor Heinrich Böll were able to speak on that anniversary with the kind of soul-searching thoughtfulness or the attempt to reach out that characterized von Weizsäcker's speech. Günter Grass addressed his audience on May 5, in the studio of the Academy of Arts in Berlin. The title of the talk, "Freedom as a Gift," is an ironically phrased observation that the freedom from Nazism was a gift of the Allies, not an achievement the Germans had fought for. The tone of the speech is harsh and angry. Mixed with autobiographical reflections particularly of his formative, early postwar years, it is an indictment of both Germanies and a lament over the missed opportunities for a "different Germany." Where von Weizsäcker could speak unreflectively of the end of the war as "liberation . . . from the inhumanity and tyranny of the National Socialist regime," Grass delves repeatedly into the distinctions between victory, liberation, and defeat. Just as von Weizsäcker enumerated all those who had suffered at German hands, Grass specifies that May 8, 1945, meant

for Frenchmen and Russians, Dutchmen and Poles, Czechs and Norwegians, for concentration camp survivors, prisoners of war, forced laborers and emigrants who had had to suffer under German occupation and from the crimes committed by Germans, the final victory over fascism and liberation from the Germans for whom this day indicated above all military and ideological defeat; morally, in the political and religious sense, they had already unconditionally surrendered on January 30, 1933. . . . Therefore, the Germans were not liberated on May 8th, but defeated. Therefore they lost provinces; I lost my hometown. Of graver consequences yet: the Germans lost their identity.[7]

The speech presents an extended reckoning with the perceived misguided political paths taken in the postwar years and ends with a plea for pacifism. The crimes of the Holocaust are acknowledged, together with the realization that they can never be "mastered" or resolved. If there were Jews in Grass's audience, they heard his anger and shame over having been marked by such a history, but they did not hear concern for themselves as Jews. The Holocaust remained an intra-German matter.

[T]he immense crime summarized in the name Auschwitz is today, from the distance of forty years, more incomprehensible than it was in the hour of the first shock, when I saw and did not want to believe. Unmastered, not to be mastered, like a millstone this genocide hangs on us Germans, even on the successors, planned, executed, tolerated, denied, repressed, and yet openly visible (10).

In preparation for the same anniversary, Heinrich Böll wrote a "Letter to my Sons or Four Bicycles," which was published on March 22, 1985, in the liberal newspaper *Die Zeit*.[8] In this "letter," Böll reminisces above all about the privations that Germans suffered toward the end of the Nazi regime, both the army and the civilian population. He explains to his sons that many of his postwar mannerisms (e.g., his reluctance to throw food away, his tendency to hoard, etc.) originated in these hard times. Like Grass, he sees the interpretation of the end of the war and the Nazi regime as either "defeat" or "liberation" as the great intellectual divide. Like Grass in *From the Diary of a Snail*, Böll addresses his children. But where Grass wanted to educate them about the destruction of the Danzig Jewish community, Böll remains within the personal sphere, describing how he coped with the engulfing chaos at the end of the war. He does so in vivid, evocative images and scenes, full of his usual criticism of those in power during the Nazi regime and of the Nazis in power in the postwar years. Yet the Holocaust, which was at the root of Grass's desire to address his children, is in Böll's letter given short shrift.

After the war, after this war, I expected the worst: decade-long forced labor in Siberia or elsewhere; but then it was not really bad—only half as bad, when you consider what devastation the war had caused, and more so when you consider that without the German army, of which I was a member, not a single concentration camp could have lasted even for a year. And you should also know that the death rate for Soviet prisoners of war in German camps was 57.8 percent (81).

What strikes one in this admission of devastation wrought by Germans is the single focus on the war, as if what had happened elsewhere, on the home front, in occupied Europe, and particularly in Poland and Russia—that is, the Nazi regime in all its aspects—were of no interest. The expectation of punishment is an admission that the horrors perpetrated were so enormous that they deserved "the worst." (Here Böll touches on what was, in the immediate postwar period, a general sentiment—one that was soon, however, subverted in the cold war atmosphere.) This expectation of punishment evokes the notion of an outside agent who will administer it and assume the responsibility for seeing that it is justly meted out. Just as the Germans obeyed orders during the Nazi regime, they would now have submitted to punishment—in both instances being "good" citizens. One can here speculate that the absence of expressions of shame and guilt for the crimes committed during the Third Reich is due in part to the fact that they were never adequately punished. The Allies' mild treatment of the Germans was taken to mean that there was no great cause for punishment. This view, along with the realization that the cold war had made West Germany a valuable partner of the Allies, created a cynical and self-righteous mood that helped the postwar citizenry to repress all that was inconvenient to remember.

Böll mentions the concentration camps and the role of the German army in maintaining their existence. He does so in one dependent clause in a text of thirty-four printed pages. And in a dependent clause within that clause, he notes that he himself was a member of that army, without, however, noting what it was that he or the army did to preserve the existence of the camps. As on other occasions, it is not clear whether including himself in this army is an admission of complicity or an indication of *esprit de corps* and *Kameradschaft*. The next sentence turns to the Soviet prisoners of war. He speaks of their barbaric treatment in German camps and this then leads him into a lengthy indictment of their treatment, fueled by his profound affinity with POWs as underdogs. If one compares the space allotted to the concentration camps with the attention he accords the Soviet prisoners, one understands where Böll's true interests and affective responses are invested and gains a sense for

the difference between an intellectually honest acknowledgment and an affectively bonded affinity.

A few months later, in fall of 1985, a controversy that began almost ten years earlier came to a head when Rainer Werner Fassbinder's play *Garbage, The City and Death* was to be finally staged in Frankfurt/ Main.[9] The play presents a nameless "Rich Jew" who benefits from postwar real estate speculations in that city, and it has some of the characters use vile, anti-Semitic language. Several political and religious organizations, as well as the Jewish community in Frankfurt, condemned the play as anti-Semitic, while other groups demanded its performance as an expression of free speech. Discussions of the aesthetic merits of the play (there were none) further detracted from the core issue (whether or not anti-Semitic statements should be freely expressed). Conflicting opinions characterized not only the various political factions but also the Jewish participants in the protests and a sit-in, and cut across liberal-conservative and left-right boundaries. The discussions, protests, and the sit-in at the theater the night the first performance was scheduled had an effect—the play was taken off the bill, but only after much public furor.[10] A few months after Bitburg, where Jewish protesters had demonstrated, Jews in Germany again seized the occasion to take an active position on an issue that concerned them intimately, and they left no doubt that they would speak out whenever the situation called for it.

Ultimately, nobody disagreed about the anti-Semitic language in the play, but the focus shifted away from that issue to a question that had been simmering underneath a surface of silence—namely, whether the time had not come to "normalize" relations with Jews; this would mean abandoning the special considerations (*Schonzeit*) they had, presumably, so far enjoyed as a consequence of the Holocaust. The Fassbinder scandal served to bring to light issues that had been circumvented before, but there was no resolution. The political scientists Andrei Markovits and Beth Simone Noveck concluded their assessment of the Fassbinder scandal with a question:

> Does this so-called normalization, this right to break old taboos and criticize the Jews, reflect the development of an ideological democracy and flexibility or the emergence of ideological narrow-mindedness, rigidity, and the infiltration of public opinion by a new, socially permissible anti-Semitism?[11]

The Historikerstreit

In early summer of 1986, the Historians' Controversy erupted over the issue of the uniqueness of the Holocaust.[12] The controversy was primar-

ily an academic one, but since it was conducted in the German press a
larger public was drawn into it. It highlighted, in often vituperative lan-
guage, the polarity between those who sought to reestablish a sense of
German national identity, one in which the Nazi regime and the Holo-
caust would be seen as lamentable but also as over and done with, and
those who felt that the Holocaust had made the reestablishment of any
such emotional nationalist bonding impossible—and indeed that it was
just such bonds that the Nazi regime had been built on. There were
crosscurrents, of course, and overlapping views, but in simple terms the
debate was started when the social scientist and philosopher Jürgen
Habermas took issue, in an article in the newspaper *Die Zeit*, with the
revisionist tendencies in the writings of two prominent historians,
Ernest Nolte and Andreas Hillgruber. Ernst Nolte maintained that in
implementing the Final Solution Hitler was not the aggressor but rather
was defending the nation against its enemies, and he adduced as proof
Chaim Weizmann's declaration at the Zionist World Congress of 1938
that Jews all over the world would fight on Britain's side against Ger-
many. Moreover, Nolte held that the Nazi atrocities should not be seen
as unique in history, noting that the genocide had its predecessors in
Stalin's gulag and in the Turkish attempts to annihilate the Armenians.

If Ernst Nolte tried to place the Holocaust in relation to other, earlier
and presumably no less horrendous atrocities, thus removing the stigma
of unique barbarity from the Germans, the historian Andreas Hillgruber
lamented the "German catastrophe" and the "Jewish catastrophe" as
two components of the general "ruin" of Germany's position in Central
Europe. His book, *Two Kinds of Ruin: The Shattering of the German
Reich and the End of European Jewry*, received a respectful reading,
since Hillgruber acknowledged the complexities of the issues and raised
legitimate questions that needed to be answered. But its very title raised
questions of a different kind, opposing the forceful and emotive "shat-
tering" to a neutral and distanced "end."[13] It contrasted the "German
Reich" with a Jewry whose international status dissociated it from the
German nation. This dichotomy is maximized in the two parts of the
book. Part I, *The Shattering of the German Reich*, focuses on the "Ger-
man catastrophe": the expulsion of the Germans from Eastern Europe
and the hardships of the German soldiers on that front. Hillgruber writes
with considerable emotion—perhaps in part because he himself was one
of the expellees from former East Prussia—about the "desperate and sac-
rificial efforts" of the German army, during their retreat, to protect the
German population from "the vengeful advance of the Red Army, with
its train of savageries and deportations."[14] By contrast, part II, *The End of
European Jewry*, is cool, distanced, devoid of affect, and there is no plea

for an emotional identification with the fate of the Jews. The enormous difference in affective investment tells its own story. Moreover, Hillgruber fails to point out that the "Jewish catastrophe" was not self-inflicted, as the "German catastrophe" was. A focus on the sufferings of the German population does not make them victims in the same manner that all Jews were victims. The German "victims" in the East, whether soldiers or civilians, were not the targets of a systematic genocide but rather suffered the hardships of a merciless war and retribution for barbarities that the German military had first visited on the Soviet military and civilians. They were in a position to flee, and if they were lucky they escaped to the West. These opportunities were not open to Jews.

Foremost among those who argued for the continuing immediacy and relevance of the Holocaust to German history and German self-perception was Jürgen Habermas, who suggested, as a political bonding for Germans, not a renewal of nationalism but a "constitutional patriotism."[15] Habermas saw the great political achievement of the Federal Republic as its firm anchoring in the Western alliance, and in a rationalism that embraced "universalistic principles consistent with the notion of a world citizenship."[16] These ascetic principles had no place for concepts such as "nation" or "Volk" or "Heimat," which had been preempted and defiled by the Nazis and, as the newly emerging neonationalists would charge, had in effect been unduly tabooed. One of the far-reaching results of the Historians' Controversy was that national identity could be openly discussed and actually seen as desirable. Habermas's suggestions were deemed unsatisfactory by Ernst Nolte and other historians of the *Tendenzwende* who considered a national identity, in the words of the historian Richard Evans, "far more powerful than an identity based on loyalty to the Federal German Constitution."[17]

Ultimately, the *Historikerstreit* was fought over the control of history—over what interpretation of the Nazi regime and the Holocaust would best serve German self-perceptions. Charles Maier has perhaps best summarized what was at stake:

> The central issue has been whether Nazi crimes were unique, a legacy of evil in a class by themselves, irreparably burdening any concept of German nationhood, or whether they are comparable to other national atrocities, especially Stalinist terror. Uniqueness, it has been pointed out, should not be so important an issue; the killing remains horrendous whether or not other regimes committed mass murder. Comparability cannot really exculpate. In fact, however, uniqueness is rightly perceived as a crucial issue. If Auschwitz is admittedly dreadful, but dreadful as only one specimen of genocide—as the so-called revisionists have implied—then Germany can still aspire to reclaim a national

acceptance that no one denies to perpetrators of other massacres, such as Soviet Russia. But if the Final Solution remains non-comparable— as the opposing historians have insisted—the past may never be "worked through," the future never normalized, and German nation-hood may remain forever tainted, like some well forever poisoned. . . . So for both sides the controversy is one over current politics as well as past history. And because all participants have recognized that there can be no discussion of a national community without a confrontation of the darkest aspects of the national past, the controversy is also about the German future.[18]

Joachim Fest, advocate of "normalizing" German history, proposed a solution in a postscript to the controversy. If the thought of a nationhood "forever tainted . . . forever poisoned" had rankled the revisionists who provided the platform for neonationalists, Fest consigns this "forever" to the flow of history. The Holocaust will not be forgotten but be institu-tionally acknowledged at pertinent way stations in a future that is farther and farther removed from the Nazi past. Fest maintained confidently:

> [T]he process of historicization will continue. It cannot be stopped. Be-cause it has the most powerful imaginable force on its side: time. Not the time that makes you forget, but the time that leads from new kinds of questioning to a sharpened sense of morality. The fact that Haber-mas and his fellow travelers in a discourse guided by the dominant power constellations, not only plead for a static image of the NS-regime but also fight against the passing of time makes them the advo-cates of a hopeless undertaking.[19]

All these debates instrumentalized the Holocaust and fitted it into a wider view of German history—a view with a more self-assertive agenda. All participants in the controversy focused on German interests and tried to envision Germany's future and how Germans would deal with the knowledge of the genocide. The nature of silence was no longer one of repression or obtuseness but of disregard for the victims.

The Jenninger Affair

Two years later, yet another anniversary brought about fresh controversy and, in the ambivalent atmosphere surrounding public mention of the atrocities, caused a scandal. The occasion was the commemoration of *Kristallnacht*, the pogrom of November 9, 1938. The Jewish community commemorated that day in the synagogue in Frankfurt/Main; on the fol-

lowing day, Philipp Jenninger, president of the West German Bundestag, was the principal speaker at a commemorative ceremony in the Bundestag. The parliamentarians took offense with his speech, faulting him for failing to express, as expected, sentiments of remorse about the German past; but what upset them most—so much so that a great number of them left the auditorium during his speech—was his use of Nazi language. Jenninger used Nazi vocabulary in order to re-create the mindset that led to *Kristallnacht,* and he broke linguistic taboos that had raised a wall of silence around this language. He spoke, for example, of "Hitler's obsessive notion of the black-haired, hook-nosed Jew who violates the blond, curly-haired German woman with his blood."[20] The parliamentarians, used to institutionalized commemorations, heard and received these sentiments as Jenninger's own. The following paragraph exemplifies Jenninger's technique, where an initial declarative sentence is followed by a slide into the perspective and the language of the Nazis.

> While in earlier times Jews had been made responsible for epidemics and catastrophes, later for economic hardship and "un-German" activities, Hitler saw in them the ones guilty for all evil per se. They were behind the "November criminals" of 1918, [they were] the "bloodsuckers" and "capitalists," the "Bolshevists" and "Free Masons," the "Liberals" and the "Democrats," the "defilers of culture" and "corrupters of morals," in short they were the actual wire pullers and those causing all military, political, economic, and social disasters that had afflicted Germany (9).

Jenninger pierced the language of silence when he broke the taboos. Nevertheless, there are blind spots in his speech that show the persistence of silence even in one as seemingly outspoken as he. He refers, for example, to Hitler as if he were the only culprit ("Hitler saw in them the guilty ones" or "Hitler's atrocities and crimes"); his indictment of Nazi Germany is outspoken, as when he states: "Germany had bid farewell to all humanitarian ideas that constituted Europe's intellectual identity; the descent into barbarism was deliberate and premeditated" (8), but he can speak of Jewish suffering only by quoting someone else and has no words at all to express sorrow for the victims. Jenninger offended all those who wanted to demonstrate their distance to the past by eschewing its language and, presumably, the thinking that went with it. But what appeared, at first, as a protest against the "resurrection" of an offensive vocabulary was rather an attempt to banish unpleasant aspects of the past. Jenninger, under much public and political pressure, resigned from office. Yet soon after his resignation, and particularly after his speech was read and analyzed, some observers wondered why there had

been such outrage over it. A publication of his speech, with commentaries, and a TV broadcast were planned to rehabilitate Jenninger at the next anniversary, but by that time the crumbling of the Berlin wall absorbed all attention and preempted these gestures. The historian Elisabeth Domansky's sharp-eyed analysis of the Jenninger affair suggests, however, that his critics had an agenda that went far beyond a criticism of Jenninger—an agenda that shows how not only the Holocaust but speaking about it served purposes of self-interest.

> The controversy over his speech was rather seen as a success. The public outcry seemed to be even better suited than a perfect ceremony in the Bundestag to convince the world and Germany herself of her successful conversion to a liberal democracy—one that had come to terms with its difficult past. Jenninger provided West German society with a golden opportunity to demonstrate that not just her political leaders but the majority of her citizens had undergone a process of radical political transformation. To call for Jenninger's resignation was part of the play "West Germany Remembers and Rejects the Holocaust" that was staged for an international as well as the domestic audience watching the commemorative ceremony in the Bundestag.[21]

The controversy over the Jenninger speech arose out of the uncomfortable confrontation with a past that was clearly not worked through but reopened. Jenninger had dared to give voice to a tabooed language, in a public ceremony. The "affair" demonstrated that it was impossible to speak openly without incurring public protest and that the silence was a silence of false reverence and hidden, self-interested agendas.

Unification

The events leading to unification occurred precipitously. Over a period of forty years, the two Germanies had developed into "two competing states with different systems of government, opposing military alliances, contradictory economic systems, incompatible social structures, and conflicting ideologies."[22] But when Hungary opened its borders to Austria in September of 1989, many East Germans "voted with their feet" and marched from Hungary to Austria and from there to West Germany. Those who did not march to West Germany marched in East German rallies and mass demonstrations, some of which were one million strong. In November, numerous East German artists and writers, seconded by West German writers such as Günter Grass and Günter Wallraff, signed a petition titled "For Our Country," in which they de-

manded that East Germany remain a separate state, "with the chance to develop a socialist alternative to the Federal Republic, as a neighbor with equal rights vis-à-vis all other European states."[23] A month later, East Germany opened its borders for visits, hoping that free traffic across the borders would temper the desire of its professionals and its young people to leave the country permanently. In the spirit of Gorbachev's *perestroika,* East Germans demanded free elections, and intellectuals and politicians worked on a number of alternatives to reform the government from within and arrive at a workable relation with West Germany. But in the first free elections, held on March 18, 1990, the overwhelming victory went not to the Socialists or the Socialist Unity Party (the former party organ of the GDR) but to the Alliance for Germany, a party connected to and heavily supported by West German Chancellor Helmut Kohl's Christian Democratic Union. The success of the East German CDU was repeated in local elections, in May. As a consequence, the "Two-plus-Four" (the two German states and the four Allies of World War II) talks were initiated, and from then until unification on October 3, 1990, intense negotiations on every level went on without interruption. The political negotiations defined the agenda, but the people of East Germany had accomplished an unbloody revolution. (Grass would contrast East Germany's "velvet revolution" favorably with the situation in West Germany, where freedom had been achieved not by the efforts of the citizenry but "as a gift.") During these turbulent months, the East German intellectual establishment showed that it was out of touch with the people. To many of the intellectuals, socialism uncorrupted and open to self-criticism seemed preferable to capitalism. Their elitist denigration of the people's desires undermined their positions as speakers and as seismographs of public opinion and dismantled a "long-standing, broadly based consensus."[24] At the same time, and with considerable misgivings expressed by the West German financial establishment, Chancellor Kohl pushed for monetary agreements that promised a 1:1 currency conversion (whereas the unofficial exchange rate had been ten East German marks to one DM). Many of the problems that were to haunt a unified Germany in the years to come—low productivity, obsolete industrial equipment, noncompetitive products, resulting high unemployment, complex property tangles stemming from expropriation and collectivization—were recognized but brushed aside.

Along with the tumultuous political activity there occurred a tumultuous literary dispute. In June of 1990, in the midst of the intense negotiations over unification, Christa Wolf, the most prominent East German writer and a thoughtful (though never outraged) observer of the conditions in East Germany, published *Was bleibt (What Remains),* a

short book she had written in 1979 describing her surveillance for sev-
eral weeks by the Stasi, the East German secret police. At best, the tim-
ing of her publication was naive, at worst opportunistic. She was
perceived as claiming, retrospectively, solidarity with those who were
spied upon and victimized, when in fact she had been a privileged writer
and showcase for the GDR and did not speak out until it was no longer
dangerous to do so. The political dimension of her book fitted right in
with the revelations about the extent of Stasi surveillance, which be-
came a major issue after unification.

Here, the problem was whether or not the files of the legions of "unof-
ficial collaborators" should be made accessible, and the situation was
compared to the postwar existence of Nazi files. Should the past be done
with or should former Stasi members and the "unofficial collaborators"
be punished—for example, by being denied positions of prominence and
responsibility in a unified Germany? Was this a chance to refute West
German practices, when West Germany had covered and protected for-
mer Nazis with a wall of silence? The Gauck commission (its head was
the Protestant pastor Joachim Gauck) was charged with archiving and
granting access to the Stasi material; the archives frequently held painful
and frightening revelations for those demanding to see their files.[25]

In all these disputes, release from Communist rule was compared to
the end of the Nazi regime, but awareness of the Holocaust played no
role. East Germany had from its inception kept its distance from the
Holocaust.[26] Its Marxism interpreted fascism, and hence the Nazi
regime, as an outgrowth of capitalism, and in the immediate postwar pe-
riod (paralleling efforts at democratic reeducation in the Western occu-
pation zones) the citizens of the GDR underwent an ideological
cleansing in the "antifa" (antifascism) schools. This severance from a
common past left the Federal Republic as the only heir to the Nazi
legacy. It was therefore remarkable that in February of 1990, as Prime
Minister Hans Modrow was still trying to save East German autonomy
by shuttling back and forth between Moscow and Bonn, he admitted in a
message to the Jewish World Congress "the GDR's share of the responsi-
bility for Germany's past" and promised "material assistance for former
persecutees."[27] The GDR clearly understood, as had the Federal Repub-
lic from its early years, that if it was to be considered a viable nation it
had to address the Nazi crimes. On April 12, Lothar de Maizière, mem-
ber of the East German branch of the CDU, was elected prime minister
at the head of a coalition government. On that very day, the newly
elected parliament adopted a four-point declaration which in its first
point recognized the GDR's co-responsibility for "the humiliations, per-
secutions and murder of the Jews" and asked the state of Israel for for-

giveness for the "hypocrisy and hostility" of the old GDR leadership. In distinction to West German ambivalence, the East German "acknowledgment of responsibility and participation in guilt for the past and the future" is of a moving directness.

> We, the first freely elected parliamentarians of East Germany, admit our responsibility as Germans in East Germany for their history and their future and declare unanimously before the world:
> Immeasurable suffering was inflicted on the peoples of the world by Germans during the time of National Socialism. Nationalism and racial madness led to genocide, particularly of the Jews in all European countries, of the people of the Soviet Union, the Polish people and the Gypsy people.
> Parliament admits joint responsibility on behalf of the people for the humiliation, expulsion, and murder of Jewish women, men and children. We feel sad and ashamed and acknowledge this burden of German history.
> We ask the Jews of the world to forgive us. We ask the people of Israel to forgive us for the hypocrisy and hostility of official East German policies toward Israel and for the persecution and degradation of Jewish citizens also after 1945 in our country.
> We declare our willingness to contribute as much as possible to the healing of mental and physical sufferings of survivors and to provide just compensation for material losses.[28]

Unification absolved East Germany of making good on its words.

Grass vs. Walser

In distinction, for example, to quarrels over PEN membership, the Holocaust was not a point of debate among East and West German writers when they began to consider unification. West German writers disagreed among themselves, however, about the wisdom of such a move. Günter Grass and Martin Walser, two of West Germany's most widely recognized authors, held perhaps the two most polar opinions. Grass was adamantly against unification; Walser thought it long overdue. For both, however, "Auschwitz" was the touchstone of the dispute. In a lecture at the University of Frankfurt on February 13, 1990, titled "Schreiben nach Auschwitz" ("Writing after Auschwitz"), Grass announced that Auschwitz was the single most formative event of his life. Speaking in terms that recalled the Historians' Controversy, he concluded that Auschwitz constitutes so deep a caesura that the history of humankind must now be dated as pre- and post Auschwitz.

[T]he horror summarized in the name "Auschwitz" has remained in-
conceivable; precisely because it is not comparable, cannot be histori-
cally contextualized, is not open to any confession of guilt, it is not
far-fetched to date the history of mankind and our concept of human
existence as occurring before and after Auschwitz.[29]

In a TV debate of the same month with Rudolf Augstein, the editor of
the news magazine *Der Spiegel*, Grass traced the injunction against uni-
fication back to 1960 and a similar TV debate between Augstein and the
philosopher Karl Jaspers. In a searching and pathbreaking book pub-
lished soon after the end of the war, Jaspers had addressed *The Question
of German Guilt*, and while he had not endorsed collective guilt he had
spoken of collective liability. The earlier debate occurred more than a
year before the Berlin wall and the wall through Germany were built and
was emblematic of that division. Expressing thoughts that Grass would
iterate thirty years later in greater detail and with greater fervor, Jaspers
at that time held that

> reunification is not only unreal but politically and philosophically in its
> self-conception unreal. Because reunification would be based on . . . tak-
> ing the Bismarck state as the measure. . . . But the Bismarck state is, due
> to the events, irrevocably past. . . . Reunification would be so-to-speak
> the consequence of not wanting to recognize what has happened.[30]

Like Jaspers, Grass saw the beginning of the calamities that led to the
Holocaust rooted in Bismarck's unification of the divergent German states
into the German Empire. Augstein, in contrast, took revisionism to a
level of unabashed self-righteousness. After paying lip service to the hor-
rors of Auschwitz, Augstein offered historicizing points of view, even al-
luding to Chancellor Kohl's "grace of late birth" as a response to Grass's
"Auschwitz is part of us, the ever remaining stigma of our history."[31]

> I must say that nobody who is not directly affected can find Auschwitz
> more horrible than I do. I only think that we cannot perpetuate it in
> practical politics. Our children cannot possibly place themselves in
> that position, that is impossible. We have experienced it, even when
> we experienced it too late, but nevertheless experienced it—but they
> can no longer experience it. . . . History automatically relativizes
> Auschwitz.[32]

Not surprisingly, in the face of these statements and the general polit-
ical and popular mood, which was focused more on the problematics and
technicalities of unification than on the question of whether or not it
should occur at all, Grass's insistence on a "third way" that was neither

unification nor continued division did not receive much serious attention. As an indication of how smudged the lines between right and left had become, Grass proposed a confederation—an idea that had also been proposed by the neonationalists in their attempts to revive the concept of one nation. To the neonationalists, confederation would mean a coming together of the two parts of Germany in the spirit of renewed nationalism; in Grass's view, it would insure the continued separation and relative autonomy of the two states as a reminder of Auschwitz and a bulwark against any future grandiose nationalistic aspirations.

Martin Walser, another distinguished interpreter of postwar German malaise, agreed with many of Grass's concerns, yet eventually arrived at an opposite view. It is interesting to follow the evolution of his thought since it reflects in an idiosyncratic way the reemergence of the concept of one nation. In 1962, Walser had argued that Germany was never a nation but a conglomeration of tribes, that Bismarck had been less instrumental in bringing these tribes together than had the railroads and two world wars, that the two Germanies were again drifting rapidly apart, and he found consolation in the thought that "now we are probably forever protected against idiotic dynastics or half-crazed fanatics of the 'Reich' who want to *weld* us together as a nation. For a terrible price, we are relieved of the pressure to become a nation."[33] Walser's answer to the (West) German predicament at that time was very much part of a general consensus—namely, to integrate into Europe. "[W]e must hope that our political weaknesses will be canceled out by Europeanization. The more Europe integrates us, the more pleasant it will be to be a German" (28).

Three years later, during the Auschwitz trials in 1965, Walser wrote a newspaper article titled "Our Auschwitz" that showed his increasing preoccupation with the problematics of individual vs. collective guilt. The article is written in a profound sense of shame and fueled by an outrage that is vented in a language steeped in irony and cynicism. He is outraged that the trials' focus on individual criminals exculpates the majority of German people. The abyss between the victims' experiences and memories of Auschwitz, and the trials' perceived distancing effect on the perpetrator generations provoked him to propose, sarcastically, that "for us" Auschwitz had no consequences.

> Only the victims, as far as they still have their lives and those who are on the side of the victims can neither forget Auschwitz nor continue to live as if Auschwitz had never occurred. For us, however, Auschwitz will have no consequences.[34]

Almost a decade and a half later, in 1979, Walser gave a speech at the opening of the exhibit "Survival and Resistance," which featured draw-

ings by prisoners of Auschwitz. The very first sentence of the speech, "Since Auschwitz not one day has passed,"[35] anticipated what Grass would confirm a decade later when he said: "This will not cease to remain ever present"[36] and constituted a powerful argument against historicizing. He tried to address the fact that Auschwitz and the crimes committed there remain incomprehensible and was now adamant in embracing collective guilt: "I believe one is a criminal when the society to which one belongs commits criminal acts. We have provided an example of this in Auschwitz" (30). At the same time, he realizes that "[a]s individuals we can admit only that we are not equipped to bear the guilt of Auschwitz" (27) and deems individual attempts to cope with this guilt insufficient or ineffective. "There are organizations for reconciliation. There are ways to keep the shame from paralyzing us. There are attempts to apologize. All this is better than nothing. All this does not quiet the battle in each of us" (26).

Walser did not supply an answer, in this speech, about how to "quiet the battle" and cope with the unbearable burden of collective guilt. But in the essay "Handshake with Ghosts," published in the same year, he sketched a tentative direction in which an answer could be sought.[37] He starts by sketching the predicament in which Germans find themselves:

> I have a troubled relation to reality. . . . I would like to prove, or at least affirm, that my troubled relation to reality has something to do with the fact that I am a German and born in 1927. I do not believe that as a German of my age one can have an untroubled relation to reality (14–5). . . . I am actually expected to bear my Germanness with composure, as one bears a pain that is not one's fault, but that one cannot get rid of. Whenever I am tempted . . . to show my Germanness in a somewhat positive light, I immediately meet with resistance. If not from others, then from myself (20).

In a tentative, highly self-conscious, even defensive step, Walser then reaches out for entities that transcend the individual and help him bear all that "Auschwitz" stands for:

> If we could master Auschwitz, we could again turn toward national tasks. But a purely secular, liberal society that flees from the religious, and in general from all that transcends the "I," can only repress Auschwitz. Where the "I" is the highest, one can only repress guilt. Only together can one accept it and bear it. But every trend toward togetherness elicits in us a sense of obsoleteness. Where togetherness, solidarity, and nation make their appearance, the liberal, world-wise child of the Federal Republic sees the Church or communism or fascism (20).

Walser stunningly links the admission of unbearable guilt to a rather conservative outlook: the abolition of the "I" in "togetherness," "solidarity," and above all "nation" were ideas that had long been tabooed as reminiscent of Nazi ideology. He also admits in this passage that if Auschwitz could be "mastered" (*bewältigt*), it could be left behind and attention could turn to "national tasks." The phrase is in the conditional, and Walser maintains elsewhere that "Auschwitz cannot be mastered" (27) but the door to revisionist thinking has been opened, a decade before unification.

In 1962, Walser had seen the division of Germany as "the consequence of a war that we had caused because we had acted as a nation" and saw integration into Europe as Germany's best future. In 1988, he spoke of the division as "punishment," deserved but not meant to go on forever. Presumably, punishment had taught the lessons that Chancellor Kohl assured his audience had been learned: the Germans were no longer Nazis, for "if we 'all' were still 'Nazis,' we would indeed have to beg for a continuation of the division."[38] Walser's shifting positions trace the reconstitution of a national sentiment and they show the conflicts and contradictions on which this sentiment is built. But more than that, they affirm the continued preoccupation with the Holocaust in the ambivalent and irresolute attempts to cope with the guilt. Would the end of "punishment" bring with it an end to guilt?

When unification came in 1990, the argument that the division of Germany was punishment for Auschwitz had to be rethought. Now it was remembered that the division of Germany had been a product of the cold war. Unification became possible not because the time for punishment was deemed to be over but because the cold war was over. Grass's refusal to accept unification because of Auschwitz was a radical and, after 1990, an irrelevant position. Walser, too, did not believe that with unification the guilt for Auschwitz would cease. But he drew a careful distinction between "unification" and "reunification"[39] and he chose to speak of unification, since reunification would imply the return to a Germany that had brought disaster.

If non-Jewish Germans had divergent interpretations invested in the fall of the Berlin wall and unification, Jews had a more single-minded view. This view, too, needed to adjust to post-unification circumstances. Sander Gilman expressed their anxiety associated with this "shift in the understanding of German history" most graphically:

For many Jews this daily reminder of the Shoah was present in the wall, the scar which marked the division of Germany. That scar, as real on the body of Germany as the tattoo on the arm of the concentra-

tion camp prisoner, became a mark, not of the cold war division of Germany . . . but of German guilt for the Shoah. It was the Wailing Wall of modern Jewish history, marking the living awareness of the Shoah for Jews outside of both German States. It was as real a sign of the guilt of the Germans as we Jews could hope for—and yet it was one which had intrinsically nothing to do with the Shoah. It was a Jewish reading of the map of contemporary Europe as a reflection of the German past, a reading shared neither by the Superpowers nor by the Germans themselves.[40]

Literature as the seismograph of a people's conscience and unstated assumptions shows a continued, though continuously skewed, preoccupation with the Holocaust after unification. Unification has not brought a lessening of the awareness of the Holocaust in Germany; on the contrary, as I will suggest in the next chapter and in the conclusion, the discussions continue in literature, but they are also shifting to larger public forums than those literature can offer. "Auschwitz will remain," but the context in which it is remembered and commemorated is still changing.

Post-Unification

Bernhard Schlink, Peter Schneider, and W. G. Sebald

There's no need to talk, because the truth of what one says lies in what one does.[1]

The powerful, ambivalent, and conflicted preoccupation with the Holocaust during the 1980s, occasioned by the various anniversaries and controversies, is sustained after unification, although it shifts away from literature to the public arena. Meanwhile, the nature of literary discourse as it relates to the Holocaust is changing in response to a relatively recent phenomenon in German life—namely, a reemerging Jewish presence in Germany. Some novels begin to reflect this presence and show Jewish protagonists who are no longer the objects of observation but act as subjects and speakers of their own histories. The three novels to be discussed in this chapter were all published in the first few years after unification. With varying emphasis, they portray Jewish characters as they make their points and interact with non-Jewish Germans; it should not surprise that the relations portrayed in these novels are tentative, fragile, and expressions of a negative symbiosis.

Bernhard Schlink

Bernhard Schlink is a professor of law and a practicing judge; before his 1995 novel *The Reader* catapulted him into the best-seller ranks and in-

ternational recognition, he had distinguished himself as the author of prize-winning crime novels. Born in 1944, Schlink belongs to the generation of the 1968ers, who published their autobiographical novels during the late 1970s and the 1980s. *The Reader* might be seen as a latter-day example of this trend. It shows a thorough acquaintance with all the issues addressed in the "literature about fathers and mothers" and recapitulates and simultaneously criticizes them.

The events of the book are recounted by the protagonist, Michael Berg, approximately thirty-five years after they begin to unfold. Berg, the I-narrator, presents the text as his own work, written over a period of ten years. Contact with the Holocaust even across the generational gap has indelibly changed Berg's life, but it has little impact on his narrative style: the gaps in his memory do not disclose a subtext. The information that the authors of the autobiographical novels had tried so hard and futilely to piece together is for Michael Berg readily accessible. Here, the search shifts from finding out about the perpetrator generation's heinous activities to a search for their motives.

The book is divided into three parts: In the first part, fifteen-year-old Michael, a high school student, enters into a sexual relationship with thirty-six-year-old Hanna Schmitz, a streetcar conductor. The year is 1958; their affair lasts from late winter until summer, when Hanna disappears and Michael is devastated by the loss. In the second part, Michael is a law student. One of his professors, a returned refugee from Nazism, asks the students in his seminar to observe and evaluate a war crimes trial in a nearby town. The defendants are five women who were SS guards, and one of them is Hanna; she is convicted and sentenced to life imprisonment. In the third part, Michael resumes a practice that had once characterized their lovemaking ritual: he reads to her. He reads to her on tapes and sends the tapes to her in prison but never visits her. After eighteen years, Hanna is paroled and Michael is asked by the warden to help her reenter ordinary life. The morning of the day on which he is to pick her up, she commits suicide. In a note to the warden, Hanna has asked Michael to give her savings to a Jewish woman—one of two survivors and a witness in the trial—to dispose of as the woman sees appropriate. On a visit to the United States, Michael visits the survivor, who rejects any gestures of atonement.

Schlink uses the generational discrepancy that was at the core of the "literature about fathers and mothers" to new purpose when he makes the bond of love between the generations sexual rather than biological. When Hanna and Michael meet, she is living by herself. She is reticent about her past; she is suspicious, ill-humored when tired, and violent when angry. (On a bicycle trip, she thinks Michael has deserted her;

upon his return, she hits him with her belt across his face, so that he bleeds.) Their *amour fou* is tinged with sadomasochism. Hanna withholds herself, and Michael, humiliated and full of resentment, must beg her forgiveness and humor her. There are signs that he will eventually outgrow the relationship. He begins to regret leaving his friends to meet Hanna, and he starts to take note of the existence of one particular young girl, a classmate. But because he does not speak with his friends about Hanna, does not share his "secret" with them, he feels he has betrayed her. Michael's withholding of information is matched by Hanna, who also has a secret: illiteracy. Withholding information is, as Hanns-Josef Ortheil showed in his novels, a common characteristic of post-Holocaust Germans.

After Hanna's abrupt disappearance, Michael falls into a state of numbness and detachment that he covers with arrogance. Only when he enrolls in the seminar and begins to prepare for the trial does he join in the spirit of communality that characterized the student movement: "I wanted to share in the general passion. . . . I had the good feeling all that winter that I belonged, and that I was at peace with myself about what I was doing and the people with whom I was doing it" (93). When Michael realizes, on the first day of the trial, that Hanna is one of the defendants, the summary condemnation of the parent generation is particularized and personalized. He now has to undergo a process of self-questioning that the other students, he feels, can avoid because "love of our parents is the only love for which we are not responsible" (170). He, in contrast to them, deliberately chose to love a criminal and feels responsible for this choice (although it is never quite clear where this responsibility lies and what it consists of).

Hanna and her codefendants worked in a women's satellite camp near Auschwitz, and they are accused of two kinds of crimes: of the regular selection of inmates to be sent back to Auschwitz, and of the death of over six hundred women on a death march when a church in which they were locked up for the night was hit by a bomb and burned down. Michael follows the trial in all its casuistic details. "The daughter," who has written a book about her time in the camps, testifies as the principal witness, while her mother, the only other survivor, is deposed in Israel. The facts are never contested. When the presiding judge pushes Hanna for an answer to the question of how she selected the women to be sent back to Auschwitz, Schlink presents a most direct confrontation of a perpetrator with his crime. Here, finally, the silence can be broken. The exchange between the judge and Hanna moves toward what is surely the most pointed question of the book—and then collapses into moral obtuseness and platitudes.

"Did you know that you were sending the prisoners to their death?"

"Yes, but the new ones came, and the old ones had to make room for the new ones."

"So because you wanted to make room, you said you and you and you have to be sent back to be killed?"

Hanna didn't understand what the presiding judge was getting at.

"I . . . I mean . . . so what would you have done?"

Everything was quiet for a moment. It is not the custom at German trials for defendants to question the judge. But now the question had been asked, and everyone was waiting for the judge's answer. He had to answer; . . . he could take a little time to find an answer. But not too long; the longer he took, the greater the tension and expectation, and the better his answer had to be.

"There are matters one simply cannot get drawn into, that one must distance oneself from, if the price is not life and limb."

The judge's answer came across as hapless and pathetic. Everyone felt it (111–2).

In her explanation ("Yes, but the new ones came . . ."), Schlink reveals Hanna as similar to the killers in many other trials: they treated human beings as objects and disposed of them as such. Did it never occur to her that she was dispensing life and death, or only that she had to fill quotas? But the judge's pontificating answer also misses the mark; his language betrays a lack of conviction and in the "if"-clause makes room for the genocide.[2]

The second major charge against the defendants is that they did not unlock the doors of the burning church to let the trapped women escape. (The daughter and her mother escaped by fleeing up to a gallery so narrow that the burning beams missed it as they fell.) A record found in the SS archives and written by one of the guards states that the guards were commanded to stay behind to prevent a spread of the fire and any escape attempts by the prisoners. The defendants deny the veracity of the report and accuse Hanna of fabricating it, which she denies. A prosecutor suggests that an expert compare the handwriting in the report with Hanna's, and, reluctant to reveal her illiteracy, she falsely confesses that she has indeed written it. In an intuitive moment, Michael realizes that Hanna cannot read or write (131–2). Now he understands that Hanna's postwar life was dominated by a personal disability. It was the fear that her illiteracy might be discovered—she had been offered a promotion, for which she would have had to fill out forms—not the uncovering of her Nazi crimes that prompted her abrupt disappearance. Now Michael Berg is confronted with the same impenetrable wall that his fellow students faced in the investigations of their parents' past.

I could understand that she was ashamed at not being able to read or write, and would rather drive me away than expose herself. I was no stranger to shame as the cause of behavior that was deviant or defensive, secretive or misleading or hurtful. But could Hanna's shame at being illiterate be sufficient reason for her behavior at the trial or in the camp? To accept exposure as a criminal for fear of being exposed as an illiterate? To commit crimes to avoid the same thing?

How often I have asked myself these same questions, both then and since. If Hanna's motive was fear of exposure—why opt for the horrible exposure as a criminal over the harmless exposure as an illiterate? Or did she believe she could escape exposure altogether? Was she simply stupid? And was she vain enough, and evil enough, to become a criminal simply to avoid exposure?

Both then and since, I have always rejected this (133).

It is not surprising that Michael wants to salvage his image of the woman he has loved, but his lack of abhorrence at Hanna's acts and the way she speaks—or does not speak—about them is amazing. Even though he has no personal contact with her, he becomes an interpreter of Hanna's answers and courtroom behavior, as when he states that she "didn't understand what the presiding judge was getting at." But he cannot find any explanation for her acts except a duty-driven obedience to orders—a banal answer and one that has been cited innumerable times.

Another charge leveled against Hanna by the codefendants was that she had favorite young girls, whom she treated well before sending them back to Auschwitz. The obvious insinuation was that she used them for sexual purposes, but the daughter-as-witness testifies that the girls had to read to Hanna.[3] In prison, Hanna finally teaches herself to read and write, and when Michael visits her cell after she has committed suicide he finds books by victims of the Holocaust, scholarly literature on the camps, and Rudolph Hess's autobiography (205). Schlink seems to suggest that her criminality and general brutality went hand in hand with her illiteracy, but that once she could read she became morally alert and wanted to know more about the Holocaust. This is not much of an argument. Illiteracy cannot serve as an explanation for cooperating in and committing criminal acts. If hiding her illiteracy is more important to Hanna than saving lives, and she can enjoy being read to by victims who are marked for death, what kind of a person is she? But if illiteracy is not the explanation—and excuse—for Hanna's acts, then what function does it serve in the novel? At the very point where Schlink needs to make a strong case with respect to the Nazi crimes and those who perpetrated them, the novel is weakest.

In Hanna, Michael confronts the crimes of the Nazi past in a direct and unmediated way and experiences the pain of those who ignorantly and innocently become guilty through association. But his refusal to visit her in prison shows a callousness that comes close to her cruel treatment of him and may be an expression of a resentment he harbors toward her. This silence also costs him the opportunity of setting himself free.

One of the central issues in the Historians' Controversy was the attempt to relativize the Holocaust. Michael, though consciously opposed to it, follows this lead. As the trial progresses, he sees a particular numbness take hold of all those involved in the daily proceedings:

> It was like being a prisoner in the death camp who survives month after month and becomes accustomed to the life, while he registers with an objective eye the horror of the new arrivals: registers it with the same numbness that he brings to the murders and death themselves. All survivor literature talks about this numbness, in which life's functions are reduced to a minimum, behavior becomes completely selfish and indifferent to others, and gassing and burning are everyday occurrences. In the rare accounts by perpetrators, too, the gas chambers and ovens become ordinary scenery, the perpetrators reduced to their few functions and exhibiting a mental paralysis and indifference, a dullness that makes them seem drugged or drunk (102–3).

The confusion and lack of a moral compass inherent in a comparison of the numbness of the prisoners in the death camp and that of the perpetrators, to say nothing of the courtroom participants, surely needs no comment. This confusion does not become less outrageous when Michael admits that he is made uncomfortable by his assessment: "[W]hen I likened perpetrators, victims, the dead, the living, the survivors, and their descendants to each other, I didn't feel good about it and I still don't" (103). But he does not say why he likened them in the first place or why he does not feel good about it, and he insists on differences which have no consequences. "When I began to make such comparisons in discussions, I always emphasized that the linkage was not meant to relativize the differences between being forced into the world of the death camps and entering it voluntarily, between enduring suffering and imposing it on others, and that this difference was of the greatest, most critical importance" (103). How Michael could make such "linkages" and simultaneously insist that there were differences of "the greatest, most critical importance" he does not explain. As in other instances, Schlink suggests that he is aware of current debates and wants them included in his novel. But he does not seem to have arrived at clear positions of his own. In-

stead, he tinges Michael with an element of petulant sharpness and impatience and, at the same time, insinuates a sense of closure.

> What should our second generation have done, what should it do with the knowledge of the horrors of the extermination of the Jews? We should not believe we can comprehend the incomprehensible, we may not compare the incomparable, we may not inquire, because to inquire is to make the horrors an object of discussion . . . instead of accepting them as something in the face of which we can only fall silent in revulsion, shame, and guilt. Should we only fall silent in revulsion, shame, and guilt? To what purpose? . . . [T]hat some few would be convicted and punished, while we of the second generation were silenced by revulsion, shame, and guilt—was that all there was to it now? (104)

It is significant, and demonstrates a continued "inability to mourn," that Michael cannot conceive of mourning or experiencing grief and sorrow when he asks rhetorically: "What should [our second generation] do with the knowledge of the horrors of the extermination of the Jews?" Schlink portrays Michael's limitations, his inner conflicts, and his bonds to an SS killer as they influence his life and relations with others, and he shows Michael unaware of his attempts to find explanations—if not excuses— for Hanna's acts. But Schlink cannot separate Michael's confusions from his own and leaves many of the issues he brings up (e.g., relativization of the crimes, Hanna's character, Michael's attachment) unanswered.

Schlink is much clearer when he has Michael meet with "the daughter," in New York. This survivor of Auschwitz speaks and acts as a subject, on her own behalf, and it is she who determines the course of the dialogue. She is cool and reserved, but not unfriendly. Neither she nor her mother are ever given a name in the narrative, as if to suggest that they stand for innumerable victims; before their meeting, Michael cannot recall what she looks like, and when he sees her he has the impression that "[h]er face was oddly ageless, the way faces look after being lifted. But perhaps it had set because of her early suffering" (212). Her namelessness and facelessness are perhaps also emblematic of Michael's reluctance to confront those who suffered—particularly those who suffered under Hanna's supervision. When Michael and the daughter speak to each other, they embody the "negative symbiosis" of which the historian Dan Diner has said:

> Since Auschwitz—what a sad twist—one can indeed speak about a "German-Jewish symbiosis." Of course, it is a negative one: for both Germans as well as for Jews, the result of a mass annihilation has become the starting point for their self-understanding. It is a kind of contradictory mutuality, whether they want it or not, for Germans as well

as Jews have been linked to one another anew through this event. Such a negative symbiosis, constituted by the Nazis, will stamp the relationship of each group to itself, and above all, each group to another for generations to come.[4]

The daughter sees Hanna's wish to bequeath the money to her as an effort to compel an absolution. She does not want the money used "for something to do with the Holocaust [for that] would really seem like an absolution to me, and that is something I neither wish nor care to grant" (214). Michael finds it difficult to accept this thought and, as he has done so often, tries to justify Hanna's intentions; then he realizes that "[h]er years of imprisonment were not merely to be the required atonement: Hanna wanted to give them her own meaning, and she wanted this giving of meaning to be recognized" (212). But Michael, who would like unambiguous answers that promise closure, cannot read the daughter's response: she shakes her head. "I didn't know if this meant she was refusing to accept my interpretation or refusing to grant Hanna the recognition" (212). The daughter, however, perceives matters on a level below the surface. She senses Michael's concern for Hanna and addresses it: "You like her, don't you? What was your relationship?" (213) And Michael, as if to make up for his earlier failed attempts to speak about Hanna, tells the daughter of their affair. She responds with an insight that Michael had always hidden from himself. "That woman was truly brutal," she says. "Did you ever get over the fact that you were only fifteen when she . . ." (213). In a fantasy of reverse restitution, the victimization of the successor generation by the perpetrators is validated by a Holocaust victim.

The daughter ultimately decides that Hanna's money should be given to a Jewish foundation for illiteracy (although, as she concedes, illiteracy "is hardly a Jewish problem") and asks Michael to locate such a foundation, suggesting that the donation be made in Hanna's name. She decides, further, to keep the tin can in which Hanna kept the small change, as a souvenir of one she had as a child and that meant so much to her that she had taken it to Auschwitz, where it was stolen. Although the novel deals almost exclusively with Hanna and Michael, the last words are not Hanna's but the daughter's. They are not words of reconciliation, but the beginning of a dialogue—albeit a tenuous and painful one.

Peter Schneider

Peter Schneider was born in 1940 and lives in Berlin. He is a novelist and one of Germany's foremost cultural and social critics. He sprang upon

the West German literary scene in 1968 with his novel *Lenz*, named after its disaffected and spiritually homeless hero and modeled on Georg Büchner's novella of the same name. The novel was a great success, as it captured the rebellious yet unfocused spirit of the 1968ers. It also set a pattern in Peter Schneider's literary oeuvre in that it addressed with great sensitivity the poignant issues of a generation. Schneider was to repeat this culling of the precise moment in his *. . . schon bist du ein Verfassungsfeind (In No Time at All You Are an Enemy of the Constitution)* of 1975, which took issue with the "decrees against the radicals" and exposed, with a sharp eye for the ridiculous, the bureaucratic chicanery and communal malevolence toward "outsiders"—namely, those not living in conformity with petit-bourgeois standards. In *The Wall Jumper* of 1982, the first novel of his proposed Berlin trilogy, he brought his critical and mocking sense to bear on the Berlin wall and showed, years before it actually fell, how porous it had become.[5]

In all these writings, Schneider combines a light, bemused, ironic, occasionally even humorous touch with serious critical insights. This is also true of *Couplings* (1992), the second novel in his trilogy[6] and the one that most deliberately aspires to social satire. The multistranded and carefully structured narrative of twenty-seven chapters is arranged in three parts that roughly approximate the three acts of a play: the first presents the exposition, the second culminates in turmoil and chaos, and the third leads to a resolution. Yet the composition of the novel is fluid and loose, even though each chapter consists of episodes that have some kind of temporary closure.

The novel presents three no-longer-quite-young men, Eduard, Theo, and André, and their travails in love and marriage. Most of the principal characters are identified only by their first names; the exception is Eduard, whose last name is Hoffmann.[7] Theo is a writer and poet from East Berlin; his marriage to Pauline needs continual tests to keep the fires of love blazing. André, a composer, gets married and divorced in the course of the novel and at its end is preparing to marry the physician who treats his lung cancer. Eduard, a molecular geneticist, lives in a stable relationship with Klara but breaks it off when Jenny, another girlfriend, becomes pregnant by him. At the end of the novel, he is living with (presumably married to) Jenny and they have a baby daughter. The novel thus ends with the three protagonists more or less settled with their partners, but the last scene is an open-ended burlesque. The three friends meet in Warsaw—the city of the ghetto uprising—for the premiere of André's opera *Don Giovanni*, for which Theo has written the libretto. They spend the night in a bar, only to be gypped by a young woman who walks away with their hard currency and the one designer sports jacket the three of them were sharing.

Narrated in the third person singular but from Eduard's point of view, Schneider's novel can exploit Eduard's limited perspective and simultaneously poke fun at it. The narrative events occur mostly between 1983 and 1985. 1985 is an important year in the postwar history of Germany—the year of Bitburg and of the anniversary of the victory of the Allies over Nazi Germany, and a year after Chancellor Kohl tried to sever Nazi from postwar Germany by referring to himself as the first postwar chancellor to enjoy "the grace of late birth." Eduard wryly notes that "forty years too late" the entire nation now seems compelled "to peer into the abyss of its recent history," and he cannot remember another time "when the Nazi past had been discussed and debated in such depth and breadth" (203). He mocks this observation, however, when he adds that "[t]he debates and documentations were mostly broadcast late at night on public TV" (203–4).

These references to Germany's Nazi past are the understated but omnipresent background for the adventures of the three protagonists. *Couplings* presents the absurd, self-inflicted tribulations of those who have the leisure to indulge in them, but there is a sombre, indeed sinister *basso continuo* beneath the surface jocularity. "Coupling" and its opposite, "separation" or "division" or "divorce," provide the theme and focus for many of the issues discussed in the novel, starting from the premise that the "arrangements between the sexes no longer function" (259). The complexities of these couplings and separations are most easily traced in the love lives of the protagonists, but these disrupted and reconstituted love lives are also metaphors, as is evident in the question "Wasn't his attempt at breaking out, the light-headed abandonment of his love, just a symptom of a much broader disintegration?" (223) Since Eduard is a molecular geneticist, scientific examples of coupling and division abound, extending from single-celled microorganisms to the sex lives of gorillas and chimpanzees. Eduard is also "coupled" to a younger brother (and rival), Lothar, who is a sociologist. The basic assumptions of the two disciplines clash: the arguments of nature vs. nurture, heredity vs. environment, blind chance vs. free choice, run through the entire narrative.

Coupling and separating also serve as identification markers for the other principal characters. Theo, the writer, lives in East Berlin, Berlin being the symbol and reality of a decoupled unity. It is a perfect place to live for someone who takes "the most extreme viewpoint on any given situation, as a matter of principle, in order to achieve the greatest possible distance from the speaking partner and challenge whatever his opponent—or he himself—considered absolutely certain. . . . A city which could boast two irreconcilable versions of the news seemed the perfect

place for Theo's conversational strategy" (84). Theo is Jewish and holds a "double passport" that allows him to leave and reenter East Berlin at will, and "to disappear for days or even weeks on the other side— whichever it might be" (42). André, the composer, is also Jewish and offers his own East-West version of "coupling" when he marries the Russian Jewess Esther. The description of their wedding mirrors the cultural clashes between East and West European Jewry, but also the desire to overcome that separation. (The fact that this particular coupling is short-lived is part of the general thrust of the novel: what are the conditions, if any, that make stable and lasting relationships possible in today's world?) The theme of the *Doppelgänger* as a split person, or as a "double," and as a division into the past and present aspects of a person, also wanders through the novel, layering the theme of "coupling" even more densely.

A powerful subtext in this narrative are the many references to the Nazi past, the use of Nazi phrases, and of post-Holocaust concepts and vocabulary. It may seem problematic that they crop up in seemingly unrelated circumstances. Is Schneider's use of language that derives its specific meaning from the Holocaust a trivialization of the suffering, or does he use it to indicate that the Holocaust and post-Holocaust discourse have infiltrated common awareness? Schneider is careful about what situations and for what purposes he uses this vocabulary. When Eduard is temporarily threatened by the thought that he might be unable to father a child, he anticipates "a lifelong work of mourning" (129), and after he and Klara have separated she speaks of "the work of being alone" (222). Both passages are clear allusions to the Mitscherlichs' *Inability to Mourn* and refer to the labor/work of mourning that Freud postulated as a necessary phase in adjustment to a loss. On another occasion, his pain over the separation from Klara is even more clearly couched in post-Holocaust language: he feels like "one of the perpetrators," "a culprit hiding behind his scruples, a murderer with a sensitive soul" (250).

If "the work of mourning," "perpetrator," "culprit," "murderer" relate to post-Holocaust awareness, there is another layer that relates directly to the Nazi past. An inconsiderate bus driver is a "traffic Nazi" (17); the mailman appears as though "he had stepped down from the pedestal of some heroic Nazi sculpture by Arno Breker" (80); when Eduard sees him drunk on the job, he contemplates registering a complaint, but "the whole project foundered due to his aversion to denunciations. This quintessentially German crime was permissible only against Fascists, if even then" (81); when he sees a group of retirees at a spa, he is certain that they were "veterans of the movement that had burst forth a half century earlier to save the world" (269). Eduard is specific and precise when he

sees the past in the present, but other characters use clichés referring to
the Nazis easily and at random. When a woman in a bar is upset over the
shooting down of the Korean Airliner, she butts into the discussions of
the disaster and in her anger and desire to offend has recourse to these
clichés: "With your beards and rimless glasses, you're all still the same,
still in love with death; the Germans never change, you have Fascism in
your bones, and your mania for explaining things, your twisted thinking,
your pseudo-sensitive, acquired stutter, it's all a disguise! You still are
and always will be mass murderers!" (85)

The facile use of Nazi language as accusations hurled by the most cur-
rent student generation at their elders, and of Nazi practices used by
them to intimidate, is a replay of habits developed by the older genera-
tion when they were active as the 1968ers. Having long graduated from
the ranks of the 1968ers, Schneider now takes issue with the new gener-
ation for their cliché-infested, bigoted fervor. Eduard is doing research
that could lead to the identification of the gene carrying multiple sclero-
sis, and for his experiments he needs mice. He portrays the rebels of the
new generation by showing how they protest.

> During the last lecture of the semester Eduard was bothered by four stu-
> dents wearing Mickey Mouse masks. . . . He had grown accustomed to
> freshmen performing any number of activities in class: knitting
> sweaters, darning socks, trimming their fingernails, or practicing Yoga,
> but never before had they turned his lecture into a children's party (159).

When he asks what this performance is all about, the four unroll a ban-
ner with the inscription: "Stop the mouse concentration camps! Free-
dom and happiness for all lab mice!" (159).[8] He tries not to argue with
the students, but is adamant about one point: "[T]he words 'concentra-
tion camp' cannot be tolerated as a means to convey your protest." With
this statement he tries to maintain the uniqueness and specificity of the
Nazi crimes and slips into the role of the educator as he continues: "Evi-
dently you don't have a very clear, well-informed picture of what went
on in the German concentration camps" and he concludes with an ap-
peal to their understanding: "otherwise you yourselves would have
found [these words] utterly inappropriate" (160). But when he speaks of
"using" mice at the institute, he is shouted down by a student with
"[T]hat's the language of the Wannsee Conference!" (160). The easy
transfer of Nazi terms trivializes the occasions that gave rise to them
and dilutes their specific heinous meaning, even though their wide-
spread use as an aggressive weapon acknowledges their hideous impact.
The Nazi past has filtered into ordinary language, but the ubiquitous use
of that language destroys specific memory. Demonstrating that they are

not open to argument, the protesters vandalize his lab, release all the mice, and spray-paint the walls with the same slogan as on their banner. (In this and similar scenes, Schneider formulates a critique of the habits of totalitarianism evident in the fanatical fervor of current groups of young people.)

The furor over animal experimentation leads Eduard to an inquiry into the history of his discipline during the Nazi regime. He discovers that "[a]lmost all the laws which had been enacted or even planned against Jews, schizophrenics, psychopaths, and 'social aliens' stemmed from the recommendations of expert scholars like himself" (204) and, with a swipe at those who professed that they had to cooperate to save their own lives, he adds: "Moreover, a small army of well-educated assessors, physicians, technicians, and reseachers had placed themselves at the disposal of the program of annihilation: the few who refused to be part of the murderous machinery were not made to suffer any disadvantages: there were enough others eager to acquire a position" (205). He is horrified when he realizes that the building in which he and thousands of other students matriculated had at one time housed the anthropological institute where "research" on the body parts of murdered human beings was conducted— and was conducted by scientists who "were able to continue their professional careers after the war and retire with honors" (205). Here Schneider makes the same point as those who have voiced profound disagreement with the continuity of bureaucrats and academics from the Nazi into the postwar period, and he observes that even buildings "continue" and guard their silence. "To this very day there is no tablet, no clue that would recall the history of the building" (205).

If the Nazi past gradually encroaches on Eduard by way of the history of his profession and the familiar university building, it overwhelms him precipitously when his brother informs him that a former SS officer in the "Office of Jewish Affairs" (and reporting directly to Adolf Eichmann) may have been their maternal grandfather (201). As in *The Reader* and some of the autobiographical novels, the Nazi past now becomes charged with an affect that had been absent before. While waiting for archival information to verify the relationship (there is none), Eduard ponders the impact that the existence of such a grandfather will have on him and his brother, anticipating "a hitherto-unknown pressure to justify whatever they said or did" (202). And he asks a question at the core of much contemporary engagement with the Holocaust: "How far removed does a person have to be for his descendants to be no longer connected to him?" (216) Schneider has lost patience with the outraged posturings of the generation of 1968, who tried to "decouple" from their parents in order to demonstrate their own innocence—as he has lost pa-

tience with their progeny, the protectors of mice. Noting that "[i]f guilt was not hereditary, neither was innocence" (207), he takes an important step toward personal and political adulthood and away from intellectual evasions of the Nazi legacy.

> You, me, we, the sons and daughters of the Nazis, all suffer from an in-nocence complex. It's true: never before was there a generation so tempted by history to declare their parents completely guilty and themselves completely innocent. But what does that give us—apart from eternal immaturity? . . . We compete with one another as to who is the most damaged. Whoever can most fully explain his biography, his weaknesses and defeats, his suffering, his complexes as a series of wounds inflicted upon him by society deserves the crown of victim-hood. . . . Even if we succeed in proving that all our weaknesses are ef-fects of a polluted environment, or the delayed results of a past still not overcome, sooner or later, at some point in our lives, we will have to accept them and recognize them as our own (102–3).

In Schneider's view, "coupling" involves acceptance and responsibil-ity (as when Eduard, on a personal level, accepts fatherhood and com-mitment to his newly constituted family) and that includes acceptance of and a sense of responsibility for the Nazi past.

"Coupling" as the metaphor for the diverse relationships in the novel also includes the relations between Germans and Jews. As the couples undergo trials, separations, and reconfigurations, Eduard gains a sense of his friends as Jews. During André and Esther's wedding, he reflects on their lives in Germany. It is a rather bleak assessment.

> Only gradually did it dawn on Eduard that for the first time he was in a largish gathering made up mostly of Jews. During the 1920s an occa-sion like this would have been an everyday event; now, almost forty years after the German crimes against the Jews, there was something ephemeral about the whole affair, something almost unreal. It was as if they were restaging a memory which could find no handle or hold in the present. In a few days the guests would again depart for wherever their families had saved themselves a half century earlier, and sud-denly Eduard realized that even André and Theo were living on bor-rowed time in the city where he felt at home. Both kept the passports of the countries where their parents had found refuge; they themselves moved around like resident refugees who refused to be deceived by a forty-year calm, two somewhat pampered, watchful sons, always on the alert for the moment their "mother tongue" might suddenly reacti-vate the words of murder and deportation which had been temporarily suppressed (153).

When Eduard first learns that someone from the Nazi Office of Jewish Affairs may have been his grandfather, he is so upset that he wants to call André and Theo (perhaps hoping they will exonerate him). For the first time in their friendship, he cannot anticipate what their reaction will be, and he recognizes the gap existing between himself and them. The putative grandfather has forced him to reevaluate the fact that "two of his best friends [are] Jewish" (206). Schneider doesn't want these friendships to be interpreted as philo-Semitism; when the three become friends, Eduard does not know that André and Theo are Jewish. Nevertheless, the philo-Semitic interpretation is hard to avoid, for surely Schneider as author could have concocted more pertinent reasons for Eduard to become friends with Theo and André than that they "just seemed more attractive, more entertaining, more talented than other people" (206). As if to correct a possible philo-Semitic charge, Schneider has Eduard in retrospect evaluate his first impression as "at best frivolous" (206), and he wonders how he would have related to them had he known they were Jewish. Only now, sensitized by his own situation, does he realize that André and Theo are not just friends of his but Jews marked by a devastating history. Suddenly, he sees "the murdered relatives of Theo and André hovering over their heads" (206). He remembers an argument he and Theo had in a pub three years earlier, after Theo had been (in Eduard's opinion) overly complimentary to a literary critic who was drinking with them. (It is interesting that Schneider presents the argument not in the narrative present but as remembered, thereby avoiding the immediacy of a "hot" confrontation.) Annoyed by Theo's exhibition of flattery, Eduard blurts out an insult that "presumably had been outlawed forever:"

> When I look at you, the way you get in good with everybody, the way you schmooze, I can almost understand how people could come up with something like anti-Semitism. This fawning! All you're doing is proving the stereotype (208).

At this point, Schneider does not allow Eduard to abandon himself to silent self-incriminations or to wallow in feelings of guilt. He has a Jewish voice take issue with the insult. André speaks up for the Jews of postwar Germany, and he addresses Eduard with unquestioned authority:

> Under no circumstances ever are you allowed to say anything like that. . . . Neither smashed nor sober and certainly not in front of us. Say that Theo is a careerist, say he'd sell his grandmother for a good verse, say that he's an unscrupulous bastard. But never say that he's this or that because he is a Jew (208–9).

And Theo makes the concluding, slightly sarcastic comment to André: "He has to be able to tell us what traits we have that stick out . . . just like we have to be able to tell him that every now and then you can see a bit of Nazi in our beloved goy" (209). The argument does not destroy their friendship, but it points to the fragility inherent in any German-Jewish coupling.

In presenting Jews as individuals with their own voices and in showing the interaction among the friends in their moment of crisis, Schneider accomplishes a rare feat. When Eduard realizes what it feels like for Jews to live in Germany today, he has crossed a boundary few others have even begun to think about. There is no question that the "contradictory mutuality" of the negative symbiosis weighs heavily on German gentiles and Jews alike and may, in Dan Diner's assessment, continue to do so "for generations to come." It has taken nearly half a century after the Holocaust for Jews to be seen—and reflected in literature—as individuals and subjects of their own actions, speakers of their own words, insistent on their own opinions. Schneider seems to suggest that perhaps one way of "working through" the legacy of the Holocaust is to "work through" one's own individual relationships.

There are few Germans today who would deny that the Holocaust is an integral part of German history. Schneider clearly depicts the knowledge of this past, the pervasive extent to which it has become an "unstated assumption" in German consciousness, and the anxieties associated with it. He is not utopian—or even an optimist. But he points to the possibilities of couplings, and even of confrontational friendships, between Jews and non-Jews in the new Germany. Here is the point at which the language of silence ceases to exist.

W. G. Sebald

Winfried Georg Sebald was born in South Germany in 1944 and in 1970 settled permanently in England, where he teaches German literature at the University of East Anglia. He is the author of works of fiction and of literary studies, particularly on Austrian fiction. His most recent novel, *The Emigrants*, was published in 1992, the year of Schneider's *Couplings* and of Ortheil's *A Farewell to the War Veterans*, and has won several literary prizes and much critical acclaim.[9]

The book consists of four sections, each titled after its protagonist. "Dr. Henry Selwyn," living in England, is the child of Lithuanian Jewish emigrants who set out for America at the turn of the century, only to be abandoned by the shipping company and left stranded in London. "Paul

Bereyter" is an elementary school teacher in a small Bavarian town, who "emigrated" from the world at large when he was not allowed to teach during the Nazi regime because one of his grandfathers was Jewish. "Ambros Adelwarth," at age thirteen, leaves his native Bavarian village at the turn of the century to make his way in the grand hotels of Europe. In the United States, he becomes the personal attendant of a distressed Jewish genius his own age and settles in as the family butler. "Max Ferber" is a painter whose parents sent him to England to escape the Nazis and themselves perished in the Holocaust.

Like much of the literature from the 1970s on, these four stories are hybrids. Sebald exploits the tension inherent in the polarity of "facts" and "fiction" by introducing documents, such as photographs of people and scenes described, or of diaries and memoirs left behind and now paraphrased and/or excerpted by the narrator, who in the course of exploring their lives speaks with their relatives and friends. In each instance, the narrator has early contacts with the protagonist but comes to know him only later, so that the juxtapositions of narrated and narrative time create complex patterns. The documentary aspect of each narrative is undermined by the various views of the narrator's informants and the fragmented recollections of the principals themselves; photographs are blurred, or downright unreliable—some are shown to be forgeries (183). Sometimes the narrator records in indirect discourse what he is told, or limits his account to what has impressed him, and sometimes he supplies his own version or interpretation of a story altogether. Throughout, he is aware that memory is fallible, a territory that can be partially reclaimed but is dotted with "lagoons of oblivion" (174).

The narrator describes the circumstances of his own life at the time he becomes interested in the lives of these "others"; he describes the note-taking and the travels necessary for his research, so that the narratives are also works-in-progress constructed in front of the reader. The gaps between the narrative fragments and the narrator's frequent revisitations of the same event create what one might call "dense" time—a time in which past and present intersect, commingle, and overlap. This commingling destroys sequence and evokes the sense of a labyrinth with no exit, contributing to a mood that suffuses the novel with a melancholy sense that there are no goals, no hope, no future. Max Ferber expresses the fundamental tenor of all four narratives when he says that time "is an unreliable way of gauging these things, indeed it is nothing but a disquiet of the soul. There is neither a past nor a future. At least, not for me" (181). All four narratives continue the techniques and express the post-Holocaust worldview associated with fragmentation, disruption, severance, destruction of sequence, and a closed universe devoid of hope. Although

each of the four stories seems self-contained, together they recapitu-
late—in fragments—the history of the relations of Jews and non-Jewish
Germans over the last century and the failed—and denied—assimila-
tion. Most significantly, they succeed in breaking the narrative patterns
and perspectives in which the Nazi past has been discussed in postwar
German literature. The book is remarkable—and unique—in that it
portrays without authorial self-consciousness or self-absorption these
relationships and ventures into territory where Jews and non-Jews are
equal as subjects and partners. And it shows the results of this now bro-
ken and shattered relationship in an all-engulfing melancholy.

 The narratives are arranged in order of increasing complexity. In the
first, the narrator meets Dr. Henry Selwyn in 1971, when Selwyn is sev-
enty-nine years old. Selwyn tells him that after they landed in London a
teacher took an interest in him and helped him on the road to becoming
a successful physician. He married a Swiss woman, Elli, and lived well
in the twenties and thirties, but then the couple began to drift apart. In
1960, he gives up his practice and becomes a recluse, "a kind of orna-
mental hermit" (5) in his overgrown and unkempt garden, where "al-
most my only companions have been plants and animals" (21). He
confesses to the narrator that "in recent years" he has been "beset with
homesickness more and more" (18). Leaving his home village was the
first uproooting; the second was changing his name from Hersch Sew-
eryn to Henry Selwyn (20). When Selwyn changed his name, he denied
his past, and he concealed even from his wife his true background "for a
long time" (20–1). He knows that "perhaps, at one point" (21) he sold
his soul. His self-imposed isolation, the desolation of his surroundings,
and his lack of purpose all reinforce a melancholy that is the condition
of this emigrant. He ends his life by shooting himself with his favorite
hunting rifle.

 Henry Selwyn's is the story of an East European Jew who wants to as-
similate and ostensibly succeeds in doing so but who pays "with his
soul." Paul Bereyter, the protagonist of the next story, comes from the nar-
rator's hometown of S. in southern Germany, where Bereyter père owned
the only department store of the region. The narrator remembers him as a
superb teacher (excellent teachers appear in all the stories), while the
events of his life are filled in by Mme Landau, a friend of Paul's during the
last thirteen years of his life. Mme Landau is herself an emigrant who in
1933, at the age of seven, left Frankfurt with her father, a widowed art his-
torian, to live in Switzerland (42). In 1952, when the narrator-as-a-young-
boy meets his teacher, he is not aware that Paul Bereyter is part Jewish
and had suffered during the Nazi regime. Mme Landau bluntly comments
on the silence that surrounded Bereyter's history in the town.

I do not find it surprising . . . not in the slightest, that you were un-aware of the meanness and treachery that a family like the Bereyters were exposed to in a miserable hole such as S. then was, and such as it still is despite all the so-called progress; it does not surprise me at all, since that is inherent in the logic of the whole wretched sequence of events (50).

Paul Bereyter's life was devastated by the Holocaust. An impassioned teacher, he was denied a teaching position in Nazi Germany; the young Austrian woman he had fallen in love with vanished in the Holocaust; his father died "from the fury and fear that had been consuming him ever since; precisely two years before his death, the Jewish families, res-idents of his home town of Gunzenhausen for generations, had been the target of violent attacks" (53); his mother, ostracized by the townspeople and forced to sell the store after her husband's death for "next to noth-ing," fell into a deep depression and within a few weeks also died. Since both his grandfather and his father had married Christian women and Paul is only one-quarter Jewish, he is not deported to a concentration camp but, ironically, made to serve in the German army. After the war, he moves back to his native town. Mme Landau reflects on this decision as "an aberration" and surmises:

What moved and perhaps even forced Paul to return in 1939 and in 1945 was the fact that he was a German to the marrow, profoundly at-tached to his native land in the foothills of the Alps, and even to that miserable place S. as well, which in fact he loathed and, deep within himself, of that I am quite sure . . . would have been pleased to see de-stroyed and obliterated, together with the townspeople, whom he found so utterly repugnant (57).

Homesickness created for Paul the paradoxical situation that he felt most alienated and "other" where he felt most at home. Living in his hometown, he was an "emigrant" "consumed by the loneliness within him" (44). At age seventy-four, he lay down and let a train, symbol of freedom and movement and one of his passions, run over him.

Ambros Adelwarth emigrated to America before World War I. In con-trast to Selwyn and Bereyter, where the alienating and isolating events are clearly identified, Ambros's important life experiences are shrouded in silence, open only to guesses and hypotheses. Whether his hard child-hood, an early departure from home, or the geographic dislocations made him an "emigrant" cannot be ascertained; the fact that, as the narrator's Uncle Kasimir points out, "he was of the other persuasion" (88) may have been of greater consequence.

In this particular story, Jews are not the protagonists, but they are major figures in the lives of Ambros and the relatives he helps to settle in New York. The Solomon family are rich New York bankers (88), and Ambros works as their majordomo. Within a short period of time, he becomes the personal attendant of Cosmo Solomon, an extremely gifted and eccentric young man a few years younger than Ambros. In the early 1920s, when there are no prospects in Germany, Ambros's niece Fini, a trained teacher, finds a position as governess with the Seligmans; Theres, a seamstress, becomes a lady's maid to Mrs.Wallerstein (76)— and suffers excruciatingly all her life from homesickness which she tries to soothe by collecting Hummel figurines. His nephew Kasimir, who had worked in Germany as a tinsmith and helped to repair the synagogue in Augsburg, which needed a new roof after the Jews of Augsburg donated the old copper roof for the war effort, moves in with a Mrs. Risa Litwak on the Lower East Side after his arrival in New York and finds work "making stainless-steel boilers and vats of various sizes" (84). During Prohibition, old Mr. Seckler, "a Jew from Brünn," sells them "with utmost discretion" to illicit distilleries and recommends Kasimir as a metalworker for the construction of a yeshiva. In all these instances (and in the marriages of Selwyn and the two Bereyter men), interactions between Jews and non-Jewish Germans are seen as daily events. There is no tinge of anti-Semitism; there is no philo-Semitic posturing. Some Jews, such as the Augsburg community, are loyal patriots; some Jews, such as old Seckler, are on the wrong side of the law. In these sketches, Sebald resurrects a pre-Nazi era in which Germans and Jews were not polarized into victims and perpetrators. For postwar German literature, this is something new.

When Cosmo succumbs to severe mental depression, Ambros takes him to a mental hospital in Ithaca, where "that same year, without saying a word or moving a muscle, he faded away" (98). Like Selwyn and Bereyter, who toward the end of their lives become ever more despondent, Ambros becomes so depressed that "he could no longer shape a single sentence, nor utter a single word, or any sound at all" (103). Silence has engulfed him before he dies, in a way that reconnects him, as was the case with Selwyn and Bereyter, with moments of enjoyment or love: he consigns himself to the same asylum in Ithaca where Cosmo died. There, experimentation in massive shock therapy kills him. When the narrator visits the sanatorium thirty years later, he finds it abandoned and dilapidated. A former therapist, Dr. Abramsky (himself an "emigrant" from life and now a lonesome beekeeper in an overgrown garden), remembers Ambros as the most melancholic person he had ever met—someone who seemed "filled with some appalling grief" and whose "every casual utter-

ance, every gesture, his entire deportment . . . was tantamount to a constant pleading for leave of absence" (111).

"Max Ferber" is the longest of the four narratives.[10] Ferber's biography is presented twice. The narrator, soon after his arrival in Manchester as a young man, meets Ferber, a painter. At that time, Ferber gives the narrator an "extremely cursory version of his life" (166)—mainly about missing military service during World War II because of jaundice and resuming his art studies in Manchester after the war. Some twenty-five years later, the narrator sees one of Ferber's paintings exhibited in the Tate Gallery and reads a review about him. He learns that Ferber at the age of fifteen fled Munich for London, but that his parents were among the first German Jews to be deported and were murdered in Riga in November 1941 (178). He now realizes that, like Parcival, he had never asked Ferber interested questions about his life, and he travels back to Manchester, where he finds Ferber in the same time-defying studio where they first met. Ferber recounts his early childhood memories, talks about his family's reactions to the Nazis, about his father's brief internment in Dachau, about his own escape to London to join his uncle, and his parents' hopes that they, too, would join them soon. For Ferber, Manchester is the immigrant city par excellence, and "for a hundred and fifty years, leaving aside the poor Irish, the immigrants were chiefly Germans and Jews" (191). As in Ambros Adelwarth's New York, Germans and Jews of all nationalities live together in Manchester, all of them emigrants and laboring under the same sense of uprootedness and alienation. For this reason Ferber feels this is his place: "[T]he German and Jewish influence was stronger in Manchester than in any other European city; and so, although I had intended to move in the opposite direction, when I arrived in Manchester I had come home, in a sense" (192).

But Manchester is no longer the bustling industrial city it once was. It is a city in decay. In fact, the entire "Max Ferber" narrative abounds with descriptions of desolate, abandoned districts and grimy, crumbling structures. This decay can also be read as a symbol of the destruction of relations between German Jews and non-Jews. Ferber's first impressions of Manchester were of a place that resembled an extermination camp; like the playwright Peter Weiss, a refugee who visited Auschwitz in the postwar period and realized that this was the place that had been destined for him,[11] Ferber connects so closely with this devastation that, arriving in Manchester in 1945, he feels that "I had found my destiny." Looking at Manchester from the distance, he tells the narrator, his eyes took in

the crammed and interlinked rows of houses, the textile mills and dying works, the gasometers, chemicals plants and factories of every

kind, as far as what he took to be the centre of the city, where all
seemed one solid mass of utter blackness, bereft of any further distin-
guishing features. The most impressive thing, of course, . . . were all the
chimneys that towered above the plain and the flat maze of housing, as
far as the eye could see. Almost every one of those chimneys . . . has
now been demolished or taken out of use. But at that time there were
still thousands of them, side by side, belching out smoke by day and
night. Those square and circular smokestacks, and the countless chim-
neys from which a yellowy-grey smoke rose, made a deeper impression
on me when I arrived than anything else I had previously seen, . . . I can
no longer say exactly what thoughts the sight of Manchester prompted
in me then, but I believe I felt I had found my destiny (168–69).

The image of the chimneys, now extinct, but "belching out smoke"
when he arrived, is a powerful symbol for Ferber's survival and post-
Holocaust existence, and his observation "with every year I have spent
since then in this birthplace of industrialization, amidst the black
façades, I have realized more clearly than ever that I am here, as they
used to say, to serve under the chimney" (192) can be understood as a
reference to the industrialized aspect of the Holocaust as much as to the
fact that Ferber's life is led under the lasting impact of "the chimney."
As the narrator departs, Ferber hands him some photographs and his
mother's memoirs, which she wrote for Max after it became clear she
and her husband would no longer be able to get out of Germany, and
which reached Max only after the war. The memoirs of her childhood
and young adult life in Steinach and Bad Kissingen, where Jews had lived
since "at least as far back as the late seventeenth century" (193) are a
monument to the Jewish culture in which she grew up. Her memoirs
come from the other side of the Holocaust, as memoirs of a culture now
destroyed and recorded to conjure up a counterworld in the face of anni-
hilation. They are the last testimony to pre-Holocaust life in Germany.
Sebald does not usurp the mother's voice or persona but respects the
voice of the "other" as it celebrates her own culture and simultaneously
mourns its destruction.[12] Ferber's handing these memoirs over to the
narrator is not only a sign of friendship and personal trust but a sur-
vivor's charge to the successor generations to honor and value what is
left of the Jewish heritage. The narrator travels to Bad Kissingen to ex-
plore what vestiges of Jewish life there are left, and he begins to write
Ferber's story. When he hears that Ferber is suffering from pulmonary
emphysema and has entered a hospital, he goes back to Manchester. The
last image of the book (there is no closure in this last episode, just as Fer-
ber does not die) is of the narrator sitting on a dreary and rainy early

evening in his hotel room in Manchester, in the same hotel where Ferber has taken lodgings (hotels are the appropriate abodes of emigrants). As he is invaded by memories, he sees in his mind's eye photographs from an exhibition the year before in Frankfurt of "the Litzmannstadt ghetto" (235). In one picture, three young women sit behind a loom, permitted to look up from their work "solely for the fraction of a second that it took to take the photograph" (237). Looking into the camera, they also look directly at the viewer, one "with so steady and relentless a gaze" that the narrator cannot meet it for long. In the last sentence of the book, and in vain trying to re-create them as individuals, he wonders "what the three women's names were—Roza, Luisa, and Lea, or Nona, Decuma, and Morta, the daughters of night, with spindle, scissors, and thread" (237). The steady and relentless gaze across the abyss of destruction is, as much as the memoirs of Ferber's mother, the legacy of those annihilated.

This final narrative is also the most self-reflective, in the sense that it reflects on the conditions under which art in a post-Holocaust universe can be created (and of which the book written by Sebald is, of course, another instance). Ferber's art is an art of erasures and annihilations that leave vestiges of debris and dust. This is how the narrator sees Ferber's work:

> Since he applied the paint thickly, and then repeatedly scratched it off the canvas as his work proceeded, the floor was covered with a largely hardened and encrusted deposit of droppings, mixed with coal dust (161) . . . and that process of drawing and shading on the thick, leathery paper, as well as the concomitant business of constantly erasing what he had drawn with a woollen rag already heavy with charcoal, really amounted to nothing but a steady production of dust . . . (162)

In his art, Ferber strives to attain what the city and the sanatorium at Ithaca already prefigure: a point of stillness and immobility "where things remained undisturbed, muted under the grey, velvety sinter left when matter dissolved, little by little, into nothingness" (161). The return to dust and "sinter" echoes his sense that he felt he had found his destiny in Manchester—for dust, powder, sinter, ashes were the substances emerging from the belching chimneys. But these substances cannot create lasting images and a lasting memory, which, after all, art is struggling to produce. The narrator marvels that "with the few lines and shadows that had escaped annihilation," Ferber could create portraits "of great vividness" (162) even though the surfaces of his canvases were "badly damaged by the continual destruction." Significantly, Ferber is not interested in creating landscapes or still lives, but tries instead to "excavate" human beings. In a post-Holocaust universe, the subjects of

the portraits are remembered as they undergo and transcend annihilation. The "long lineage of grey, ancestral faces, rendered unto ash but still there" (162) expresses the apparent paradox that despite destruction, presence is not extinguished. This powerful artistic image could well serve as a parable for post-Holocaust attempts to express how to live with the Holocaust: it is the realization that a "long lineage" has been destroyed but is "still there" and speaks through its ashes, "as ghostly presences." In their annihilation these faces, like the mother's memoirs and the photograph of the young women in the Lodz ghetto, speak of their indelible presence.

Ferber's efforts to express annihilation through erasures and, simultaneously, to have annihilation speak of what was annihilated are equally binding for the narrator. As he works on what he calls self-deprecatorily his "cut-down rendering" (231) of Ferber's life, he is overcome by doubts as to whether or not he can do justice to his subject, but also by doubts about the efficacy of any kind of writing. He says that he

> not infrequently . . . unravelled what I had done, continuously tormented by scruples that were taking tighter hold and steadily paralysing me. These scruples concerned not only the subject of my narrative, which I felt I could not do justice to, no matter what approach I tried, but also the entire questionable business of writing. I had covered hundreds of pages with my scribble, in pencil and ballpoint. By far the greater part had been crossed out, discarded, or obliterated by additions. Even what I ultimately salvaged as a "final" version seemed to me a thing of shreds and patches, utterly botched (230–1).

Writing a "cut-down rendering" of Ferber's life that has, just like Ferber's portraits, an ancestral depth, is a labor of mourning. Sebald remembers—and mourns—the last hundred years of German Jews and non-Jews living together. In writing these four narratives, Sebald has responded to the Mitscherlichs' diagnosis of "the inability to mourn" and suggests that the time to mourn has come, at least in his writing.

The lack of boundaries and definitions in this universe of disintegration is repeated in the attempt to abolish the boundaries between the living and the dead—or, rather, to make the dead part of the present. The narrator dreams of Ambros and Cosmo—dreams in which "they were silent, as the dead usually are when they appear in our dreams" (122); Ferber "felt as if he were tightening his ties to those who had gone before" and "was aware of a sense of brotherhood that reached far back beyond his own lifetime or even the years immediately before it" (167); the narrator leafs through the album Paul Bereyter left behind and thinks "it truly seemed to me, and still does, as if the dead were coming

back, or as if we were on the point of joining them" (46). He expresses this thought even more strongly when the body of an alpine guide, a friend of Dr. Selwyn, who was lost in a glacier, is found seventy-two years after he disappeared: "And so they are ever returning to us, the dead" (23). Cemeteries, too, are an important part of this universe. "Like Death itself, the cemeteries of Constantinople are in the midst of life" (131) and Manchester not only has a cemetery, it is "a necropolis or a mausoleum" (151).

The Emigrants preserves the memories of those who have gone or have been annihilated. The book in its entirety can be considered as one of the tombstones it describes. Like Ferber's paintings and his mother's memoirs, Sebald's book keeps alive the memory of people and a culture destroyed. In this sense, it is a book of remembrance and of mourning, and the process of writing the book (which is itself part of the story of the book) can be considered a labor of mourning, an act of atonement, and a restitution of individuality. Yet when one considers the images that dominate, it is a book of dissolution and erasures, best symbolized by dust and shapeless clouds, and a book of profound melancholy that expresses a longing for absence, for ultimate stillness and abandonment of time. Here the book sustains a tension between mourning, which attempts to preserve and memorialize, and a melancholic longing, which prefers to dissolve and erase.

When Sebald makes melancholy the underlying and all-pervasive mood of the four narratives, he does not follow Freud's distinction between mourning and melancholy, which Freud describes in his paper "Mourning and Melancholia"[13] and which was such an important guideline for the Mitscherlichs. Sebald defines melancholy not as *sui generis* but as a form of the labor of mourning (*Trauerarbeit*) and sees melancholy as a "non-comprehended dejection."[14] But the promise of renewed life and of renewed interest in life contained in Freud's hypothesis that the labor of mourning can be completed is absent in Sebald. On the contrary, Sebald sees the "constant condition of melancholy" connected to "the insight into the impossibility of redemption" (44). Sebald takes issue with the message of hope implicit in Freud's theory of mourning—a message rarely ever broached in discussions about Germany and the Holocaust, since it would imply an eventual release from the burden and guilt of the Holocaust once an appropriate way of mourning was found. Sebald, who creates labyrinthian and closed narrative structures, radically denies such a possibility.

There is much sadness and bitter irony in the fact that the places where Jews and non-Jewish Germans got along best were outside Germany—in New York and in Manchester. And it is highly ironic that

Manchester is seen as the melancholic city par excellence, while German cities—and the German population—avoided collective melancholy, as the Mitscherlichs so cogently diagnosed. Displacing mourning to a locale outside Germany rests perhaps on an assessment that chances for mourning within Germany are slim; perhaps Sebald is also suggesting that only an "emigrant"— someone with an outsider's view—can engage in mourning, since emigrants are unencumbered by intra-German self-absorbed controversies.

In these few narratives, there is a considerable shift in the "language of silence." There is no silence about the Holocaust, although mention of the atrocities remains in the background—perhaps because the atrocities were by the time of this writing widely known. But Sebald's text is steeped in images of the Holocaust and a language of mourning and melancholy so pervasive that it applies even when the text speaks of other events and times. In this mourning, Sebald restitutes individuality to the victims he portrays and in doing so introduces a new kind of silence—the silence of the victims. Paul Bereyter, for example, "preserved a resolute silence" on the subject of Helen Hollaender, the woman he had fallen in love with; Henry Selwyn had "a blinding, bad time . . . about which I could not say a thing even if I wanted to" (21); and Ferber noted "that of those things we could not speak of we simply said nothing" (183).[15] He adds that "all my family and relatives remained largely silent about the reasons why my grandmother Lily Lanzberg took her own life" (183) and he remembers when his parents drove him to the airport for his escape to London, "none of us said a word" (187). This is the other side of the "language of silence," so far not heard in the literature of the successor generations. In so much of postwar German literature, "the language of silence" not only expressed strategies of avoidance or omission but also was incapable of giving voice to the victims. In Sebald's book, the victims speak, and they fall silent when the limits of what can be said have been reached. Theirs is the silence of too much endurance, not the silence of too little acknowledgment. The relentless gaze of the young woman from the Lodz ghetto crosses the abyss from one silence into the other.

Conclusion

The murder of the Jews is being recognized as an integral yet non-integratable part of German history.[1]

The Jewish Presence in Contemporary Germany

During the 1980s, before the fall of the Berlin wall and unification, several new developments started to shape the discourse about the Holocaust in Germany. They have been taking place outside literature. The first is the reemergence of a Jewish presence and culture in Germany; the second is the shift away from literature to the most conspicuous of public arts: architecture—specifically to the construction of Holocaust museums, monuments, and memorials.

To be sure, over the postwar decades, there have been various attempts on a regional and community level to salvage remnants of Jewish culture in Germany, to establish academic, artistic, and student exchanges, to teach about the Holocaust in school,[2] and to build volunteer groups (Action Reconciliation/Services for Peace is perhaps the best known; service in it fulfills the requirement of military service). Many of these activities were initiated by private citizens and citizen groups who wanted to show their concern (and perhaps even remorse) and to make amends through personal acts of commitment.[3] They were not reflected in literature, perhaps because they never became commonly held, unconscious assumptions. More recently, members of the third

postwar generation participate in excavations and reconstructions of de-
stroyed Jewish sites, concentration camps, and other sites of terror. In an
eerie juxtaposition of then and now

> [s]tudents devote their summers to concentration camp archaeology at
> Neuengamme, excavating artifacts from another, crueler age. Or they
> take hammer and nails to rebuild a synagogue in Essen, or to build a
> monument at the site of Dachau's former satellite camp at Landsberg.
> Brigades of young Germans once again report dutifully to Auschwitz,
> where they now repair dilapidated exhibition halls, tend shrubs around
> the barracks, and hoe weeds from the no-man's-land strip between for-
> merly electrified fences. No less industrious than the generations pre-
> ceding them, German teenagers now work as hard at constructing
> memorials as their parents did in rebuilding the country after the war,
> as their grandparents did in building the Third Reich itself.[4]

These activities conform with a recent and keener interest in past
Jewish life and culture and coincide with the emergence of a new and
outspoken Jewish culture in Germany.

The Jews living in Germany today live there for a variety of reasons
and come from widely divergent backgrounds. The number of Jews liv-
ing in Germany in the mid-1990s is estimated at about 100,000—as op-
posed to half a million when the Nazis came to power.[5] Sander Gilman
gives an intimation of this diversity as it relates to cultural life:

> They are Jews of Eastern European, German, and Sephardic ancestry,
> Jews of American ancestry only one or two generations away from
> their European roots, Jews who are ethnically Jewish or religiously
> Jewish, Jews who have discovered that one or the other parent was Jew-
> ish and have reclaimed their cultural tradition, if not their religious
> heritage, Jews who speak English and write German or speak German
> and write English, who have married into German families who were
> not Jewish and into German families who were Jewish, and Israeli
> Jews, sabras who have moved to Germany as children or as adults and
> who see themselves as Israelis and/or Jews in Germany. But from all
> these groups come players on the cultural scene.[6]

Not specifically mentioned in this array is the relatively large and re-
cent influx of Russian Jews. As former Communists, they are in large
measure not religious and are strangers not only to German society but
also to the Jewish communities in Germany. They have not yet become
"players on the cultural scene," but, if only because of their numbers,
they will eventually transform the tenor of Jewish and non-Jewish com-
munities alike.[7] In addition to dealing with this externally occasioned

diversity, any Jew who has chosen to live in Germany must experience a profound ambivalence about his or her choice and personal and/or group identity, and also contend with the disapproval of world Jewry—particularly from a large segment of the American Jewish community.[8]

Nevertheless, the Jewish presence and the impact of Jewish thought on postwar Germany have been constants—so much so that the young German Jewish writers and intellectuals emerging over the last decade and a half are considered "third generation."[9] According to Sander Gilman and Jack Zipes, both of whom have examined the significant Jewish contributions to post-Nazi German intellectual life, the "first generation" consists of scholars and intellectuals who had established reputations during the Weimar Republic and who continued to exert a profound influence on postwar Germany, such as the social philosophers Theodor Adorno and Max Horkheimer, the philosopher Ernst Bloch, the literary critics Hans Mayer and Werner Krauss. The "second generation" comprises writers and intellectuals who survived the Holocaust in their youth and began to give voice to their experiences in the post-Nazi period. (Quite a number of writers in this group chose to live outside Germany.) Members of this second generation are Jurek Becker, Jakov Lind, Wolfgang Hildesheimer, Edgar Hilsenrath, Ralph Giordano, the playwright Peter Weiss, the philologist and diarist Victor Klemperer, the essayist Jean Améry, the literary critic Marcel Reich-Ranicki, and the poets Paul Celan, Nelly Sachs, and Rose Auslaender. The "third generation" made its literary and journalistic debut mostly in the 1980s: it includes the writers Jeannette Lander, Barbara Honigmann, Esther Dischereit, Rafael Seligmann, Maxim Biller, Katja Behrens, the essayist Chaim Noll, and the journalist Hendryk Broder. As successors to the Holocaust generation, this third generation is concerned with the fragile balancing act of living in Germany as Jews, the difficult struggle of self-definition, and the search for a Jewish identity in the country of the murderers. Its members' complex self-identification as Jews living in Germany is constantly put to the test by the attitudes of the non-Jewish citizens—attitudes that are profoundly marked by the largely unresolved consciousness of the Holocaust.

The efforts of the new generation of Jewish intellectuals in Germany must be appreciated against this background. They reject the dominant culture's stereotypes and its silences; they define their own problematics, ambivalences, and struggles; they determine how they want to be perceived; and they protest vigorously when they feel slighted or insulted (as they did on the occasion of Bitburg and during the Fassbinder affair). This is indeed a departure: when earlier generations of German Jews and Jews living in Germany opted for assimilation, it was always

on the dominant culture's terms, never on their own. Today, as Jack Zipes notes, "German Jews themselves are stimulating this interest and defining themselves in a way that they had not done in the immediate postwar years."[10] Influenced by the French philosophers Gilles Deleuze and Felix Guattari's formulation of a minor literature, Zipes finds that "Jews have themselves developed an alluring if not fertile 'minor' culture of their own in Germany that enables them to view themselves in a much different light than . . . Germans [view them]." Despite some reservations, Zipes is hopeful about

> the resurgence of Jewish culture in Germany as a 'minor' culture that has compelled the attention of Germans during the past fifteen years and altered their views of Jewishness and themselves and perhaps has laid the groundwork for a different kind of relationship, not dominated by guilt and certainly opposed to the anti-Semitism and xenophobia exhibited by a small minority of Germans today.[11]

Sander Gilman affirms the resurgence of Jewish life in Germany in even stronger terms:

> We can now observe in detail the struggles and desires of a new version of modern Diaspora Judaism, a portrait of the reestablishment of Jewish cultural life in a culture that destroyed its Jewish community. We have had such moments in the past. . . . But never have we had a chance in recent times to examine the reconstitution of a Diaspora Jewish community under such circumstances. The post-Shoah image of Germany without Jews has passed. Now we are at the point of observing the way a Jewish community in all of its complexity and with a unique history reemerges from oblivion.[12]

While the Jews in Germany have begun to seize the initiative and determine how they want to be perceived, non-Jewish Germans respond by evincing great interest, in Jack Zipes's phrase, in "things Jewish." He quotes the journalist Ian Buruma, who found on a trip to Germany that

> [t]he sections on Judaica in German book shops are expanding all the time. In one average week of watching German television, I saw a program on historical Jewish communities in Europe, two programs on aspects of the Holocaust, a report on Jews returning to Germany, and several documentaries about Jewish artists and intellectuals. The biggest exhibition in Berlin this year was on the history of Jewish culture, accompanied by a festival of old Yiddish films.[13]

But as the literature written by non-Jews and Jews alike makes evident, there is still little contact or dialogue between Jews and non-Jews,

little "unsettling" of the major culture, and little integration on the level of unconscious assumptions, where "things Jewish" should be part of a common culture, not exotic exhibition pieces. Gilman notes that "the German public . . . finds dealing with Jews easier in museums than on the streets"[14]—a succinct way of saying that Germans are more comfortable with Jews and their culture when they can be viewed from the distance rather than with the Jews living among them.[15] Where there was once a denial of the Holocaust, there is now a concentrated preoccupation with it, which nevertheless avoids an engagement with Jews "on the street." The language of silence is no longer silent about the Holocaust but shies away from an engagement with living Jews which might result in painful confrontations. So far, and with only a few exceptions, Jack Zipes's observation of the "Contemporary German Fascination for Things Jewish" seems a self-absorbed concern with the past, in which Jews remain objects. It is compatible with a continued "inability to mourn" where "genuine attempts at mourning are hopelessly entangled with narcissistic injury, ritual breast-beating, and repression,"[16] and with a lack of interest in and concern for Jews as equally entitled others and acting subjects of their own history and present. Are books like *Couplings* and *The Emigrants* testifying to a new, more open relation between Jews and non-Jews in Germany, do they allow mourning and sorrow to emerge, or will they remain exceptions?

The Institutionalization of the Holocaust

Architecture is a relatively recent field for ongoing debates about the Holocaust. Public discourse about monuments and memorials has become prominent particularly in the past two decades, roughly coinciding with the jolt the TV series *Holocaust* gave to German awareness of the Holocaust and the *Tendenzwende* shortly afterward, that brought Chancellor Kohl to office along with the attempts to acknowledge but also to historicize the Holocaust. In Germany as elsewhere, public memorializations and commemorations began shortly after liberation, but they were initially organized by the victims or the Allies. There are now thousands of monuments and memorial sites in Europe, the United States, and Israel dedicated to the mass murder of the Jews, and dozens more are proposed and erected every year. Over one hundred museums and other memorial institutions have been built and many more are planned, so that the scholar of Judaic studies James E. Young can speak of a "veritable explosion of Holocaust monuments in recent years."[17] In Germany, the establishment of memorial sites and monuments has fre-

quently been accompanied by controversy, for rarely has a nation been confronted with the problem of building memorials to its own crimes. The controversy bears on whom to remember (the victims of the Holocaust were primarily Jews, but the Sinti and Roma, political prisoners, religious opponents, and homosexuals were also persecuted and need to be remembered as victims), on what precisely should be remembered (East Germany took great pride in the German Communist resistance to the Nazis and took no responsibility for the Holocaust), on the material and aesthetic shape these memorials should take, and on what audience they should speak to (Germans as perpetrators only or also as victims of National Socialism). The ambiguities and ambivalences have been heightened by changing German self-perceptions and perceptions about what kind of grounding in history the monuments should provide.

One answer has been to subvert and reconceptualize the old, established forms of monuments. Andreas Huyssen sees the contradiction inherent in memorializing the Nazi crimes in these terms: "In contrast to the tradition of the legitimizing, identity-nurturing monument, the Holocaust monument must be considered, rather, as a kind of countermonument."[18] These countermonuments may be negatives or inversions of specific monuments; they may be interactive, in flux, or constructed to disappear over time. When James Young thinks of "the conflicted, self-abnegating motives for memory in Germany today," he finds them impressively represented in "the vanishing monument"[19] as one kind of countermonument. To him, one of the important aspects of these countermonuments is their ability to incite debate—since debate militates against forgetting. In a radical conclusion, he suggests that debates about memorials can assume the role of the memorials themselves—they carry out the memory work in all its convoluted and self-conscious insufficiencies.

> Holocaust memorial-work in Germany today remains a tortured, self-reflective, even paralyzing preoccupation. Every monument, at every turn, is endlessly scrutinized, explicated, and debated. Artistic, ethical, and historical questions occupy design juries to an extent unknown in other countries. In a Sisyphian replay, memory is strenuously rolled nearly to the top of consciousnesss only to clatter back down in arguments and political bickering, [whence] it starts all over again. . . . In fact, the best German memorial to the Fascist era and its victims may not be a single memorial at all—but simply the never-to-be-resolved debate over which kind of memory to preserve, how to do it, in whose name, and to what end.[20]

The glaring omissions, circumventions, repressions,. and insensitivities of the language of silence in literary discourse find their equivalent

architectural disputes. A few examples should illustrate this point: In 1982, Richard von Weizsäcker, then lord mayor of Berlin, invited a competition to design a public space at the site of the ruined Gestapo headquarters. The challenge was "to reconcile the historical depth of the location with practical applications, such as the establishment of a park, playground, and exercise area."[21] How a place where hideous torture was practiced should retain an aura of "historical depth" and simultaneously provide enjoyment and relaxation as "a park, playground, and exercise area" defies comprehension. Does this notion simply betray a monstrous thoughtlessness and a total lack of understanding of what the site signified, or did a desire for efficiency and maximum utilization of space rule out other considerations? After the customary disagreements and arguments, the site was never developed; a temporary exhibit, "The Topography of Terror," was eventually mounted which retains the site's temporary quality, including the postwar neglect (itself an expression of an attempt to evade history and keep it buried under rubble). In 1993, protest erupted over the rededication of the *Neue Wache*, the historic guardshouse completed in 1818 in Berlin, which Chancellor Kohl wanted as a "worthy common memorial for the victims of both world wars, tyranny, racial persecution, resistance, expulsion, division, and terrorism."[22] Kohl's umbrella approach to memorialization recalled for many the Historians' Controversy: by commemorating all victims (the victims of the Nazi regime and the Holocaust along with the perpetrators and the perpetrator generation), including the victims of World War I, German history would be "normalized" and would remind the visitor of a historical context larger than the Nazi regime. The protests failed to dissuade Kohl, and he made only one concession: a bronze plaque listing the various groups of victims was added at the building's entrance. As the historian Brian Ladd wryly notes, "Nazi officials and SS men were of course not among them."[23] In 1992, plans for the construction of a Holocaust memorial on an enormous, five-acre site vacated by the former wall plunged Berliners (and the entire country) into vivid and convoluted debate. An overwhelming number of five hundred and twenty-seven design entries competed, but no decision could be reached; ultimately Kohl called for a new competition. Whether or not and how to build this Holocaust memorial even became a campaign issue in the Federal elections in September 1998. As of the end of 1998, there is still no resolution in sight.

While the public discourse about monuments, memorials, and architecture magnifies positions that were already evident in the Language of Silence, the structures themselves display stylistic characteristics similar to those in literature. In both literature and architecture, the Holocaust as radical discontinuity and break in civilization has made it

impossible to rely on traditional art forms, which strive for wholeness and closure. Instead, fragmentations, inversions, and absences abound. As the literary boundaries between fiction, documentary texts, autobiographies, and their simulations have been abolished and photographs have become part of the text, so boundaries between sculptures, graphics, photographic projections, and spectator-triggered light projections, and between ruins as ruins and ruins as memorial spaces, have become fluid. In literature, silences and fragmentations always carry the double weight of striving to find a language that expresses the horror (if not the sorrow) even while caught in self-absorption and revealing unconscious blind spots that bar access to a genuine working through of the past. In architecture, the broken forms, the absences, the inversions are unambiguous attempts to depict annihilation and loss, while the ambivalences and ir-resolutions come to the foreground in the debates.

In this general atmosphere, the architect Daniel Libeskind has accomplished a unique feat. His design for the extension of the Berlin Museum with the Jewish Museum illustrates the reemergence of a Jewish presence that speaks for its own positions and concerns. Libeskind has used the properties of broken lines (the broken Star of David), of absences and of voids to achieve the extraordinary experience of the absence of Jewish life in Berlin and at the same time express its past integral presence. The underground connection and integration of the two buildings (the Baroque structure of the Berlin Museum and the new Jewish Museum with its broken outline) attains a spiritual quality that removes commemoration from ritualistic public observances and elevates it to an individual, affect-loaded experience. Libeskind explains: "Physically, very little remains of the Jewish presence in Berlin—small things, documents, archive materials, evocative of an absence rather than a presence. I thought therefore that this 'void' which runs centrally through the contemporary culture of Berlin should be made visible, accessible." For this reason, "[t]he new extension is conceived as an emblem where the not visible has made itself apparent as a void, an invisible. The idea is very simple: to build the museum around a void that runs through it, a void that is to be experienced by the public."[24] The void commemorates, for the survivors and perpetrators and their successor generations alike, annihilation and irredeemable loss. Reemphasizing the negative symbiosis of which Dan Diner has spoken, where in a "kind of contradictory mutuality . . . Germans as well as Jews have been linked to one another anew," Libeskind designed the void in such a way that no visitor, Jewish or non-Jewish, can circumvent it—and "no visitors could pass through the museum without being aware of the Jewish presence, nor could a Jewish visitor withdraw to a separate wing and sink into the past of Jews

alone."[25] In Libeskind's design, Jewish expectations are met which liter-
ature written by non-Jewish Germans is only beginning to recognize—
the expectation that Jews will be seen as subjects of their own history.
Vera Bendt, curator of the new Jewish Museum, makes this very clear:
"Whether [the new Jewish Museum] is seen as a museum or as a depart-
ment, the term Jewish can only be justified when it is not only con-
cerned with exhibitions *about* Jews but when an arrangement is
achieved which Jews will support . . . both spiritually and materially, [so
that] it is their house for their history."[26]

The void as gaping absence and indelible memorial is a singular ac-
complishment and stands in opposition to what the sociologist Y. Michal
Bodemann has called "a culture, an industry, or even an epidemic of com-
memorating in Germany today."[27] This "epidemic of commemorating"
is an indication that the Holocaust has become part of Germany's—al-
beit conflicted—historical self-understanding. Remembrance engages in
works of atonement, erupts in conflicts and protests, settles as spectacle
and ritual, but always retains its ambivalent, irresolute quality. There is
danger that public observances of remembrance days and anniversaries
lead to ritualization and relieve the individual from the responsibility to
remember. This increasingly public memory work is further enhanced
through a plethora of films and TV series, documentaries, and exhibi-
tions, and amounts to what Michael Geyer and Miriam Hansen call a
"spectacularization of the past."[28] Institutionalization, ritualization,
mythization, spectacularization—all tend to absorb and obscure the rea-
sons for which they were created and to replace individual memory work
with public gestures. The historian Saul Friedländer sees the conse-
quences of such public commemorations of the Holocaust in these terms:
"[I]f we make allowance for some sort of ritualized form of commemora-
tion, already in place, we may foresee, in the public domain, a tendency
toward closure without resolution, but closure nonetheless."[29] Yet individ-
ual memory work is beginning to express sorrow and mourning at the
very moment when public commemorations tend to assign the Holocaust
its place in history and suggest a sense of closure. Günter Grass suggested
mourning as a future possibility as far back as 1972 in *From the Diary of a
Snail* and W. G. Sebald enacted it two decades later in *The Emigrants*. Per-
haps individual memory work is finally beginning to find voice.

Germans—sometimes more than the citizens of other countries—
have tried to address the Holocaust. They have done so not always con-
vincingly, and they have been ambivalent and conflicted about their
motives and in their efforts. For half a century, literature has reflected
these tortured, convoluted, even brazen and self-serving struggles and
has fashioned many languages of silence to cope with the knowledge and

the legacy of the atrocities committed. While the private silences have become public debates, literature has begun to chart new areas. It has begun to express sorrow and mourning, and has started to acknowledge and include the Jewish presence in Germany. One should expect that as the seismograph of unconsciously held values German literature will persevere in its search for new articulations in its continuing efforts to come to terms with the Holocaust.

Notes

Introduction

1. Ilse Aichinger in Klaus Briegleb and Sigrid Weigel, eds. *Gegenwartsliteratur seit 1968* (Munich: dtv, 1992) 47.

2. Jean-François Lyotard, *Heidegger and "The Jews"* (Minneapolis: University of Minnesota Press, 1988).

3. The Oxford English Dictionary defines "Holocaust," derived from the Greek, as a "complete consumption by fire, . . . complete destruction, esp. of large number of persons; a great slaughter or massacre" and adds that "the specific application (i.e. the mass murder of the Jews by the Nazis in the war of 1939–1945) was introduced by historians during the 1950s . . ." A brief exposition of the origins of the term is found in Susan E. Cernyak-Spatz, *German Holocaust Literature* (New York: Peter Lang, 1985) 9–10. Dominick LaCapra has discussed the problems associated with the use of the term "Holocaust" in detail in his *Representing the Holocaust: History, Theory, Trauma* (Ithaca: Cornell University Press, 1994) 45 n. 4. Peter Haidu rejects "Holocaust" as much as "Shoah" and prefers to speak of "the Event," as explained in his "The Dialectics of Unspeakability," in Saul Friedländer, ed., *Probing the Limits of Representation: Nazism and the "Final Solution"* (Cambridge: Harvard University Press, 1992) 279. On the inappropriate use of the word "Holocaust" in the German language, see Ralph Gehrke's agreement with Detlev Claussen, who feels that as a foreign word the term allows a dissociation from what it designates. Ralph Gehrke, "Es ist nicht wahr, daß die Geschichte nichts lehren könnte, ihr fehlen bloß die Schüler," *Der Deutschunterricht*, Jg. 44, 3 (1992) 92 n.1.

4. Jean Améry, "On the Necessity and Impossibility of Being a Jew," in his *At the Mind's Limits: Contemplations by a Survivor on Auschwitz and Its Realities,* trans. Sidney and Stella P. Rosenfeld (Bloomington: Indiana University Press, 1980) 86.

5. Sidra DeKoven Ezrahi, *By Words Alone: The Holocaust in Literature* (Chicago: University of Chicago Press, 1980) 10.

6. Terry Eagleton, *Literary Theory: An Introduction* (Minneapolis: University of Minnesota Press, 1983) 178.

7. Stuart Parkes in Arthur Williams, Stuart Parkes, and Roland Smith, eds., *Literature on the Threshold: The German Novel in the 1980s* (New York: Berg, 1990) 6.

8. Peter Schneider, "Concrete and Irony," *Harper's Magazine* (April 1990) 56.

9. Jean-Paul Bier, *Auschwitz et les nouvelles littératures allemandes* (Brussels: Editions de l'Université de Bruxelles, 1979) 217.

10. Lawrence L. Langer, *The Holocaust and the Literary Imagination* (New Haven: Yale University Press, 1975) 3.

11. Mary Nola, "The *Historikerstreit* and Social History," *new german critique* 44 (Spring/Summer 1988) 78.

12. Wolfdietrich Schnurre's *Jenö war mein Freund* (1960) is one of the few exceptions.

13. Peter Haidu elaborates this point from a deconstructive perspective in "The Dialectics of Unspeakability" when he says: "Silence resembles words . . . in that each production of silence must be judged in its own contexts, in its own situations of enunciation. Silence

can be a mere absence of speech; at other times it is both the negation of speech and a production of meaning. . . . [But] silence is enfolded in its opposite, in language. As such, silence is simultaneously the contrary of language, its contradiction, and an integral part of language. Silence, in this sense, is the necessary discrepancy of language with itself, its constitutive alterity" (278).

14. Hamida Bosmajian, *Metaphors of Evil: Contemporary German Literature and the Shadow of Nazism* (Iowa City: University of Iowa Press, 1979) 17.

15. Saul Friedländer in *Probing the Limits of Representation*, 5.

16. Theodor W. Adorno, "Cultural Criticism and Society," written in 1949, first published in 1951, rept. in his *Prisms* (Cambridge: MIT Press, 1981) 34.

17. Theodor W. Adorno, "Commitment" in his *Notes to Literature*, vol. 2 (New York: Columbia University Press, 1991) 87, 88.

18. Michael Wyschogrod as quoted by Alvin H. Rosenfeld in "The Problematics of Holocaust Literature," in Alvin H. Rosenfeld and Irving Greenberg , eds., *Confronting the Holocaust: The Impact of Elie Wiesel*, (Bloomington: Indiana University Press, 1978) 3.

19. Lawrence Langer, *The Holocaust and the Literary Imagination*, 2.

20. Ibid., 2.

21. As quoted by Klaus Laermann, "'Nach Auschwitz ein Gedicht zu schreiben, ist barbarisch," in Manuel Köppen, ed., *Kunst und Literatur nach Auschwitz* (Berlin: Erich Schmid Verlag, 1993) 15.

22. George Steiner, "The Hollow Miracle" in his *Language and Silence* (New York: Atheneum, 1974) 123.

23. Alvin H. Rosenfeld, *Confronting the Holocaust*, 4.

24. Walter Hinderer, "Die Gegenwart der Vergangenheit: ein deutsches Problem," in his *Arbeit an der Gegenwart: zur deutschen Literatur nach 1945* (Würzburg: Könighausen & Neumann, 1994) 114 ff.

25. Ezrahi, *By Words Alone*, 11.

26. Heinrich Vormweg, "Deutsche Literatur 1945–1960: Keine Stunde Null," in Manfred Durzak, ed., *Deutsche Gegenwartsliteratur: Ausgangspositionen und aktuelle Entwicklungen* (Stuttgart: Reclam, 1981) 20.

27. Steiner, *Language and Silence*, 100.

28. Ibid., 109.

29. Alexander and Margarete Mitscherlich, *The Inability to Mourn*, trans. Beverley R. Placzek (New York: Grove Press, 1975).

30. Dominick LaCapra, *Representing the Holocaust: History, Theory, Trauma* (Ithaca: Cornell University Press, 1994) 171.

31. In a recent study, Günter Butzer suggests that mourning, if it could be accomplished, would eventually lead to individual and social reintegration in *Fehlende Trauer. Verfahren epischen Erinnerns in der deutschsprachigen Gegenwartsliteratur* (Munich: Wilhelm Fink Verlag, 1998).

32. Eric Santner, *Stranded Objects: Mourning, Memory, and Film in Postwar Germany* (Ithaca: Cornell University Press, 1990) 37.

33. Dan Diner, ed., *Zivilisationsbruch. Denken nach Auschwitz* (Frankfurt/Main: Fischer, 1988).

34. Barbara Johnson, "The Surprise of Otherness: A Note on the Wartime Writings of Paul de Man," in Peter Collier and Helga Geyer-Ryan, eds., *Literary Theory Today* (Ithaca: Cornell University Press, 1990) 14.

35. Fredric Jameson in his foreword to Jean-François Lyotard, *The Postmodern Condition: A Report on Knowledge*, trans. Geoff Bennington and Brian Massumi (Minneapolis: University of Minnesota Press, 1984) ix.

36. Santner, *Stranded Objects*, 12.

37. Zygmunt Baumann, *Modernity and the Holocaust* (Ithaca: Cornell University Press, 1991) 84.

38. Robert Schindel, *Gebürtig* (Frankfurt/Main: Suhrkamp, 1992) 216; trans. Michael Roloff, *Born-Where?* (Riverside, CA: Ariadne Press, 1995).

Chapter One

1. Karl Jaspers, *The Question of German Guilt*, trans. E. B. Ashton (New York: Dial Press, 1947).

2. Eugen Kogon, *The Theory and Practice of Hell: The German Concentration Camps and the System behind Them*, trans. Heinz Norden (New York: Octagon, 1973).

3. Jean-Paul Bier, "The Holocaust, West Germany, and Strategies of Oblivion, 1947–1979," in Anson Rabinbach and Jack Zipes, eds., *Germans and Jews since the Holocaust* (New York: Holmes & Meier, 1986) 185.

4. Felicia Letsch, *Auseinandersetzung mit der Vergangenheit als Moment der Gegenwartskritik* (Cologne: Pahl-Rugenstein Verlag, 1982) 61.

5. Heinrich Vormweg, "Deutsche Literatur 1945–1960: Keine Stunde Null," in Manfred Durzak, ed., *Deutsche Gegenwartsliteratur: Ausgangspositionen und aktuelle Entwicklungen* (Stuttgart: Reclam, 1981) 15.

6. Quoted by Peter Demetz in "Literature under the Occupation in Germany," in Ernestine Schlant and J. Thomas Rimer, eds., *Legacies and Ambiguities: Postwar Fiction and Culture in West Germany and Japan* (Washington, DC/Baltimore: The Woodrow Wilson Center Press/The Johns Hopkins University Press, 1991) 125.

7. Quoted by Peter Demetz, *Postwar German Literature: A Critical Introduction* (New York: Western Publishing, 1970) 47.

8. Demetz in "Literature under the Occupation," 125.

9. Demetz, *Postwar German Literature*, 49.

10. Ibid.

11. Ibid.

12. Group 47 dominated West German literary culture for about twenty years, until it disbanded in 1967. See Justus Fetscher, Eberhard Lämmert, Jürgen Schutte, eds., *Die Gruppe 47 in der Geschichte der Bundesrepublik* (Würzburg: Königshausen & Neumann, 1991); also Herbert Lehnert, "Die Gruppe 47. Ihre Anfänge und ihre Gründungsmitglieder" and Rudolf Walter Leonhardt, "Aufstieg und Niedergang der Gruppe 47," both in Durzak, ed., *Deutsche Gegenwartsliteratur*.

13. Vormweg, "Deutsche Literatur 1945–1960," 17.

14. Walter Hinderer, *Arbeit an der Gegenwart: Zur deutschen Literatur nach 1945* (Würzburg: Königshausen & Neumann, 1994) 118.

15. Quoted in Vormweg, "Deutsche Literatur 1945–1960," 25.

16. Nancy A. Lauckner, "The Jew in Post-War German Novels," *Leo Baeck Institute Yearbook* 20 (1975) 275–291.

17. Frank Stern, *The Whitewashing of the Yellow Badge: Antisemitism and Philosemitism in Postwar Germany*, trans. William Templer (Oxford/New York: Pergamon Press, 1992) 388.

18. Klaus Schröter, *Heinrich Böll: in Selbstzeugnissen und Bilddokumenten* (Reinbek: Rowohlt, 1992) 69.

19. Heinrich Böll, "Across the Bridge," in his *Children are Civilians Too*, trans. Leila Vennewitz (New York: Penguin Books, 1970) 9.

20. The German text speaks of a "großen gelben Mappe" (7). The English translation has only "a large manila folder" (9) and since it omits the word "yellow" misses the point.

21. Victor Klemperer, *LTI: Die unbewältigte Sprache* (Munich: dtv, 1969) 169.

22. Heinrich Böll, *And Where Were You, Adam?*, trans. Leila Vennewitz (1951; Evanston: Northwestern University Press, 1994).

23. Alan Bance, "Heinrich Böll's 'Wo warst du, Adam?': National Identity and German War Writing—Reunification as the Return of the Repressed?" *Forum for Modern Language Studies* xxix, 4 (1993) 316 and 318.

24. The term "ordinary men" is taken from the title of Christopher R. Browning's *Ordinary Men: Reserve Police Battalion 101 and the Final Solution in Poland* (New York: Harper Perennial, 1992).

25. Quoted in Lew Kopelew, *Verwandt und verfremdet: Essays zur Literatur der Bundesrepublik und der DDR*, trans. Heddy Pross-Weerth (Frankfurt/Main: Fischer, 1976) 70.

26. Hannah Arendt, *Eichmann in Jerusalem: A Report on the Banality of Evil* (New York: Viking, 1963).

27. See Rainer Nägele, *Heinrich Böll: Einführung in das Werk und in die Forschung* (Frankfurt/Main: Athenäum Fischer Taschenbuch Verlag, 1976) 149 and 152.

28. The tailor whispers to Ilona that he was arrested because he had bought a pair of pants from an officer. This statement may work for Böll's fictional purposes—reinforcing the structure of *La Ronde*, when various protagonists reappear in interconnected episodes—but it is a falsely benign explanation. Jews were persecuted because they were Jews, not because they had violated any regulations.

29. Wolfgang Koeppen, *Pigeons in the Grass*, trans. David Ward (New York: Holmes & Meier, 1988); *Das Treibhaus (The Hothouse)* (Stuttgart: Scherz & Goverts Verlag, 1953); *Death in Rome*, trans. Michael Hofmann (New York: Penguin Books, 1992).

30. Marcel Reich-Ranicki notes in 1961 that "there is very little in the German prose of these years that can be compared to Koeppen's." "Der Fall Wolfgang Koeppen" in Ulrich Greiner, ed., *Über Wolfgang Koeppen* (Frankfurt/Main: Suhrkamp, 1976) 105–6.

31. See Reich-Ranicki's interview with Koeppen in *Wolfgang Koeppen, Ohne Absicht*, Ingo Hermann, ed. (Göttingen: Lamuv Verlag, 1994) 93.

32. Reich-Ranicki, "Der Fall Wolfgang Koeppen," 105–6.

33. Norbert Frei, *Vergangenheitspolitik. Die Anfänge der Bundesrepublik und die NS-Vergangenheit* (Munich: Beck, 1996).

34. Ibid., 19.

35. Lily Gardner Feldman, *The Special Relationship between West Germany and Israel* (Boston: Allen & Unwin, 1984) 73 and 75.

36. Alfred Andersch, "Choreographie des politischen Augenblicks" (1955), in Greiner, ed., *Über Wolfgang Koeppen*, 72–79.

37. This is the title of Walter Jens's review (April 1955) reprinted in Greiner, ed., *Über Wolfgang Koeppen*, 80–83.

38. Christiane Schmelzkopf, *Zur Gestaltung jüdischer Figuren in der deutschsprachigen Literatur nach 1945* (Hildesheim: Georg Olms Verlag, 1983) 241.

39. While "Jewish bitch" and "Jewish cunt" may be offensive enough, they do not carry the specific, devastating Nazi connotations of the German "Judenschickse" and "Judensau."

40. Thomas Richner, *Der Tod in Rom: Eine existential-psychologische Analyse von Wolfgang Koeppens Roman* (Zurich/Munich: Artemis Verlag, 1982) 26, where he states: "The motif of meaninglessness is the leitmotif in Koeppen's entire oeuvre."

41. Klaus Haberkamm, "Wolfgang Koeppen. 'Bienenstock des Teufels'—Zum naturhaft-mythischen Geschichts- und Gesellschaftsbild in den Nachkriegsromanen," in Hans Wagener, ed., *Zeitkritische Romane des 20. Jahrhunderts: Die Gesellschaft in der Kritik der deutschen Literatur* (Stuttgart: Reclam, 1975) 257.

42. Hans-Ulrich Treichel, *Fragment ohne Ende: Eine Studie über Wolfgang Koeppen* (Heidelberg: Carl Winter Universitätsverlag, 1984) 104 and 114.

43. Klaus Haberkamm, "Wolfgang Koeppen. 'Bienenstock des Teufels,'" 267.

Chapter Two

1. Alexander Kluge, *Lernprozesse mit tödlichem Ausgang (Learning Processes with Deadly Results)* (Frankfurt/Main: Suhrkamp, 1973) 103.

2. Martin Walser, *Ehen in Philippsburg (Marriages in Philippsburg)* (Frankfurt/Main: Suhrkamp, 1957).

3. Heinrich Böll, *Billiards at Half Past Nine*, trans. Patrick Bowles (London: Calder & Boyars, 1961).

4. *In Pursuit of Justice: Examining the Evidence of the Holocaust* (Washington, DC: United States Holocaust Memorial Council, 1996), esp. the chapters "War Crimes Chronology" and "Trials Appendix."

5. Paul Michael Lützeler considers the shooting of Benno Ohnesorg in June of 1967 as the decisive radicalizing event. See "Von der Intelligenz zur Arbeiterschaft" in Paul Michael Lützeler and Egon Schwarz, eds., *Deutsche Literatur in der Bundesrepublik seit 1965* (Königstein/Ts.: Athenäum, 1980) 119.

6. Martin Walser, "Engagement als Pflichtfach für Schriftsteller," ("Engagement as a Required Course for Writers") in *Heimatkunde: Aufsätze und Reden* (Frankfurt/Main: Suhrkamp, 1968) 122.

7. Thomas Elsaesser, "subject positions, speaking positions: from *holocaust, our hitler,* and *heimat* to *shoah* and *schindler's list,*" in Vivian Sobchack, ed., *The Persistence of History: Cinema, Television, and the Modern Event* (New York: Routledge, 1996) 157.

8. Andreas Huyssen, "The Politics of Identification: 'Holocaust' and the West German Drama" in his *After the Great Divide* (Bloomington: Indiana University Press, 1986) 95.

9. Rolf Hochhuth, *A German Love Story,* trans. John Brownjohn (Boston: Little, Brown, 1980); *Juristen* (Reinbek: Rowohlt, 1979).

10. Jan Bruck, "Brecht's and Kluge's Aesthetics of Realism," *Poetics* 17 (1988) 57–68.

11. Ingo Helm, "Literatur und Massenmedien," in Klaus Briegleb and Sigrid Weigel, eds., *Gegenwartsliteratur seit 1968* (Munich: dtv, 1992) 548.

12. Andreas Huyssen, "Alexander Kluge: An Analytic Storyteller in the Course of Time," in his *Twilight Memories: Marking Time in a Culture of Amnesia* (New York and London: Routledge, 1995) 150.

13. Hayden White, "the modernist event," in Sobchack, ed., *The Persistence of History,* 24.

14. Ibid., 32.

15. Huyssen, "Alexander Kluge,"150.

16. Alexander Kluge, *Case Histories,* trans. Leila Vennewitz (New York: Holmes & Meier, 1988). Excerpts from Kluge's text appear in my translation.

17. Comp. Stefanie Carp, "Wer Liebe Arbeit nennt hat Glück gehabt. Zu Alexander Kluges Liebesprosa," in Thomas Böhm-Christl, ed., *Alexander Kluge* (Frankfurt/Main: Suhrkamp, 1983) 207 n.58. Carp also points to possible sources for Kluge's text.

18. Ulrike Bosse sees in the inmates' lack of response not an act of resistance and a refusal to have their emotions and past history exploited but an indication of extreme isolation. Ulrike Bosse, *Alexander Kluge—Formen literarischer Darstellung von Geschichte* (Frankfurt/Main: Peter Lang, 1989) 46.

19. Klaus Briegleb, "Negative Symbiose," in Briegleb and Weigel, eds., *Gegenwartsliteratur seit 1968,*123.

20. Alexander Kluge, *Neue Geschichten. Hefte 1–18. "Unheimlichkeit der Zeit" (New Stories. Notebooks 1–18. "The Uncanniness of Time")* (Frankfurt/Main: Suhrkamp, 1977).

21. This is a reference to the "founding years" of the German Empire, the early 1870s, when Germany obtained colonies, most notably in Africa. Comp. Gerhard Bechtold, "Das KZ als Modell des Zivilisationsprozesses," *Text und Kritik* 85/86 (January 1985) 63 ff.

22. Stefanie Carp, *"Schlachtbeschreibungen:* Ein Blick auf Walter Kempowski und Alexander Kluge," in Hannes Heer and Klaus Naumann, eds., *Vernichtungskrieg: Verbrechen der Wehrmacht 1941–1944* (Hamburg: Hamburger Edition, 1995) 677.

23. Günter Grass, *From the Diary of a Snail,* trans. Ralph Manheim (New York: Harcourt, Brace, Jovanovich, 1972) 9.

24. Sidra DeKoven Ezrahi sees the "ironic mode" as practiced by Grass in *The Tin Drum* as "the most radical expression of ruptures with tradition," in *By Words Alone: The Holocaust in Literature* (Chicago and London: University of Chicago Press, 1980) 113. Ruth Angress, in contrast, sees *The Tin Drum* as "the most successful attempt to reduce the Holocaust to manageable size by sentimentalizing a victim" and views the moving chapter on the "night of broken glass" as "Edelkitsch" [sentimental claptrap], in "A 'Jewish Problem' in German Postwar Fiction," *Modern Judaism* 5 (1985) 222/3.

25. Günter Grass, *The Tin Drum,* trans. Ralph Manheim (New York: Random House, 1961) 202.

26. Quoted in Sander Gilman, "Jewish Writers in Contemporary Germany: the Dead Author Speaks," *Studies in Twentieth Century Literature* 13.2 (1989): 218–9.

27. Günter Grass, *Schreiben nach Auschwitz (Writing after Auschwitz)* (Frankfurt/Main: Luchterhand, 1990) 14 and 41.

28. George Steiner in a review of Robert Musil's work in *The New Yorker*, April 17, 1995: 101.

29. Günter Grass, *Schreiben nach Auschwitz*, 34.

30. A. L. Mason asks whether "a reader may go so far as to take the book as fiction rather than reportage, as written by a literary persona rather than the historical personality of Günter Grass" and comes to the conclusion that the book seems "to intentionally prohibit a decision between these alternatives." "The Artist and Politics in Günter Grass' *Aus dem Tagebuch einer Schnecke*," in Patrick O'Neill, ed., *Critical Essays on Günter Grass* (Boston: G. K. Hall, 1987) 172.

31. Erwin Lichtenstein, *Die Juden der Freien Stadt Danzig unter der Herrschaft des Nationalsozialismus* (Tübingen: J. C. B. Mohr, 1973).

32. "Karthaus" suggests the order of the *Karthäuser* (Carthusians), a contemplative order in which each monk lives by himself, separate from the affairs of the world. In another such allusion, Doubt says to Stomma: "I'm looking for something monastic, something Carthusian" (126).

33. Kurt Lothar Tank, "Deutsche Politik im literarischen Werk von Günter Grass," in Manfred Jurgensen, ed., *Grass: Kritik—Thesen—Analysen* (Bern: Francke, 1973) 184.

34. Winfried Georg Sebald, "Konstruktionen der Trauer: Zu Günter Grass, 'Tagebuch einer Schnecke' und Wolfgang Hildesheimer 'Tynset,'" *Der Deutschunterrrricht* 35,5 (October 1983) 39.

35. Grass pays homage to Paul Celan and acknowledges Celan's encouragement of Grass's work in *Schreiben nach Auschwitz*, 29–30.

36. Sebald, "Konstruktionen der Trauer," 38; emphasis added.

37. Ibid., 41.

Chapter Three

1. Richard Wolin in Jürgen Habermas, *The New Conservatism. Cultural Criticism and the Historians' Debate*, ed. and trans. Shierry Weber Nicholsen, introd. Richard Wolin (Cambridge: MIT Press, 1990) xi.

2. Bernd Neumann, "Die Wiedergeburt des Erzählens aus dem Geist der Autobiographie?" in Reinhold Grimm and Jost Hermand, eds., *Basis 9. Jahrbuch für deutsche Gegenwartsliteratur* (Frankfurt/Main: Suhrkamp, 1979) 91.

3. Miriam Hansen speaks of "a left disintegration into individuals, into ecological, peace, and women's movements" in her foreword "The Seventies: Decade of Disjunction" to Oskar Negt and Alexander Kluge, *Public Sphere and Experience: Toward an Analysis of the Bourgeois and Proletarian Public Sphere* (Minneapolis: University of Minnesota Press, 1993) xv.

4. Johann August Schülein, "Von der Studentenrevolte zur Tendenzwende oder der Rückzug ins Private: eine sozialpsychologische Analyse," *Kursbuch* (1977) 110.

5. The events leading up to and constituting the "German Autumn" of 1977 were the murder of Generalbundesanwalt Buback in April of 1977; the murder of the head of the Dresdner Bank, Jürgen Ponto, in July; the abduction of Hanns-Martin Schleyer, president of the Federal Association of German Employers, in September; the hijacking of a Lufthansa airliner to Mogadishu and the taking of hostages from October 13 to 18; and, within a few hours, the death of the imprisoned terrorists Andreas Baader, Jan-Carl Raspe, and Gudrun Ensslin in their prison cells in Stuttgart-Stammheim, followed the next day by the discovery of the dead body of Hanns-Martin Schleyer.

6. Peter Schneider, "Hitler's Shadow: On Being a Self-Conscious German," *Harper's Magazine*, September 1987: 52.

7. Elisabeth Domansky, "'Kristallnacht,' the Holocaust and German Unity," *History and Memory* 4, i (1992) 77.

8. Michael Schneider, "Fathers and Sons, Retrospectively: The Damaged Relationship between Two Generations," trans. Jamie Owen Daniel, *new german critique* 31 (Winter 1984) 50.

9. Leon Botstein, "German Terrorism from Afar," *Partisan Review* XLVI, 2 (1979) 188–204; Iring Fetscher, *Terrorismus und Reaktion* (Reinbek: Rowohlt, 1981); Norbert Elias, "Der bundesdeutsche Terrorismus—Ausdruck eines sozialen Generationskonflikts," *Studien über die Deutschen* (Frankfurt/Main: Suhrkamp, 1989) 300–89.

10. Peter Schneider, "Hitler's Shadow," 52.

11. Ralph Gehrke, *Literarische Spurensuche. Elternbilder im Schatten der NS-Vergangenheit* (Opladen: Westdeutscher Verlag, 1992) 46.

12. Ibid., 47.

13. Peter Henisch, *Die kleine Figur meines Vaters* (Frankfurt/Main: Fischer, 1975); Elisabeth Plessen, *Mitteilung an den Adel* (Zurich: Benzinger, 1976); Hermann Kinder, *Der Schleiftrog* (Zurich: Diogenes, 1977); Bernward Vesper, *Die Reise* (Berlin: März Verlag, 1977); Paul Kersten, *Der alltägliche Tod meines Vaters* (Königstein/Ts.: Athenäum, 1979); Roland Lang, *Die Mansarde* (Königstein/Ts.: Athenäum, 1979); E. A. Rauter, *Brief an meine Erzieher* (Munich: Weismann, 1979); Ruth Rehmann, *Der Mann auf der Kanzel. Fragen an einen Vater* (Munich: Hanser, 1979); Sigfried Gauch, *Vaterspruen* (Königstein/Ts.: Athenäum, 1979); Barbara Bronnen, *Die Tochter* (Munich: Piper, 1980); Ingeborg Day, *Ghost Waltz* (New York: Viking, 1980); Peter Härtling, *Nachgetragene Liebe* (Darmstadt/Neuwied: Luchterhand, 1980); Christoph Meckel, *Suchbild. Über meinen Vater* (Düsseldorf: Claassen, 1980); Brigitte Schwaiger, *Lange Abwesenheit* (Vienna/Hamburg: Zsolnay, 1980); Irene Rodrian, *Der Hausfrieden* (Munich: Verlag Steinhausen, 1981). The novels of the Austrians Peter Henisch and Brigitte Schwaiger are here included since they share the same characteristics and have the same agenda as those of the West German writers.

14. See Norbert Elias, *The Germans. Power Struggles and the Development of Habitus in the 19th and 20th Centuries*, trans. Eric Dunning and Stephen Mennell (New York: Columbia University Press, 1996).

15. Sandra Frieden, *Autobiography: Self into Form. German-Language Autobiographical Writing in the 1970s* (New York: Peter Lang, 1983) 73.

16. Gehrke, *Literarische Spurensuche,*225.

17. Almost a decade after the literary self-explorations, a slew of interviews with and psychoanalytical case studies of members of the successor generation expand further on the subject. See Peter Sichrovsky, *Born Guilty: Children of Nazi Families*, trans. J. Steinberg (New York: Basic Books, 1988); Dörte von Westernhagen, *The Legacy of Silence: Encounters with Children of the Third Reich* (Cambridge: Harvard University Press, 1989); Barbara Heimannsberg and Christoph J. Schmidt, *The Collective Silence*, trans. Cynthia Oudejans Harris and Gordon Wheeler (San Francisco: Jossy-Bass, 1993).

18. Eric Santner, *Stranded Objects: Mourning, Memory, and Film in Postwar Germany* (Ithaca: Cornell University Press, 1990) 37.

19. Jack Zipes, "The Return of the Repressed," *new german critique* 31 (Winter 1984) 204.

20. Santner, *Stranded Objects*, 41.

21. Jean Améry, *At the Mind's Limit: Contemplations by a Survivor on Auschwitz and its Realities*, trans. Sidney and Stella P. Rosenfeld (Bloomington: Indiana University Press, 1980) 96.

22. Anton Kaes, *From Hitler to Heimat: The Return of History as Film* (Cambridge: Harvard University Press, 1989) 30–31.

23. Thomas Elsaesser, "subject positions, speaking positions. from *holocaust, our hitler,* and *heimat* to *shoah* and *schindler's list*," in Vivian Sobchack, ed., *The Persistence of History: Cinema, Television, and the Modern Event* (New York: Routledge, 1996) 159.

24. Ibid., 181 n.46. Elsaesser points out that reception was not uniform, and that "there was also much outrage and condemnation about the screening" (159).

25. Kaes, *From Hitler to Heimat*, 34.

26. Ibid., 35.

Chapter Four

1. Hanns-Josef Ortheil, *Schauprozesse (Show Trials)* (Munich: Piper, 1990) 95.

2. Hanns-Josef Ortheil, *Fermer* (Frankfurt/Main: Fischer, 1979); *Hecke (Hedges)* (Frankfurt/Main: Fischer, 1983); *Schwerenöter (Go-Getter)* (Munich: Piper, 1987).

3. Hanns-Josef Ortheil, *Abschied von den Kriegsteilnehmern (A Farewell to the War Veterans)* (Munich: Piper, 1992).

4. Manfred Durzak, "Formzüge des Initiationsromans. Zu Ortheils Roman *Fermer*," in Manfred Durzak and Hartmut Steinecke, eds., *Hanns-Josef Ortheil im Innern seiner Texte* (Munich: Piper, 1995) 53.

5. Hanns-Josef Ortheil, *Schauprozesse*, 100.

6. The noun *Geborgenheit* and the adjective *geborgen* indicate a space of physical protection as well as an emotional resting place. Being *geborgen* means being calm, relaxed, and at ease because the sense of feeling protected and taken care of wards off any dangers coming from the outside. The surroundings within which one feels *geborgen* can vary: it can be God, the fatherland, a structure, an ideology, a person. Because of the complexity of the term, I will continue to use the German original in the text.

7. The description of these drawings seems to be based on the work of Wilhelm Klemm. In his introduction to *Wilhelm Klemm. Ein Lyriker der "Menschheitsdämmerung"* (Stuttgart: Kröner, 1979), Ortheil describes Klemm's drawings, e. g. 15 and 85, in terms very similar to those of the novel.

8. As quoted by Timothy Garton Ash, "True Confessions," *The New York Review of Books*, July 17, 1997: 37.

9. The houses in *Fermer* and *Hedges*, and even the house of Lotta's parents and of Fermer's uncle, a priest, are similar in appearance and function. They have a respectable pantry (H 16), plenty of good wine and other alcoholic beverages, and they are kept in immaculate order. They are also well provided with locks, keys, window shutters, and "hedges" to keep the dangerous world out.

10. Volker Wehdeking also notes a "farewell" in relation to literary trends in his "Ortheils *Abschied von den Kriegsteilnehmern* als Generationenkonflikt und Geschichtslektion," in Durzak and Steinecke, eds., *Hanns-Josef Ortheil - Im Innern seiner Texte*, 148.

11. The death of the two older brothers—one stillborn and one killed by a hand grenade—are told in *Hedges*. Two more brothers are born and die in the postwar years, before the narrator, the fifth child, is born and survives.

12. The Jews of Cracow were first expelled in 1940 and those who remained, together with new arrivals, were subjected to the horrible conditions of ghettoization. See Raul Hilberg, *The Destruction of the European Jews* (New York: Holmes & Meier, 1985), vol. 1, 208 ff. and 399. For a literary account of the barbaric conditions of ghetto life, see among many Edgar Hilsenrath's *Nacht (Night)* of 1964.

13. In stressful situations, the father habitually takes refuge in denial; this is also evident when he denies the seriousness of his wife's temporary lapse into autism (389).

Chapter Five

1. Fredric Jameson, *The Political Unconscious: Narrative as a Socially Symbolic Act* (Ithaca: Cornell University Press, 1981) 20.

2. Omer Bartov, *Murder in Our Midst* (New York: Oxford University Press, 1996) 141.

3. These novels are *Verlassene Zimmer (Deserted Rooms)* (Cologne: Hegner, 1966); *Andere Tage (Different Days)* (Cologne: Hegner, 1968); *Neue Zeit (New Times)* (Frankfurt: Insel, 1975); *Tagebuch vom Überleben und Leben (Diary of Survival and Living)* (Frankfurt: Insel, 1978); *Ein Fremdling (A Stranger)* (Frankfurt: Insel, 1983); *Der Wanderer (The Wanderer)* (Frankfurt: Insel, 1986); *Seltsamer Abschied (Strange Farewell)* (Frankfurt: Insel, 1988); *Herbstlicht (Autumnal Light)* (Frankfurt: Insel, 1992); and *Freunder (Friends)* (Frankfurt/Main: Insel, 1997).

4. See Hanns-Josef Ortheil, "Suchbewegungen der Lebensklugheit" in his *Köder, Beute und Schatten. Suchbewegungen (Bait, Booty, and Shadow. Movements of Search)* (Frankfurt/Main: Fischer, 1983) 144–226.

5. It is interesting to note that other writers (Peter Handke and Hanns-Josef Ortheil) first pointed to the affinities between Lenz and Proust. See Rainer Moritz, *Schreiben, wie man ist: Hermann Lenz: Grundlinien seines Werkes* (Tübingen: Niemeyer, 1989) 289 n.98.

6. *Der innere Bezirk (The Inner Realm)* (Frankfurt/Main: Insel, 1980) of which the first volume, "Afternoon of a Lady," was published in 1961, "In the Inner Realm" in 1970, and "Constantinsallee" in 1980.

7. Peter Handke, "Tage wie ausgeblasene Eier. Einladung, Hermann Lenz zu lesen," *Süddeutsche Zeitung* 22 December 1973, 57–8; rpt. as "Jemand anderer: Hermann Lenz," in Peter Handke, *Als das Wünschen noch geholfen hat* (Frankfurt/Main: Suhrkamp, 1974) 81–100.

8. Hans Dieter Schäfer, "Hinweis auf Hermann Lenz," in Helmut and Ingrid Kreuzer, eds., *Über Hermann Lenz: Dokumente seiner Rezeption (1947–1979)* (Munich: Wilhelm Fink Verlag, 1981) 45.

9. Birgit Graafen, *Konservatives Denken und modernes Erzählbewußtsein im Werk von Hermann Lenz* (Frankfurt/Main: Peter Lang, 1992) 201.

10. Lenz's conflict with his father, who had little sympathy with the "absentmindedness" of his son, is repeatedly worked out in Lenz's literary work. See Moritz, *Schreiben*, 260 ff.

11. Graafen, *Konservatives Denken*, 159.

12. On Swabian pietism, see Gerhard Kaiser, *Pietismus und Patriotismus im literarischen Deutschland: Ein Beitrag zum Problem der Säkularisation* (Frankfurt/Main: Athenäum, 1975), esp. 1–14. Mary Fulbrook in her study *Piety and Politics: Religion and the Rise of Absolutism in England, Württemberg and Prussia* (Cambridge/London: Cambridge University Press, 1983) singles out Württembergian pietism for its general tendency "toward pluralism and passivity . . . a passive piety, rather than rebelling against authority" (149), "a passive, disunited picture of pluralism and retreat" (151), and mentions that "Pietists in Württemberg withdrew into quietistic disapproval" (151). Joachim Trautwein adds in his *Religiosität und Sozialstruktur. Untersucht anhand der Entwicklung des württembergischen Pietismus* (Stuttgart: Calwer Verlag, 1972) to this list of qualities the "reservations against working in leading positions of government" (49) and notes its "restorative tendencies" in the 19th century (56 ff.).

13. Peter Demetz sees this humility as snobbism in reverse: "Lenz is a snob, I suspect, but of a particular kind, secretly proud of being inconspicuous, withdrawn, and provincial." *After the Fires: Recent Writing in the Germanies, Austria and Switzerland* (New York: Harcourt, Brace, Jovanovich, 1986) 331.

14. Fritz Stern, *The Failure of Illiberalism* (New York: Alfred Knopf, 1972) 17.

15. Hermann Lenz, *Neue Zeit*, 185.

16. See Manfred Durzak's comparison of Ernst Jünger and Hermann Lenz in "Die Wiederentdeckung der Einzelgänger. Zu einigen 'Vaterfiguren' der deutschen Gegenwartsliteratur," in his *Deutsche Gegenwartsliteratur. Ausgangspositionen und aktuelle Entwicklungen* (Stuttgart: Reclam, 1981) 385–6.

17. Peter Handke, "Der Krieg ist nicht vorbei," in Kreuzer, eds., *Über Hermann Lenz*, 136–7.

18. The term is used by Dominick LaCapra in his *Representing the Holocaust. History, Theory, Trauma* (Ithaca: Cornell University Press, 1994) 10.

19. A reference to Stalingrad and to General Timoshenko's breakthrough at Leningrad dates, for example, a particular section as winter 1943 (229). But even these references are not always reliable: thus Heydrich's assassination in Prague in June of 1942 is reported in March of 1942 (145/6) and there is a further reference to it as happening in winter (149).

20. On the brutality of the scorched-earth commands see Omer Bartov, *The Eastern Front 1941–1945: German Troops and the Barbarisation of Warfare* (New York: St. Martin's Press, 1986) 140.

21. Hedwig Rohde, "Warten als Lebenshaltung" in Kreuzer, eds. *Über Hermann Lenz*, 150.

22. Birgit Graafen quotes Lenz as he discusses dialect and *Heimat*. "My homeland (*Heimat*) . . . well, what was 'the homeland?' A sentiment fused with dialect (*ein mit Dialekt verschmolzenes Gefühl*)" (483/484). *Konservatives Denken*, 178 n.158.

23. Comp. Arnd Müller, *Geschichte der Juden in Nürnberg 1146–1945* (Nürnberg: Selbstverlag der Stadtbibliothek Nürnberg, 1968) 236–9.

24. See Uwe Dietrich Adam, *Judenpolitik im Dritten Reich* (Düsseldorf: Droste Verlag, 1972), esp. the subchapter "Der Kampf um die Mischehen und 'Mischlinge,'" 316–33; also John A. S. Grenville, "Die 'Endlösung' und die 'Judenmischlinge' im Dritten Reich" in Ursula Büttner, ed., *Das Unrechtsregime: Internationale Forschung über den Nationalsozialismus* (Hamburg: Hans Christians Verlag, 1986) vol. 2, 91–121.

25. See Adam, *Judenpolitik*, and John A. S. Grenville, "Die 'Endlösung.'" With respect to the death of Hanni's mother, Mrs. Lenz asserted in a private conversation that her mother died of a heart ailment.

26. See Nathan Stoltzfus's study *Resistance of the Heart: Intermarriage and the Rosenstrasse Protest in Nazi Germany* (New York: Norton & Co., 1996). The successful protest of non-Jewish women married to Jews against the deportation of their husbands shows that the publicity-conscious Nazis did make concessions if the protests were public and vigorous enough. A similar renunciation of their practices occurred when the bishop of Münster, Count Galen, inveighed in a sermon against the euthanasia program. Grenville mentions that the bishop, in his sermon, omitted speaking about the persecution of the Jews and wonders how much suffering could have been avoided if more Germans, above all in high positions, had spoken out. "'Die Endlösung,'" 115/6. Nevertheless, there is now literature about "righteous gentiles" in Germany. See for example Inge Deutschkron, *Sie blieben im Schatten. Ein Denkmal für "stille Helden"* (Berlin: Edition Hentrich, 1996).

27. One of the most compelling of these records is Victor Klemperer's diaries, *Ich will Zeugnis ablegen bis zum letzten. Tagebücher*, ed. Walter Nowojski (Berlin: Aufbau Verlag, 1995); but see also Ilse Koehn, *Mischling, Second Degree: My Childhood in Nazi Germany* (New York: Greenwillow Books, 1977).

28. On the extremely high number of German soldiers court-martialed and "put to death by their own army" see Omer Bartov, *Hitler's Army: Soldiers, Nazis and War in the Third Reich* (New York: Oxford University Press, 1992) 95 ff.

29. Christian Streit, *Keine Kameraden. Die Wehrmacht und die sowjetischen Kriegsgefangenen 1941-1945* (Stuttgart: Deutsche Verlagsanstalt, 1978) 109.

30. See Helmut Krausnick's detailed study on this cooperation in Helmut Krausnick and Hanns-Heinrich Wilhelm, eds., *Die Truppe des Weltanschauungskrieges* (Stuttgart: Deutsche Verlagsanstalt, 1981), esp. the chapter "Das Verhältnis zwischen Heer und Einsatzgruppen während des Feldzuges," 205–78.

31. *Einsatzgruppe* A is the subject of Hanns-Heinrich Wilhelm's detailed study "Die Einsatzgruppe A der Sicherheitspolizei und des SD 1941/42: eine exemplarische Studie" in Krausnick and Wilhelm, eds., *Die Truppe*, 281–636.

32. Raul Hilberg, *The Destruction of the European Jews* (New York: Holmes & Meier, 1985) vol. 1, 294.

33. See the Operational Situation Reports of *Einsatzgruppe* A in Itzhak Brad, Shmuel Krakowski, Shmuel Spector, eds. *The Einsatzgruppen Reports* (New York: Holocaust Library, 1989).

34. On Vilnius as the "Lithuanian Jerusalem" and its decimation, see Wilhelm in Krausnick and Wilhelm, eds., *Die Truppe*, 318.

35. Since Eugen was mobilized in 1940, 1943 is—for him—the third year of the war. The discrepancy with the official dates again highlights his rigorously subjective point of view.

36. Jean-François Lyotard, *Heidegger and "the jews,"* trans. Andreas Michel and Mark S. Roberts (Minneapolis: University of Minnesota Press, 1990) 26.

Chapter Six

1. Elias Canetti as quoted in Alvin H. Rosenfeld, *A Double Dying: Reflections on Holocaust Literature* (Bloomington & London: Indiana University Press, 1980) 187.

2. Robert Gellately, *The Gestapo and German Society. Enforcing Racial Policy 1933–1945* (Oxford: Clarendon Press, 1990) 135–6.

3. Gellately opines that "by the end of 1944 there were approximately 32,000 in the force." *The Gestapo*, 44.

4. Rolf Hochhuth, *Eine Liebe in Deutschland* (Reinbek: Rowohlt, 1978); *A German Love Story*, trans. John Brownjohn (Boston: Little, Brown, 1980).

5. Gert Hofmann, *Die Denunziation (The Denunciation)* (Darmstadt/Neuwied: Luchterhand, 1979).

6. In addition to *The Denunciation*, these are the novel *Unsere Eroberung (Our Conquest)* of 1984, the narrative [*Erzählung*] *Veilchenfeld* of 1986, the novel *Unsere Vergeßlichkeit (Our Forgetfulness)* of 1987, the novel *Vor der Regenzeit (Before the Rainy Season)* of 1989, and the novel *Der Kinoerzähler (The Movie Narrator)* of 1990.

7. Comp. Benno von Wiese, *Novelle* (Stuttgart: Metzler, 1964) 5, 19, and 24.

8. Lily Maria von Hartman, "Auf der Suche nach dem Autor. Erählstrukturen im Werk Gert Hofmanns," in Hans Christian Kosler, ed., *Gert Hofmann: Auskunft für Leser* (Darmstadt/Neuwied: Luchterhand, 1987) 110 sees Flohta as the "double" of the I-narrator Karl, while the "narrative agent" is supposedly Hofmann himself.

9. *Verschiebungen* (displacements, dislocations, shifts) is the word the text provides. In a technique that will be discussed in more detail below, Hofmann's language provides the concepts with which the narrative should then be analyzed.

10. In the quoted texts, my omissions will be marked by ellipses within brackets: [. . .]. Ellipses without brackets are Hofmann's.

11. Anton Kaes, "Holocaust and the End of History: Postmodern Historiography in Cinema," in Saul Friedländer, ed., *Probing the Limits of Representation: Nazism and the "Final Solution"* (Cambridge: Harvard University Press, 1992) 222.

Chapter Seven

1. Ruth Klüger, *weiter leben. Eine Jugend* (Munich: dtv, 1994) 96.

2. Nancy A. Lauckner, "The Jew in Post-War German Novels. A Survey," *Leo Baeck Institute Yearbook* (1975) 275–91.

3. Sander Gilman, "Jewish Writers in Contemporary Germany: the Dead Author Speaks," *Studies in Twentieth Century Literature* 13.2 (1989): 242 n. 5. The studies he refers to are those of Christiane Schmelzkopf, *Zur Gestaltung jüdischer Figuren in der deutschsprachigen Literatur nach 1945* (Hildesheim: Georg Olms Verlag, 1983) and Heidy M. Müller, *Die Judendarstellung in der deutschsprachigen Erzählprosa (1945–1981)* (Königstein/Ts.: Verlagsgruppe Athenäum, Hain, Hanstein, 1984).

4. Ruth K. Angress, "A 'Jewish Problem' in German Postwar Fiction," *Modern Judaism* 5 (1985): 215–33.

5. Klaus Briegleb, "Negative Symbiose," in Klaus Briegleb and Sigrid Weigel, eds., *Gegenwartsliteratur seit 1968* (Munich: dtv, 1992) 122–3.

6. Andreas Huyssen, "The Politics of Identification: 'Holocaust' and West German Drama" in Huyssen, *After the Great Divide* (Bloomington: Indiana University Press, 1986) 100.

7. Eric L. Santner, *Stranded Objects: Mourning, Memory, and Film in Postwar Germany* (Ithaca: Cornell University Press, 1990) 7.

8. Guy Stern, "The Rhetoric of Anti-Semitism," in Sander L. Gilman and Steven T. Katz, eds., *Anti-Semitism in Times of Crisis* (New York: New York University Press, 1991) 304.

9. Robert G. Moeller, "War Stories: The Search for a Usable Past in the Federal Republic of Germany," *The American Historical Review* 101, 4 (October 1996) 1033 and 1034.

10. Eva Kolinsky, "Remembering Auschwitz: A Survey of Recent Textbooks for the Teaching of History in German Schools," *Yad Vashem Studies* 22 (1992): 287–307.

11. Alfred Andersch, *Efraim's Book,* trans. Ralph Manheim (New York: Doubleday & Co., 1970).

12. Hans Schwab-Felisch, "Efraim und Andersch," *Merkur* 10 (1967): 990.

13. Marcel Reich-Ranicki, "Sentimentalität und Gewissensbisse" in *Lauter Verrisse* (Munich: Piper, 1970) 47–56.

14. See Harry James Cargas, "The Holocaust in Fiction," in Saul S. Friedman, ed., *Holocaust Literature: A Handbook of Critical, Historical, and Literary Writings* (Westport, CT: Greenwood Press, 1993) 533–46 where he says: "Sentiment reflects a compassion, a praiseworthy reaction to someone's situation. Sentimentality, on the other hand, cheapens. It is an excess of emotion that trivializes the subject under consideration. It comes very close to writing by formula." And he concludes: "Stock situations in books such as injured animals or missing children could be counted on to produce stock responses in unsophisticated audience members" (533).

15. This quote is from the back cover of the volume. Peter Härtling, *Felix Guttmann* (Munich: dtv, 1985).

16. Wolfgang Pohrt, "Der Härtling-Effekt," *Konkret* 11 (1985) 81.

17. Jack Zipes, "The Negative German-Jewish Symbiosis," in Dagmar Lorenz and Gabriele Weinberger, eds., *Insiders and Outsiders: Jewish and Gentile Culture in Germany and Austria* (Detroit: Wayne State University Press, 1994) 144. Dan Diner, to whom Zipes refers in his title, similarly denies that a "German-Jewish symbiosis" ever existed in his "Negative Symbiose" in Dan Diner, ed., *Ist der Nationalsozialsmus Geschichte? Zur Historisierung und Historikerstreit* (Frankfurt/Main: Fischer TV, 1987) 185.

18. There are two different dates for Guttmann's return: 1947 (94) and 1948 (286). If he came back in 1947, he could not have come as an Israeli citizen. It is also doubtful that he could have returned to Germany as an Israeli citizen but in an American uniform (286).

19. Gert Hofmann, *Veilchenfeld* (Darmstadt/Neuwied: Luchterhand, 1986).

20. Veilchenfeld's arrival in the small town is the result of a number of racial laws. Not even three months in power, Hitler's government issued on April 17, 1933, the "restoration of the professional civil service," which was the basis "for the purging of Jewish and politically unreliable civil servants, including, of course, university professors": Fritz Stern, *Dreams and Delusions* (New York: Alfred Knopf, 1987) 72–3. Veilchenfeld, who in 1938 indicates that he is over sixty-three years old (14), must have been born around 1875, which means that he qualified for the special provision that civil servants in office on August 1, 1914, or having served in World War I, were exempt from forced retirement: Joseph Walk, *Das Sonderrecht für die Juden im NS-Staat: Eine Sammlung der gesetzlichen Maßnahmen und Richtlinien,* (Heidelberg/Karlsruhe: C. F. Müller, 1981) vol.1, 46. This exemption was rescinded on December 12, 1935, and amended one week later to grant pensions to some of those dismissed (Walk, vol. 2, 68 and 85). Hans's father mentions that, as far as he knows, Veilchenfeld's only source of income is his pension (134). The fact that Veilchenfeld cannot find a housekeeper (94–5) is clearly related to the Nuremberg Laws of late 1935 (Walk, vol 2, 47). After Austria's *Anschluß,* in March of 1938, there is a general expectation that Veilchenfeld will soon be "relocated." Jacob

Toury, "Ein Auftakt zur 'Endlösung:' Judenaustreibungen über nichtslawische Reichs-grenzen 1933 bis 1939" in Ursula Büttner, ed., *Das Unrechtsregime* (Hamburg: Christians, 1986) vol. 2, 164–196. The *Juniaktion* of that year (Toury 170 ff.), the failed Evian conference at the end of July to settle the world refugee problems, and the *Sudetenkrise* in September, which ended with Hitler's diplomatic victory in the Munich agreement, all reinforced on the political level the very attitudes that encouraged harrassment of the Jews on the individual level. When Veilchenfeld petitions for a visa for Switzerland, he is addressed by the official who tears up his passport as "Herr Professor Bernhard Israel Veilchenfeld" (141) in accordance with the law of August 17, 1938, which forced Jews to add "Israel" or "Sara" to their first names. Veilchenfeld's personal papers (14) include a document attesting to his good conduct and lack of previous criminal records, in accordance with the law of August 24, 1938, which imposed restrictions on "certificates of conduct" *(Führungszeugnisse)* issued by the police. This is perhaps also the place to add that his *Konfirmationsschein* does not mean that he is a convert to Protestantism, since young Jewish men in former Prussia were frequently confirmed several years after their bar mitzvah. When Hans visits him, he wears "a flat little cap" (50), presumably a yarmulke.

21. Robert Gellately, *The Gestapo and German Society: Enforcing Racial Policy 1933–1945* (Oxford: Clarendon Press, 1990) 123.

22. On the frequency of suicide, see Marion A. Kaplan, *Between Dignity and Despair: Jewish Life in Nazi Germany* (New York: Oxford University Press, 1998) 179 ff. In general, Veilchenfeld's humiliations and ultimate destruction very much agree with Kaplan's descriptions of what it meant to live in Germany prior to *Kristallnacht*.

Chapter Eight

1. Noel Annan in his review of Timothy Garton Ash's *The File: A Personal History* in *The New York Review of Books*, September 25, 1997: 23.

2. Bulletin of the Press and Information Agency of the Federal Republic, February 2, 1984.

3. For a chronology of the events see Geoffrey Hartman, ed., *Bitburg in Moral and Political Perspective* (Bloomington: Indiana University Press, 1986) xiii–xvi.

4. Hartman, ed., *Bitburg in Moral and Political Perspective*, xv.

5. *Remembrance, Sorrow and Reconciliation. Speeches and Declarations in Connection with the 40th Anniversary of the End of the Second World War in Europe* (Bonn: Press and Information Office of the Government of the Federal Republic of Germany, n.d.) 59.

6. Hartman, ed., *Bitburg in Moral and Political Perspective*, xvi.

7. Günter Grass, *Geschenkte Freiheit. Rede zum 8. Mai 1945 (Freedom as a Gift. Speech on the Occasion of May 8th, 1945)* (Berlin: Akademie der Künste, 1985) 4 and 6.

8. Heinrich Böll, "Brief an meine Söhne oder vier Fahrräder," ("Letter to my Sons or Four Bicycles"), rpt. in *Die Fähigkeit zu trauern. Schriften und Reden 1983–1985 (The Ability to Mourn: Writings and Speeches 1983–1985)* (Bornheim-Merten: Lamuv Verlag, 1986) 79–112.

9. Rainer Werner Fassbinder, *Garbage, the City and Death* in *Rainer Werner Fassbinder: Plays*, ed. and trans. Denis Calandra (New York: PAJ Publications, 1985).

10. Andrei S. Markovits, Seyla Benhabib, and Moishe Postone, "Rainer Werner Fassbinder's *Garbage, the City and Death:* Renewed Antagonism in the Complex Relationship Between Jews and Germans in the Federal Republic of Germany," *new german critique* 38 (Spring/Summer 1986) 3–27 and Sigrid Meuschel, "The Search for 'Normality' in the Relationship between Germans and Jews" in the same issue, 39–56.

11. Andrei S. Markovits and Beth Simone Noveck, "Rainer Werner Fassbinder's play *Garbage, the City and Death*, produced in Frankfurt, marks a key year of remembrance in Germany," in Sander L. Gilman and Jack Zipes, eds., *Yale Companion to Jewish Writing and Thought in German Culture, 1096–1996* (New Haven: Yale University Press, 1997) 811.

12. See *"Historikerstreit:" Die Dokumentation der Kontroverse um die Einzigartigkeit der nationalsozialistischen Judenvernichtung* (Munich: Piper, 1987); *Forever in the Shadow of Hitler? Original Documents of the "Historikerstreit," the Controversy Concerning the Singularity of the Holocaust,* trans. James Knowlton and Truett Cates (Atlantic Highlands, NJ: Humanities Press, 1993).

13. This observation was first made by Jürgen Habermas, who was attacked for "overinterpretation and insinuation" by Immanuel Geiss in *Forever in the Shadow of Hitler?,* 256.

14. Perry Anderson, "On Emplotment: Two Kinds of Ruin" in Saul Friedländer, ed., *Probing the Limits of Representation: Nazism and the "Final Solution"* (Cambridge: Harvard University Press, 1992) 58.

15. Habermas, *Forever in the Shadow of Hitler?* 43.

16. John Torpey, "Introduction: Habermas and the Historians," *new german critique* 44 (Spring/Summer 1988)13.

17. Richard J. Evans, "The New Nationalism and the Old History," *Journal of Modern History* 59 (December 1987) 783.

18. Charles S. Maier, *The Unmasterable Past: History, Holocaust, and German National Identity* (Cambridge: Harvard University Press, 1988) 1 and 2.

19. Joachim Fest, *Historikerstreit,* 390, trans. E.S.

20. Philipp Jenninger's speech is quoted from the publication in *Foreign Broadcast Information Service—Western Europe* (FBIS-WEU-88–226) (November 23, 1988) 9; the German original was published in the newspaper *Frankfurter Allgemeine* (November 11, 1988) 6–7.

21. Elisabeth Domansky, "'Kristallnacht,' the Holocaust and German Unity: The Meaning of November 9 as an Anniversary in Germany," *History and Memory* 4 (1992) 71.

22. Konrad Jarausch, *The Rush to German Unity* (New York: Oxford University Press, 1994) 4.

23. Dietger Pforte, "Disunitedly United: Literary Life in Germany," *World Literature Today* 71,i (Winter 1977) 61–74.

24. Andreas Huyssen, "After the Wall: The Failure of German Intellectuals," *new german critique* 52 (Winter 1991) 109.

25. On the Gauck commission see Charles S. Maier, *Dissolution. The Crisis of Communism and the End of East Germany* (Princeton: Princeton University Press, 1997) 312 ff. For a personal account of someone who found that files had been kept on him and who gained access to them, see Timothy Garton Ash, *The File: A Personal History* (New York: Random House, 1997).

26. See Jeffrey Herf, *Divided Memory: The Nazi Past in the Two Germanys* (Cambridge: Harvard University Press, 1997).

27. *From Division to Unity. 1945–1990. An Illustrated Chronicle* (Bonn: Presse- und Informationsamt der Bundesregierung, November 1992) entry under February 8, 1990.

28. *Texte zur Deutschlandpolitik.* Reihe III, Band 8 a (Bonn: Bundesministerium für innerdeutsche Beziehungen, 1991),158 ff. Excerpts in English among other sources in the *New York Times* (Friday, April 13, 1990) A7.

29. Günter Grass, *Schreiben nach Auschwitz (Writing After Auschwitz)* (Frankfurt/Main: Luchterhand, 1990) 9–10.

30. Jaspers, as quoted in Rudolf Augstein/Günter Grass, *Deutschland, einig Vaterland? Ein Streitgespräch (Germany, Fatherland United? A Disputation)* (Göttingen: Steidl, 1990) 19–20.

31. Grass, *Schreiben nach Auschwitz,* 42.

32. Augstein/Grass, *Deutschland, einig Vaterland?* 56–8.

33. Martin Walser, "Ein deutsches Mosaik" (1962) ("A German Mosaic") in *Erfahrungen und Leseerfahrungen* (Frankfurt/Main: Suhrkamp, 1965) 8 and 9.

34. Martin Walser, "Unser Auschwitz" (1965) ("Our Auschwitz") in *Heimatkunde* (Frankfurt/Main: Suhrkamp, 1968) 22.

35. Martin Walser, "Auschwitz und keine Ende" (1979) ("Auschwitz and No End") in *Über Deutschland reden* (Frankfurt/Main: Suhrkamp, 1989) 24.

36. Günter Grass, *Schreiben nach Auschwitz*, 9.

37. Martin Walser, "Händedruck mit Gespenstern" (1979) ("Handshake with Ghosts") in *Über Deutschland reden*.

38. Walser, "Über Deutschland reden" (1988) ("Speaking about Germany") in *Über Deutschland reden*, 86.

39. Klaus Siblewski, ed., *Martin Walser. Auskunft* (Frankfurt/Main: Suhrkamp, 1991) 223 and 225.

40. Sander L. Gilman, "German Reunification and the Jews," *new german critique* 52 (Winter 1991) 178.

Chapter Nine

1. Bernhard Schlink, *The Reader*, trans. Carol Brown Janeway (New York: Pantheon, 1997) 174. The word "reader" does not quite capture the *Vorleser* of the German title, which implies that the reader reads *to* someone.

2. The price was not regularly "life and limb" when one refused to obey unconscionable orders. David H. Kittermann, "Those Who Said 'No!': Germans Who Refused to Execute Civilians during World War II," *German Studies Review* XI, 2 (May 1988) 241–54.

3. D. J. Enright surmises in a review that Hanna afforded these young girls, when they read to her, "a few days or weeks of rest from forced labor before being 'selected' for return to Auschwitz and to death." *The New York Review of Books*, March 26, 1998: 4.

4. Quoted from Jack Zipes, "The Negative German-Jewish Symbiosis" in Dagmar Lorenz and Gabriele Weinberger, eds., *Insiders and Outsiders: Jewish and Gentile Culture in Germany and Austria* (Detroit: Wayne State University Press, 1994) 144. Original "Negative Symbiose. Deutsche und Juden nach Auschwitz," in Dan Diner, ed., *Ist der Nationalsozialismus Geschichte? Zu Historisierung und Historikerstreit* (Frankfurt/Main: Fischer TV, 1987).

5. Peter Schneider, *The Wall Jumper*, trans. Leigh Hafrey (New York: Random House, 1983).

6. Peter Schneider, *Couplings*, trans. Philip Boehm (New York: Farrar, Straus & Giroux, 1996). The third novel with the working title *Stadt ohne Mitte (City without a Center)* is not yet completed.

7. The name Eduard Hoffmann suggests the name of the 19th-century writer of the fantastic and macabre, E. T. A. Hoffmann, with E–du–a(rd) echoing E–T–A.

8. These mouse scenes must also be seen in relation to Art Spiegelman's *Maus: A Survivor's Tale* (New York: Pantheon, 1986). Spiegelman infuses the stylized form of the comic book with bitter satire and presents an extremely touching account of the Holocaust. In *Couplings*, Schneider is working toward the difficult juggling act of maintaining a mock-satiric mode of expression while reflecting as a serious social critic.

9. W. G. Sebald, *Die Ausgewanderten* (Frankfurt/Main: Eichhorn Verlag, 1992); *The Emigrants*, trans. Michael Hulse (New York: New Directions, 1997).

10. The German original has the name "Max Aurach." Gabriele Annan suggests in her review of the book that Max Ferber's portrait is in part based on the British painter Frank Auerbach, whose work also hangs in the Tate Gallery. *The New York Review of Books*, September 25, 1997: 30.

11. Peter Weiss, "Meine Ortschaft" ("My Place") in *Rapporte* (Frankfurt/Main: Suhrkamp, 1970).

12. Historiography has also begun to recognize the voices of the victims as an integral part of the presentation. This is not an easy task, as Saul Friedländer concedes when he tried to write such a history: *Nazi Germany and the Jews*. vol. 1: *The Years of Persecution 1933–1939* (New York: HarperCollins, 1997), 1–2. For a similar approach see also Wolfgang Benz, ed., *Die Juden in Deutschland 1933–1945. Leben unter nationalsozialistischer Herrschaft* (Munich: Beck, 1988).

13. Sigmund Freud, "Mourning and Melancholia," in *The Standard Edition of the Complete Psychological Works of Sigmund Freud*, trans. James Strachey (London: Hogarth Press, 1953–74) 14: 237–58.

14. W. G. Sebald, "Konstruktionen der Trauer: Zu Günter Grass *Tagebuch einer Schnecke* und Wolfgang Hildesheimer *Tynset*," *Der Deutschunterricht* 35, 5 (October 1983) 32 and 41.

15. This sentence seems an echo of Ludwig Wittgenstein's famous statement in his foreword to the *Tractatus logico-philosophicus* of 1921: "[W]hat one cannot speak of, one must be silent about." (Frankfurt/Main: Suhrkamp, 1966). There are further references to Wittgenstein in the text, as when young Ferber lives in the same house in which Wittgenstein once lived, and there is even a photograph included in the text (166–7).

Conclusion

1. Michael Geyer and Miriam Hansen, "German-Jewish Memory and National Consciousness," in Geoffrey Hartman, ed., *Holocaust Remembrance: The Shape of Memory* (Oxford: Blackwell, 1994) 189.

2. The manner in which the Holocaust is taught in German schools is open to criticism. See Eva Kolinsky, "Remembering Auschwitz: A Survey of Recent Textbooks for the Teaching of History in German Schools," *Yad Vashem Studies* XXII (1992) 287–307 or Walter Renn, "The Holocaust in the School Textbooks of the Federal Republic of Germany" in Saul S. Friedman, ed., *Holocaust Literature. A Handbook of Critical, Historical and Literary Writings* (Westport, CT: Greenwood Press, 1993) 481–520.

3. On these efforts, see Björn Krondorfer, *Remembrance and Reconciliation. Encounters between Young Jews and Germans* (New Haven: Yale University Press, 1995) and Guy Stern, "Non-Jewish Germans in the Service of Present-Day Jewish Causes: A Footnote to German Cultural History" in Peter Penves, Richard Block, Helmut Müller-Sievers, eds., *Festschrift for Geza von Molnar* (Evanston: Northwestern University Press, 1998).

4. James E. Young, "The Counter-Monument: Memory against Itself in Germany Today," *Critical Inquiry* 18, 2 (Winter 1992) 269. Similarly Geyer and Hansen in "German-Jewish Memory and National Consciousness," 183.

5. Y. Michal Bodemann, "A Reemergence of German Jewry?" in Sander L. Gilman and Karen Remmler, eds., *Reemerging Jewish Culture in Germany: Life and Literature since 1989* (New York: New York University Press, 1994) 49; also John Borneman and Jeffrey M. Peck, *Sojourners: The Return of German Jews and the Question of Identity* (Lincoln: University of Nebraska Press, 1995) 8.

6. Sander L. Gilman, *Jews in Today's German Culture* (Bloomington: Indiana University Press, 1995) 2.

7. On the influx of Russian Jews into Germany, see Bodemann, "A Reemergence of German Jewry?" 48–50.

8. See the section titled "Jewish Responses" in Anson Rabinbach and Jack Zipes, eds., *Germans and Jews Since the Holocaust: The Changing Situation in West Germany* (New York: Holmes & Meier, 1986) and the series of interviews with Jews living in Germany today in *Sojourners*. Also Gilman, *Jews in Today's German Culture*, 36/7, Lynn Rapaport, *Jews in Germany after the Holocaust: Memory, Identity and Relations with Germans* (New York: Cambridge University Press, 1996), and Elena Lappin, ed., *Jewish Voices, German Words: Growing up Jewish in Postwar Germany and Austria* (North Haven, CT: Catbird Press, 1994).

9. This is the title of Karen Remmler's article: "The 'Third Generation' of Jewish-German Writers after the Shoah Emerges in Germany and Austria" in Sander L. Gilman and Jack Zipes, eds., *Yale Companion to Jewish Writing and Thought in German Culture 1096–1996* (New Haven: Yale University Press, 1997) 796 ff.

10. Jack Zipes, "The Contemporary German Fascination for Things Jewish: Toward a Jewish Minor Culture," in Gilman and Remmler, eds., *Reemerging Jewish Culture in Germany*, 16.

11. Ibid.

12. Gilman, *Jews in Today's German Culture*, 39.

13. Zipes, "The Contemporary German Fascination for Things Jewish," 15.

14. Gilman and Remmler, eds., *Reemerging Jewish Culture in Germany*, 2.

15. The argument that Germans show more interest in Jews of the past than those living with them runs through several chapters of Gilman and Remmler, *Reemerging Jewish Culture in Germany*. See Jack Zipes, "The Contemporary German Fascination for Things Jewish," 18; Katharina Ochse, "What Could Be More Fruitful, More Healing, More Purifying? Representations of Jews in the German Media after 1989," 123; Kizer Walker, "The Persian Gulf War and the Germans' 'Jewish Question,'" 150; Susan Neiman, "In Defense of Ambiguity," 254 and 262; Esther Dischereit, "No Exit from This Jewry," 272.

16. Andreas Huyssen, "Monument and Memory in a Postmodern Age" in *The Art of Memory: Holocaust Memorials in History* (Munich and New York: Prestel Verlag and the Jewish Museum, 1994) 15.

17. James E. Young, *The Texture of Memory: Holocaust Memorials and Meaning* (New Haven: Yale University Press, 1993) x.

18. Huyssen, "Monument and Memory in a Postmodern Age," 15.

19. Young, "The Counter-Monument: Memory against Itself in Germany Today," 268.

20. Young, *The Texture of Memory*, 20–1.

21. The episode is recounted by Young in *The Texture of Memory*, 86.

22. Brian Ladd, *The Ghosts of Berlin: Confronting German History in the Urban Landscape* (Chicago: University of Chicago Press, 1997) 218.

23. Ibid., 220.

24. Daniel Libeskind, "Between the Lines," in Kristin Feireiss, ed., *Erweiterung des Berlin Museums mit Abteilung Jüdisches Museum/Extension to the Berlin Museum with Jewish Museum Department* (Berlin: Ernst & Sohn Verlag, 1992) n.p.

25. Geyer and Hansen, "German-Jewish Memory and National Consciousness," 175.

26. Rolf Bothe, "Das Berlin Museum und sein Erweiterungsbau/The Berlin Museum and its Extension," in Kristin Feireiss, ed., *Erweiterung des Berlin Museums mit Abteilung Jüdisches Museum/Extension to the Berlin Museum with Jewish Museum Department*, 48 (emphasis added).

27. Y. Michal Bodemann, "Reconstructions of History: From Jewish Memory to Nationalized Commemoration of Kristallnacht in Germany," in Y. Michal Bodemann, ed., *Jews, Germans, Memory: Reconstructions of Jewish Life in Germany* (Ann Arbor: University of Michigan Press, 1996) 182.

28. Geyer and Hansen, "German-Jewish Memory and National Consciousness," 183.

29. Saul Friedländer, *Memory, History, and the Extermination of the Jews of Europe* (Bloomington and Indianapolis: Indiana University Press, 1993) 133.

Selected Bibliography

Primary Literary Sources

Andersch, Alfred, *Efraim's Book*, trans. Ralph Manheim (1967; New York: Doubleday & Co., 1970).

Böll, Heinrich, "Across the Bridge," in *Children are Civilians Too.*

——. *And Where Were You Adam?* trans. Leila Vennewitz (1951; Evanston: Northwestern University Press, 1994).

——. *Billiards at Half Past Nine*, trans. Patrick Bowles (1959; London: Calder & Boyars, 1961).

——. "Brief an meine Söhne oder vier Fahrräder" ("Letter to my Sons or Four Bicycles"), in *Die Fähigkeit zu trauern.*

——. *Children are Civilians Too*, trans. Leila Vennewitz (1950; New York: Penguin Books, 1970).

——. *Die Fähigkeit zu trauern. Schriften und Reden 1983–1985 (The Ability to Mourn. Writings and Speeches 1983–1985)* (Bornheim-Merten: Lamuv Verlag, 1986).

——. *Group Portrait with Lady*, trans. Leila Vennewitz (1971; New York: McGraw-Hill, 1973).

Born, Nicolas, *Die erdabgewandte Seite der Geschichte (The Part of the Story Turned Away from Earth)* (Reinbek: Rowohlt, 1976).

Bronnen, Barbara, *Die Tochter (The Daughter)* (Munich: Piper Verlag, 1980).

Day, Ingeborg, *Ghost Waltz* (New York: Viking, 1980).

Dorst, Tankred, *Dorothea Merz* (Frankfurt/Main: Suhrkamp, 1976).

Enzensberger, Hans Magnus, *Der kurze Sommer der Anarchie: Buenaventura Durrutis Leben und Tod (The Brief Summer of Anarchy: Buenaventura Durrutis Life and Death)* (Frankfurt/Main: Suhrkamp, 1972).

Fassbinder, Rainer Werner, *Garbage, the City and Death* in *Rainer Werner Fassbinder: Plays*, ed. and trans. Denis Calandra (1975; New York: PAJ Publications, 1985).

Gauch, Sigfried, *Vaterspuren (Father's Tracks)* (Königstein/Ts.: Athenäum, 1979).

Grass, Günter, *Cat and Mouse*, trans. Ralph Manheim (1961; Harcourt, Brace & World, 1963).

——. *From the Diary of a Snail*, trans. Ralph Manheim (1972; New York: Harcourt, Brace, Jovanovich, 1972).

——. *Geschenkte Freiheit, Rede zum 8. Mai 1945 (Freedom as a Gift. Speech on the Occasion of May 8, 1945)* (Berlin: Akademie der Künste, 1985).

——. *Schreiben nach Auschwitz (Writing after Auschwitz)* (Frankfurt/Main: Luchterhand, 1990).

Handke, Peter, "Jemand anderer: Hermann Lenz," in Handke, *"Is das Wünschen noch geholfen hat* (Frankfurt/Main: Suhrkamp, 1974).

Härtling, Peter, *Felix Guttmann* (Munich: dtv, 1985).

——. *Nachgetragene Liebe (Belated Love)* (Darmstadt/Neuwied: Luchterhand, 1980).

Henisch, Peter, *Die kleine Figur meines Vaters (The Small Figure of My Father)* (Frankfurt/Main: Fischer, 1975).

Hilsenrath, Edgar, *Night* (1964; New York: Doubleday, 1966).

Hochhuth, Rolf, *The Deputy*, trans. Richard and Clara Winston (1963; New York: Grove Press, 1964).
——. *A German Love Story*, trans. John Brownjohn (1978; Boston: Little, Brown, 1980).
——. *Juristen (Jurists)* (Reinbek: Rowohlt, 1979).
——. *Soldiers*, trans. Robert David MacDonald (1967; New York: Grove Press, 1968).
Hofmann, Gert, *Die Denunziation (The Denunciation)* (Darmstadt/Neuwied: Luchterhand, 1979).
——. *Der Kinoerzähler (The Movie Narrator)* (Munich: Hanser, 1990).
——. *Unsere Eroberung (Our Conquest)* (Darmstadt/Neuwied: Luchterhand, 1984).
——. *Unsere Vergeßlichkeit (Our Forgetfulness)* Darmstadt/Neuwied: Luchterhand, 1987).
——. *Veilchenfeld* (Darmstadt/Neuwied: Luchterhand, 1986).
——. *Vor der Regenzeit (Before the Rainy Season)* (Munich: Hanser, 1989).
Johnson, Uwe, *Anniversaries I* and *II*, trans. Leila Vennewitz and Walter Arndt (1970–1983; New York: Harcourt, Brace, Jovanovich, 1973 and 1987).
Kersten, Paul, *Der alltägliche Tod meines Vaters (The Everyday Death of my Father)* (Königstein/Ts.: Athenäum, 1979).
Kinder, Hermann, *Der Schleiftrog (The Grinding Trough)* (Zurich: Diogenes, 1977).
Kipphart, Heinar, *Bruder Eichmann (Brother Eichmann)* (Reinbek: Rowohlt, 1983).
——. *In the Matter of J. Robert Oppenheimer*, trans. Ruth Speirs (1964; New York: Hill & Wang, 1964).
——. *Joel Brand. Die Geschichte eines Geschäfts (Joel Brand. The History of a Business Deal)* (Frankfurt/Main: Suhrkamp, 1965).
——. *März* (Cologne: Kiepenheuer & Witsch, 1980).
Kluge, Alexander, *Case Histories*, trans. Leila Vennewitz (1962; New York: Holmes & Meier, 1988).
——. *Lernprozesse mit tödlichem Ausgang (Learning Processes with Deadly Results)* (Frankfurt/Main: Suhrkamp, 1973).
——. *Neue Geschichten. Hefte 1–18. "Unheimlichkeit der Zeit" (New Stories. Notebooks 1–18. "The Uncanniness of Time")* (Frankfurt/Main: Suhrkamp, 1978).
Koeppen, Wolfgang, *Death in Rome*, trans. Michael Hofmann (1954; New York: Penguin Books, 1992).
——. *Pigeons in the Grass*, trans. David Ward (1957; New York: Holmes & Meier, 1998).
——. *Das Treibhaus (The Hothouse)* (Stuttgart: Scherz & Goverts Verlag, 1953).
Lang, Roland, *Die Mansarde (The Attic)* (Königstein/Ts.: Athenäum, 1979).
Lenz, Hermann, *Andere Tage (Different Days)* (Cologne: Hegner, 1968).
——. *Ein Fremdling (A Stranger)* (Frankfurt/Main: Insel, 1983).
——. *Freunde (Friends)* (Frankfurt/Main: Insel, 1997).
——. *Herbstlicht (Autumnal Light)* (Frankfurt/Main: Insel, 1992).
——. *Der innere Bezirk (The Inner Realm)* (Frankfurt/Main: Insel, 1980).
——. *Neue Zeit (New Times)* (Frankfurt/Main: Insel, 1975).
——. *Seltsamer Abschied (Strange Farewell)* (Frankfurt/Main: Insel, 1988)
——. *Tagebuch vom Überleben und Leben (Diary of Survival and Living)* (Frankfurt/Main: Insel, 1978).
——. *Verlassene Zimmer (Deserted Rooms)* (Cologne: Hegner, 1966).
——. *Der Wanderer (The Wanderer)* (Frankfurt/Main: Insel, 1986).
Mann, Thomas, *Death in Venice*, trans. H. T. Lowe-Porter (1913; New York: Alfred Knopf, 1965).
——. *The Magic Mountain*, trans. H. T. Lowe-Porter (1924; New York: Alfred Knopf, 1953).
Meckel, Christoph, *Suchbild. Über meinen Vater (Composite Portrait. Concerning My Father)* (Düsseldorf: Claassen, 1980).
Ortheil, Hanns-Josef, *Abschied von den Kriegsteilnehmern (A Farewell to the War Veterans)* (Munich: Piper, 1972).
——. *Fermer* (Frankfurt/Main: Fischer, 1979).

——. *Köder, Beute und Schatten. Suchbewegungen (Bait, Booty, and Shadow. Movements of Search)* (Frankfurt/Main: Fischer, 1983).

——. *Hecke (Hedges)* (Frankfurt/Main: Fischer, 1983).

——. *Schauprozesse (Show Trials)* (Munich: Piper, 1990).

——. *Schwerenöter (Go-Getter)* (Munich: Piper Verlag, 1987).

——. intro., *Wilhelm Klemm. Ein Lyriker der "Menschheitsdämmerung"* (Stuttgart: Kröner, 1979).

Plessen, Elizabeth, *Mitteilung an den Adel (Informing the Nobility)* (Zurich: Benzinger, 1976).

Rauter, E. A., *Brief an meine Erzieher (Letter to My Educators)* (Munich: Weismann, 1979).

Rehmann, Ruth, *Der Mann auf der Kanzel. Fragen an einen Vater (The Man in the Pulpit. Questions to My Father)* (Munich: Hanser, 1979).

Rodrian, Irene, *Der Hausfrieden (House Peace)* (Munich: Verlag Steinhausen, 1981).

Schindel, Robert, *Gebürtig,* (Frankfurt/Main: Suhrkamp, 1992); trans. Michael Roloff, *Born-Where?* (Riverside, CA: Ariadne Press, 1995).

Schlink, Bernhard, *The Reader,* trans. Carol Brown Janeway (1995; New York: Pantheon Books, 1997).

Schneider, Peter, *Couplings,* trans. Philip Boehm (1992; New York: Farrar, Straus & Giroux, 1996).

——. *Lenz* (Berlin: Rotbuch Verlag, 1973).

——. *schon bist du ein Verfassungsfeind (And in No Time at All You Are an Enemy of the Constitution)* (Berlin: Rotbuch Verlag, 1975).

——. *Vati (Daddy)* (Darmstadt/Neuwied: Luchterhand, 1987).

——. *The Wall Jumper,* trans. Leigh Hafrey (1982; New York: Random House, 1983).

Schnurre, Wolfdietrich, *Jenö war mein Freund (Jenö was my Friend)* (Frankfurt/Main: Hirschgraben Verlag, 1962).

Schweiger, Brigitte, *Lange Abwesenheit (Long Absence)* (Vienna/Hamburg: Zsolnay, 1980).

Sebald, W. G., *The Emigrants,* trans. Michael Hulse (1992; New York: New Directions, 1997).

Strauß, Botho, *Devotion,* trans. Sophie Wilkins (1977; New York: Farrar, Straus & Giroux, 1979).

Vesper, Bernward, *Die Reise (The Trip)* (Berlin: März Verlag, 1977).

Walser, Martin, "Auschwitz und keine Ende" (1979) ("Auschwitz and No End") in *Über Deutschland reden.*

——. "Ein deutsches Mosaik" (1962) ("A German Mosaic") in *Erfahrungen und Leseerfahrungen.*

——. "Engagement als Pflichtfach für Schriftsteller" ("Engagement as a Required Course for Writers") in *Heimatkunde.*

——. *Erfahrungen und Leseerfahrungen* (Frankfurt: Suhrkamp, 1965).

——. *Ehen in Philippsburg (Marriages in Philippsburg)* (Frankfurt/Main: Suhrkamp, 1957).

——. "Händedruck mit Gespenstern" (1979) ("Handshake with Ghosts") in *Über Deutschland reden.*

——. *Heimatkunde: Aufsätze und Reden* (Frankfurt/Main: Suhrkamp, 1968).

——. *Über Deutschland reden* (Frankfurt/Main: Suhrkamp, 1989).

——. "Über Deutschland reden" (1988) ("Speaking about Germany") in *Über Deutschland reden.*

——. "Unser Auschwitz" (1965) ("Our Auschwitz") in *Heimatkunde.*

Weiss, Peter, *The Investigation,* trans. John Swan and Ulu Grosbard (1965; New York: Atheneum, 1966).

——. "Meine Ortschaft" ("My Place") in *Rapporte* (Frankfurt/Main: Suhrkamp, 1970).

Wiese, Benno von, *Novelle* (Stuttgart: Metzler, 1964).

Wolf, Christa, *Was bleibt (What Remains)* (Frankfurt/Main: Luchterhand, 1990).

Secondary Sources

Adam, Uwe Dietrich, *Judenpolitik im Dritten Reich* (Düsseldorf: Droste Verlag, 1972).

Adorno, Theodor W., "Commitment," in his *Notes to Literature*, vol. 2 (New York: Columbia University Press, 1991).

——. "Cultural Criticism and Society" (1949) in his *Prisms* (Cambridge: MIT Press, 1981).

Améry, Jean, *At the Mind's Limit: Contemplations by a Survivor on Auschwitz and its Realities*, trans. Sidney and Stella P. Rosenfeld (1966; Bloomington: Indiana University Press, 1980).

Andersch, Alfred, "Choreographie des politischen Augenblicks," in Greiner, ed., *Über Wolfgang Koeppen*.

Anderson, Perry, "On Emplotment: Two Kinds of Ruin," in Friedländer, ed., *Probing the Limits*.

Angress, Ruth, "A 'Jewish Problem' in German Postwar Fiction," *Modern Judaism* 5 (1985).

Annan, Gabriele, review of W. G. Sebald in *The New York Review of Books*, September 25, 1997.

Annan, Noel, review of Timothy Garton Ash in *The New York Review of Books*, September 25, 1997.

Arendt, Hannah, *Eichmann in Jerusalem: A Report on the Banality of Evil* (New York: Viking, 1963).

The Art of Memory: Holocaust Memorials in History (Munich and New York: Prestel Verlag and the Jewish Museum, 1994).

Ash, Timothy Garton, *The File: A Personal History* (New York: Random House, 1997).

——. "True Confessions," *The New York Review of Books*, July 17, 1997.

Augstein, Rudolf and Grass, Günter, *Deutschland, einig Vaterland? Ein Streitgespräch (Germany, Fatherland United? A Disputation)* (Göttingen: Steidl, 1990).

Bance, Alan, "Heinrich Böll's 'Wo warst du, Adam?': National Identity and German War Writing—Reunification as the Return of the Repressed?" *Forum for Modern Language Studies* xxix, 4 (1993).

Bar-On, Daniel, *The Legacy of Silence: Encounters with Children of the Third Reich* (Cambridge.: Harvard University Press, 1989).

Bartov, Omer, *The Eastern Front 1941–1945: German Troops and the Barbarisation of Warfare* (New York: St. Martin's Press, 1986).

——. *Hitler's Army: Soldiers, Nazis and War in the Third Reich* (New York: Oxford University Press, 1992).

——. *Murder in our Midst* (New York: Oxford University Press, 1996).

Baumann, Zygmunt, *Modernity and the Holocaust* (Ithaca: Cornell University Press, 1991).

Bechtold, Gerhard, "Das KZ als Modell des Zivilisationsprozesses," *Text und Kritik* 85/86 (January 1985).

Bier, Jean-Paul, *Auschwitz et les nouvelles littératures allemandes* (Brussels: Editions de l'Université de Brussels, 1979).

——. "The Holocaust, West Germany, and Strategies of Oblivion 1947–1979," in Rabinbach and Zipes, eds., *Germans and Jews*.

Bodeman, Y. Michael, ed., *Jews, Germans, Memory. Reconstruction of Jewish Life in Germany* (Ann Arbor: University of Michigan Press, 1996).

——. "A Reemergence of German Jewry?" in Gilman and Remmler, eds., *Reemerging Jewish Culture in Germany*.

——. "Reconstruction of History: From Jewish Memory to Nationalized Commemoration of Kristallnacht in Germany," in Bodeman, ed., *Jews, Germans, Memory*.

Böhm-Christl, Thomas, ed., *Alexander Kluge* (Frankfurt/Main: Suhrkamp, 1983).

Borneman, John and Peck, Jeffrey M., *Sojourners: The Return of German Jews and the Question of Identity* (Lincoln: University of Nebraska Press, 1995).

Bosmajian, Hamida, *Metaphors of Evil: Contemporary German Literature and the Shadow of Nazism* (Iowa City: University of Iowa Press, 1979).

Bosse, Ulrike, *Alexander Kluge. Formen literarischer Darstellung von Geschichte* (Frankfurt/Main: Peter Lang, 1989).

Bostein, Leon, "German Terrorism from Afar," *Partisan Review* XLVI, 2 (1979).

Bothe, Rolf, "Das Berlin Museum und sein Erweiterungsbau" in Feireiss, ed., *Erweiterung des Berlin Museums*.

Brad, Itzhak, Krakowski, Shmuel, and Spector, Shmuel, eds., *The Einsatzgruppen Reports* (New York: Holocaust Library, 1989).

Briegleb, Klaus, "Negative Symbiose," in Briegleb and Weigel, eds., *Gegenwartsliteratur*.

Briegleb, Klaus and Weigel, Sigrid, eds., *Gegenwartsliteratur seit 1968* (Munich: dtv, 1992).

Browning, Christopher R., *Ordinary Men: Reserve Police Battalion 101 and the Final Solution in Poland* (New York: Harper Perennial, 1992).

Bruck, Jan, "Brecht's and Kluge's Aesthetics of Realism," *Poetics* 17 (1988).

Büttner, Ursula, ed., *Das Unrechtsregime: Internationale Forschung über den Nationalsozialismus* (Hamburg: Hans Christians Verlag, 1986).

Butzer, Günter, *Fehlende Trauer. Verfahren epischen Erinnerns in der deutschsprachigen Gegenwartsliteratur* (Munich: Wilhelm Fink Verlag, 1998).

Cargas, Harry James, "The Holocaust in Fiction," in Friedman, ed., *Holocaust Literature*.

Carp, Stephanie, "Wer Liebe Arbeit nennt hat Glück gehabt. Zu Alexander Kluges Liebesprosa," in Böhm-Christl, ed., *Alexander Kluge*.

———. "Schlachtbeschreibungen: Ein Blick auf Walter Kempowski and Alexander Kluge," in Heer and Naumann, eds., *Vernichtungskrieg*.

Cernyak-Spatz, Susan E., *German Holocaust Literature* (New York: Peter Lang, 1985).

Collier, Peter and Geyer-Ryan, Helga, eds., *Literary Theory Today* (Ithaca: Cornell University Press, 1990).

Demetz, Peter, *After the Fires: Recent Writing in the Germanies, Austria and Switzerland* (New York: Harcourt, Brace, Jovanovich, 1986).

———. "Literature under the Occupation," in Schlant and Rimer, eds., *Legacies and Ambiguities*.

———. *Postwar German Literature: A Critical Introduction* (New York: Western Publishing, 1970).

Deutschkron, Inge, *Sie blieben im Schatten. Ein Denkmal für "stille Helden"* (Berlin: Edition Hentrich, 1996).

Diner, Dan, ed., *Ist der Nationalsozialismus Geschichte? Zu Historisierung und Historikerstreit* (Frankfurt/Main: Fischer, 1987).

———. "Negative Symbiose. Deutsche und Juden nach Auschwitz," in Diner, ed., *Ist der Nationalsozialismus Geschichte?*

———. ed., *Zivilisationsbruch. Denken nach Auschwitz* (Frankfurt/Main: Fischer, 1988).

Domansky, Elisabeth, "'Kristallnacht,' the Holocaust and Germany Unity: The Meaning of November 9 as an Anniversary in Germany," *History and Memory* 4 (1992).

Durzak, Manfred, ed., *Deutsche Gegenwartsliteratur: Ausgangspositionen und aktuelle Entwicklungen* (Stuttgart: Reclam, 1981).

———. "Formzüge des Initiationsromans. Zu Ortheils Roman Fermer," in Durzak and Steinecke, eds., *Hanns-Josef Ortheil*.

———. "Die Wiederentdeckung der Einzelgänger. Zu einigen 'Vaterfiguren' der deutschen Gegenwartsliteratur," in Durzak, ed., *Deutsche Gegenwartsliteratur*.

———. and Steinecke, Hartmut, eds., *Hanns-Josef Ortheil im Innern seiner Texte* (Munich: Piper, 1995).

Eagleton, Terry, *Literary Theory: An Introduction* (Minneapolis: University of Minnesota Press, 1983).

Elias, Norbert, *The Germans. Power Struggles and the Development of Habitus in the 19th and 20th Centuries*, trans. Eric Dunning and Stephen Mennell (1989; New York: Columbia University Press, 1996).

Elsaesser, Thomas, "subject positions, speaking positions: from *holocaust, our hitler,* and *heimat* to *shoah* and *schindler's list,*" in Sobchack, ed., *The Persistence of History.*

Enright, D. J., review of Bernhard Schlink in *The New York Review of Books,* March 26, 1998.

Evans, Richard J., "The New Nationalism and the Old History," *Journal of Modern History* 59 (December 1987).

Ezrahi, Sidra DeKoven, *By Words Alone: The Holocaust in Literature* (Chicago and London: University of Chicago Press, 1980).

Feireiss, Kristin, ed., *Erweiterung des Berlin Museums mit Abteilung Jüdisches Museum/Extension of the Berlin Museum with Jewish Museum Department* (Berlin: Ernst & Sohn Verlag, 1992).

Feldman, Lily Gardner, *The Special Relationship Between West Germany and Israel* (Boston: Allen & Unwin, 1984).

Fetscher, Iring, *Terrorismus und Reaktion* (Reinbek: Rowohlt, 1981).

Fetscher, Justus, Lämmert, Eberhard, and Schutte, Jürgen, eds., *Die Gruppe 47 in der Geschichte der Bundesrepublik* (Würzburg: Königshausen & Neumann, 1991).

Forever in the Shadow of Hitler? Original Documents of the "Historikerstreit," the Controversy Concerning the Singularity of the Holocaust, trans. James Knowlton and Truett Cates (1987; Atlantic Highlands, NJ: Humanities Press, 1993).

Frei, Norbert, *Vergangenheitspolitik. Die Anfänge der Bundesrepublik und die NS-Vergangenheit* (Munich: Beck, 1996).

Freud, Sigmund, "Mourning and Melancholia," in *The Standard Edition of the Complete Psychological Works of Sigmund Freud,* trans. James Strachey (London: Hogarth Press, 1953–74).

Frieden, Sandra, *Autobiography: Self into Form. German-Language Autobiographical Writing in the 1970s* (New York: Peter Lang, 1983).

Friedländer, Saul, *Memory, History, and the Extermination of the Jews of Europe* (Bloomington: Indiana University Press, 1993).

———. *Nazi Germany and the Jews.*Vol. 1: *The Years of Persecution 1933–1939* (New York: HarperCollins, 1997).

———. ed., *Probing the Limits of Representation: Nazism and the "Final Solution"* (Cambridge: Harvard University Press, 1992).

Friedman, Saul S., ed., *Holocaust Literature: A Handbook of Critical, Historical, and Literary Writings* (Westport, CT: Greenwood Press, 1993).

From Division to Unity. 1945–1990. An Illustrated Chronicle (Bonn: Presse- und Informationsamt der Bundesregierung, November 1992).

Fulbrook, Mary, *Piety and Politics: Religion and the Rise of Absolutism in England, Württemberg and Prussia* (Cambridge/London: Cambridge University Press, 1983).

Gehrke, Ralph, *Literarische Spurensuche. Elternbilder im Schatten der NS-Vergangenheit* (Opladen: Westdeutscher Verlag, 1992).

———. "Es ist nicht wahr, daß die Geschichte nichts lehren könnte, ihr fehlen bloß die Schüler," *Der Deutschunterricht* 44,3 (1992).

Gellately, Robert, *The Gestapo and German Society: Enforcing Racial Policy 1933–1945* (Oxford, Clarendon Press, 1990).

Geyer, Michael and Hansen, Miriam, "German-Jewish Memory and National Consciousness," in Hartman, ed., *Holocaust Remembrance.*

Gilman, Sander L. and Katz, Steven T., eds., *Anti-Semitism in Times of Crisis* (New York: New York University Press, 1991).

———. "German Reunification and the Jews," *new german critique* 52 (Winter 1991).

———. "Jewish Writers in Contemporary Germany: The Dead Author Speaks," *Studies in Twentieth Century Literature* 13.2 (1989).

———. *Jews in Today's German Culture* (Bloomington: Indiana University Press, 1995).

———. and Remmler, Karen, eds., *Reemerging Jewish Culture in Germany: Life and Literature since 1989* (New York: New York University Press, 1994).

———. and Zipes, Jack, eds., *Yale Companion to Jewish Writing and Thought in German Culture 1096–1996* (New Haven:Yale University Press, 1997).

Graafen, Birgit, *Konservatives Denken und modernes Erzählbewußtsein im Werk von Hermann Lenz* (Frankfurt/Main: Peter Lang, 1992).

Greiner, Ulrich, ed., *Über Wolfgang Koeppen* (Frankfurt/Main: Suhrkamp, 1976).

Grenville, John A. S., "Die 'Endlösung' und die 'Judenmischlinge' im Dritten Reich, in Büttner, ed., *Das Unrechtsregime*.

Grimm, Reinhold and Hermand, Jost, eds., *Basis 9. Jahrbuch für deutsche Gegenwartsliteratur* (Frankfurt/Main: Suhrkamp, 1979).

Haberkamm, Klaus, "Wolfgang Koeppen. 'Bienenstock des Teufels'—Zum naturhaft-mythischen Geschichts- und Gesellschaftsbild in den Nachkriegsromanen," in Wagener, ed., *Zeit-kritische Romane des 20. Jahrhunderts*.

Habermas, Jürgen, *The New Conservatism. Cultural Criticism and the Historians' Debate*, ed. and trans. Shierry Weber Nicholsen, introd. Richard Wolin (Cambridge: MIT Press, 1990).

Haidu, Peter, "The Dialectics of Unspeakability," in Friedländer, Saul, ed., *Probing the Limits*.

Handke, Peter, "Der Krieg ist nicht vorbei," in Kreuzer, eds., *Über Hermann Lenz*.

Hansen, Miriam, foreword to Oskar Negt and Alexander Kluge, *Public Sphere and Experience: Toward an Analysis of the Bourgeois and Proletarian Public Sphere* (Minneapolis: University of Minnesota Press, 1993).

Hartman, Geoffrey, ed., *Bitburg in Moral and Political Perspective* (Bloomington: Indiana University Press, 1986).

——. ed., *Holocaust Remembrance: The Shape of Memory* (Oxford: Blackwell, 1994).

Hartmann, Lily Maria von, "Auf der Suche nach dem Autor. Erzählstrukturen im Werk Gert Hofmanns," in Kosler, ed., *Gert Hofmann*.

Heer, Hannes and Naumann, Klaus, eds., *Vernichtungskrieg. Verbrechen der Wehrmacht 1941–1944* (Hamburg: Hamburger Edition, 1995).

Heimannsberg, Barbara and Schmidt, Christoph J., *The Collective Silence*, trans. Cynthia Oudejans Harris and Gordon Wheeler (1988; San Francisco: Jossey-Bass, 1993).

Helm, Ingo, "Literatur und Massenmedien," in Briegleb and Weigel, eds., *Gegenwartsliteratur*.

Herf, Jeffrey, *Divided Memory: The Nazi Past in the Two Germanys* (Cambridge: Harvard University Press, 1997).

Hermann, Ingo, ed., *Wolfgang Koeppen: Ohne Absicht* (Göttingen: Lamuv Verlag, 1994).

Hilberg, Raul, *The Destruction of the European Jews*, 3 vols. (New York: Holmes & Meier, 1985).

Hillgruber, Andreas, *Zweierlei Untergang. Die Zerschlagung des Deutschen Reiches und das Ende des europäischen Judentums* (Berlin: Siedler, 1986).

Hinderer, Walter, *Arbeit an der Gegenwart: Zur deutschen Literatur nach 1945* (Würzburg: Königshausen & Neumann, 1994).

Huyssen, Andreas, *After the Great Divide* (Bloomington: Indiana University Press, 1986).

——. "After the Wall: The Failure of German Intellectuals," *new german critique* 52 (Winter 1991).

——. "Alexander Kluge: An Analytic Storyteller in the Course of Time," in Huyssen, *Twilight Memories*.

——. "Monument and Memory in a Postmodern Age," in *The Art of Memory*.

——. "The Politics of Identification: 'Holocaust' and the West German Drama," in Huyssen, *After the Great Divide*.

——. Twilight Memories: Marking Time in a Culture of Amnesia (New York and London: Routledge, 1995).

In Pursuit of Justice: Examining the Evidence of the Holocaust (Washington, DC: United States Holocaust Memorial Council, 1996).

Jameson, Fredric, *The Political Unconscious: Narrative as a Socially Symbolic Act* (Ithaca: Cornell University Press, 1981).

Jarausch, Konrad, *The Rush to German Unity* (New York: Oxford University Press, 1994).

Jaspers, Karl, *The Question of German Guilt*, trans. E. B. Ashton (1946; New York: Dial Press, 1947).

Jens, Walter, "Totentanz in Rom," in Greiner, ed., *Über Wolfgang Koeppen.*

Johnson, Barbara, "The Surprise of Otherness: A Note on the Wartime Writings of Paul de Man," in Collier and Geyer-Ryan, eds., *Literary Theory Today.*

Jurgensen, Manfred, ed., *Grass; Kritik—Thesen—Analysen* (Bern: Francke, 1973).

Kaes, Anton, *From Hitler to Heimat: The Return of History as Film* (Cambridge: Harvard University Press, 1989).

——. "Holocaust and the End of History: Postmodern Historiography in Cinema," in Friedländer, ed., *Probing the Limits.*

Kaiser, Gerhard, *Pietismus und Patriotismus im literarischen Deutschland: Ein Beitrag zum Problem der Säkularisation* (Frankfurt/Main: Athenäum, 1975).

Kaplan, Marion A., *Between Dignity and Despair. Jewish Life in Nazi Germany* (New York: Oxford University Press, 1998).

Kittermann, David H., "Those who Said 'No!': Germans Who Refused to Execute Civilians during World War II," *German Studies Review* XI, 2 (May 1988).

Klemperer, Victor, *I Will Bear Witness. The Diaries*, trans. Martin Schalmers (1995; New York: Random House, 1998).

——. *LTI: Die unbewältigte Sprache* (Munich: dtv, 1969).

Klüger, Ruth, *weiter leben. Eine Jugend* (Munich: dtv, 1994).

Koehn, Ilse, *Mischling, Second Degree: My Childhood in Nazi Germany* (New York: Greenwillow Books, 1977).

Kogon, Eugen, *The Theory and Practice of Hell: The German Concentration Camps and the System behind Them*, trans. Heinz Norden (1946; New York: Octagon, 1973).

Kolinsky, Eva, "Remembering Auschwitz: A Survey of Recent Textbooks for the Teaching of History in German Schools," *Yad Vashem Studies* 22 (1992).

Kopelew, Lew, *Verwandt und verfremdet: Essays zur Literatur der Bundesrepublik und der DDR*, trans. Heddy Pross-Weerth (Frankfurt/Main: Fischer, 1976).

Köppen, Manuel, ed., *Kunst und Literatur nach Auschwitz* (Berlin: Erich Schmid Verlag, 1993).

Kosler, Hans Christian, ed., *Gert Hofmann: Auskunft für Leser* (Darmstadt/Neuwied: Luchterhand, 1987).

Krausnick, Helmut and Wilhelm, Hanns-Heinrich, eds., *Die Truppe des Weltanschauungskrieges* (Stuttgart: Deutsche Verlangsanstalt, 1981).

Kreuzer, Helmut and Kreuzer, Ingird, eds., *Über Hermann Lenz: Dokumente seiner Rezeption* (Munich: Wilhelm Fink Verlag, 1981).

Krondorfer, Björn, *Remembrance and Reconciliation. Encounters between Young Jews and Germans* (New Haven: Yale University Press, 1995).

LaCapra, Dominick, *Representing the Holocaust: History, Theory, Trauma* (Ithaca: Cornell University Press, 1994).

Ladd, Brian, *The Ghosts of Berlin: Confronting German Hiustory in the Urban Landscape* (Chicago: University of Chicago Press, 1997).

Laermann, Klaus, "Nach Auschwitz ein Gedicht zu schreiben, ist barbarisch," in Köppen, ed., *Kunst und Literatur.*

Langer, Lawrence L., *The Holocaust and the Literary Imagination* (New Haven: Yale University Press, 1975).

Lappin, Elena, ed., *Jewish Voices, German Words: Growing up Jewish in Postwar Germany and Austria* (North Haven, CT: Catbird Press, 1994).

Lauckner, Nancy A., "The Jew in Post-War German Novels. A Survey," *Leo Baeck Institute Yearbook* 20 (1975).

Lehnert, Herbert, "Die Gruppe 47. Ihre Anfänge und ihre Gründungsmitglieder," in Durzak, ed., *Deutsche Gegenwartsliteratur.*

Leonhardt, Rudolf Walter, "Aufstieg und Niedergang der Gruppe 47," in Durzak, ed., *Deutsche Gegenwartsliteratur.*

Letsch, Felicia, *Auseinandersetzung mit der Vergangenheit als Moment der Gegenwartskritik* (Cologne: Pahl-Rugenstein Verlag, 1982).

Libeskind, Daniel, "Between the Lines," in Feireiss, ed., *Erweiterung des Berlin Museums.*

Lichtenstein, Erwin, *Die Juden der Freien Stadt Danzig unter der Herrschaft des Nationalsozialismus* (Tübingen: J. C. B. Mohr, 1973).

Lorenz, Dagmar and Weinberger, Gabriele, eds., *Insiders and Outsiders: Jewish and Gentile Culture in Germany and Austria* (Detroit: Wayne State University Press, 1994).

Lützeler, Paul Michael and Schwarz, Egon, eds., *Deutsche Literatur in der Bundesrepublik seit 1965* (Königstein/Ts.: Athenäum, 1980).

———. "Von der Intelligenz zur Arbeiterschaft," in Lützeler and Schwarz, eds., *Deutsche Literatur.*

Lyotard, Jean-François, *Heidegger and "the jews,"* trans. Andreas Michel and Mark S. Roberts (1988; Minneapolis: University of Minnesota Press, 1990).

———. *The Postmodern Condition,* trans. Geoff Bennington and Brian Massumi (Minneapolis: University of Minnesota Press, 1984).

Maier, Charles S., *Dissolution. The Crisis of Communism and the End of East Germany* (Princeton: Princeton University Press, 1997).

———. *The Unmasterable Past: History, Holocaust, and German National Identity* (Cambridge: Harvard University Press, 1988).

Markovits, Andrei S. and Noveck, Beth Simone, "Rainer Werner Fassbinder's play *Garbage, the City and Death,* produced in Frankfurt, marks a key year of remembrance in Germany," in Gilman and Zipes, eds., *Yale Companion.*

———. Benhabib, Seyla, and Postone, Moishe, "Rainer Werner Fassbinder's *Garbage, the City and Death*: renewed Antagonisms in the Complex Relationship Between Jews and Germans in the Federal Republic of Germany," *new german critique* 38 (Spring/Summer 1986).

Mason, A. L., "The Artist and Politics in Günter Grass' Aus dem Tagebuch einer Schnecke," in O'Neill, Patrick, ed., *Critical Essays on Günter Grass.*

Meuschel, Sigrid, "The Search for 'Normality' in the Relationship between Germans and Jews," *new german critique* 38 (Spring/Summer 1986).

Mitscherlich, Alexander and Margarete, *The Inability to Mourn,* trans. Beverley R. Placzek (1967; New York: Grove Press, 1975).

Moeller, Robert G., "War Stories: The Search for a Usable Past in the Federal Republic of Germany," *The American Historical Review* 101,4 (October 1996).

Moritz, Rainer, *Schreiben, wie man ist: Hermann Lenz: Grundlinien seines Werkes* (Tübingen: Niemeyer, 1989).

Müller, Arnd, *Geschichte der Juden in Nürnberg 1146–1945* (Nürnberg: Selbstverlag der Stadtbibliothek Nürnberg, 1968).

Nägele, Rainer, *Heinrich Böll: Einführung in das Werk und in die Forschung* (Frankfurt/Main: Athenäum Fischer Taschenbuch Verlag, 1976).

Neumann, Bernd, "Die Wiedergeburt des Erzählens aus dem Geist der Autobiographie?" in Grimm and Hermand, eds., *Basis 9.*

Nolan, Mary, "The Historikerstreit and Social History," *new german critique* 44 (Spring/Summer 1988).

O'Neill, Patrick, ed., *Critical Essays on Günter Grass* (Boston: G. K. Hall, 1987).

Penves, Peter, Block, Richard, and Müller-Sievers, Helmut, eds., *Festschrift for Geza von Molnar* (Evanston: Northwestern University Press, 1998).

Pforte, Dietger, "Disunitedly United: Literary Life in Germany," *World Literature Today* 71, i (Winter 1991).

Philipp Jenninger's speech quoted in *Foreign Broadcast Information Service—Western Europe* 23 November 1988.

Pohrt, Wolfgang, "Der Härtling-Effekt," *Konkret* 11 (1985).

Rabinbach, Anson and Zipes, Jack, eds., *Germans and Jews since the Holocaust: The Changing Situation in West Germany* (New York: Holmes & Meier, 1986).

Rapaport, Lynn, *Jews in Germany after the Holocaust: Memory, Identity and Relations with Germans* (New York: Cambridge University Press, 1996).

Reich-Ranicki, Marcel, "Der Fall Wolfgang Koeppen," in Greiner, ed., *Über Wolfgang Koeppen.*

———. "Sentimentalität und Gewissensbisse," in Reich-Ranicki, *Lauter Verrisse* (Munich: Piper, 1970).

Remembrance, Sorrow, and Reconciliation. Speeches and Declarations in Connection with the 40th Anniversary of the End of the Second World War in Europe (Bonn: Press and Information Office of the Government of the Federal Republic of Germany, n.d.).

Remmler, Karen, "The 'Third Generation' of Jewish-German Writers after the Shoah Emerges in Germany and Austria," in Gilman and Zipes, eds., *Yale Companion.*

Renn, Walter, "The Holocaust in the School Textbooks of the Federal Republic of Germany," in Friedman, ed., *Holocaust Literature.*

Richner, Thomas, *Der Tod in Rom: Eine existential-psychologische Analyse von Wolfgang Koeppens Roman* (Zurich/Munich: Artemis Verlag, 1982).

Rohde, Hedwig, "Warten als Lebenshaltung," in Kreuzer, eds., *Über Hermann Lenz.*

Rosenfeld, Alvin H., *A Double Dying: Reflections on Holocaust Literature* (Bloomington: Indiana University Press, 1980).

———. and Greenberg, Irving, eds., *Confronting the Holocaust: The Impact of Elie Wiesel* (Bloomington: Indiana University Press, 1978).

———. "The Problematics of Holocaust Liteature" in Rosenfeld and Greenberg, eds., *Confronting the Holocaust.*

Santner, Eric L., *Stranded Objects: Mourning, Memory, and Film in Postwar Germany* (Ithaca: Cornell University Press, 1990).

Schäfer, Hans Dieter, "Hinweis auf Hermann Lenz," in Kreuzer, eds., *Über Hermann Lenz.*

Schlant, Ernestine and Rimer, J. Thomas, eds., *Legacies and Ambiguities: Postwar Fiction and Culture in West Germany and Japan* (Washington, DC/Baltimore: The Woodrow Wilson Center Press/The Johns Hopkins University Press, 1991).

Schmelzkopf, Christiane, *Zur Gestaltung jüdischer Figuren in der deutschsprachigen Literatur nach 1945* (Hildesheim: Georg Olms Verlag, 1983).

Schneider, Michael, "Fathers and Sons, Retrospectively: The Damaged Relationship between Two Generations," trans. Jamie Owen Daniel, *new german critique* 31 (Winter 1984).

Schneider, Peter, "Concrete and Irony," *Harper's Magazine* April 1990.

———. "Hitler's Shadow: On Being a Self-Conscious German," *Harper's Magazine* September 1987.

Schröter, Klaus, *Heinrich Böll: in Selbstzeugnissen und Bilddokumenten* (Reinbek: Rowohlt, 1992).

Schülein, Johann August, "Von der Studentenrevolte zur Tendenzwende oder der Rückzug ins Private: eine sozialpsychologische Analyse," *Kursbuch* (1977).

Schwab-Felisch, Hans, "Efraim und Andersch," *Merkur* 10 (1967).

Sebald, Winfried Georg, "Konstruktiioned der Trauer: Zu Günter Grass, 'Tagebuch einer Schnecke' und Wolfgang Hildesheimer 'Tynset,' " *Der Deutschunterrricht* 35,5 (October 1983).

Siblewski, Klaus, ed., *Martin Walser. Auskunft* (Frankfurt/Main: Suhrkmap, 1991).

Sichrovsky, Peter, *Born Guilty: Children of Nazi Families*, trans. J. Steinberg (1986; New York: Basic Books, 1988).

Sobchack, Vivian, ed., *The Persistence of History: Cinema, Television, and the Modern Event* (New York: Routledge, 1996).

Spiegelman, Art, *Maus: A Survivor's Tale* (New York: Pantheon, 1986).

Steiner, George, *Language and Silence* (New York: Atheneum, 1974).

———. review of Robert Musil in *The New Yorker*, April 17, 1995.

Stern, Frank, *The Whitewashing of the Yellow Badge: Antisemitism and Philosemitism in Postwar Germany*, trans. William Templer (1991; Oxford/New York Pergamon Press, 1992).

Stern, Fritz, *Dreams and Delusions* (New York: Alfred Knopf, 1987).

———. *The Failure of Illiberalism* (New York: Alfred Knopf, 1972).

Stern, Guy, "Non-Jewish Germans in the Service of Present-Day Jewish Causes: A Footnote to German Cultural History," in Penves, Block, and Müller-Sievers, eds., *Festschrift*.

———. "The Rhetoric of Anti-Semitism," in Gilman and Katz, eds., *Anti-Semitism*.

Stoltzfus, Nathan, *Resistance of the Heart: Intermarriage and the Rosenstrasse Protest in Nazi Germany* (New York: Norton & Co., 1996).

Streit, Christian, *Keine Kamaraden. Die Wehrmacht und die sowjetischen Kriegsgefangenen 1941–1945* (Stuttgart: Deutsche Verlagsanstalt, 1978).

Tank, Lothar, "Deutsche Politik im literarischen Werk von Günter Grass," in Jurgensen, ed., *Grass*.

Texte zur Deutschlandpolitik. Reihe III, Band 8a (Bonn: Bundesministerium für innerdeutsche Beziehungen, 1991).

Torpey, John, "Introduction: Habermas and the Historians," *new german critique* 44 (Spring/Summer 1988).

Toury, Jacob, "Ein Auftakt zur 'Endlösung:' Judenaustreibungen über nichtslawische Reichsgrenzen 1933 bis 1939" in Büttner, ed., *Das Unrechtsregime*.

Trautwein, Joachim, *Religiosität und Sozialstruktur. Untersucht anhand der Entwicklung des württembergischen Pietismus* (Stuttgart: Calwer Verlag, 1972).

Treichel, Hans-Ulrich, *Fragment ohne Ende: Eine Studie über Wolfgang Koeppen* (Heidelberg: Carl Winter Universitätsverlag, 1984).

Vormweg, Heinrich, "Deutsche Literatur 1945–1960: Keine Stunde Null," in Durzak, ed., *Deutsche Gegenwartsliteratur*.

Wagener, Hans, ed., *Zeitkritische Romane des 20. Jahrhunderts: Die Gesellschaft in der Kritik der deutschen Literatur* (Stuttgart: Reclam, 1975).

Walk, Joseph, *Das Sonderrecht für die Juden im NS-Staat: Eine Sammlung der gesetzlichen Maßnahmen und Richtlinien* (Heidelberg/Karlsruhe: C. F. Müller, 1981).

Wehdeking, Volker, "Ortheils Abschied von den Kriegsteilnehmern als Generationskonflikt und Geschichtslektion," in Durzak and Steinecke, eds., *Hanns-Josef Ortheil*.

Westerhagen, Dörte von, *Die Kinder der Täter* (Munich: Kösel, 1987).

White, Hayden, "the modernist event," in Sobchack, ed., *The Persistence of History*.

Wilhelm, Hanns-Heinrich, "Die Einsatzgruppe A der Sicherheitspolizei und des SD 1941–42: eine exemplarische Studie," in Krausnick and Wilhelm, eds., *Die Truppe*.

Williams, Arthur, Parkes, Stuart, and Smith, Roland, eds., *Literature on the Threshold: The German Novel in the 1980s* (New York: Berg, 1990).

Wittgenstein, Ludwig, *Tractatus logico-philosophicus* (1921; Frankfurt/Main: Suhrkamp, 1966).

Young, James E., "The Counter-Monument: Memory against Itself in Germany Today," *Critical Inquiry* 18,2 (Winter 1992).

———. *The Texture of Memory: Holocaust Memorials and Meaning* (New Haven: Yale University Press, 1993).

Zipes, Jack, "The Contemporary German Fascination for Things Jewish: Toward a Jewish Minor Culture," in Gilman and Remmler, eds., *Reemerging Jewish Culture in Germany*.

———. "The Negative German-Jewish Symbiosis," in Lorenz and Weinberger, eds., *Insiders and Outsiders*.

———. "The Return of the Repressed," *new german critique* 31 (Winter 1984).

Index